APOSTLES OF BEAUTY: ARTS AND CRAFTS FROM BRITAIN TO CHICAGO

APOSTLES OF BEAUTY
ARTS AND CRAFTS
FROM BRITAIN TO CHICAGO

EDITED BY JUDITH A. BARTER ❦ WITH ESSAYS BY
JUDITH A. BARTER, SARAH E. KELLY, ELLEN E. ROBERTS,
BRANDON K. RUUD, AND MONICA OBNISKI

THE ART INSTITUTE OF CHICAGO
YALE UNIVERSITY PRESS, NEW HAVEN AND LONDON

Apostles of Beauty: Arts and Crafts from Britain to Chicago was published in conjunction with an exhibition of the same title organized by and presented at the Art Institute of Chicago from November 7, 2009, to January 31, 2010.

Support for this exhibition is generously provided in part by the Terra Foundation for American Art.

First edition
Printed in Belgium
Library of Congress Control Number: 2009905955
ISBN: 978-0-300-14113-9

Published by
The Art Institute of Chicago
111 South Michigan Avenue
Chicago, Illinois 60603-6404
www.artic.edu

Distributed by
Yale University Press
302 Temple Street, P.O. Box 209040
New Haven, Connecticut 06520-9040
www.yalebooks.com

Produced by the Publications Department of the Art Institute of Chicago,
Robert V. Sharp, Executive Director

Edited by Elizabeth Stepina and Susan Rossen
Production by Carolyn Ziebarth and Kate Kotan
Photography research by Joseph Mohan and Molly Heyen

Designed and typeset by Joan Sommers Design, Chicago, Illinois
Separations by Professional Graphics, Rockford, Illinois
Printing and binding by Die Keure, Bruges, Belgium

This book was made using paper and materials certified by the Forest Stewardship Council, which ensures responsible forest management.

Front jacket: Frank Lloyd Wright, *Tree of Life Window*, 1904, detail (cat. 171); back jacket: Marblehead Pottery, *Vase*, c. 1909 (cat. 90); details: p. 2: cat. 159; p. 6: cat. 70; p. 9: cat. 95; p. 45: cat. 37; p. 83: cat. 57; p. 119: cat. 146; p. 151: cat. 150.

All works in the collection of the Art Institute of Chicago were photographed by the Department of Imaging, Christopher Gallagher, Associate Director. All works in the collection of Crab Tree Farm were photographed by Jamie Stukenberg, Professional Graphics, Inc., except the following: cat. 4: Paul Reeves; cats. 58–59, 101, 113, 136, 138, 141, 144–145: Andy Johnson of A. J. Photographics. Unless otherwise noted, all remaining works from public or private collections appear courtesy of those institutions. Every effort has been made to contact and acknowledge copyright holders for all reproductions.

CONTENTS

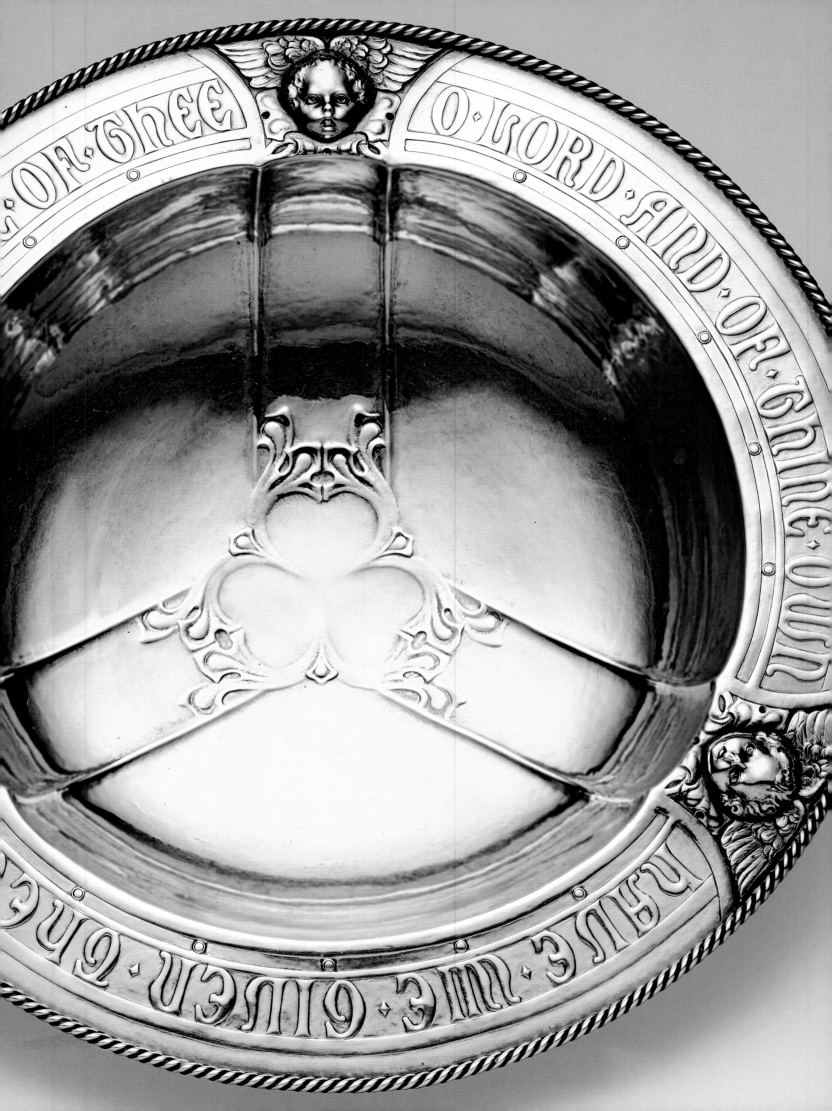

PREFACE and ACKNOWLEDGMENTS

FEATURING NEARLY TWO HUNDRED OBJECTS IN A wide variety of media, *Apostles of Beauty: Arts and Crafts from Britain to Chicago* showcases works drawn exclusively from institutional and private collections in the Chicago area. This comprehensive group of works reflects the scope of the Arts and Crafts movement, from the return to handcraftsmanship and historical revivals that formed its impetus in nineteenth-century Britain, to the communal associations and the therapeutic proselytizing in the United States of Gustav Stickley, the Roycrofters, and the Art Pottery movement, to the ramifications on Chicago's art and culture. In many ways, the city can be considered a nexus of Arts and Crafts. In the 1890s, it was home to a wide range of people and organizations committed to progressive beliefs and to changing the social order. Indeed, the experiments of Chicago's architects, artists, designers, educators, philosophers, and reformers fit perfectly within a larger cultural shift at the turn of the nineteenth to the twentieth century, described by historian T. J. Jackson Lears as a recoil from capitalism's over-civilized, spiritually empty modern society. The interest of Arts and Crafts practitioners in preindustrial societies eventually led to progressive reform of the arts and culture and a new understanding of what was modern. The five distinct essays in this catalogue address some of the many viewpoints and influences—commercialism, medievalism, Japanism, socialism, and utopianism— that permeated the Arts and Crafts movement and are woven together in objects crafted between 1840 and 1926.

Exhibitions drawn from museums and private collections provide curators with great opportunities and pleasure. Chicago's many distinguished institutional and private collectors allowed colleagues to share their expertise and come together in common cause. I am grateful to my colleagues at the Art Institute whose departments lent so generously: Jack Brown and Christine Fabian, Ryerson and Burnham Libraries; Christopher Monkhouse and Ghenete Zelleke, European Decorative Arts; Suzanne McCullagh, Martha Tedeschi, Harriet Stratis, Christine Conniff-O'Shea, and Kristi Dahm, Prints and Drawings; Christa Thurman and Lauren Chang, Textiles; Richard Townsend and Elizabeth Pope, African and Amerindian Art; Douglas Druick and Gloria Groom, Medieval through Modern European Painting and Sculpture; Joseph Rosa, Architecture and Design; Matthew Witkovsky, Elizabeth Siegel, and Newell Smith, Photography. In the Publications Department, Elizabeth Stepina and Susan Rossen diligently edited the manuscript, and Carolyn Ziebarth, Sarah Guernsey,

Kate Kotan, Joseph Mohan, and Molly Heyen coordinated production and photography for objects in private collections and cleared the rights for the images. In the Imaging Department, Caroline Nutley supplied photographs from the permanent collection. I would also like to thank Art Institute photographers Robert Hashimoto and Robert Lifson, as well as Jamie Stukenberg of Professional Graphics. In Museum Registration, Darrell Green and Patricia Loiko coordinated travel and shipment of the art. Conservators Suzanne Schnepp and Kirk Vuillemot prepared the works for display. In the Graphic Design Department, Lyn DelliQuadri and Jeff Wonderland contributed to the design of the exhibition's labels and signage. Markus Dohner designed the installation, and the Art Institute's amazing painters and carpenters, under the direction of William Caddick, transformed the spaces. Finally, I would like to thank President and Eloise W. Martin Director James Cuno, as well as Meredith Mack, Dorothy Schroeder, Jeanne Ladd, and Julie Getzels.

Chicago's institutional lenders extended their collegiality from start to finish. I am grateful to Cheryl Bachand and Brian Reis, Frank Lloyd Wright Preservation Trust; Julie Katz, Chicago History Museum; Richard Born and Angela Steinmetz, David and Alfred Smart Museum of Art, University of Chicago; Scott Krafft, McCormick Library of Special Collections, Northwestern University; Ann Weller, Special Collections, University of Illinois at Chicago Library; Alice Schreyer and Patti Gibbons, Special Collections Research Center, University of Chicago Library; Donald Santelli, the Cliff Dwellers Club; Margot Navolio, Allison Johnson, and Linda Celesia, the Fortnightly of Chicago; William Tyre, Glessner House Museum; and Ira Simon for both his generosity and counsel. I am also indebted to Nancy McClelland of McClelland-Rachen for sound advice.

Special thanks are reserved for John H. Bryan, Jr., who provided access to the extraordinary collections of Crab Tree Farm. These marvelous objects form almost a quarter of the checklist, and the exhibition and book would not have been possible without John's enthusiasm for the project and his love of the Arts and Crafts movement. Tom Gleason, Jan Toftey, Marcia Kronenberg, and the rest of the Crab Tree Farm staff provided hours of assistance to help bring the project to fruition. My sincere thanks also go to John Bryan III.

Finally, I would like to thank the staff of the American Art Department. Denise Mahoney applied her sophisticated organizational skills to maintaining data files. Christopher Shepherd and Abraham Ritchie oversaw the meticulous installation of the objects. Monica Obniski was diligent in bringing so many important research threads and details together in important overviews for the project. She, and my other coauthors, Sarah Kelly, Ellen Roberts, and Brandon Ruud, provided the research and the shape of this volume based on their own areas of expertise. I appreciate their intelligence, hard work, intellectual sharing, and unfailing congeniality in this departmental effort.

Judith A. Barter
FIELD-MCCORMICK CHAIR AND CURATOR OF AMERICAN ART
THE ART INSTITUTE OF CHICAGO

CHAPTER ONE ❧ JUDITH A. BARTER

BRITISH HISTORICISM AND THE ROAD TO MODERNISM

THE TERM *ARTS AND CRAFTS* WAS COINED by English bookbinder T. J. Cobden-Sanderson and was first used as the title for the Arts and Crafts Exhibition Society in 1887. The society was created to provide an educational and public face for the Art Workers' Guild, organized in 1884 by architects and designers to promote unity among the various arts, and to host regular exhibitions of good design that would inspire the public and create income for the exhibitors. The first exhibition was held in the New Gallery, London, in 1888.[1]

It was no accident that the Arts and Crafts movement began in Victorian England, the cradle of the industrial revolution, the heart of mechanization, and the epitome of capitalist ownership of the means of production. The movement was far more a philosophy than a style, although, as we shall see, it permeated many artistic forms. All Arts and Crafts productions—decorative arts, furniture, painting, and textiles—sprang from anti-industrialism and the glorification of the worker. Especially in Britain, the movement expressed uneasiness with, and provided a moral critique of, the values of Victorian society. At its inception, it centered on the redefinition of work: the authority of the craftsman-artist over the capitalist factory owner; the preference for handmade rather than machine-produced objects; and the theory that beauty unifies by providing moral uplift for people of all classes. To find models for such a utopian society, Arts and Crafts designers and philosophers returned to historical antecedents.

However, as the historian Edward Palmer Thompson pointed out, the philosophically radical nature of the Arts and Crafts movement was diluted by its lack of a political base. Thompson saw it as a revolution without revolutionaries.[2] Its leaders—humane, cultured, educated individuals—belonged to the moneyed class, yet they sought to liberate the working class. Becoming laborers themselves often put them at odds with the social expectations of their own rank. Consequently, most of the Arts and Crafts movement's major practitioners were academically trained architects and designers who employed others to do their craft work. As the movement progressed, and especially as it became prevalent in America, several designers began to incorporate mechanical processes into their production methods, using machinery to help create "handmade" wares. It was not the machine per se that they opposed, but the dehumanization of factory work. This break from the initial

anti-industrial approach of production reveals the tension between past models and modern innovations that was inherent to the Arts and Crafts movement. Additionally, the rise of department stores and the wider availability of serial publications, such as Gustav Stickley's *Craftsman*, increased the audience for new design models. Among these were examples from previously unfamiliar cultures, such as Japan, as well as works in new media, such as the burgeoning realm of photography. In their reinterpretation of past crafts and styles, Arts and Crafts practitioners may have been inspired by historical models, but they were creating objects for an ever-increasing climate of modernization.

BRITISH BEGINNINGS

The roots of the Arts and Crafts movement trace back to the mid-nineteenth century, when reformers, seeking to express a sense of mysticism and faith, were drawn to art forms and techniques associated with Roman Catholicism. In England, where the monarchy was the titular head of both the Anglican Church and the state, to support Catholicism was to revolt against the establishment. Both John Henry Cardinal Newman, an Oxford University don who led the academic rebellion against the status quo, and Henry Edward Cardinal Manning, a champion of workers, were former Anglican clergymen who turned to the Roman Catholic Church looking for a purer expression of faith, and, in Manning's case, advocating a new sense of social justice.

In his writings, architect and designer Augustus Welby Northmore Pugin embraced Catholicism, finding in it a connection to the medievalism that influenced his designs. Pugin imagined the Gothic world, with its great cathedrals and art dedicated to God, as a society in which individual talent and craft were honored. Compared to his own time, that era seemed purer, less corrupt. He designed buildings covered in brightly colored "medieval" ornament, such as the Saint Giles Church, Cheadle (SEE FIG. 1), and the more famous interiors of the Houses of Parliament, which he finished in 1852.[3] The interior of Saint Giles Church is clad in specially produced encaustic floor tiles and enameled and gilt wall tiles by Minton and Company. Pugin designed tableware in the Gothic taste for Minton, including a prototype for a dessert plate (FIG. 2) with a lobed quatrefoil border and polychromatic floral decoration.[4] In an effort to create harmonious Gothic works, he also designed oak hall chairs (FIG. 3), some with leather seats and brass nail trim, and gilt and enameled goblets set with semiprecious stones (FIG. 4). Like the interior of Saint Giles, a cabinet designed by Pugin's contemporary William Burges and painted by Nathaniel Westlake (FIG. 5) is a brilliantly colored and gilt fantasy of what the Victorians believed Gothic furniture looked like. Yet artistic license and humor pervade: the cabinet was intended as both a traditional sideboard and a more modern wine cupboard. Its theme, the martyrdom of "Saint Bacchus,"

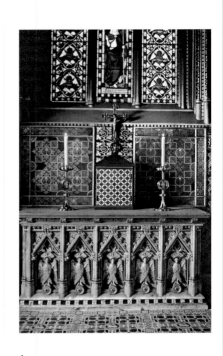

1

Augustus Welby Northmore Pugin, interior altar of Saint Giles Church, Cheadle, Staffordshire, England, 1841–46.

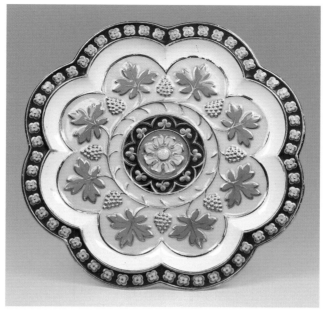

2
Augustus Welby Northmore Pugin
Minton and Company
Dessert Plate
c. 1849
The David and Alfred Smart Museum
of Art, Chicago
Cat. 108

3
Augustus Welby Northmore Pugin
Hall Chair
c. 1840
Private collection
Cat. 107

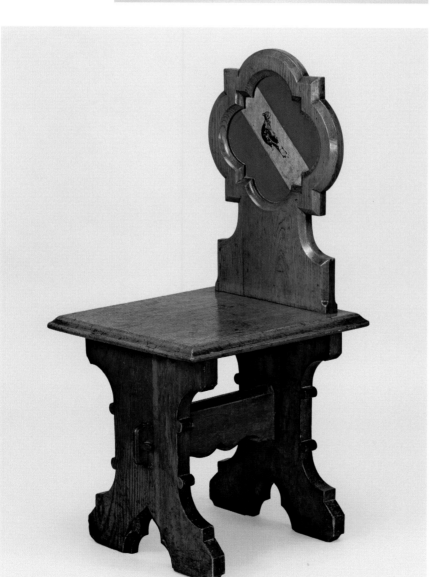

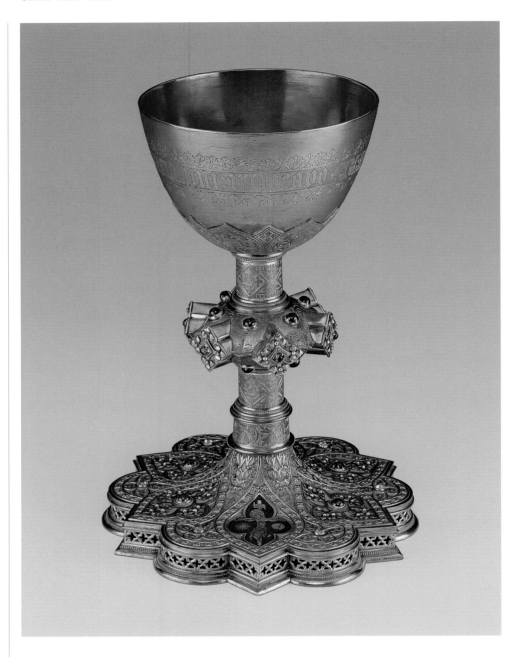

4
Augustus Welby Northmore Pugin
John Hardman and Company
Model Chalice
c. 1849
The Art Institute of Chicago
Cat. 109

blends pagan and Christian concepts that celebrate the benefits of wine and the miracles performed by the "saint" for the inebriated.[5] Eventually, Bacchus is "martyred" when pushed into a wine barrel and drowned.

Anxiety about the effects of industrialization also runs through the writings of Thomas Carlyle. In *Past and Present* (1841), Carlyle explored the dehumanization of society, comparing the life of a medieval abbot in a monastic community to the world of contemporary man. According to the author, the superiority of the monastery's social organization was owed to its emphasis on spiritual values and the importance and dignity of each member, whereas Victorian culture was impersonal and motivated only by economic gain. While Carlyle believed in the worth of the

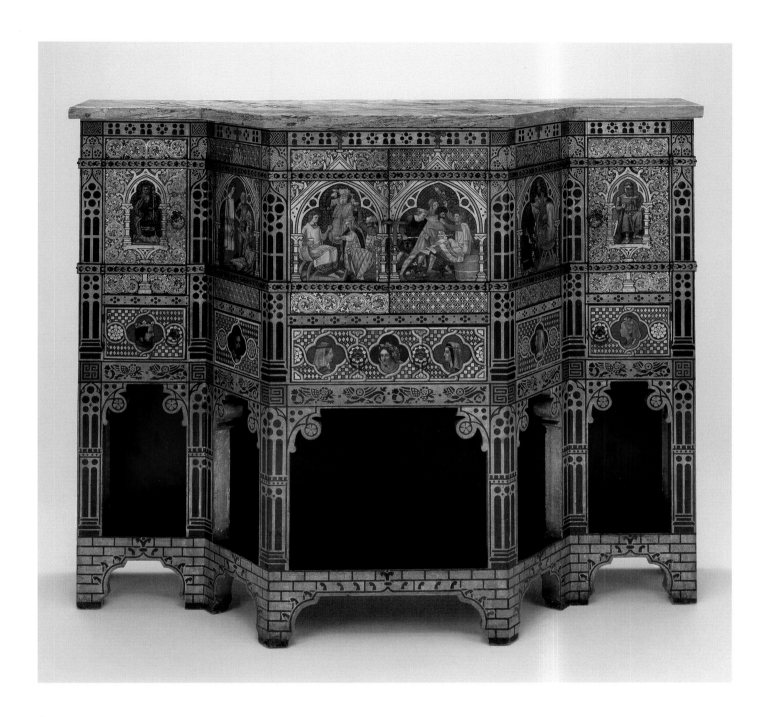

5
Designed by William Burges
Painted by Nathaniel Hubert John
Westlake
Made by Harland and Fisher
Sideboard and Wine Cabinet
1859
The Art Institute of Chicago
Cat. 21

individual, he also decried the isolating force of individualism and longed for a communal social system. Carlyle's ideas influenced two other utopian thinkers, John Ruskin and William Morris, and would eventually contribute significantly to the Socialist movement in Britain.[6]

Like Carlyle, Ruskin romanticized the medieval world. He became Oxford University's first art-history professor in 1869 after publishing books on the moral importance of architecture, including *The Seven Lamps of Architecture* (1849) and *The Stones of Venice* (1851). In the latter, he promoted "decorated Gothic" as the purest form of architecture, preferable to classical or Renaissance building styles. His essay "On the Nature of Gothic," published in the second volume of *Stones* (1853), influenced an entire generation of artists. In it he argued that in the Gothic period, a more humane means of artistic expression evolved that reflected positive cultural values. Ruskin revered Gothic architecture because its ornamentation was integral to the building, rather than merely applied to its surface. He believed that the forms of decoration must reflect the forms of the architecture (anticipating Louis Sullivan's famous phrase "form follows function," which would prove so important to modern architects) and that ornament must be based on nature. But above all Ruskin extolled Gothic art because it was handmade by trained craftsmen rather than manufactured by a production line of unskilled workers. Ruskin and Carlyle believed that mechanization, standardization, and the emphasis on the economic value of work that characterized the factory system had ruined the crafts-man's ability to be in charge of his own labor and had robbed him of dignity.[7]

Ruskin's impact prompted the formation in 1848 of the Pre-Raphaelite Brotherhood, a fellowship of artists—including William Holman Hunt, John Everett Millais (who later married Ruskin's estranged wife), and Dante Gabriel Rossetti—who based their compositions on ancient stories with moral overtones.[8] Ruskin sup-ported their work by giving it favorable reviews and providing financial backing. The July 1851 issue of London's *Art-Journal* called the group "the Gothic school, or that school which might be engendered by the contemplation of monumental brasses or ancient stained glass windows, where the objects are flat, and inlaid, and coloured without any reference to harmony or chiaro-oscuro [*sic*]."[9] As a group, these artists sought to return to the simplicity of early Italian painting, mixed with a devotion to nature and an emotional purity achieved through symbolism. Rossetti's *Beata Beatrix* (FIG. 6) is a prime example of this style. Ten years after the death of his wife, Elizabeth Siddal, Rossetti was inspired to create this allegorical portrait of her, which references the thirteenth-century poet Dante Alighieri's love for Beatrice, his unattainable muse.

The Pre-Raphaelite circle later expanded to include Sir Edward Burne-Jones and William Morris. Burne-Jones learned to paint in London under Rossetti's guidance, but later turned to decorative arts. His skill in translating his artistic vision into materials such as stained glass can be seen in a cartoon for a window in the Lady

6
Dante Gabriel Rossetti
Beata Beatrix
1872
The Art Institute of Chicago
Cat. 116

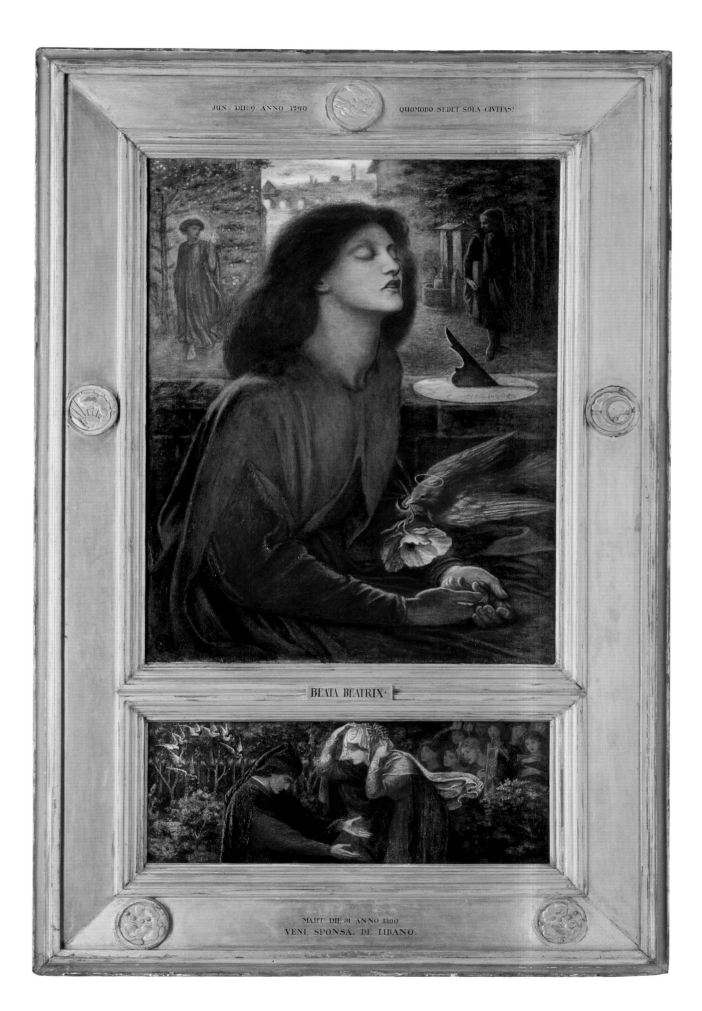

Chapel, Christ Church Cathedral, Oxford (FIGS. 7–8), which features a contemplative figure in a robe with exaggerated folds. Morris, the leading proponent of Ruskin's social-reform theories, would become the single most influential figure in the early Arts and Crafts movement. His early interest in becoming a priest sparked his attraction to Gothic architecture. He first trained as an architect and then as a painter, but finally found his true calling, when, in the spring of 1861, he and Burne-Jones—along with architect Philip Webb; painters Rossetti, Ford Maddox Ford, and Peter Paul Marshall; and university professor Charles Faulkner—joined together to decorate Morris's austere, red-brick country home, known as the Red House, in Bexleyheath, Kent.[10] This collaboration proved fruitful, and the men soon formed a professional design partnership. Morris, Marshall, Faulkner, and Company advertised as Fine Arts Workmen, effectively erasing the division between fine art and craft.[11] Morris opened a shop in Bloomsbury in 1865, and one of the firm's first commissions was the Green Dining Room (1867) made for the South Kensington Museum, today known as the Victoria and Albert. The complementary ceiling decoration, cornice, furniture, painted tiles, stained glass, and wallpaper created a unified ensemble, which became one of the hallmarks of the Arts and Crafts movement.

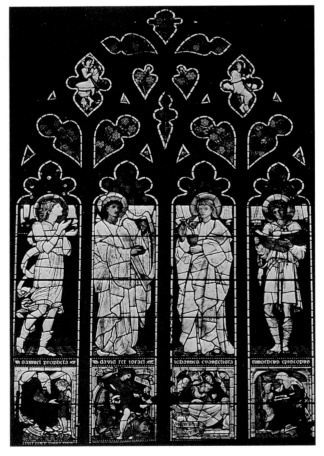

7
Sir Edward Burne-Jones
Timothy (Cartoon for the Vyner Memorial Window, Lady Chapel, Christ Church, Oxford)
March 1872
The Art Institute of Chicago
Cat. 23

8
Sir Edward Burne-Jones, Vyner Memorial Window, Lady Chapel, Christ Church, Oxford, 1872–73.

Renamed Morris and Company in 1875, the firm continued to serve as one of the premier suppliers of Arts and Crafts wares for many years. The company undertook architectural carving, embroidery and other textiles, furniture design, hand-printed wallpapers, metalwork, painted mural decoration, and stained glass. Webb designed much of the furniture, metalwork, and tiles. Morris's wife, Jane Burden, executed many of the firm's embroideries; their youngest daughter, May, eventually became head of the embroidery department in 1885. Additionally, John Henry Dearle designed textiles and became art director and chief pattern designer after Morris's death in 1896. It is likely that Dearle designed and May Morris approved the patterns for poppy-, anemone-, and poppy-and-briony-patterned embroideries that were once part of a folding screen (FIG. 9). The delicate color effects seen in these examples resulted from William Morris's refusal to use the commercially available aniline dyes popular in Britain at the time. Instead, he worked with Thomas Wardle at his Hencroft Dye Works to develop natural dyes for silks and wools.

In addition to honoring the union of work, craft, and the dignity of the artisan, Morris believed that a rebirth of craftsmanship would provide a leveling influence on Britain's class system. In one of his last lectures, Morris acknowledged, "We are living in an epoch where there is combat between commercialism, or the system of reckless waste, and communism, or the system of neighbourly common sense."[12] An avid believer in socialism, Morris hoped that the restoration of purity to work and the desire of all classes for handmade beauty in the home would be steps toward the common ownership of all property and a classless society.[13] "I do not want art for a few, any more than education for a few, or freedom for a few," he declared. Morris's motto, "Have nothing in your houses that you do not know to be useful, or believe to be beautiful," became the byword for the unified, simplified home decorated with natural patterns and materials made by craftsmen.[14]

The problem with Morris's beautiful, handmade objects was that they were more expensive to produce than machine-made items. Ironically, only the wealthy could afford Morris's products. Warington Taylor, who became Morris's business manager in 1865, seems to have been aware of the disparities between good design, quality craftsmanship, and affordability. He complained of the cost and impracticality of the firm's painted, heavy, oak furniture, saying, "It is hellish wickedness to spend 15/- on a chair when the poor are starving in the street . . . ," and proposed that the firm design lighter, simpler pieces based on traditional rural forms.[15] To cut time and costs, the company eventually used machinery to shape certain parts of furniture, while the artists concentrated on the design work. Inspired by rustic seventeenth- and eighteenth-century furniture and crafts, Morris and his followers began to plant the first seeds of change in the Arts and Crafts movement, as medieval prototypes began to be replaced by more practical "country" styles. One of the firm's simpler pieces is a chair designed by Rossetti after Sussex country models (SEE FIG. 10). Made of ebonized beech with a rush seat, the chair emulates eighteenth-

9

Attributed to John Henry Dearle

Morris and Company

Three Panels Entitled "Poppy,"
"Anemone," and "Poppy and Briony"

1885/90

Collection of Crab Tree Farm

Cat. 96

century country furniture. A drawing by Rossetti depicts Morris's wife, Jane Burden (who often posed for Rossetti and later left Morris to live with the painter), seated in the chair (SEE FIG. 11). Variants of this popular chair continued to be made by the firm long after Morris's death. Taylor also suggested to designer Philip Webb that he create an adjustable chair similar to one he had seen belonging to an old Sussex carpenter. The result was an adjustable-back chair (FIG. 12), which features slats across the seat and back to hold cushions and an adjustable bar and groove system to change the reclining angle.[16]

The Gothic Revival style, however, remained particularly dominant in the company's textile designs. While Burne-Jones preferred to design figurative panels such as *Pomona* (FIG. 13), Morris, influenced by Ruskin's emphasis on the beauty of nature, preferred patterns derived from flora and fauna. Morris's printed panels, such as *Snakeshead* (CHECKLIST, CAT. 93) or *Peacock and Dragon* (CHAPTER 2, FIG. 4), display a dense, sinuous interweaving of stylized and repeated organic forms akin to late-medieval millefleurs tapestries. Two later block-printed cotton

10
Attributed to Dante Gabriel Rossetti
Morris, Marshall, Faulkner, and Company
Sussex Armchair
c. 1863
Collection of Crab Tree Farm
Cat. 91

11
Attributed to Dante Gabriel Rossetti
Mrs. William Morris Seated in Chair
May 1870
The Art Institute of Chicago
Cat. 115

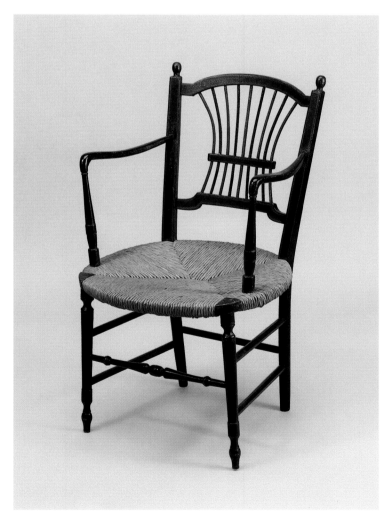

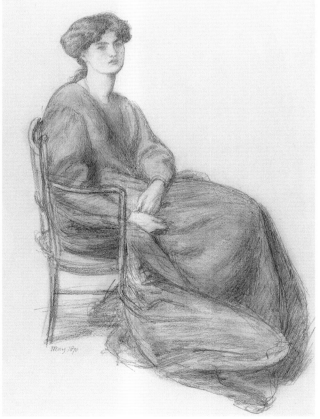

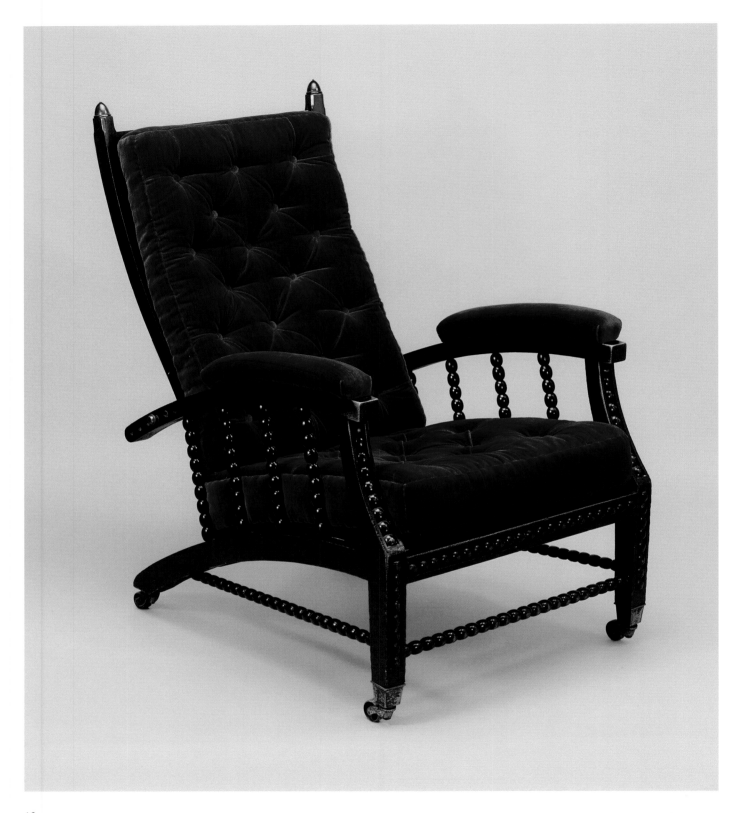

12
Philip Webb
Morris, Marshall, Faulkner, and
Company
Adjustable-Back Chair
c. 1866
Collection of Crab Tree Farm
Cat. 92

panels entitled *Cray* (FIG. 14) exhibit the meandering, flattened, ornamental quality of seventeenth-century Italian silks and velvets that Morris had seen in the South Kensington Museum.[17] Requiring thirty-four blocks, *Cray* was the most complicated, and therefore the most expensive, pattern ever printed at the Merton Abbey Workshop, opened in 1881. Despite its cost, it was one of the firm's most popular fabrics.[18]

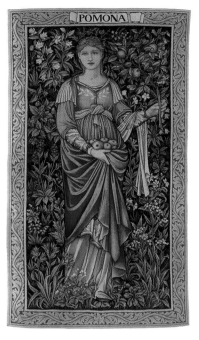

13
Sir Edward Burne-Jones and William Morris
Morris and Company
Hanging Entitled "Pomona"
1898–1918
Cotton, wool, and silk, double interlocking tapestry weave; two selvages present; 92.9 x 165.1 cm (36 ½ x 65 in.)
The Art Institute of Chicago, Ida E. Noyes Fund, 1919.792

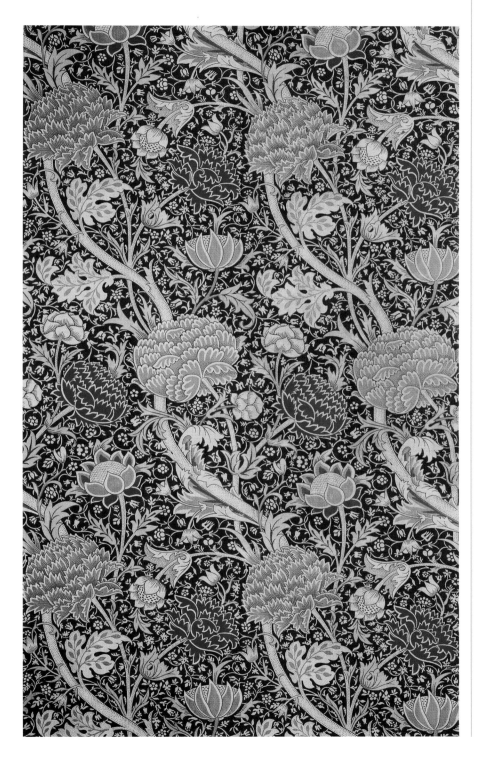

14
William Morris
Morris and Company
Woven and printed at Merton Abbey Works
Two Panels Entitled "Cray"
1884 (produced 1885)
The Art Institute of Chicago
Cat. 95

Morris's decorative interests also extended to book publishing. His new concern for printed media possibly resulted from his friendships with the craftsmen of the Century Guild, started in 1882 by designer and architect Arthur Heygate Mackmurdo. The guild aimed "to render all branches of art the sphere no longer of the tradesman but the artist."[19] Mackmurdo's *Wren's City Churches* (FIG. 15) is often considered one of the earliest and most influential Arts and Crafts book designs. The flat perspective and graphic quality of the design, which may have derived in part from Japanese woodcuts, influenced the language of late-nineteenth-century graphic artists, including Aubrey Beardsley and Will Bradley (SEE CHAPTER 2). On the cover, Mackmurdo's spectacular curvilinear treatment of two roosters and flames represents the Great Fire of 1666, which destroyed London and provided the opportunity for Sir Christopher Wren to rebuild many of the city's churches.

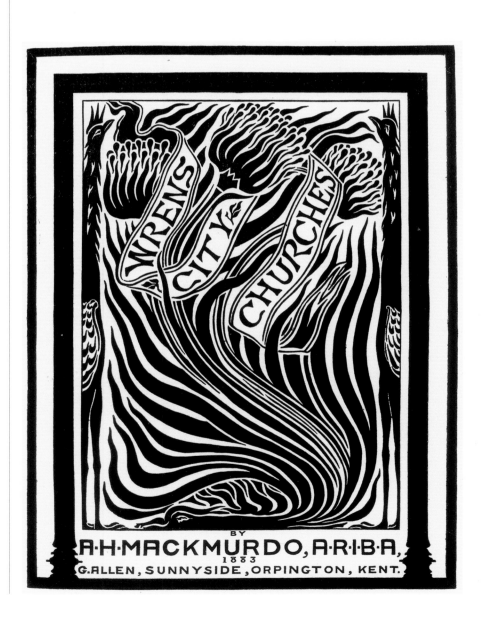

15
Arthur Heygate Mackmurdo
Published by G. Allen, Kent
Title page from *Wren's City Churches*
1883
The Art Institute of Chicago, Ryerson and Burnham Libraries
Cat. 86

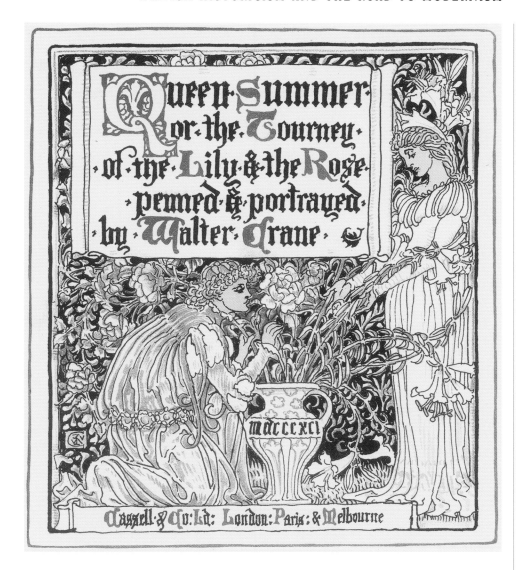

16
Walter Crane
Published by Cassell and Company
Title page from *Queen Summer*, or
The Tourney of the Lily and the Rose
1891
The Art Institute of Chicago, Ryerson
and Burnham Libraries
Cat. 27

Mackmurdo's friend and colleague Walter Crane, a founder and the first president of the Arts and Crafts Society (established in 1888), became one of the most important book illustrators of the time. He wrote two important publications on book design, *The Decorative Illustration of Books* (1896) and *Line and Form* (1900), both of which promote the integration of illustration with text in a book's overall layout. Unlike Mackmurdo's aggressively graphic abstracted designs, Crane's illustrations for the book of children's poetry *Queen Summer*, or *The Tourney of the Lily and the Rose* (FIG. 16) display a delicacy and anecdotal quality akin to medieval tapestry design. They evoke the sophisticated and complicated patterning of Morris's wallpaper designs such as *Cray*. Crane's illustrations were perfect compliments to tile designs used in nurseries or baths. Such joy and innocence in children's books depicted chivalrous themes or times that certainly bespoke the optimism of Arts and Crafts design and its elevation of common crafts. That same year, Morris established his Kelmscott Press and began publishing books.[20] The press produced

sixty-five volumes between 1891 and 1898, including a reprint of Ruskin's essay "On the Nature of Gothic" in 1892. Morris's most famous publication is the hand-made edition of Geoffrey Chaucer's *Canterbury Tales*, called the *Kelmscott Chaucer* (FIG. 17), completed shortly before his death in 1896. Illustrated by Morris and Burne-Jones, the book was typeset in a Gothic style in two columns on handmade paper, which gives it the appearance of an early printed volume. Four years in the making, the *Kelmscott Chaucer* set a new benchmark for book design.

A NEW GENERATION

By around 1890, Morris's architect-designer disciples—among them Charles Robert Ashbee—began to move away from Gothic Revival ideals. A follower of Ruskin, Ashbee was educated at Cambridge and embraced the social-reform philosophy so prevalent during the 1880s at both Cambridge and Oxford. Later he studied architecture in London with the Gothic Revivalist George Frederick Bodley. While working in Bodley's office, Ashbee lived at Toynbee Hall, the pioneering univer-

17
Written by Geoffrey Chaucer
Designed by William Morris
Illustrated by William Morris and Sir Edward Burne-Jones
Published by Kelmscott Press
Title page from *The Works of Geoffrey Chaucer Now Newly Imprinted*
1896
The Art Institute of Chicago, Ryerson and Burnham Libraries
Cat. 97

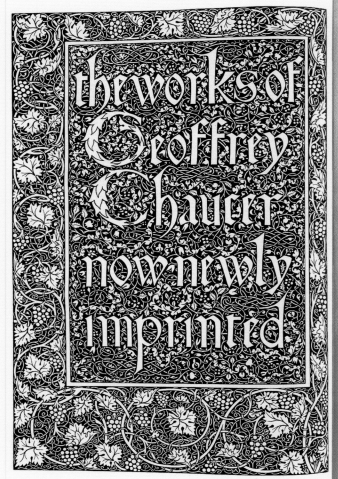
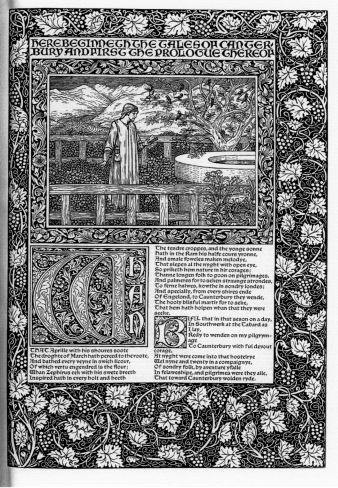

sity-sponsored settlement house in London's Whitechapel neighborhood. There, students worked with and stayed among some of the poorest residents of the East End in an attempt to learn about the problems of the slums and to find solutions for them by training people to earn a living in crafts.

Rejecting both ardent individualism and mindless conformity, Ashbee, like Morris, considered cooperative societies, trade unions, voluntary organizations, and worker's guilds (based on medieval prototypes) the best means to escape poverty and improve society.[21] While living at Toynbee, Ashbee taught classes on the writings of Ruskin and wrote that he felt close to the workingmen who attended his lectures and that he now understood the "Whitmanic" position—a reference to American poet Walt Whitman's poems about democracy and the common man.[22] In 1888 the idealistic designer founded a technical and art school, practically next door to Toynbee Hall, named the School and Guild of Handicraft. The establishment was socialist in spirit and provided practical training; however, the idea of the guild was radical—it was a cooperative workshop of individuals who contributed a portion of the profits to the guild itself.[23] The guild successfully exhibited its products at the first exhibition of the Arts and Crafts Society in the autumn of 1888. All seventeen items displayed were metalwork. Indeed, Ashbee's reputation would rest on the metalwork and jewelry he designed in subsequent years (SEE FIG. 18).

The guild's first repoussé pieces were made by John Pearson, who had been employed in William De Morgan's tile works.[24] Like De Morgan's ceramics (SEE CHECKLIST, CATS. 34–35), Pearson's early metalwork is vigorous, animated by images of galleons, grotesques, and fish (SEE FIG. 19), much like the pottery and the repoussé copper items produced during the late Middle Ages. More refined than Pearson's medievalist designs, Ashbee's metalwork is technically very sophisticated; he used both lost-wax and sand-casting methods to create delicate details such as brackets and finials. Many of his pieces reference sixteenth-century ceremonial drinking cups, which feature a bowl on a narrow stem. Ashbee altered this early Renaissance form, replacing the stem with sinuous handles and a cover (SEE FIG. 20).

Like Morris, Ashbee also turned to seventeenth- and eighteenth-century vernacular prototypes in his furniture and interior design. This can be seen in his Chelsea residence (1893–94), named the Ancient Magpie and Stump after an old inn that once stood on the site. The dining room was an austere ensemble of light-hued walls and furnishings, and the space contained only unbroken vertical and horizontal lines (SEE FIG. 21) The furniture included guild-produced trestle tables, a boxlike sideboard, and ladder-back chairs. The latter are an interpretation of a traditional form enhanced by the addition of a curved crest rail and arm supports (SEE FIG. 22).[25] Relieving the stark simplicity of the room was a modeled plaster frieze at the top of the walls and the pronounced oval shapes of blue and white porcelain in the sideboard.[26]

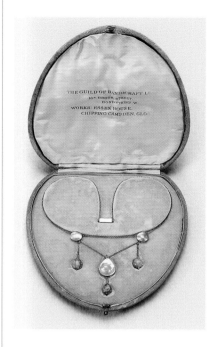

18
Charles Robert Ashbee
Guild of Handicraft
Necklace
c. 1905
Collection of Crab Tree Farm
Cat. 9

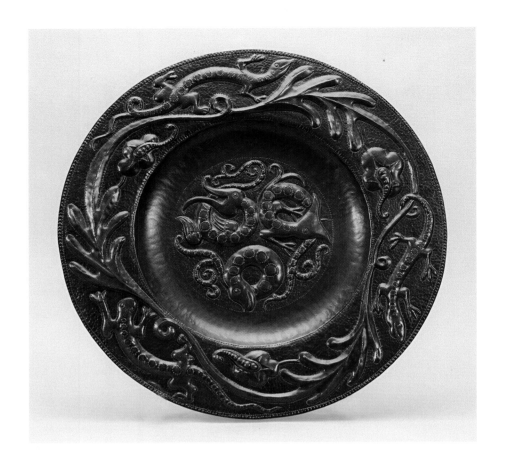

19
John Pearson
Newlyn Industrial Class
Charger
1901
Collection of Crab Tree Farm
Cat. 103

20
Attributed to Charles Robert Ashbee
Guild of Handicraft
Two-Handled Cup and Spoon
Cup: 1903; spoon: 1902
Collection of Crab Tree Farm
Cat. 7

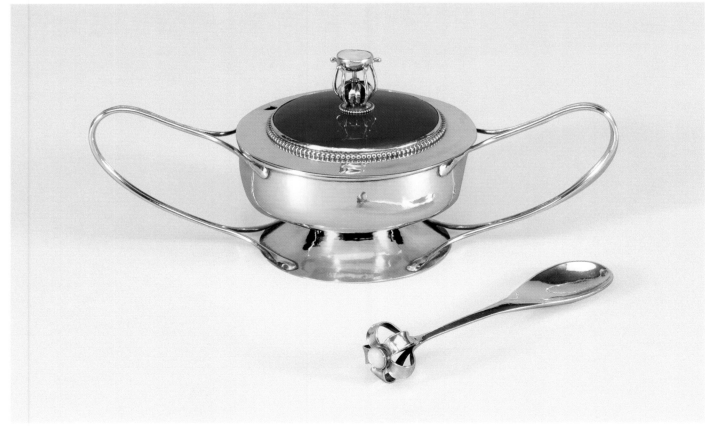

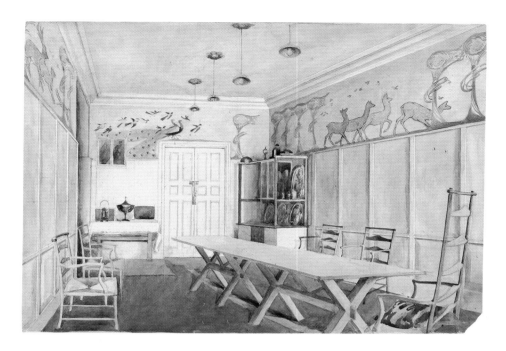

21
Fleetwood C. Varley (English, 1863–1942)
*Dining Room of Charles Robert Ashbee's
Ancient Magpie and Stump*
1901
Pencil and watercolor on paper; 51 x
65.4 cm (20 x 25 ³/₄ in.)
Victoria and Albert Museum, London,
E.1903–1990

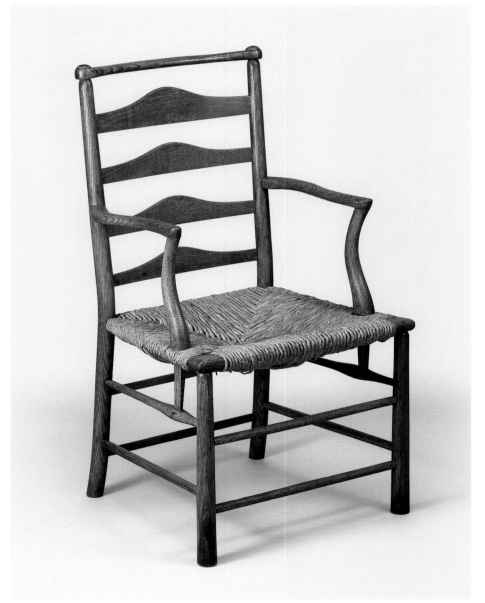

22
Charles Robert Ashbee
Guild of Handicraft
Armchair
1893/94
Collection of Crab Tree Farm
Cat. 3

Motivated by a passion for rural sixteenth- and seventeenth-century stone build-ings and a back-to-the-land mentality, Arts and Crafts practitioners romanticized country living as purer, healthier, and more natural than what was possible in an urban environment. The writings of Ruskin and Morris, and those of American authors popular in England, such as Emerson and Whitman, all glorify the inspira-tion of nature in art and thought. For these reasons, in 1902 Ashbee's Guild of Handicraft moved from London to the Cotswolds, at Chipping Campden in south-central England, where it was also much less expensive to start and maintain a commune, craft guild, school, or workshop.

Like Morris, Ashbee energized the areas of metalwork and jewelry, furniture design, architectural planning, setting up a press as well as the Guild and School of Handicraft (first in London and then in Chipping Campden). Eventually, Ashbee, perhaps through his meeting with Frank Lloyd Wright at Chicago's Hull House in 1900, softened his perceptions about the machine, even while he believed it must be controlled and railed against the modern world. Writing about his vision, and the state of the Arts and Crafts movement as it began to decline in 1908, Ashbee's ideals coincided with those of Morris, and he lamented the preciousness that had overtaken the products of the guilds:

> [T]his Arts and Crafts movement, which began with the earnestness of the
> Pre-Raphaelite painter, the prophetic enthusiasm of Ruskin and the titanic
> energy of Morris, is not what the public has thought it to be, or is seeking to
> make it; a nursery for luxuries, a hothouse for the production of mere trivi-
> alities and useless things for the rich. It is a movement for the stamping out
> of such things by sound production on the one hand, and the inevitable
> regulation of machine production and cheap labor on the other. My thesis is
> that expensive superfluity and the cheap superfluity are one and the same
> thing, equally useless, equally wasteful, and that both must be destroyed. The
> Arts and Crafts movement, if it means anything, means Standard, whether
> of work or of life, the protection of Standard, whether in the product or in
> the producer, and it means that these two things must be taken together.[27]

Ashbee, while romantically and idealistically looking to the past for inspiration, accepted the conditions of the modern age and sought to reform its products and eliminate its wastefulness. The defense against extravagance that appealed to Ashbee was associated with the healthful countryside that also attracted architect Ernest Gimson. He followed in the steps of his teachers Morris and Webb by first joining a design firm consisting of trained architects, Kenton and Company, in London in 1890, but two years later the firm disbanded and Gimson moved to the Cotswolds. He believed that there he would find inspiration in local, traditional buildings and materials, avoid the highly competitive London architecture and decorating scene, and live out the principles of the artistic and socialist framework

of the movement.[28] Gimson was among the first designer-craftsmen to relocate to the area—although Morris and Rossetti had leased Kelmscott Manor in 1871, Ashbee did not arrive until the turn of the new century, nine years after Gimson and Ernest and Sidney Barnsley had moved there in 1893.[29] Settled in Pinsbury, the three men lived off the land and read Whitman's poetry and Henry David Thoreau's writings on nature.[30] Many of the Cotswold villages had been left virtually intact since Elizabethan and Jacobean times. Gimson learned the art of decorative, painted plasterwork popular during the sixteenth and seventeenth centuries. He also utilized a similar technique in furniture making, using gesso to build up surfaces. Inspired by Jacobean furniture forms, Gimson designed chests-on-stands, and spindle-back and ladder-back country chairs. A favorite Gimson motif was the Tudor rose, which he used repeatedly in plaster designs, on fall-front cabinets, and in firedogs. A pair of firedogs (FIG. 23), made by Gimson's metalworker Alfred Bucknell, features roses and climbing tulips like those found on chests produced in rural England (and America) in the 1600s. The firedogs' shape recalls forms that Gimson might have studied at Haddon Hall and other nearby Elizabethan and Jacobean great houses. In general, however, Gimson envisioned his furnishings in country-cottage-like interiors, with low, beamed ceilings and whitewashed stone walls such as those at the workshop's showroom, Daneway House (SEE FIG. 24).

Like Gimson, William Arthur Smith Benson favored the handmade look of Elizabethan and Jacobean metalwork, but he also embraced the machine in the execution of his wares.[31] Instead of hiding the effects of mechanical processes, Benson's products readily show the signs of stamping and the lathe. This break with the Arts and Crafts philosophy put Benson at the forefront of the changing movement. In fact, by 1895 he employed more than one hundred people in his large London factory. Benson's metalwares were immediately popular, and the knock-offs that appeared in London shops were the sincerest form of flattery.[32] His elegant oil lamps, electric chandeliers, and gas hanging fixtures were much in demand. He also made beautiful andirons, candlesticks, dutch ovens, firescreens, jacketed pots, kettles and stands (SEE CHECKLIST, CAT. 14), sconces (SEE CHECKLIST, CAT. 13), and tablewares of all types in brass, copper, electroplated silver, and wrought iron. Mixing metals in the same object was also an important feature of Benson's work. A copper and brass firescreen (FIG. 25) resembles a flower or propeller, providing a reflective surface that both protected the sitter from heat and enhanced the light from the open fire. Benson's simple and elegant designs, combined with his embrace of technological advances such as electricity (and the ability to effectively hide wires), made him a pioneering modernizer of Arts and Crafts ideas.

The tendency of the younger generation of Arts and Crafts designers to simplify forms—perhaps to facilitate manufactured production techniques—is especially apparent in the carpets, wallpapers, and textiles of Charles Francis Annesley Voysey. Unlike Morris, Voysey did not involve himself in the production aspects

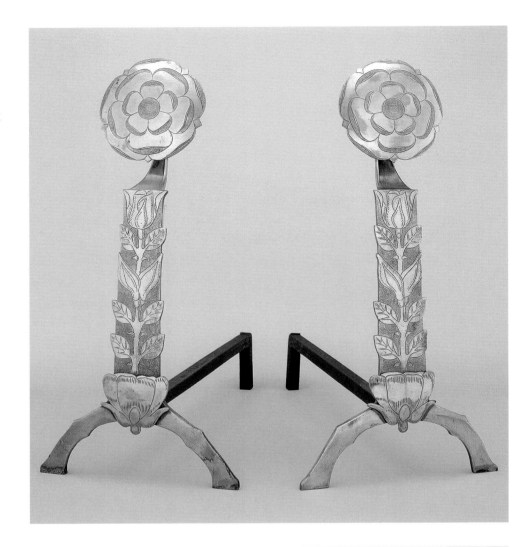

23
Ernest Gimson
Alfred Bucknell
Firedogs
c. 1905
The Art Institute of Chicago
Cat. 48

24
Ernest Gimson, showroom at
Daneway House, c. 1905. Photo:
Cheltenham City Art Gallery and
Museum, Cheltenham, England.

25
William Arthur Smith Benson
W. A. S. Benson and Company
Firescreen
c. 1900
The Art Institute of Chicago
Cat. 15

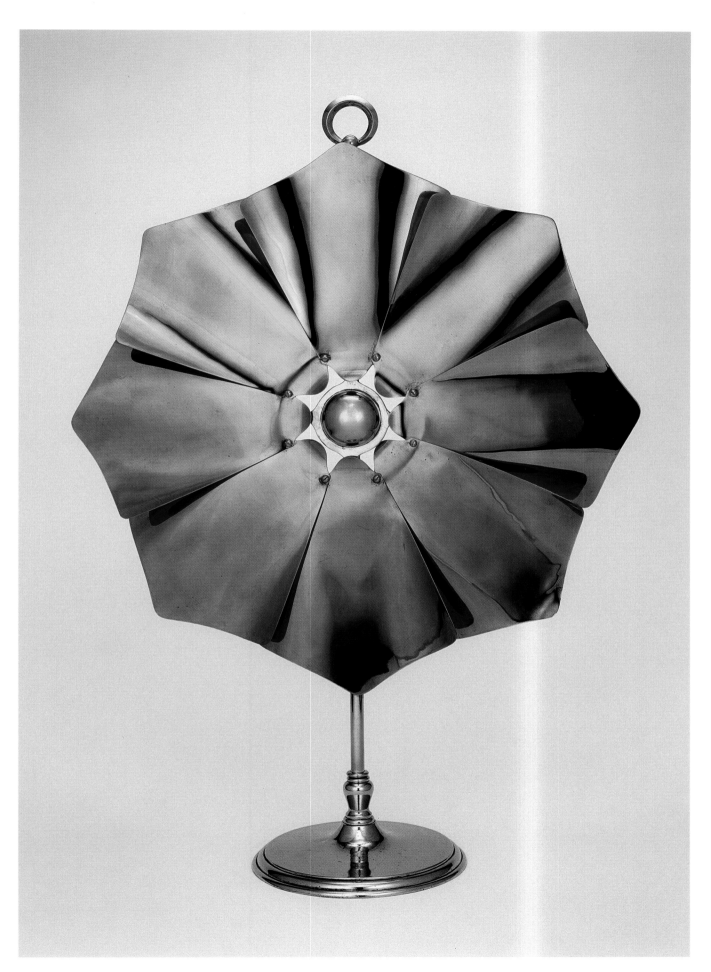

of his designs but instead sold them to various manufacturers. One example is a sample panel fabricated by Alexander Morton and Company, which decided to produce Voysey's design (FIG. 26) in a double cloth, a textile that is made in two layers woven on the same loom. This technique added texture to the bold palette of green, orange, and burgundy. Another reason for Voysey's simple, abstracted patterns, with their sinuous and elegant curves, was his focus on nature. A trained architect, Voysey was taught by Mackmurdo, who emphasized the importance of graphic simplification of pattern and natural forms. The younger designer believed that nature was the source of all inspiration, but that it could not be realistically described, for literal translation would not make for good ornament.[33] Morris's complicated and decorative patterns (SEE FIG. 14) seem almost fussy in relation to the pared-down silhouettes of birds, leaves, and berries in Voysey's *Purple Bird* (FIG. 27).

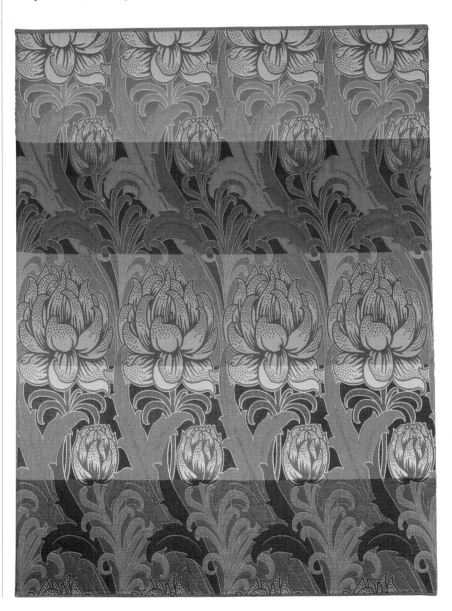

26
Charles Francis Annesley Voysey
Alexander Morton and Company
"Oswin" Retailer's Sample Panel
1896
Collection of Crab Tree Farm
Cat. 159

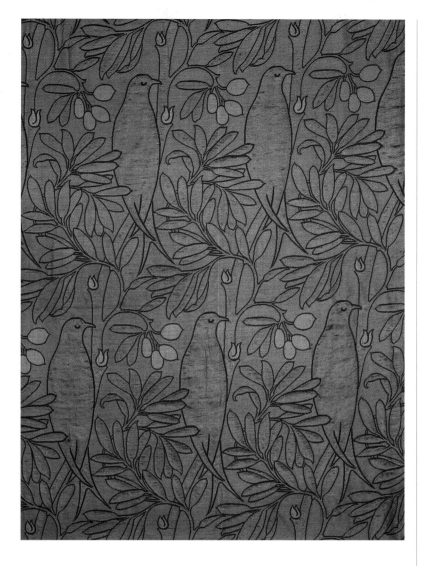

27
Charles Francis Annesley Voysey
Alexander Morton and Company
Panel Entitled "Purple Bird"
c. 1899
The Art Institute of Chicago
Cat. 161

Voysey began to focus on furniture design in the mid-1890s. Unlike earlier Arts and Crafts practitioners, he used the machine to his advantage, claiming it "has come to liberate men's minds for more intellectual work. . . . You will think of the machine that is going to help in the making, and choose such shapes as are easily worked by machinery."[34] Materials, forms, and proportions dictated by the machine determined Voysey's design vocabulary, which was extremely simple, plain, and modernist. His finest furniture, designed from 1895 to 1910, features inlaid panels, chamfered legs, and posts that extend above their normal height to form a continuous element and finial. Semicircular shapes and green-stained quarter-sawn oak predominate.[35] Cut-outs on chairs, or beautifully wrought strap hinges with his trademark heart shape, underscore Voysey's attention to detail, scale, and positive and negative space (SEE FIG. 28). Voysey's own home, the Orchard, at Chorleywood, Hertfordshire (designed in 1899), demonstrated, as one periodical put it, his "elaborate and patient study, for its one aim is 'proportion, proportion, proportion'" (SEE FIG. 29).[36] Architect Edward Lutyens wrote of his achievement:

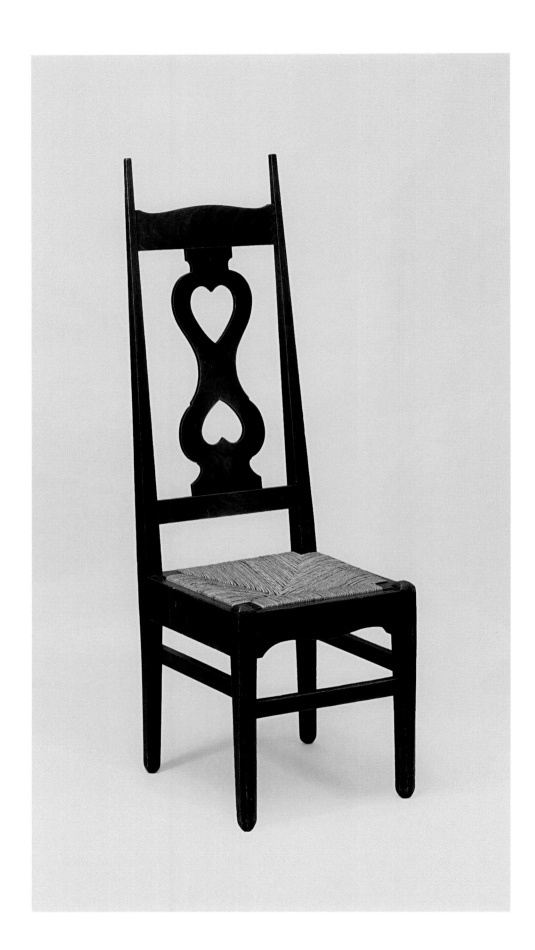

28
Charles Francis Annesley Voysey
Story and Company
Dining Chair
1898
Private collection
Cat. 160

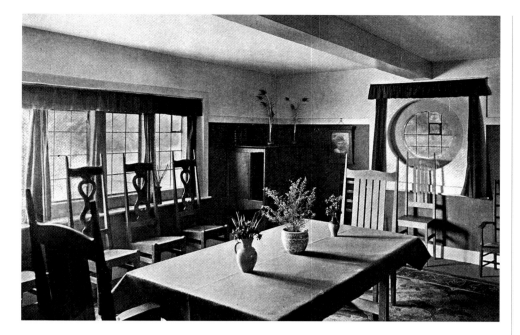

29
Charles Francis Annesley Voysey, dining room of the Orchard, Chorleywood, Hertfordshire, 1899, from Charles Holme, ed., *Modern British Domestic Architecture and Decoration* (1901), p. 191.

"No detail was too small for Voysey's volatile brain. . . . Simple, old world forms, moulded to his own passion, as if an old testament had been rewrit in vivid print, bringing to light a renewed vision in turning of its pages, an old world made new, and with it, to younger men of whom I was one, the promise of a new, exhilarating sphere of invention."[37]

Around 1900 Voysey worked with Ashbee on the execution of the *Lovelace Escritoire* (FIG. 30), a writing desk that was named for its owner, Mary Caroline Wortley, who became the Countess of Lovelace. A friend of Burne-Jones, Lady Lovelace had studied at the Slade School of Art with William De Morgan's wife, Evelyn. She became a patron of Ashbee's Guild of Handicraft in the 1880s. In 1895 she met Voysey, and over the next two decades he designed houses and furnishings for her family. The desk was a gift commissioned by Anne Blunt, Lady Lovelace's sister. Ashbee designed the desk; Voysey was responsible for its interior. The dark green outside contrasts with the bold, red-painted poplar inside, which is offset by the delicate silhouettes of wrought-iron escutcheons and morocco leather-backed hinges. An inscription, "The Gift of Anne Isabella Noel Blunt to Her Sister Mary Caroline Lovelace," surrounds a kestrel, the symbol of the Lovelace family. In this collaboration, the fine materials, desk-on-stand form, and painting all recall earlier models and Arts and Crafts values, but the simplicity of proportion and design look forward to the modern.

Voysey was a particular mentor to one of his contemporaries, Mackay Hugh Baillie Scott. An upright piano (FIG. 31)—called *Manxman*, to indicate Baillie Scott's residence on the Isle of Man—shows Voysey's influence in its wrought-metal pulls, fine copper fittings, mother-of-pearl roses, and inlaid panels depicting bird and

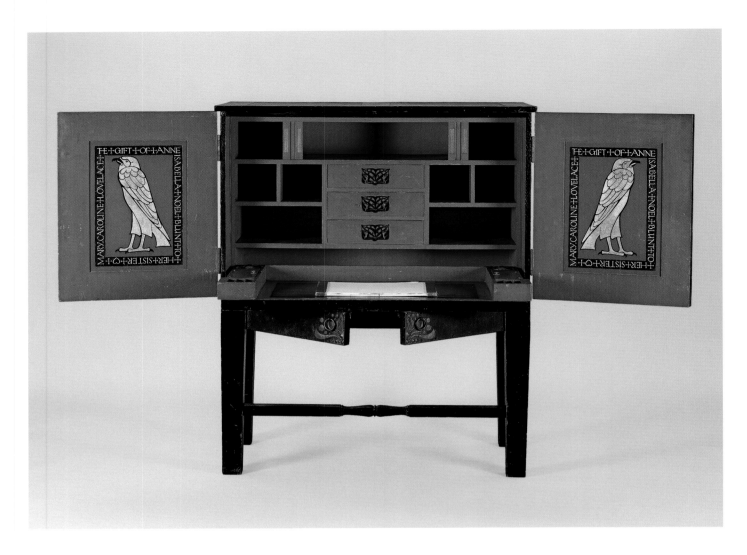

30
Charles Robert Ashbee
Guild of Handicraft
Interior painting by Charles Francis
Annesley Voysey
Lovelace Escritoire
c. 1900
Private collection
Cat. 4

floral motifs. The mechanisms of the awkward form of the upright piano are cleverly enclosed within the cabinet, and the keyboard is hidden behind two doors, which, when opened, reveal inlaid panels of trees and primroses. Baillie Scott's pianos were intended for small-scale, simple cottages like those published in *Studio* magazine during the late 1890s, which featured romanticized elements such as built-in inglenook seating areas, wall frescos, and prominent fireplaces with oversize firedogs.[38] After the turn of the century, Baillie Scott increasingly used bold colors, stains, and patterns. His work was much admired in Germany, where in 1897 he was commissioned to design decorations for the home of the Grand Duke of Hesse in Darmstadt. He collaborated with Ashbee's Guild of Handicraft to manufacture the furniture, lighting fixtures, and metalwork for the project. Baillie Scott's reputation earned him a place at two German exhibitions in 1903: the Wertheim department store rooms (Berlin) and the Deutsche Werkstätten show (Dresden).[39] In Dresden he displayed two rooms: a bedroom in natural oak; and a lady's sitting room in which the furniture was stained black and inlaid with mother-of-pearl. The sitting room (FIG. 32) had gray floors and walls, white woodwork, and dark

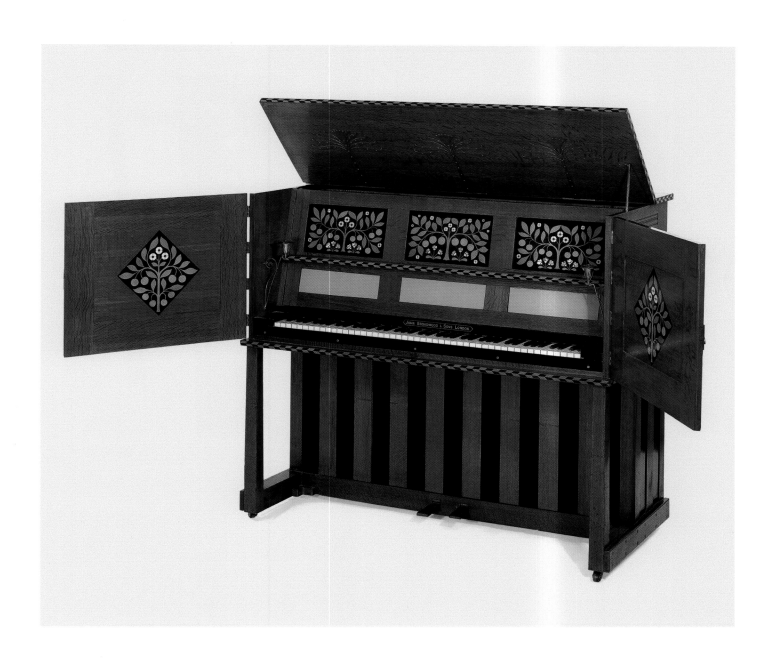

31

Mackay Hugh Baillie Scott

Movement made by John Broadwood
and Sons

Cabinet and metalwork attributed to
Charles Robert Ashbee, Guild of
Handicraft

Manxman Pianoforte

1897

The Art Institute of Chicago

Cat. 10

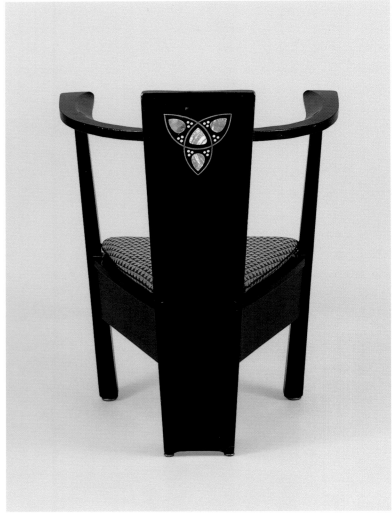

32
Mackay Hugh Baillie Scott, lady's sitting room, Deutsche Werkstätten, Dresden, 1903, from *Deutsche Kunst und Dekoration* 13 (1903/04), p. 236.

33
Mackay Hugh Baillie Scott
Deutsche Werkstätten or Pyghtle Works
Chair
c. 1903
Private collection
Cat. 11

violet curtains with light blue trim. A three-legged pearwood chair (FIG. 33) designed for the room is varnished black and features mother-of-pearl inlay and a "lily violet" cushion.[40] Its elegant simplicity and sweeping curves make its prototype, the medieval corner chair, seem distant indeed.

THE MOVEMENT SPREADS

Objects designed by Baillie Scott, Benson, Morris, Voysey, and other Arts and Crafts practitioners were available in large department stores. These symbols of consumerism provided the platform that made mainstream customers aware of Arts and Crafts products. During the 1880s, 1890s, and into the first years of the twentieth century, knowledgable clients decorating their homes in the Arts and Crafts manner often did not pick only one style or commission just one firm, but purchased a variety of items that appealed to them. They mixed Arts and Crafts wallpapers with Georgian reproduction furniture, tiles and metalwork inspired by

medieval and Japanesque designs, and nineteenth-century pieces acquired in their travels. Liberty and Company, named after its founder, Arthur Lasenby Liberty, was particularly influential. Its London showrooms were darkly timbered, carved, faux-Elizabethan spaces that perfectly set off the beautiful handwork and shimmering colors and surfaces of Arts and Crafts fabrics, furniture, and metalwork. Lauded silversmith Archibald Knox loved Celtic design and contributed to Liberty's Cymric silver line (1899) and to the Tudric pewter wares (1901), both of which were instrumental in promoting the Liberty style in Britain during the first decade of the twentieth century. Effortlessly modern in their simplicity, Knox's works feature balanced, sinuous curves, and interlocking Celtic-inspired ornament and stylized plant forms.[41] The *Rose Bowl* (FIG. 34), from the Cymric line, epitomizes the elegance of the firm's objects. The bowl is bold in form and restrained in decoration, the shapes of legs and handles effectively harmonizing with the turquoise cabochons and interlacing blue and green enamel. Knox also designed boxes, clocks, cups, and jewelry that reflect efficient production methods. Some of his jewelry was initially die-stamped flat, and then hand finished with decorative elements (SEE CHECKLIST, CATS. 78–79).

By the turn of the century, regard for British design was high, and English designers were invited to participate in the antiestablishment exhibits organized by Les Vingt in Brussels and the Secessionists in Vienna. These Continental groups, which supported the advancement of avant-garde art and decoration, admired some of the flattened, abstract, decorative qualities of British Arts and Crafts productions,

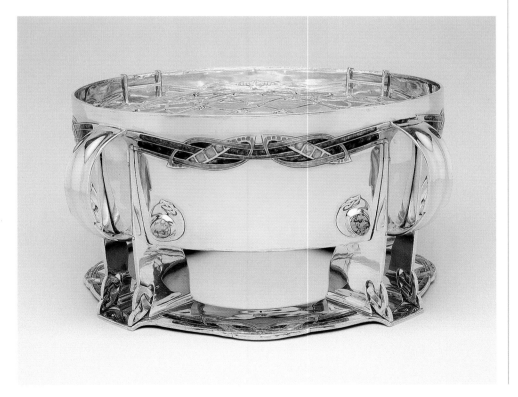

34
Archibald Knox
Liberty and Company
Rose Bowl
1902
The Art Institute of Chicago, promised gift of Crab Tree Farm Foundation
Cat. 80

including books made by Morris, works by Ashbee and Voysey, and illustrations by Crane. Works by Morris and Benson and Liberty textiles were also displayed after 1895 at Siegfried Bing's shop, the Maison de l'Art Nouveau, in Paris, and at Liberty's new branch in the city.[42] The widespread exposure of new British design was also the result of publications that focused on art and decoration. Available to designers in Europe and America during the 1890s were magazines such as *Studio* (founded in 1893; after 1897 *International Studio*), *Architectural Review* (1896), *Art et Décoration* (1897), *L'art décoratif* (1898), *Country Life* (1898), *Deutsche Kunst und Dekoration* (1898), as well as the highly influential books by the anglophilic German architectural historian Hermann Muthesius: *Master of Interior Decoration: The House of an Art Lover* (c. 1902), which features the work of Baillie Scott, and the three-volume *The English House* (1904–05 and 1908–11). All of these initiatives made British Arts and Crafts architecture, interiors, objects, and gardens increasingly accessible to an international audience.

The influence of Scottish designer Charles Rennie Mackintosh on Continental European design was enormous. While his 1897 oak armchair (FIG. 35) is dependent on British Arts and Crafts models, his white-painted ovoid table (FIG. 36),

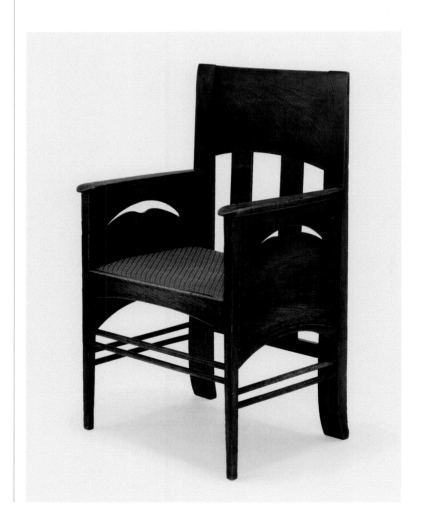

35
Charles Rennie Mackintosh
Armchair
1897
The Art Institute of Chicago
Cat. 82

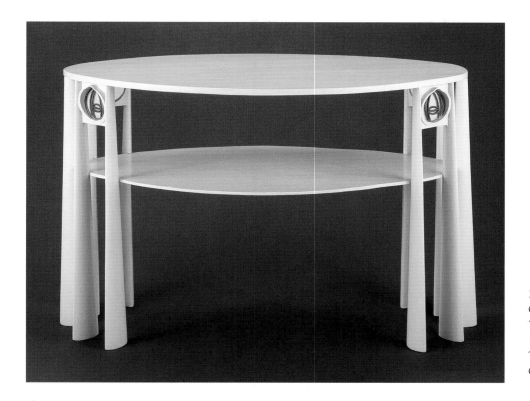

36
Charles Rennie Mackintosh
Table
1902
The Art Institute of Chicago
Cat. 83

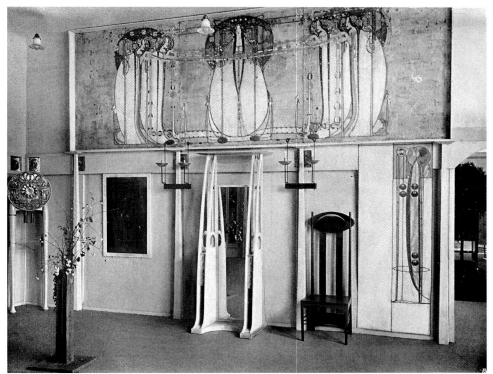

37
Charles Rennie Mackintosh, installation at the eighth exhibition of the Vienna Secession, November 1900, from *Dekorative Kunst* 7 (1907), p. 63.

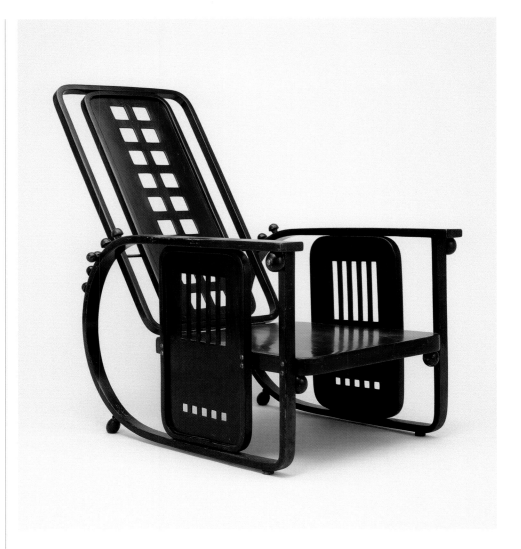

38
Josef Hoffmann (Austrian, 1870–1956)
Reclining Armchair
1900/06
Beechwood; 109.9 x 65.2 x 81 cm
(43 ¼ x 25 ¹¹⁄₁₆ x 31 ⅞ in.)
The Art Institute of Chicago, gift of
René Harth Thompson in memory of her
father, Charles John Harth (1870–1916),
1971.743

designed only five years later, displays a new purism of style, a more modern sensi-bility derived from overall unity of design, or, as British scholar Nikolaus Pevsner believed, the ideal of rational simplification.[43] Mackintosh also eschewed the pre-ciousness of materials used by the first Arts and Crafts designers, choosing instead to work with an early plastic, erinoid, and ebonized woods in objects such as a plainly geometric mantel clock (SEE CHECKLIST, CAT. 85). Mackintosh's white interiors and furniture had a profound effect on the Viennese Secessionists (SEE FIG. 37), especially founding members such as architect Josef Maria Olbrich and artist-designers Josef Hoffmann and Kolomon Moser. One needs only to compare the original adjustable-back chair of the 1860s (SEE FIG. 12) with Hoffmann's reclining armchair of around 1900 (FIG. 38) to see how early Arts and Crafts forms gave way to geometric, simplified designs in which screws and bolts are visible and sparely applied ornament lends the piece a mechanical appearance.

As we have seen, the early proponents of the Arts and Crafts movement—Ruskin, Pugin, and Morris—felt the need to look back in order to achieve their goals of

democratizing society, redefining the nature of work, and erasing the boundaries between fine and decorative arts. Basing their designs on medieval and rustic models, they romanticized the past, taking a stance that could be interpreted as a retreat from the modern. By the early twentieth century, the succeeding generation—Ashbee, Knox, Mackintosh, and Voysey—had consciously created a sleeker, more modern style that eliminated the remnants of such historicism. As Muthesius aptly observed:

> Once the movement had gathered momentum, another way out emerged: the way of modern art. The essential means towards it had been the ethical values preached by those apostles on the basis of medieval art, the sincerity, faithfulness, the pleasure taken by the workmen in their work, in general; the good workmanship, genuine materials and sound construction, in particular. The medieval forms that the apostles had advocated as indispensable concomitants of these values disappeared at last and out of the ashes rose the phoenix of modern art.[44]

1. Greensted 2005, p. 1.

2. Thompson 1994, p. 66.

3. Other secular buildings were indebted to the Gothic Revival. The Natural History Museum (1873–81) was designed by Alfred Waterhouse and Sir Charles Barry was the architect of the Houses of Parliament (1841–52). Pugin worked on the interiors of the Lords Chamber and the Commons Chamber between 1847 and 1852.

4. A possible design drawing for this pattern is reproduced on page 54 of Joan Jones, *Minton: The First 200 Years of Production* (Swann Hill Press, 1993).

5. Zelleke 2005, p. 24.

6. It is not inconsequential that Karl Marx was studying and writing on political economy at the British Museum Reading Room in 1850.

7. See Sussman 1968, pp. 13–40 and 76–103.

8. Other members of the Pre-Raphaelite Brotherhood were the painter James Collinson; Rossetti's brother, William, a publisher and critic; and the sculptor Thomas Woolner.

9. *Art-Journal* 13 (July 1851), p. 185. Quoted in Landow 1979.

10. Webb had designed Morris's Red House in 1860. Made of red brick, it was loosely based on simplified medieval tower houses with steep roofs and massed gables.

11. Crawford 1998, p. 9.

12. Quoted in Thompson 1994, p. 67.

13. Morris had been a founding member of the Society for the Protection of Ancient Buildings (1878)—an attempt to stop incorrect "restorations" or remodelings of churches and other historic structures. Morris enlisted his artist friends as well as the Victorian intelligentsia, and by 1890 there were over four hundred members. Together with Sir John Lubbock, a liberal member of Parliament, they were responsible for the passage of the first Ancient Monuments Act in 1882. The "Anti-Scrape," as it was nicknamed, not only focused on the protection and preservation of ancient monuments and medieval churches, but proved to be a valuable teaching seminar where Arts and Crafts proponents exchanged information about building customs, materials, and designs.

14. Morris delivered "The Beauty of Life" before the Birmingham Society of Arts and the Birmingham School of Design on Feb. 19, 1880. Sections of this lecture are reprinted in Naylor 1988, p. 210.

15. Quoted in ibid., p. 40.

16. Ibid.

17. Zelleke 2005, p. 84.

18. Morris's designs were popular in England and later in America, where they, along with his wallpapers and carpets, graced the rooms of such well-to-do Arts and Crafts enthusiasts as Chicagoans John J. and Frances Glessner (see chapter 5).

19. Durant 1990, p. 24.

20. The magazine of Mackmurdo's guild, *The Hobby Horse* (begun in 1884), emphasized printing as a craft. The third volume (1888) contained facsimiles of sixteenth-century Florentine printing and may have influenced Morris's desire to set up a press.

21. Crawford 1985, p. 25.

22. William Rossetti edited the first British edition of the poetry of Walt Whitman, which was published in 1868.

23. Crawford 1985, p. 34.

24. Ibid., p. 314.

25. Rendell 1901, pp. 461–67.

26. *Particulars of an Artist's Residence: The Magpie and Stump House, 37 Cheyne Walk, S.W., Built by a Distinguished Architect*, sale cat. (Hampton and Sons and Andrews and Hitch, Oct. 18, 1921). This catalogue describes fourteen chairs: ten side and four arm with cushions. The side chairs were described as painted green, and the sideboard as painted gray.

27. Greensted 2005, p. 60.

28. Ibid., p. 68. Gimson also participated in the socialist experiment.

29. Greensted 1980.

30. Ibid., p. 75.

31. A lifelong friend of both Burne-Jones and Morris, Benson was one of the principals behind the formation of the Arts and Crafts Exhibition Society in 1887. He became chairman of Morris and Company in 1905.

32. Hamerton 2005, p. 59.

33. "An Interview with Mr. Charles F. Annesley Voysey, Architect and Designer," *Studio* 1 (Sept. 1893), pp. 231–37.

34. Quoted in Brandon-Jones et al. 1978, p. 67.

35. Many of these same features would be used in the furniture designs of Americans Gustav Stickley, Harvey Ellis, and Frank Lloyd Wright.

36. E. B. S. "Some Recent Designs by Mr. Voysey," *Studio* 7 (May 1896), pp. 209–18. Voysey's domestic architecture also featured whitewashed walls; small, high windows; and long, broad gables found in Prairie school homes.

37. Quoted in Simpson 1979, p. 18.

38. See Zelleke 1993, pp. 161–73.

39. Much of Baillie Scott's furniture exhibited on the Continent was built in Munich or Dresden by the Deutsche Werkstätten.

40. Kornwolf 1972, pp. 326–29.

41. The Celtic Revival of the late nineteenth century was in part influenced by the discovery of the *Ardagh Chalice*, now in the National Museum of Ireland, Dublin. For more on this, see chapter 5, fig. 16.

42. In fact, Bing was criticized in 1897 for his gallery's "servitude to English art and its derivatives," including Belgian art and other foreign influences. Troy 1991, p. 32.

43. Pevsner 1936.

44. Muthesius 1987, p. 155.

THE SPELL OF JAPAN WAS UPON THEM: JAPANISM AND THE ARTS AND CRAFTS MOVEMENT

IN 1909 CHARLES ROBERT ASHBEE wrote of Charles Sumner Greene and Frank Lloyd Wright, "The spell of Japan is upon [them]."[1] This statement could be made about a great many British and American Arts and Crafts designers. In both countries, the Arts and Crafts movement coincided with the craze for all things Japanese, or Japanism, that was launched in 1854 when American Commodore Matthew Perry forced Japan to recommence international trade after over two centuries of virtual isolation.[2] The Japanese objects that soon flooded into Europe and the United States excited Westerners because of their sheer novelty. In addition, after the Western-oriented Meiji government assumed power in 1868, the Japanese encouraged foreign interest in their art both to assert the worth of their culture and to help fund the country's rapid industrialization. Japanism was thus fueled by both Western and Japanese concerns.

Just as they had sought to improve modern design by looking at previous styles such as the Gothic, Arts and Crafts practitioners embraced Japanese forms. They admired Japanese art because it, like Gothic, was thought to derive from a culture that was free from the depravities of modern industrialism.[3] In such a society, artisans could still express their own individual visions because they were working by hand. British designer Walter Crane (SEE CHAPTER 1, FIG. 16) made the connection between Japanese and medieval art specifically:

> Japan is, or was, a country very much, as regards its arts and handicrafts with the exception of architecture, in the condition of a European country in the Middle Ages, with wonderfully skilled artists and craftsmen in all manner of work of the decorative kind, who were under the influence of a free and informal naturalism. Here at least was a living art, an art of the people, in which traditions and craftsmanship were unbroken, and the results full of attractive variety, quickness, and naturalistic force. What wonder that it took Western artists by storm, and that its effects have become so patent.[4]

Such a romanticized view of Japanese culture made its art seem the perfect model for Arts and Crafts creations. Moreover, because of its relative spareness, Japanese art was praised for being less materialistic than more opulent Western styles. In

1876 critic James Jackson Jarves articulated the prevailing view when he lauded Japanese artists for their commitment to making their creations beautiful, while Westerners' "main principle . . . is to make an article expensive."[5] Emulating Japanese art, therefore, seemed to provide Arts and Crafts reformers with the sort of escape they sought from commercialism.

As artistic concerns evolved in the Arts and Crafts period, designers sought out different Japanese models and found new lessons in them. They also grew more knowledgeable about Japanese art and culture and as a result began emulating not merely the surface motifs they saw in Japanese works, but their underlying design strategies. These principles—balance, geometry, modularity, and simplicity—help to elucidate the many ideologies of the Arts and Crafts movement.

THE TURN TO NON-WESTERN SOURCES

Japanism was part of a greater interest among late-nineteenth-century European and American artists in the world beyond the West. Although some earlier European styles, such as eighteenth-century Chinoiserie, had been modeled on non-Western art, the first designer to advocate looking beyond Western sources in a systematic way was the British designer Owen Jones. After the poor showing of British manufactured goods at the 1851 Great Exhibition in London, theorists debated how to improve the nation's design and came to two opposing conclusions. John Ruskin and his followers argued that ornament should be realistic because they believed that imitating nature was a way of worshipping God.[6] In contrast, Jones contended that ornament should be conventionalized, or abstracted, so that it related appropriately to the object it decorated.[7] He believed that non-Western art provided some of the best models of such design, and he introduced these examples to many artisans through the classes he taught at London's South Kensington School and through his widely influential 1856 book, *The Grammar of Ornament*.

Jones's text betrays some traditional biases against non-Western cultures. For instance, he combined South American and South Pacific art under the heading "Ornament of Savage Tribes." Nevertheless, Jones was the first Westerner to advocate using such "savage" sources as artistic inspiration. Since *The Grammar of Ornament* was published only two years after Japan resumed international trade, it does not contain any of that country's designs. However, the fact that the book treats non-Western and Western ornament equally helped pave the way for the widespread appreciation of Japanese art in Europe and the United States a few years later. Jones's book remained influential for decades, becoming a standard publication for decorative artists. The Art Institute's copy (SEE FIG. 2) entered the Ryerson Library in 1902 and was likely consulted by Chicago designers such as Frank Lloyd Wright and Marion Mahony Griffin.

In his own designs, Jones sometimes closely followed the patterns he had collected in *The Grammar of Ornament*. A textile attributed to Jones (FIG. 1) resembles number fifteen in his illustration *Moresque No. 3* (FIG. 2).[8] Other designs by Jones reference non-Western sources less literally. In the textile *Sutherland* (FIG. 3), for example, he transformed flowers into a simplified, abstracted design. The pointed arch shape suggests Gothic ornament, but the textile's brilliant colors reveal the influence of Islamic fabrics. In such works, Jones conventionalized nature in ways inspired by a wide range of non-Western art. He argued that designers should emulate such sources' essential aesthetic characteristics rather than copying them exactly, writing: "The principles discoverable in the works of the past belong to us; not so the results."[9] Following Jones's example, later Arts and Crafts designers such as Frank Lloyd Wright would have this same relationship with Japanese art.

Led by Jones, British designers began to experiment with non-Western styles. William Morris, for example, drew from East Asian and Middle Eastern art for his textile *Peacock and Dragon* (FIG. 4). The peacock motif originated in India, while the dragon is found in cultures as disparate as Great Britain and China. Morris's "dragons" may more closely resemble phoenixes, which he would have seen in Chinese textiles.[10] The vivid color scheme of *Peacock and Dragon*—both of the version seen here and of an alternate red one—is derived from Islamic art. Morris particularly admired Islamic interiors such as the one Vincent Robinson re-created in 1878 in his London shop, which Morris described as "all vermillion and gold and ultramarine, very beautiful . . . just like going into the Arabian Nights."[11]

1
Possibly designed by Owen Jones
Panel
c. 1870
Silk; 7:1 satin weave with 3:1 and 1:3 twill interlacings of secondary binding warps and supplementary patterning wefts; 291.5 x 108.3 cm (114 ¾ x 42 ⅝ in.)
The Art Institute of Chicago, Louise Lutz Endowment, 1996.480

Despite these non-Western connections, the large scale of the repeated motif in *Peacock and Dragon* and its dense weave are characteristics that ally it with European medieval tapestries. Like other Arts and Crafts designers, Morris emulated the aspects of non-Western design that fit his aesthetic purpose. His combination of an eclectic array of non-Western elements in *Peacock and Dragon* is typical of the early European and American use of such sources. Although this became one of Morris's most popular textiles, and he even installed it in his own London house, it is important to note that the designer rarely emulated non-Western art. He had especially little appreciation for Japanese design, writing "The Japanese have no architectural, and therefore no decorative, instinct."[12] However, in this opinion, Morris was in the distinct minority.

2
Owen Jones
Day and Son
Drawn in stone by F. Bedford
Moresque No. 3, from *The Grammar
of Ornament*
1856
The Art Institute of Chicago, Ryerson
and Burnham Libraries
Cat. 65

3
Owen Jones
Warner, Sillett, and Ramm
Fragment Entitled "Sutherland"
1870/71 (produced c. 1872)
The Art Institute of Chicago
Cat. 66

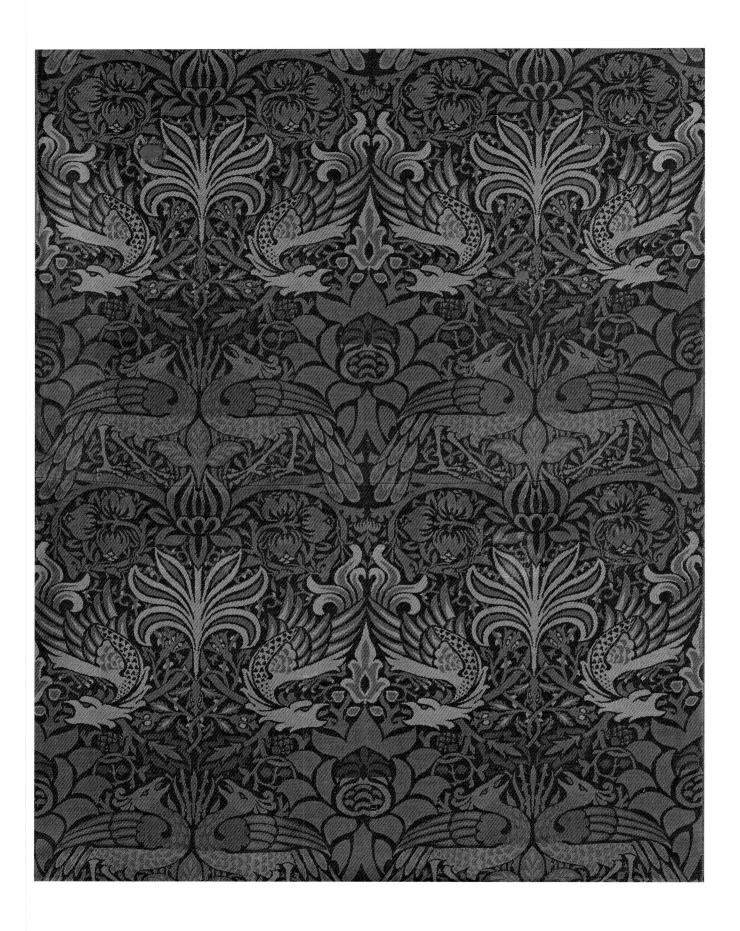

EARLY JAPANISM IN BRITAIN

British Japanism became widespread with the 1862 International Exhibition in London, which featured the first large-scale public showing of Japanese art in the West.[13] The Japanese government did not officially participate, so the presentation was organized by Sir Rutherford Alcock, British Minister to Japan, who was one of the first Westerners to take an interest in Japanese art. In the exhibition, he endeavored to represent the breadth of Japanese objects, including ceramics, enamels, illustrated books, ivory, lacquer, metalwork, painted screens, prints, and textiles. Nevertheless, Alcock had relatively little contact with Japanese experts, and consequently, his selection was somewhat limited; he chose objects only from the eighteenth and nineteenth centuries and incompletely identified them, failing to include artists' names, for example.[14] The presentation itself (SEE FIG. 5) was crowded, resembling a Western department store more than a traditional Japanese interior.

Nonetheless, British designers were fascinated by these strange new objects, which seemed to epitomize the harmonious, handcrafted aesthetic that reformers such as Jones and Morris advocated bringing to British manufactured goods. Many of them began to collect Japanese works in great numbers. To meet the demand, London dealers increased their Japanese inventory. Farmer and Rogers's Great Shawl and Cloak Emporium, where the young Arthur Lasenby Liberty worked, opened the Oriental Warehouse, where they sold many of the Japanese objects from the International Exhibition. As Alfred Lys Baldry later recalled, the Oriental Warehouse was frequented by "many prominent artists and students of the East, who were attracted to the shop by the treasures gathered there." These included "such noted masters as . . . Albert Moore, E. W. Godwin, Burges, Nesfield, Rossetti, and an array of others of equal repute."[15]

4
William Morris
Morris and Company
Woven at Queen Square or Merton Abbey Works
Panel Entitled "Peacock and Dragon"
1878 (produced 1878/1940)
The Art Institute of Chicago
Cat. 94

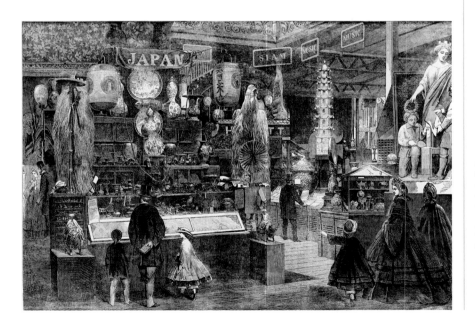

5
"The International Exhibition: The Japanese Court," engraving from the *Illustrated London News*, September 20, 1862, p. 320. Photo: Rare Books Division, The New York Public Library, Astor, Lenox and Tilden Foundations.

When Liberty founded his own enterprise in 1875, he specialized in Japanese objects. Edward William Godwin described the chaos caused by a new shipment of Japanese fans at Liberty's: "There was quite a crowd when we arrived. A distinguished traveler had button-holed the obliging proprietor in one corner; a well known baronet, waiting to do the same, was trifling with some feather dusting brushes; two architects of well known names were posing an attendant in another corner with awkward questions; [and] three distinguished painters with their wives blocked up the staircase."

Godwin also noted with dismay, "The fans of ten years ago are for the most part lovely in delicate color and exquisite in drawing, but the great majority of the fans of today . . . are impregnated with the crudeness of the European's sense of colour, and are immeasurably beneath the older examples."[16] As they embraced industrialism and its attendant commercialism in the Meiji period, the Japanese began to emulate Western objects. Moreover, in their export works, they purposefully employed Western aesthetics to appeal to foreign tastes. A pair of porcelain jars decorated by Ichiryusai Uchimatsu for the Koransha porcelain works (FIG. 6) is typical of the highly ornamented objects the Japanese made for the Western market. Arts and Crafts designers like Godwin disliked such works because they carried the taint of the industrialized West, which disturbed the romanticized notion of Japan as a preindustrial paradise.

6
Koransha Porcelain Works (Arita, Japan)
Decorated by Ichiryusai Uchimatsu
(Japanese, active nineteenth century)
Pair of Covered Jars
1875
Decorated porcelain; h. 105.4 cm
(41 ½ in.)
Wadsworth Atheneum Museum of Art,
Hartford, Connecticut, 1905.1279A,B
and 1905.280A,B

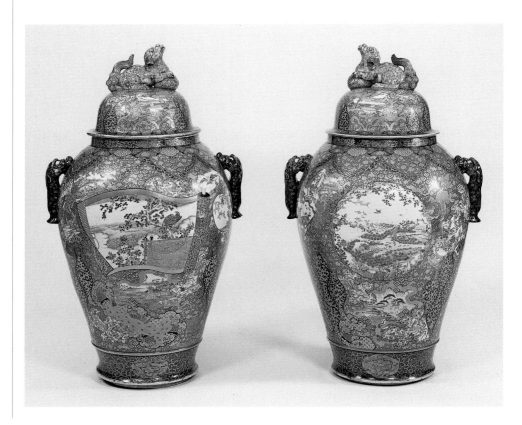

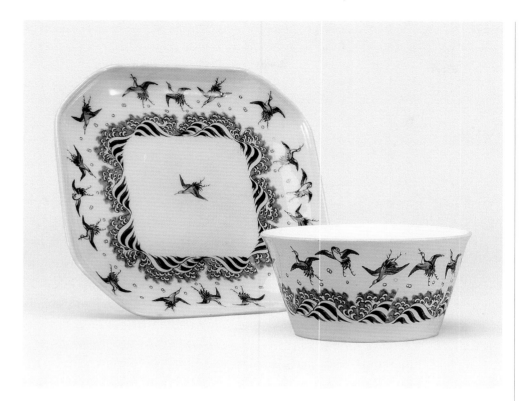

7
Christopher Dresser
Minton and Company
Plate and Bowl
1872
Collection of Crab Tree Farm
Cat. 39

Early British Japanists such as Godwin and Christopher Dresser formed significant Japanese art collections in the 1860s. Dresser's mentor was Jones; the young designer even contributed a plate, "Leaves and Flowers from Nature," to *The Grammar of Ornament*.[17] He had likely encountered his first Japanese art at the School of Design, London, in the early 1850s, and he also knew Alcock.[18] At the 1862 International Exhibition, Dresser sketched many Japanese objects, and he purchased a number of them after the show was over.[19] In his design manual of that year, *The Art of Decorative Design*, Dresser used Japanese and Chinese ornament to exemplify ideally conventionalized decoration.[20]

Dresser began experimenting with Japanism in his own work in the 1870s. In his first such objects, he applied Japanesque motifs to fundamentally Western forms. The cranes and waves in a set of dishes for Minton and Company (FIG. 7), for example, were probably inspired by both ukiyo-e prints and Japanese ceramics, such as a flowerpot displayed at the 1862 International Exhibition (FIG. 8). A turning point in Dresser's Japanism came in 1876, when the Japanese government hired him to help modernize the country's industrial-art production. As a national guest, Dresser traveled more extensively in Japan than other Western visitors and was even allowed to see the imperial collections in Nara and Kyoto. He was the first Western designer to have extensive exposure to Japanese architecture, and he went on to publish the first major treatment of the subject in English, *Japan: Its Architecture, Art, and Art Manufactures*, in 1882. Dresser's book helped to reverse

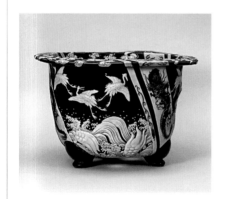

8
Japan
Flowerpot
1860–62
Glazed porcelain; diam. 54 cm
(21 ¼ in.)
Victoria and Albert Museum, London,
FE. 11-2004

the prevailing Western idea that Japanese buildings—with their simplified decoration, low height, and wood construction—were not architecture.[21]

At this stage, most Japanese objects exported to the West—whether they were made specifically for this purpose or not—were more highly ornamented, since such works appealed to High Victorian sensibilities. In Japan, such ornate art was used in the imperial court and expressed the aesthetic of *karei,* or gorgeous splendor.[22] On his trip, however, Dresser was most impressed by objects that displayed the alternate aesthetics of *soboku,* or artless simplicity, and *wabi,* or tranquil austerity. He collected works in this style (such as possibly this tea bowl [FIG. 9]) for the British dealer Londos and Company and the American silver manufacturer Tiffany and Company, both of which had commissioned him to create Japanese art study collections for them.[23] After he returned to Britain, Dresser and businessman Charles Holme founded a firm to import Asian objects, which introduced many Westerners to the more austere side of Japanese art. Although many collectors continued to prefer the more splendid *karei* works, Arts and Crafts designers looked to Dresser's sparer Japanese objects to find models of the elegant handcraftsmanship that they sought to bring to their works.

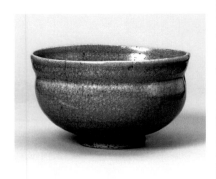

9
Japan
Tea Bowl
Late eighteenth to nineteenth century
Glazed stoneware; h. 7.6 cm x diam. 13
cm (3 x 5 ⅛ in.)
Victoria and Albert Museum, London,
608-1877

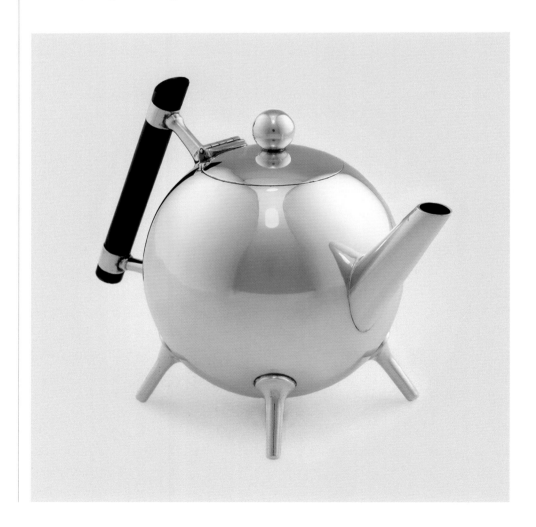

10
Christopher Dresser
James Dixon and Sons
Teapot
c. 1880
Collection of Crab Tree Farm
Cat. 40

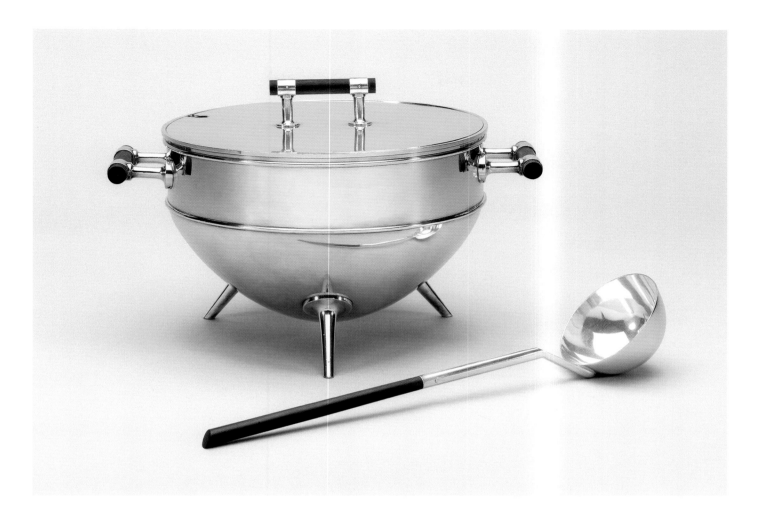

Dresser began to incorporate a Japanesque austerity into his designs in the 1880s. His electroplated silver objects, such as a teapot (FIG. 10) and a tureen and ladle (FIG. 11) have especially simplified forms.[24] His unadorned designs emphasize the medium's essential qualities—in this case, the silver's highly polished, reflective surface. Thus, by emulating the simplicity he admired in Japanese objects, Dresser brought his creations closer to the Arts and Crafts ideal of truth to material. In addition, the combination of silver and ebony in the teapot and tureen is indebted to Japanese mixed-metal objects, and the handles on the tureen resemble traditional Japanese wood joinery.[25] Dresser's later productions, such as a *Claret Jug* (FIG. 12) also display spare forms and straightforward use of materials. Even in works that are more obviously indebted to other cultures, such as an Islamic-inspired *Clutha Vase* (FIG. 13), Dresser streamlined the form to highlight the vessel's shape and delicate glass medium.

Architect and designer Edward William Godwin was another important early British Japanist.[26] Godwin was a close friend of Japanist William Burges (SEE CHAPTER 1, FIG. 5) and also knew Dresser. It is unclear when he first encountered Japanese art; Burges may have introduced Godwin to ukiyo-e prints as early as

11
Christopher Dresser
J. W. Hukin and J. T. Heath
Tureen and Ladle
c. 1880
Collection of Crab Tree Farm
Cat. 41

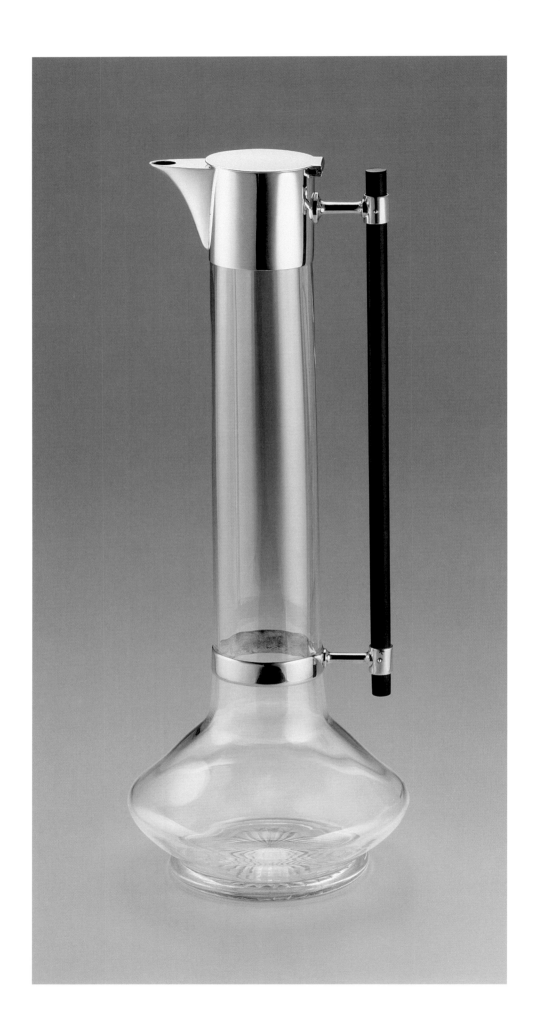

12
Attributed to Christopher Dresser
J. T. Heath and J. H. Middleton
Claret Jug
1892/93
The Art Institute of Chicago
Cat. 42

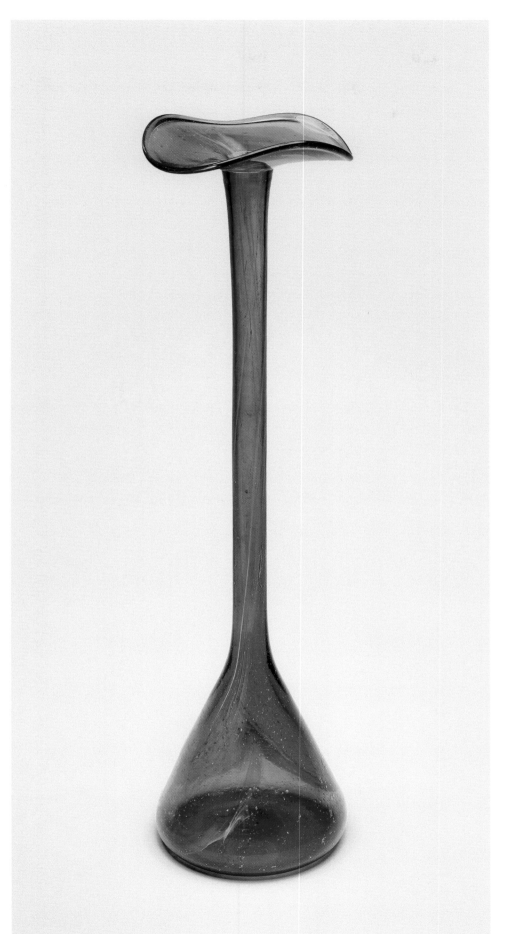

13
Christopher Dresser
James Couper and Sons
Clutha Vase
c. 1895
The Art Institute of Chicago
Cat. 43

1858.[27] Godwin likely saw the Japanese objects at the 1862 International Exhibition in London, where he had traveled from his native Bristol to attend an Architectural Alliance meeting. He went on to acquire an extensive Japanese art collection, buying objects in Bristol directly from ships that had just returned from Japan and, after moving to London in 1865, from the growing number of Japanese art dealers there.[28]

In 1867 Godwin, seeking to outfit a new home, became frustrated with the furniture then commercially available and decided to design his own. He created a spare, geometric suite in what would come to be known as his "Anglo-Japanese" style. Godwin later recalled:

> [I] set to work and designed a lot of furniture, and, with a desire for economy, directed that it should be made of deal, and to be ebonised. There were no mouldings, no ornamental metal work, no carving. Such effect as I wanted I endeavored to gain, as in economical building, by the mere grouping of solid and void and by a more or less broken outline. The scantling or substance of the framing and other parts of the furniture was reduced to as low a denomination as was compatible with soundness of construction.[29]

Unlike Dresser, Godwin never visited Japan, so his knowledge of the country's furnishings came from representations in tourist photographs, ukiyo-e prints and books, and Western publications on Japan.

Godwin found Aimé Humbert's *Le Japon illustré* (1870) and Katsushika Hokusai's *Manga* (1814–78) to be particularly useful sources of information about Japanese

14
Edward William Godwin
Sketch for a Shelf (detail)
Derived in part from illustrations in
Aimé Humbert, *Le Japon illustré*
c. 1870
Pencil, pen, and ink, colored washes;
22.9 x 16.5 cm (9 x 6 ½ in.)
Trustees of the Victoria and Albert
Museum, London, E.280–1963: 5

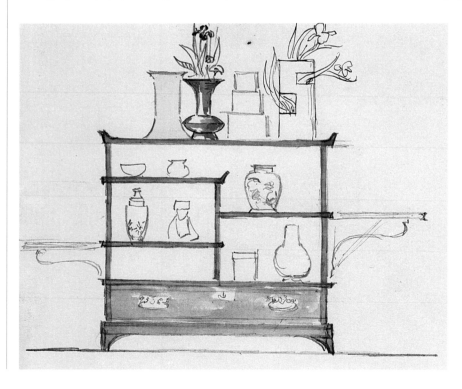

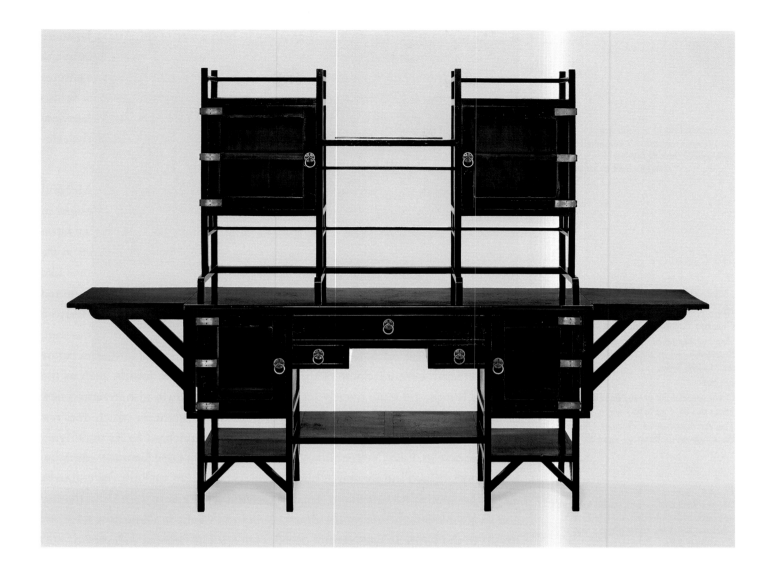

homes. Humbert had served as Swiss Minister to Japan in 1863–64 and illustrated his book with lithographs based on his photographs of the country. Godwin modeled furniture forms, such as his design for a radically streamlined shelf (FIG. 14), after the Japanese examples he saw in *Le Japon illustré*. Hokusai's *Manga*, a series of woodblock-printed books that were widely influential in the West, included many images of Japanese architecture. In his 1875 articles on "Japanese Wood Construction," Godwin reported that he had consulted "a Japanese book . . . [that] consists of fifty-six pages of illustrations, of which one-half or thereabouts are devoted to timber architecture."[30] This was volume five of Hokusai's *Manga*.[31] Godwin illustrated pages from it in his articles, and his Anglo-Japanese furniture, such as a sideboard (FIG. 15), demonstrates the influence of this source.

Although its function is Western, the sideboard's form, like the shelf Godwin sketched from the illustrations in *Le Japon illustré*, is simplified and strictly geomet-

15
Edward William Godwin
William Watt
Sideboard
c. 1876
The Art Institute of Chicago
Cat. 50

matte glazes that Rookwood designers began using in the late 1890s under the influence of traditional Japanese pottery. Such surface treatment differed tremendously from that of earlier examples such as Rettig's jug, which was finished with a shiny glaze highlighted with gold. Consequently, in the 1908 vase, the elegant simplicity of the form is emphasized as in more austere examples of Japanese pottery (SEE, FOR EXAMPLE, FIG. 9).[40] Shirayamadani's inclusion of Canada Geese marked this vase as North American; however, the literal "bird's-eye" perspective and asymmetrical arrangement of the compositional elements derive, as in Rettig's jug, from ukiyo-e prints. American artist and important early Japanist John La Farge described this latter characteristic of Japanese art as "a principle of irregularity, or apparent chance arrangement: a balancing of equal gravities, not of equal surfaces." In Japanese design, La Farge continued: "A few ornaments—a bird, a flower—on one side of this page would be made by an almost intellectual influence to balance the large unadorned space remaining."[41] The balanced asymmetry that La Farge described became one of the most popular Japanesque characteristics.

Boston art potters were especially engaged with Japanism. The city was, with New York, one of the two places in the United States with a significant Japanist community before the 1876 Centennial Exhibition. Many of the first serious American collectors of Japanese art were from Boston, including William Sturgis Bigelow, Ernest Fenollosa, and Edward Sylvester Morse.[42] In this environment, Arthur

21
Arthur Wesley Dow
Boats at Rest
c. 1895
The Art Institute of Chicago
Cat. 37

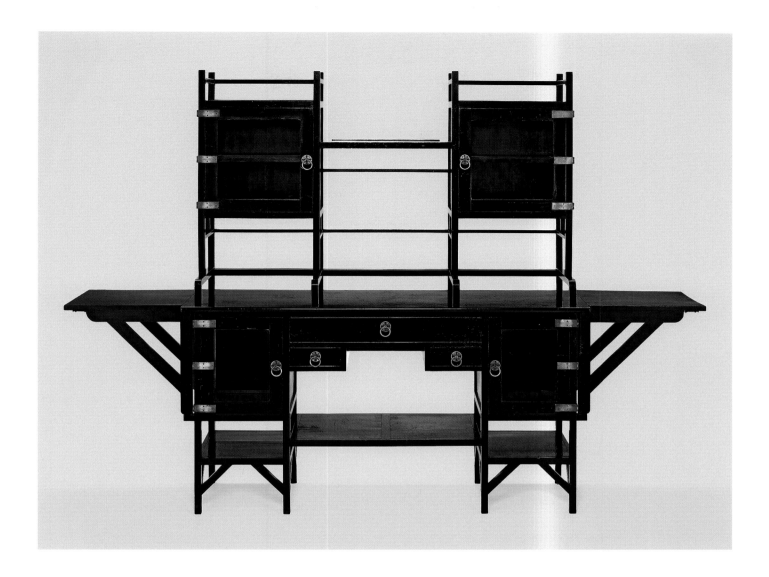

homes. Humbert had served as Swiss Minister to Japan in 1863–64 and illustrated his book with lithographs based on his photographs of the country. Godwin modeled furniture forms, such as his design for a radically streamlined shelf (FIG. 14), after the Japanese examples he saw in *Le Japon illustré*. Hokusai's *Manga*, a series of woodblock-printed books that were widely influential in the West, included many images of Japanese architecture. In his 1875 articles on "Japanese Wood Construction," Godwin reported that he had consulted "a Japanese book . . . [that] consists of fifty-six pages of illustrations, of which one-half or thereabouts are devoted to timber architecture."[30] This was volume five of Hokusai's *Manga*.[31] Godwin illustrated pages from it in his articles, and his Anglo-Japanese furniture, such as a sideboard (FIG. 15), demonstrates the influence of this source.

Although its function is Western, the sideboard's form, like the shelf Godwin sketched from the illustrations in *Le Japon illustré*, is simplified and strictly geomet-

15
Edward William Godwin
William Watt
Sideboard
c. 1876
The Art Institute of Chicago
Cat. 50

ric. The work's primary aesthetic effect is, as Godwin wrote of the Anglo-Japanese style in general, achieved "by the mere grouping of solid and void."[32] As in the traditional Japanese furnishings that he admired, the sideboard's spare form ensures that the structural supports are its dominant aesthetic element. The work is also ebonized, or painted black, a finish Godwin used in much of his Anglo-Japanese furniture. This treatment, coupled with the silvered brass fittings, makes the sideboard resemble an enlarged piece of Japanese lacquer.

Often working with American expatriate painter and designer James McNeill Whistler, Godwin also produced some of the first Japanesque interior designs in the West. Inspired by the Japanese spaces he saw in Western books such as *Le Japon illustré* and in ukiyo-e prints such as *Entertainments on the Day of the Rat in the Modern Style* (FIG. 16), Godwin designed similarly austere, geometric rooms like the studio inglenook in Frank Miles's London house (SEE FIG. 17). In the muted palette of such spaces, Godwin emulated the pale colors he admired in ukiyo-e prints. He and other early Japanists did not realize that these subtle tonalities were not original, but were caused by the fading of the fugitive inks used in Japan before the nineteenth century. Some of this inglenook's decorative motifs, such as the rounded lintels, are more overtly Japanese in origin. Godwin also invented new geometric ornamentation—in the patterned dado, for instance—which does not resemble actual Japanese architecture but is instead indebted to its underlying design principles. Like Dresser, therefore, Godwin did not copy Japanese examples, but instead utilized the general lessons he had learned from studying the country's art. Although this relationship to Japanese art and architecture was rare in Dresser and Godwin's generation, by the time the Art and Crafts movement reached its height in the United States several decades later, it had become widespread.

16
Utagawa Toyoharu (Japanese, 1735–1814)
Views of Reception Rooms in Japan—Entertainments on the Day of the Rat in the Modern Style
c. 1791
Color woodblock print; *ōban*; 25.3 x 37.3 cm (10 x 14 ⅝ in.)
The Art Institute of Chicago, Clarence Buckingham Collection, 1925.3185

17
Edward William Godwin, studio inglenook in Frank Miles's house, 44 Tite Street, Chelsea, London, 1879. Photo: 1972 © Country Life.

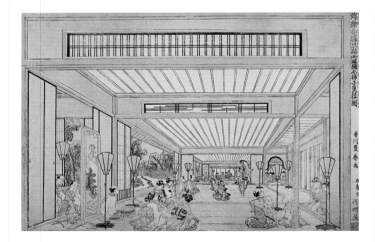

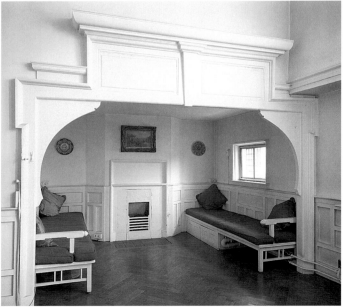

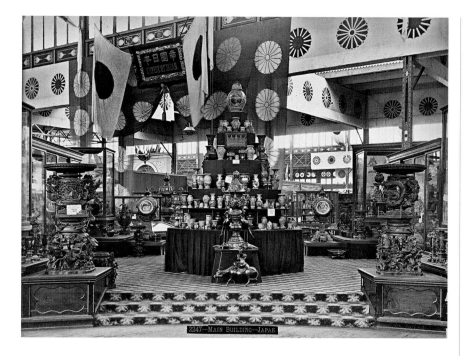

18
Empire of Japan display, Main Exhibition
Hall, Philadelphia Centennial Exposition,
1876. Photo: Print and Picture Collection,
Free Library of Philadelphia.

JAPANISM, ARTHUR WESLEY DOW, AND
AMERICAN ART POTTERY

Japanism attained popularity in the United States as a result of the Japanese
government's displays at the 1876 Centennial Exhibition in Philadelphia, where
they erected two traditional buildings: a house for their delegation and a bazaar.[33]
For most visitors to the Centennial, these structures provided their first direct
experience of Japanese architecture. Most Americans, however, were more
impressed by the Japanese art in the Main Exhibition Hall (SEE FIG. 18). Like the
Japanese display at the 1862 International Exhibition in London, this installation
resembled a Western department store rather than a traditional Japanese interior.
By this time, the Japanese may have realized that this was the most effective way
to present their art to the West. Their strategy paid off: the novel Japanese objects
in the hall caused Japanism to become broadly fashionable in the United States.

As in Britain, the first Japanesque American decorative arts and furniture feature
Japanese-derived ornamentation applied to Western forms.[34] As Americans learned
more about Japanese art in the 1880s and 1890s, however, their respect for it grew,
and they became less willing to combine Japanesque motifs with details from other
cultures. Instead, they sought to emulate whole Japanese objects and particularly
those that embodied the Arts and Crafts preference for simplified designs that were
true to their materials.

Japanism was particularly prevalent in art pottery, beginning with the Rookwood
Pottery in Cincinnati, Ohio.[35] Maria Longworth Nichols, a Cincinnati china painter,
was particularly impressed by the Japanese works at the 1876 Centennial Exhibition.

19
Rookwood Pottery
Decorated by Martin Rettig
Small Jug with Handle
1883
The David and Alfred Smart Museum
of Art, University of Chicago
Cat. 112

20
Rookwood Pottery
Decorated by Kitaro Shirayamadani
Vase
1908
The David and Alfred Smart Museum of
Art, University of Chicago
Cat. 114

Her husband, George Ward Nichols, expressed their shared conviction that "the novelty, freshness, and infinite grace of the decoration of these [Japanese] ceramics, bronzes, screens, fans, and lacquer work will exert a wide and positive influence upon American art industries."[36] In her eagerness to emulate Japanese wares, Maria Nichols first sought to import an entire Japanese pottery and its staff to Cincinnati. When this proved impossible, she founded Rookwood Pottery in 1880.

Early works by the firm, such as an 1883 jug painted by Martin Rettig (FIG. 19), display a more literal Japanism. Rettig used motifs drawn from Japanese objects, ukiyo-e prints, and Western books of Japanese decorative elements, arranging them in asymmetrical but balanced designs.[37] Other Rookwood artists at this time decorated their works with motifs drawn directly from Hokusai's *Manga*.[38] However, the underlying forms of and techniques used in the pottery during this period are fundamentally Western.

In 1887 Rookwood hired the Japanese painter Kitaro Shirayamadani, who, except for a period he spent in Japan between 1911 and 1921, worked at Rookwood until his death in 1948.[39] Shirayamadani's 1908 tall vase (FIG. 20) illustrates the new,

matte glazes that Rookwood designers began using in the late 1890s under the influence of traditional Japanese pottery. Such surface treatment differed tremendously from that of earlier examples such as Rettig's jug, which was finished with a shiny glaze highlighted with gold. Consequently, in the 1908 vase, the elegant simplicity of the form is emphasized as in more austere examples of Japanese pottery (SEE, FOR EXAMPLE, FIG. 9).[40] Shirayamadani's inclusion of Canada Geese marked this vase as North American; however, the literal "bird's-eye" perspective and asymmetrical arrangement of the compositional elements derive, as in Rettig's jug, from ukiyo-e prints. American artist and important early Japanist John La Farge described this latter characteristic of Japanese art as "a principle of irregularity, or apparent chance arrangement: a balancing of equal gravities, not of equal surfaces." In Japanese design, La Farge continued: "A few ornaments—a bird, a flower—on one side of this page would be made by an almost intellectual influence to balance the large unadorned space remaining."[41] The balanced asymmetry that La Farge described became one of the most popular Japanesque characteristics.

Boston art potters were especially engaged with Japanism. The city was, with New York, one of the two places in the United States with a significant Japanist community before the 1876 Centennial Exhibition. Many of the first serious American collectors of Japanese art were from Boston, including William Sturgis Bigelow, Ernest Fenollosa, and Edward Sylvester Morse.[42] In this environment, Arthur

21
Arthur Wesley Dow
Boats at Rest
c. 1895
The Art Institute of Chicago
Cat. 37

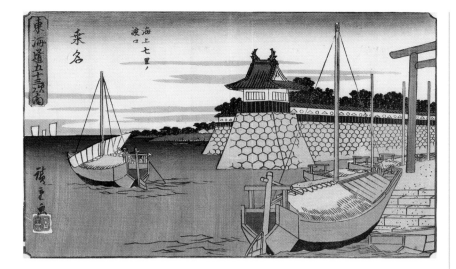

22
Ando Hiroshige I (Japanese, 1797–1858)
Kuwana: Sea Ferry Terminal at Shichiri,
from the series *The Fifty-Three Stations
of the Tokaido Road*
c. 1841–44
Color woodblock print; *aiban;*
23.2 x 35.2 cm (9 ⅛ x 13 ¹¹/₁₆ in.)
Museum of Fine Arts, Boston, William
Sturgis Bigelow Collection, 11.40023

Wesley Dow, a native of nearby Ipswich, Massachusetts, formulated some of the
most influential Japanesque theories of the Arts and Crafts period. Dow trained as
a painter at the Académie Julian in Paris but then discovered Hokusai's ukiyo-e
prints, writing to his future wife in 1890: "One evening with Hokasai [*sic*] gave me
more light on composition and decorative effect than years of study of pictures. I
surely ought to compose in an entirely different manner and paint better."[43] Dow
became a self-taught expert on ukiyo-e and in 1893 was named Assistant Curator
of Japanese Art at the Museum of Fine Arts, Boston. In 1903 he spent three months
in Japan, where he gained even more intimate knowledge of Japanese art.[44]

Japanese influence began to appear in Dow's work in the 1890s. His painting *Boats
at Rest* (FIG. 21) displays the elevated perspective, radical cropping, and asymme-
try found in ukiyo-e landscapes such as Ando Hiroshige's *Kuwana: Sea Ferry
Terminal at Shichiri* (FIG. 22), a print that Dow likely knew since it had been
brought to Boston in 1889 by William Sturgis Bigelow. Dow's color scheme here
is not Japanesque, but is instead related to the brilliant palette of French Post-
Impressionist artists such as Paul Gauguin, whom Dow may have met in Pont-Aven
in the late 1880s.[45] As Dow learned more about ukiyo-e, he began to make his own
prints, creating woodcuts that approximated their muted (actually faded) hues and
elegant simplicity. He experimented with different color schemes in prints of the
same composition (SEE FIGS. 23–24) to emphasize their handcrafted nature, a
characteristic he felt was connected to Japanese art:

> The masters of music have shown the infinite possibilities of variation—the
> same theme appearing again and again with new beauty, different quality and
> complex arrangement. Even so can lines, masses and colors be wrought into
> musical harmonies and endlessly varied. The Japanese color print exemplifies
> this, each copy of the same subject being varied in shade or hue or disposition
> of masses to suit the restless energy of the author.[46]

Moonrise "Common Fields" Ipswich 1905 AWD.

23
Arthur Wesley Dow
Moonrise "Common Fields" Ipswich
1905
Collection of Crab Tree Farm
Cat. 38

24
Arthur Wesley Dow
Moonrise
1898/1905
Color woodcut on cream Japanese paper;
10.8 x 17.8 cm (4 ¼ x 7 in.)
Terra Foundation for American Art,
Daniel J. Terra Collection, 1996.4

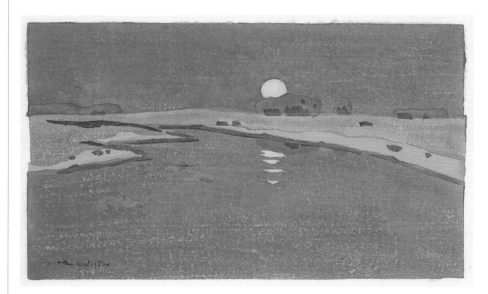

As Dresser and Godwin had before him, Dow sought to emulate the underlying aesthetic principles of Japanese art rather than copying them exactly. He wrote that he wanted to achieve "not any imitation of the Japanese but their refinement, their brilliant and powerful execution, subtle composition, and all the ennobling influences that come from them."[47] Despite any resemblance in perspective, composition, or palette to Japanese prints, Dow's primary subject—the landscape around Ipswich—ensured that his works would be seen as new creations rather than mere copies of Japanese art. Dow's prints are also more abstract than ukiyo-e. Although they often feature large areas of blank space, Japanese prints typically have sections of carefully rendered detail. Dow, in contrast, depicted the Ipswich landscape using broad blocks of flat color. His 1895 poster for Joseph Bowles's

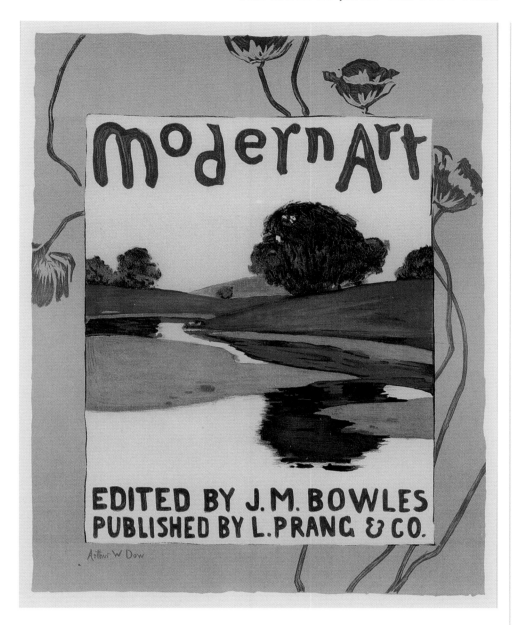

25
Arthur Wesley Dow
L. Prang and Company
Modern Art
1895
Collection of Crab Tree Farm
Cat. 36

journal *Modern Art* (FIG. 25) features one of his abstracted Ipswich landscapes. For both Dow and Bowles, such a Japanesque style embodied the characteristics they felt should be included in modern art.

In 1899 Dow published his theories on the essential formal principles of art in his book *Composition*. Effective design, he argued, depended upon harmony of line, color, and *notan*, a Japanese word meaning the relation between light and dark. Although Dow included examples from a variety of cultures in *Composition*, he promoted Japanese art as the ideal model for modern design. *Composition* influenced a generation of students in painting, printmaking, and the decorative arts. Dow also taught his Japanist theories at the Pratt Institute in Brooklyn; the Art Students' League and Columbia Teachers' College, both in New York; and the

Ipswich Summer School. Ceramist Marshall Fry wrote of Dow's impact on his field: "Mr. Dow has done much toward opening a way for us to gain that which we need. . . . [We decorators have] mistaken our ceramic forms for nothing more than surfaces upon which to represent flowers and figures, instead of first of all studying form, and to a beautiful form adding only such decoration as would be carrying further, an enhancing of the form itself."[48] Dow taught Arts and Crafts designers like Fry to emulate Japanese art as a way to achieve such goals.

Dow's influence was perhaps greatest among the designers who worked near his native Ipswich. In Boston William Grueby put Dow's ideas into practice in a series of ceramic concerns, beginning in 1894 with Grueby Faience Company.[49] Grueby's Japanism was shaped both by Dow and by the extensive Asian art collections at the Museum of Fine Arts, Boston, especially the large collection of Japanese and Korean earthenware, porcelain, and stoneware formed by Edward Sylvester Morse.[50] Grueby was one of the first American art potters to experiment with the matte glazes he saw on such Asian ceramics (SEE CHAPTER 3, FIG. 17). As at Rookwood, by using a muted finish and simplified surface decoration, Grueby's workers produced vases that emphasize the beauty of their overall form. In 1901 curators at the Tokyo Imperial Museum, perhaps recognizing Grueby's affinity with their traditional ceramics, acquired one of the firm's works for their collection.[51]

Grueby's chief tile designer, Addison Brayton Le Boutillier, also emulated Japanese art in works such as a framed set of eight tiles called *The Pines* (FIG. 26). His abstracted landscape is clearly indebted to Dow's Japanist theories. Moreover, the scene extends across the eight panels, forming an extremely horizontal composition comparable to those on traditional Japanese painted screens, such as the pair *Birds and Flowers in a Landscape* (FIG. 27), which Le Boutillier could have seen at the Museum of Fine Arts after Ernest Fenollosa and Charles Goddard Weld brought them back from Japan in 1889. In Le Boutillier's tiles, as in such screens, each individual panel is beautifully composed in itself, yet the group also unites to create an equally satisfying whole.

At the Marblehead Pottery in Marblehead, Massachusetts, only eighteen miles from Ipswich, the connections to Dow's Japanesque work were sometimes even

26
Grueby Faience Company
Designed by Addison Le Boutillier
The Pines
1906
Collection of Crab Tree Farm
Cat. 58

more explicit. Designer Annie Aldrich, for example, decorated a vase (SEE CHAPTER 3, FIG. 1) with a conventionalized landscape that is reminiscent of Dow's woodblock prints (SUCH AS FIG. 24), emulating not only his muted colors and overall abstraction, but also one of his favorite subjects, the Ipswich marshes. Like both Rookwood and Grueby pottery, Marblehead works feature decoration incised into the matte surface, making it an integral part of the object, a characteristic that Westerners admired in Japanese ceramics. Contemporary critics recognized this Japanism at Marblehead. In 1908, for instance, a writer in the *Craftsman* declared that the Marblehead productions in the National Arts Club's Arts and Crafts exhibition were "strongly suggestive of the influence of some of the best old Japanese pottery."[52]

At Newcomb Pottery in New Orleans, the connection to Dow's designs was not as overt, but was still significant. Newcomb potters had access to many of the most important texts of Arts and Crafts Japanism, including not only Dow's *Composition*, but also Dresser's *Studies in Design* and George Ward Nichols's *Pottery, How It Is Made*.[53] Inspired by such sources, Newcomb artisans created abstracted designs featuring subjects from nature, which were defined by clear outlines incised into the object's surface. In a 1903 vase (FIG. 28), for instance, Marie de Hoa Le Blanc used a lily design that complements the work's gracefully tall shape. The vessel's lower portion features contrasting panels of rose glaze, out of which the lilies emerge. At top, the blossoms highlight the swell of the shoulders. The decoration is thus integrally related to the overall shape, in accordance with Arts and Crafts objectives. Mary Sheerer, professor of ceramics at Newcomb Art School, wrote of the importance of conventionalizing natural motifs in this way, commenting: "The temptation is to give [plants] their characteristic wild grace; but this 'natural' method tends, unfortunately,—except with such masters as the Japanese—to cheapness and superficiality of production."[54] Ironically, for Sheerer, only the Japanese were skillful enough designers to be able to ignore the Japanesque rules of good composition set out by theorists such as Dow. For American Arts and Crafts potters, though, Japanism provided the surest route to harmonious design.

27
Japan
Birds and Flowers in a Landscape
Momoyama period; latter half of the sixteenth century
Pair of six-panel screens; ink, color, and gold on paper; each 154.8 x 355.6 cm (60 ¹⁵⁄₁₆ x 140 in.)
Museum of Fine Arts, Boston, Fenollosa-Weld Collection, 11.4422

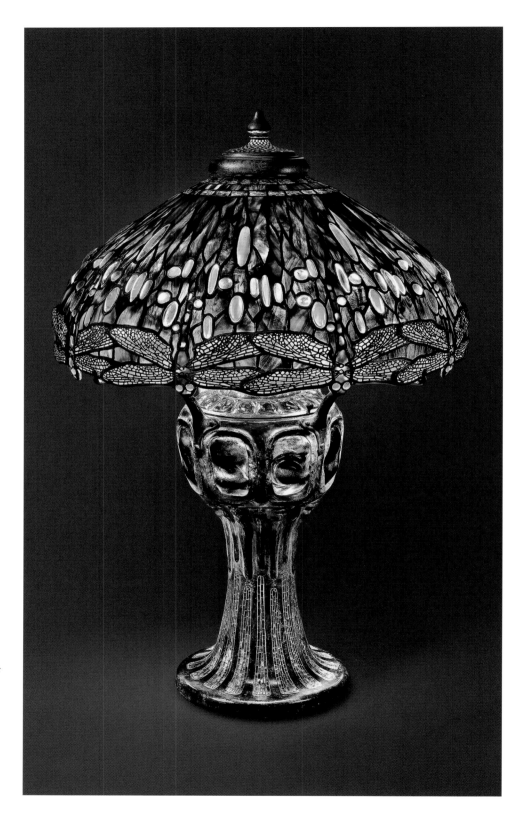

29
Tiffany Studios
Design attributed to Clara Pierce
Wolcott Driscoll
Hanging Head Dragonfly Shade on Mosaic and Turtleback Base
By 1906
The Art Institute of Chicago
Cat. 155

more explicit. Designer Annie Aldrich, for example, decorated a vase (SEE CHAPTER 3, FIG. 1) with a conventionalized landscape that is reminiscent of Dow's wood-block prints (SUCH AS FIG. 24), emulating not only his muted colors and overall abstraction, but also one of his favorite subjects, the Ipswich marshes. Like both Rookwood and Grueby pottery, Marblehead works feature decoration incised into the matte surface, making it an integral part of the object, a characteristic that Westerners admired in Japanese ceramics. Contemporary critics recognized this Japanism at Marblehead. In 1908, for instance, a writer in the *Craftsman* declared that the Marblehead productions in the National Arts Club's Arts and Crafts exhibition were "strongly suggestive of the influence of some of the best old Japanese pottery."[52]

At Newcomb Pottery in New Orleans, the connection to Dow's designs was not as overt, but was still significant. Newcomb potters had access to many of the most important texts of Arts and Crafts Japanism, including not only Dow's *Composition*, but also Dresser's *Studies in Design* and George Ward Nichols's *Pottery, How It Is Made*.[53] Inspired by such sources, Newcomb artisans created abstracted designs featuring subjects from nature, which were defined by clear outlines incised into the object's surface. In a 1903 vase (FIG. 28), for instance, Marie de Hoa Le Blanc used a lily design that complements the work's gracefully tall shape. The vessel's lower portion features contrasting panels of rose glaze, out of which the lilies emerge. At top, the blossoms highlight the swell of the shoulders. The decoration is thus integrally related to the overall shape, in accordance with Arts and Crafts objectives. Mary Sheerer, professor of ceramics at Newcomb Art School, wrote of the importance of conventionalizing natural motifs in this way, commenting: "The temptation is to give [plants] their characteristic wild grace; but this 'natural' method tends, unfortunately,—except with such masters as the Japanese—to cheapness and superficiality of production."[54] Ironically, for Sheerer, only the Japanese were skillful enough designers to be able to ignore the Japanesque rules of good composition set out by theorists such as Dow. For American Arts and Crafts potters, though, Japanism provided the surest route to harmonious design.

27
Japan
Birds and Flowers in a Landscape
Momoyama period; latter half of the sixteenth century
Pair of six-panel screens; ink, color, and gold on paper; each 154.8 x 355.6 cm (60 ¹⁵⁄₁₆ x 140 in.)
Museum of Fine Arts, Boston, Fenollosa-Weld Collection, 11.4422

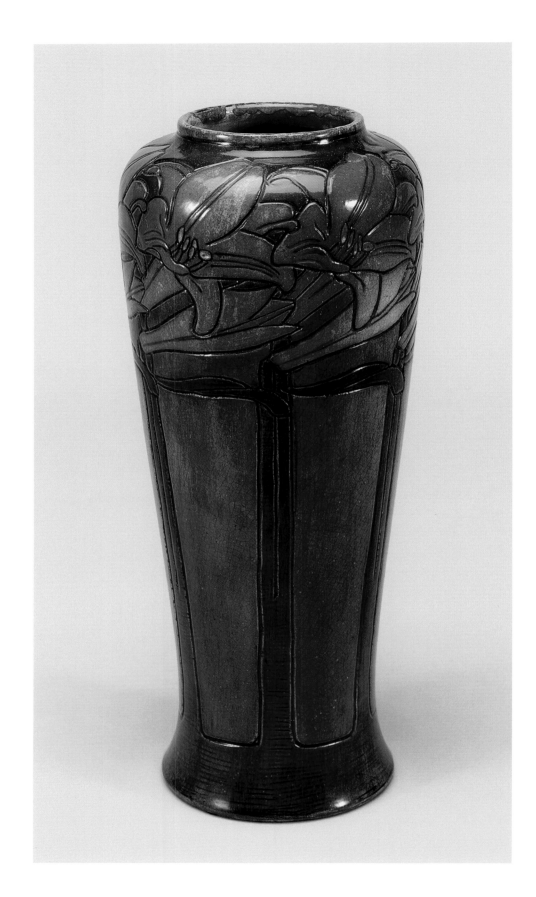

28
Newcomb
Made by Joseph Fortune Meyer
Decorated by Marie de Hoa Le Blanc
Vase
1903
Collection of Crab Tree Farm
Cat. 99

JAPANISM AND ART NOUVEAU

Some Japanist works produced during the Arts and Crafts movement can also be categorized as Art Nouveau. Recent research has shown that these two styles were international in scope, overlapped significantly, and both embraced Japanism.[55] Beginning in 1895, French art dealer Siegfried Bing exhibited a number of Arts and Crafts objects—including examples from both Grueby and Rookwood potteries—in his Galeries d'Art Japonais in Paris, called Maison de l'Art Nouveau. Bing had begun his career in 1875 as a dealer of Japanese art, and in 1888 he founded a journal, *Le Japon artistique*, in which he advocated that Westerners improve their productions by emulating Japanese art. For Bing, as for Dow, the Japanese model was attractive because it offered an alternative to Western academic styles. Also, as Bing's journal title made explicit, such Arts and Crafts theorists had an idealized view of Japanese culture, believing that it was fundamentally artistic and thus that its productions were the perfect models for design.

The Japanesque style promoted by Bing came to be called Art Nouveau, after the name of his gallery. As this phrase indicates, Bing, like Dresser and Dow, held that Westerners should not copy Japanese objects but instead should use underlying Japanese artistic principles to create new productions. Bing's Japanist ideas were widely publicized in both Europe and the United States. In Boston, Dow's friend J. M. Bowles published a translation of Bing's announcement of the opening of his Maison de l'Art Nouveau in his magazine *Modern Art*.[56] The border of Dow's poster for the journal (SEE FIG. 25) features an asymmetrical design of attenuated poppies, characteristics which were typical of Art Nouveau Japanism.

Bing particularly admired the work of American designer Louis Comfort Tiffany, whom he featured in his 1895 publication on American art, *La culture artistique en Amérique*.[57] From the beginning of his career in the 1870s, Tiffany had many connections to American Japanists, including Edward C. Moore, chief designer at Tiffany's father's silver-crafting firm Tiffany and Company, the artist John La Farge (later Tiffany's rival), and Bing, whom Tiffany likely met in Paris in 1878.[58] In a series of commercial ventures, Tiffany experimented with Japanesque design in furniture, interiors, metalwork, and stained glass. By 1906, the year his firm Tiffany Studios first advertised both the *Hanging Head Dragonfly Shade* and *Mosaic and Turtleback Base* (FIG. 29), Tiffany was approving all productions but creating few lamps himself. This shade and base were likely designed by Clara Driscoll, head of the Women's Glass-Cutting Department. By this time Japanism was so pervasive in Western two-dimensional art that Driscoll could have absorbed it from any number of sources. Nearly all of her abstracted, graphically strong designs can be linked to the trend. This shade is particularly Japanesque since it features dragonflies, a motif popular in traditional Japanese art; Driscoll created at least seven different shades with dragonflies hanging or in flight. This example also

29
Tiffany Studios
Design attributed to Clara Pierce
Wolcott Driscoll
Hanging Head Dragonfly Shade on Mosaic and Turtleback Base
By 1906
The Art Institute of Chicago
Cat. 155

30
Aubrey Beardsley
Panel
Early 20th century
The Art Institute of Chicago
Cat. 12

31
Kitagawa Utamaro (Japanese, c. 1756–
1806)
The Hour of the Hare
1796
Color woodblock print; ōban;
37.5 x 24.4 cm (14¾ x 9⅝ in.)
The Art Institute of Chicago, Clarence
Buckingham Collection, 1925.3053

displays the abstracted designs from nature characteristic of Art Nouveau. A team of glass selectors mass-produced Tiffany Studios' designs but varied the color scheme of each piece. Tiffany thus ensured that his customers would realize his lamps were handcrafted, as was favored during the Arts and Crafts movement.

The radically asymmetrical, curving forms of Art Nouveau were also used famously by British artist Aubrey Beardsley in designs such as those on a textile panel (FIG. 30). In such works, Beardsley emulated the expressive use of line and pattern in ukiyo-e prints of *bijinga*, or beautiful women, such as Kitagawa Utamaro's *Hour of the Hare* (FIG. 31).[59]

Inspired by Beardsley, Will Bradley was one of the first American graphic designers to adopt a Japanesque Art Nouveau style in his book and poster designs. Born in Boston, Bradley moved to Chicago in 1885, where interest in Japanism was then

growing rapidly. Like many Chicagoans, Bradley had his first significant exposure to Japanese art at the city's World's Columbian Exposition in 1893.[60] The fair marked the first time Japanese objects were exhibited in the fine arts pavilion alongside Western art rather than in the ethnographic area. Although Chicagoans such as Frederick Gookin had begun acquiring ukiyo-e prints in the 1880s, the exposition prompted more widespread interest in these works in the city. Businessman Clarence Buckingham, whose woodblock prints now form the core of the Art Institute's superb ukiyo-e collection, began acquiring them at this time.[61]

Like Dow and Bing, Bradley was excited by ukiyo-e prints because their aesthetic was so opposed to Western academic modes of representation; thus, emulating such examples allowed him to signal that his designs were new and modern.[62] Accordingly, Bradley incorporated an abstracted Japanist aesthetic into works such as his first design for the Chicago publisher Stone and Kimball, for Tom Hall's 1894 book *When Hearts Are Trumps* (FIG. 32). Stone and Kimball then commissioned

32
William H. Bradley
Published by Herbert Stuart Stone and
Hannibal Ingalls Kimball, Jr.
When Hearts Are Trumps
December 1894
The Art Institute of Chicago
Cat. 17

Bradley to design seven covers for a new periodical, the *Chap-Book* (SEE FIGS. 33–34) for which he used this same Art Nouveau style. Bradley's posters were exhibited at both Bing's gallery in Paris in 1895 and at the newly formed Society of Arts and Crafts, Boston, in 1897, demonstrating once again the close connection between Art Nouveau and the Arts and Crafts movement.

JAPANISM AND AMERICAN ARTS AND CRAFTS FURNITURE AND INTERIOR DESIGN

As with pottery, posters, and prints, Japanism became more pronounced in furniture and interior design as the Arts and Crafts movement evolved in the United States. The trend had first influenced smaller-scale decorative arts; it was only in this later period that it became widespread in furniture and interior design, as the initial Western prejudice against traditional Japanese architecture was replaced by a growing admiration. Californians Charles Sumner Greene and Henry Mather Greene and Chicagoan Frank Lloyd Wright embody two different Japanist approaches in these fields.

33
William H. Bradley
Published by Herbert Stuart Stone and
Hannibal Ingalls Kimball, Jr.
The Pink, for *The Chap-Book*
May 1895
The Art Institute of Chicago
Cat. 18

34
William H. Bradley
Published by Herbert Stuart Stone and
Hannibal Ingalls Kimball, Jr.
Thanksgiving, for *The Chap-Book*
November 1895
The Art Institute of Chicago
Cat. 19

Greene and Greene's Japanism stemmed from a variety of sources.[63] The brothers spent five years in the Boston area beginning in 1888, attending the Massachusetts Institute of Technology and then working in several architectural firms. In this city where interest in Asia was so great, they likely encountered both Japanese art and Japanism, including Edward Sylvester Morse's important 1886 text on Japanese architecture, *Japanese Homes and Their Surroundings*.[64] In addition, Greene and Greene apparently admired the Japanese buildings at the 1893 World's Columbian Exposition, which they visited in the course of their move from Boston to Pasadena. They were even more impressed by the Japanese pavilions at the 1904 Louisiana Purchase Exposition in St. Louis; indeed it was only after this date that Japanism began to appear consistently in their work. Greene and Greene also had access to East Asian objects in Pasadena and Los Angeles through dealers such as Fong See, whose Suie One shop sold Chinese furniture in both locations beginning in 1902.

Influenced by such sources, as well as by the Arts and Crafts theories of contemporaries like Gustav Stickley (SEE CHAPTER 3) and the curving stylizations of Art Nouveau, Greene and Greene developed their California bungalow style. In structures such as the Robert R. Blacker House in Pasadena (1907–09), crafted by John and Peter Hall, they created the sort of ideally unified interior they admired in traditional Japanese structures that they knew from sources such as Morse's book (SEE FIG. 35).[65] A view of the living room (CHAPTER 3, FIG. 35) demonstrates how Greene and Greene simplified the decoration to unify the space; the lotuses in the frieze are echoed in the art glass of the lanterns, for example. In addition, the interior architecture is indebted to traditional Japanese spaces in both the use of unpainted wood and the continuous horizontal rail above the windows and doors, which, like the Japanese *kamoi*, provides the wall's only division.

Despite their admiration for Japanese architecture, Greene and Greene's houses do not look like actual Japanese structures. In the Blacker House living room, the frieze's low-relief design of lotuses is covered with gold leaf. Although the lotus is a sacred Buddhist motif and its treatment here resembles Japanese lacquer, the large-scale of the design and its placement in the frieze makes it definitely Japanesque rather than Japanese. Likewise, in the furniture he designed for the house—such as the serving table and side chair (CHAPTER 3, FIGS. 36–37)—Charles Sumner Greene combined inlay inspired by Japanese lacquer ornamentation with bracketry and joinery derived from his study of Chinese furniture forms.[66] Nevertheless, despite the variety of influences evident in the Blacker House, contemporary critics defined it as Japanesque.[67]

Just as Japanesque as Greene and Greene's designs, although in a different way, is the work of their contemporary, Frank Lloyd Wright. Like Greene and Greene, Wright's Japanism stemmed from a variety of sources. His first employer in Chicago, architect Joseph Lyman Silsbee, collected Japanese art and was the cousin of the

35
"Guest-room Showing Writing-Place,"
from Edward Sylvester Morse, *Japanese
Homes and Their Surroundings* (1886),
p. 141, fig. 122.

36
Interior of the formal teahouse, Katsura
Detached Palace, Kyoto, Japan, 1616–63.
Photo: Werner Forman/Art Resource, NY.

first curator of Japanese art at the Museum of Fine Arts, Boston, Ernest Fenollosa.[68]
Silsbee and Fenollosa introduced Wright to key Japanist texts such as Morse's
book. Through Silsbee, Wright also learned of the Japanesque Shingle style archi-
tecture popularized by designers such as McKim, Mead, and White and used by
Silsbee in Chicago. Wright thus already had a considerable interest in Japanese
art and architecture by 1893, which drew him to the Japanese exhibits at the
World's Columbian Exposition. There, he was particularly fascinated by the pavil-
ion based on the Ho-o-den, a mid-eleventh-century Buddhist temple near Kyoto,
within which were created different kinds of traditional Japanese interiors. The
building provided Wright with his first experience of actual Japanese architecture.
Unlike Greene and Greene, Wright also gained firsthand knowledge of Japanese
structures when he traveled to the country in 1905. There, he saw at least one
example of the spare, geometric *sukiya shoin* style of architecture, likely either of
the two most famous seventeenth-century examples in Kyoto: Katsura (FIG. 36)

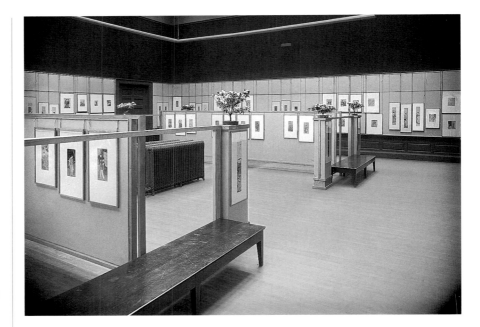

37

Exhibition of Japanese woodblock prints
at the Art Institute of Chicago, 1908,
installation designed by Frank Lloyd Wright.
Photo: Art Institute of Chicago Archives.

38

Frank Lloyd Wright, dining room,
Frederick C. Robie House, Chicago,
1908/10. Photo: c. 1910, Art Institute of
Chicago Archives.

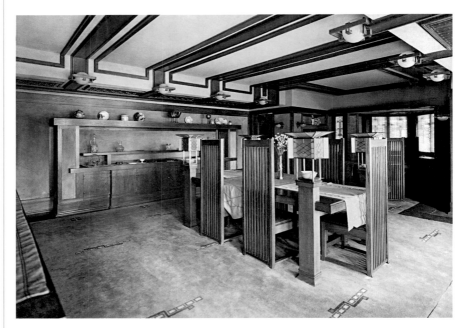

or Shugakuin.[69] Wright was intrigued both by the open plan of such structures and by their simplicity and abstraction, characteristics that appealed to his Arts and Crafts sensibility.

Wright's Prairie houses, such as the Frederick C. Robie House (1908–10) in Chicago, are also indebted to ukiyo-e prints. Wright consistently asserted the importance of them to his artistic development; in his autobiography, he wrote: "If Japanese prints were to be deducted from my education, I don't know what direction the whole might have taken."[70] Although he was a serious collector of a broad range of Japanese art, including ceramics, screens, sculptures, and textiles, it was

ukiyo-e that most excited Wright. He even acted as a dealer of woodblock prints and organized exhibitions of them.[71] At the most famous of these, held at the Art Institute of Chicago in 1908, Wright designed the galleries and their furnishings to harmonize with prints drawn from the collections of Buckingham and Gookin as well as his own in an installation that was the largest showing of ukiyo-e in the United States to date (SEE FIG. 37).

Wright was particularly taken with the austerity and underlying geometry he saw in ukiyo-e. In a 1908 lecture, later published as *The Japanese Print: An Interpretation*, he stated that Japanese objects represent "a thoroughly structural Art," concluding that "the first and supreme principle of Japanese aesthetics consists in a stringent simplification by elimination of the insignificant."[72] Influenced by both actual Japanese structures and the characteristics that he appreciated in ukiyo-e, Wright incorporated abstraction and geometric modularity into his Prairie houses.

The Robie House, for instance, has the open plan that Wright admired in Japanese *sukiya shoin* architecture. As in Greene and Greene's Blacker House, the Robie dining room (FIG. 38) features unadorned wood molding and a continuous rail in emulation of the Japanese *kamoi*. Wright also designed the residence's furnishings, such as the dining table and chairs (CHAPTER 5, FIG. 29), to harmonize with the interior. In both the furniture and architecture, he eliminated conventional orna-ment so that the underlying structure and material would be emphasized. Although this part of his project was allied with that of Greene and Greene, Wright modeled his limited ornament not on the curves of Art Nouveau and Chinese furniture but on the economy of form he so admired in ukiyo-e.

The renderings executed in Wright's architectural practice emphasize the Japanism of his buildings and demonstrate how the trend affected the entire Prairie school. Marion Mahony Griffin's drawing looking up at the Thomas P. Hardy House in Racine, Wisconsin, from Lake Michigan (FIG. 39), for instance, has an oblong format reminiscent of a Japanese pillar print.[73] The work's radically asymmetrical composition is also influenced by ukiyo-e: its great expanse of empty space is offset by only a few delicate flowered branches on the far right. Although the drawing is not an especially useful source of information about Wright's Hardy House, it is a beautifully balanced composition in its own right. Griffin's perspective rendering of her husband Walter Burley Griffin's design for Rock Crest/Rock Glen, Mason City, Iowa (FIG. 40) is also indebted to Japanese art. The bird's-eye view, oblong horizontal format, and golden clouds that frame the scene emulate similar elements in Japanese painted handscrolls and screens (such as those in FIG. 41), and the two side panels resemble pillar prints. Again, the drawing is not only an architectural proposal, but an exquisite design in itself, embodying the Arts and Crafts ideal of bringing art to everyday objects. Like the great majority of Arts and Crafts design-ers, the Griffins used Japanism to achieve this goal.

39
Marion Mahony Griffin
Thomas P. Hardy House, Racine, Wisconsin
1905
Published in *Ausgeführte Bauten und Entwürfe von Frank Lloyd Wright* (Berlin, 1911), pl. 15
The Art Institute of Chicago, Ryerson and Burnham Libraries
Cat. 54

40
Designed by Walter Burley Griffin
Delineated by Marion Mahony Griffin
*Rock Crest/Rock Glen: Perspective
Rendering*
c. 1912
The Art Institute of Chicago
Cat. 55

41
Japan
The Tale of Taishokan
Edo period; 1640/80
Pair of six-panel screens; ink, colors,
and gold on paper; each 174 x 374 cm
(68 ½ x 147 ¼ in.)
The Art Institute of Chicago, restricted gift
of Charles C. Haffner III and Muriel Kallis
Newman; Alyce and Edwin DeCosta and
Walter E. Heller Foundation Endowment;
through prior gift of Charles C. Haffner III,
1996.436.1–2

As we have seen, Japanism was one of the most significant influences on the Arts
and Crafts movement. Building on the groundbreaking work of figures such as
Dresser and Godwin, Arts and Crafts designers in the 1890s and early twentieth
century attained new knowledge of and respect for Japanese art. As a result, they
integrated a deeper understanding of these works into their productions, emulating
underlying Japanese design principles rather than only particular surface motifs.
Paradoxically, although Japanese art had originally attracted Westerners because of
its apparently premodern mode of production, Japanesque characteristics such as
simplification and abstraction led Arts and Crafts designers toward modernism.

1. Charles Robert Ashbee, Journal, Jan. 1909,
King's College Archive Centre, Cambridge,
The Papers of Charles Robert Ashbee, CRA,
p. 89. I am grateful to Tracy Wilkinson at the
King's College Archive Centre for her research
assistance with the Ashbee papers.

2. The Tokugawa shogunate, which ruled Japan
in the Edo period (1615–1868), halted virtually
all international trade in 1639, allowing only the
Chinese and Dutch to maintain limited ties.

3. On Japanism as part of the larger anti-
modernist impulse in the Arts and Crafts move-
ment, see Lears 1981, p. 85.

4. Walter Crane, *Of the Decorative Illustration of
Books Old and New* (1896; repr., G. Bell, 1972),
p. 132. In his review of the 1862 International
Exhibition in London, William Burges made
this same point, writing: "If the visitor wishes to
see the real Middle Ages, he must visit the
Japanese Court for at present day the arts of the
Middle Ages have deserted Europe and are only
to be found in the East." William Burges, "The
International Exhibition," *Gentleman's Magazine*
213 (July 1862), p. 3.

5. Jarves 1876, p. 197.

6. On this debate, see Catherine Lynn,
"Decorating Surfaces: Aesthetic Delight,

Theoretical Dilemma," in Burke et al. 1986, pp. 53–63. For Ruskin's views on the decorative arts, see Ruskin 1849.

7. On Jones, see Flores 2006. On Jones and non-Western art, see Darby 1974.

8. On Jones's textiles, see Galloway 1999, p. 94. Jones's fabrics were known in the United States; at least one of them was exhibited at the 1876 Centennial Exhibition, for example (see the drapery in Charles B. Norton, ed., *Treasures of Art, Industry and Manufacture Represented in the American Centennial Exhibition at Philadelphia 1876* [Cosack and Co., 1877], pl. 17, n.pag.).

9. Jones 1856, Preface and Propositions, p. 6.

10. Jacqueline Herald, "On Designing Textiles with Birds," in *William Morris and Kelmscott*, (Design Council, 1981), p. 120.

11. William Morris to May Morris, March 21, 1878, repr. in May Morris 1936, p. 579.

12. William Morris 1893, p. 35.

13. On Japanism in Britain, see Watanabe 1991; and Sato and Watanabe 1991.

14. See Alcock 1862.

15. Alfred Lys Baldry, "The Growth of an Influence," *Art Journal* (Feb. 1900), p. 47.

16. Edward W. Godwin, "A Japanese Warehouse," *Architect* (Dec. 23, 1876), p. 363.

17. "Leaves & Flowers from Nature No. 8," plate 158 in *The Grammar of Ornament*. On Dresser and Japanism, see Widar Halen, "Dresser and Japan," in Whiteway 2004, pp. 127–39.

18. The School of Design is now the Victoria and Albert Museum. For more on its early collection of Japanese art, see Faulkner and Jackson 1995.

19. Alcock later recalled that at the 1862 International Exhibition, "Dr. Dresser was . . . a close student of the various objects in the Japanese Court." Alcock 1878, pp. 48–49.

20. See, for example, Dresser 1862, pp. 91–92, 165–66.

21. A writer for the *New York Times* expressed the typical Western view immediately after Japan began trading with the West when he wrote in 1860 that Japanese architecture "can hardly be said to have an existence." See "Japan and the Japanese," *New York Times*, June 16, 1860, p. 2.

22. For more on the different aesthetics of traditional Japanese art, see Dunn 2001.

23. As Dresser later recalled, "Messrs. Londos & Co. at once arranged with me that I make for them during my journeyings in [Japan] a typical collection of art objects such as should illustrate as fully as possible both the present and the old manufactures of Japan, and have reliable tutorial value." Dresser 1878, p. 170. The South Kensington Museum bought this tea bowl from Londos in 1877, so it may be one of the objects Dresser brought back from Japan for that company.

24. When he was art advisor at Hukin and Heath in the late 1870s, Dresser also supervised the copying of both Japanese and Persian objects through the electrotyping process.

25. Dresser would have seen such joinery in Japan and illustrated in sources such as Edward Godwin's 1875 articles on "Japanese Wood Construction." See Godwin 1875.

26. On Godwin's Japanism, see Nancy B. Wilkinson, "E. W. Godwin and Japonisme in England," in Soros 1999, pp. 71–91.

27. Burges's ukiyo-e prints are now in the Victoria and Albert Museum, London (Victoria and Albert Museum, Department of Prints, Drawings, and Paintings, 8827).

28. Godwin's ledger from the years 1858 through 1869 is now in the Victoria and Albert Museum and includes an extensive list of the Asian objects he purchased from Wareham's, Hewett's, and Farmer and Rogers's (Victoria and Albert Museum, Archive of Art and Design, 4/9–1980, n.pag.).

29. Godwin 1876, p. 5.

30. Godwin 1875, p. 173.

31. Aslin 1986, p. 24.

32. Godwin 1876, p. 5.

33. On Japanism in the United States, see Hosley 1990. On American Japanism before the 1876 Centennial Exhibition, see Laidlaw 1996.

34. See, for example, Herter Brothers, *Cabinet*, 1878/80, Art Institute of Chicago, 1986.26. For an illustration, see *Objects of Desire: Victorian Art in the Art Institute of Chicago*, Art Institute of Chicago Museum Studies 31, 1 (Spring 2005), p. 80.

35. On Japanism at Rookwood pottery, see Trapp 1981, and Nancy E. Owen, *Rookwood Pottery at the Philadelphia Museum of Art: The Gerald and Virginia Gordon Collection*, exh. cat. (Philadelphia Museum of Art, 2003), pp. 21–37.

36. George Ward Nichols, *Art Education Applied to Industry* (G. P. Putnam's Sons, 1877), p. 203.

37. For an example of such a pattern book, see Thomas W. Cutler, *A Grammar of Japanese Ornament and Design* (London, 1880).

38. See, for example, the 1885 vase by Albert Robert Valentien in Ellis 1992, cat. 5, p. 70.

39. On Shirayamadani, see Fowler 2005.

40. Critics recognized the connection between Rookwood pottery and East Asian ceramics. A writer in 1901 noted, "Outside of Japan and China we do not know where any colors and glazes are to be found finer than those which come from Rookwood pottery." "The World Famous Rookwood Ware," *Crockery and Glass Journal* 54 (Dec. 12, 1901), p. 113.

41. La Farge 1870, p. 197.

42. On the early collecting of Japanese art in Boston, see Fontein 1992, and Chong and Murai 2009.

43. Arthur Wesley Dow to Minnie Pearson, Feb. 26, 1890, quoted without further attribution in Johnson 1934, p. 54.

44. Dow's diary from his trip to Japan is in the Arthur Wesley Dow papers, Archives of American Art, Smithsonian Institution.

45. See David Sellin, *Americans in Brittany and Normandy, 1860–1910*, exh. cat. (Phoenix Art Museum, 1982), pp. 53–54.

46. Dow 1899, p. 38.

47. Arthur Wesley Dow to Minnie Pearson [1890], quoted without further attribution in Johnson 1934, p. 56.

48. Marshall Fry, "National League," *Keramic Studio* 4 (Feb. 1903), pp. 214–15. For the influence of Dow on American art pottery, see Jessie Poesch, "Arthur Wesley Dow and Art Pottery: The Beauty of Simplicity," in Green and Poesch 1999, pp. 109–26.

49. For Japanism at Grueby Pottery, see Montgomery 1993, pp. 35–37.

50. For the Morse collection, see Morse 1903.

51. Contemporary critics recognized the Japanism of Grueby pottery. Arthur Russell wrote in *House Beautiful* in 1898: "The Japanese have taught us much, but nothing more clearly perhaps than that beauty does not depend upon intricacy or elaborateness of design and ornamentation; it is to the heart, not the hand, of the potter that we must look for it. There is less in the wonderful carved ivories of Japan than in the simplified pot thrown upon the wheel of a potter that loves his art. This has been slow to fix itself in the minds of our American potters, who are more given to deadening processes of machinery than to the inspiration of the master's mind. Yet to-day we may congratulate ourselves that we have men who know the value of individual effort and the wonderful charm of personality. They know that to see the mind of the potter in the pot is to see worth there. Such men are Mr. Taylor of Rookwood Pottery, Mr. Carey of Dedham Pottery, and Mr. Grueby of the Grueby Faïence Company." Arthur Russell, "Grueby Pottery," *House Beautiful* 5, 1 (Dec. 1898), pp. 3–4.

52. "The Annual Arts and Crafts Exhibition at the National Arts Club, New York," *Craftsman* 13, 4 (Jan. 1908), p. 482.

53. These books are Dresser 1874–76; and Nichols 1878. See Poesch and Mann 2003, pp. 34, 48, 54–59.

54. Quoted in Nathaniel Wright Stephenson, "Newcomb College and Art in Education," *Forensic Quarterly* 1 (Sept. 1910), p. 260.

55. See, for example, Livingstone and Parry 2005, and Weisberg, Becker, and Possémé, 2004.

56. "Echoes," *Modern Art* (Jan. 1897), n.pag.

57. Bing 1896.

58. On Tiffany and Japanism, see Roberts 2006.

59. On these Beardsley drawings, see Reade 1967. Like other Symbolists in fin-de-siècle Europe, Beardsley was also drawn to the grotesque tradition in Japanese art, since such works seemed appropriate models for his decadent subjects.

60. Wong 1971, p. 91.

61. On the early collecting of Japanese art in Chicago, see Elinor Pearlstein, "The Department of Asian Art," in Pearlstein and Ulak 1993, pp. 7–9, and Ulak 1995.

62. Meech and Weisberg 1990, p. 87.

63. On Greene and Greene and Japanese sources, see Virginia Greene Hales and Bruce Smith, "Charles and Henry Greene," pp. 54–55 n. 38, and Nina Gray, "'The Spell of Japan': Japonism and the Metalwork of Greene and Greene," pp. 133–53, both in Bosley and Mallek 2008.

64. Morse 1886.

65. On the Blacker House, see Bosley 2000, pp. 106–11, and Kaplan 1987, pp. 402–05.

66. On Greene and Greene's use of Chinese sources, see Edward S. Cooke, Jr., "An International Studio: The Furniture Collaborations of the Greenes and the Halls," in Bosley and Mallek 2008, p. 115.

67. See, for example, A. W. Alley, "A House in Japanese Style," *House Beautiful* 25, 4 (Mar. 1909), pp. 76–77.

68. A photograph of Silsbee's dining room, published in *Inland Architect and News Record* 16, 6 (Nov. 1890), shows a Japanese hanging scroll in situ (n.pag.). On Wright and Japanism, see Nute 1993.

69. Nute 1993, pp. 146–47.

70. Frank Lloyd Wright 1943, p. 205.

71. See Meech-Pekarik 2000.

72. Frank Lloyd Wright 1912, pp. 5, 12.

73. On Marion Mahony Griffin, see Wood 2005.

"TO PROMOTE AND TO EXTEND THE PRINCIPLES ESTABLISHED BY MORRIS": ELBERT HUBBARD, GUSTAV STICKLEY, AND THE REDEFINITION OF AMERICAN ARTS AND CRAFTS

AFTER IT CROSSED THE ATLANTIC, THE Arts and Crafts movement took on several seemingly paradoxical characteristics: the use of machines and industrial tools to satisfy market demand while simultaneously advocating the look and spirit of handcrafting; lucrative artist's cooperatives and guilds; and an emphasis on the rehabilitative possibilities of art and craft that at the same time enforced a gendered, factorylike division of labor. Lacking the unqualified socialist vision that pervaded the English movement, American designers focused on aesthetic reform. Art groups "celebrated the objects they displayed and the commodities they produced," and Arts and Crafts societies organized themselves along "business principles."[1] While many American Arts and Crafts ideologues affirmed that their goal was "to promote and to extend the principles established by Morris," according to cultural historian T. J. Jackson Lears, they "abandoned Morris's effort to revive pleasurable labor. Manual training meant specialized assembly line preparation for the lower classes and educational or recreational experiences for the bourgeoisie; in neither case did it challenge the separation of productive labor from joyful labor, nor protest the modern organization of work."[2] In other words, as Michael Kimmel has suggested, "the movement became an aesthetic protest without an overarching political vision."[3]

The seemingly contradictory pull of art and commerce—or social reform and profit—may be best exemplified by the rise of settlement houses, and with them, the conviction in artistry as a form of physical and mental therapy and manual training for immigrants and the unemployed. In 1904, for example, Herbert J. Hall established handcraft shops at his sanatorium in Marblehead, Massachusetts, for the express purpose of treating "nervously worn out patients for the blessing and privilege of quiet manual work, where as apprentices they could learn again

gradually and without haste to use their hand and brain in a normal, wholesome way."[4] In 1905 Hall hired Arthur E. Baggs, a student of ceramicist Charles Fergus Binns at New York's Alfred University—the center of the American Studio Ceramics movement—to manage the pottery shop. Within a few years, however, Baggs had turned the pottery into a commercial and critical success, employing a small, professional staff of designers and decorators.[5] Thereafter, Marblehead specialized in vessels decorated with stylized animals, floral patterns, and landscapes that contemporary critics praised for their "simplicity of form and design" and their "soft richness of color" (SEE FIG. 1).[6]

With equally reform-minded gusto, Ellsworth Woodard founded a ceramics program at New Orleans's H. Sophie Newcomb Memorial College—the women's adjunct of Tulane University—in the winter of 1894/95 for "training women for industrial art" (SEE FIG. 2).[7] By the early years of the twentieth century, Newcomb expanded its output to include metalwork and textiles (SEE FIG. 3) and turned to southern flora for inspiration: moss-draped cypress, oak, and pine trees in flat, conventionalized patterns became popular and recurring motifs, demonstrating the regional variations in turn-of-the-century craft production. While Newcomb provided some economic freedom for students through sales of their art, they were nonetheless forced to pay for materials and did not recoup money until their pieces sold; it also held conventional attitudes toward women's roles and adopted an industrial labor model that assigned men to throwing the vessels while women acted as the decorators or participated in the traditionally feminine art of needlework.[8]

This transformation of the movement from a philosophical and social ideal into an aesthetic and profitable one went hand in hand with dramatic changes in the patterns of American purchasing and consumption by the latter third of the nineteenth century. Major American cities such as Boston, Chicago, and New York boasted multiple department stores that had grown from small retail shops into behemoths with diverse and multiple stocks of merchandise. Retail catalogues and direct-market appeals proliferated, and the nation's interstate railway system ensured delivery of these mass-produced goods to even the most remote locations. Encouraged by a burgeoning faction of tastemakers and an attendant market for magazines focusing on domestic interiors, members of the middle class sought to distinguish and identify themselves through their homes and furnishings.[9] Indeed, both general and specialized periodicals catering to middle-class tastes in architecture, art, and interior decoration flourished in the late nineteenth and early twentieth centuries. Inland Architect and Architectural Record debuted in 1883 and 1891, respectively; Brickbuilder, launched in 1892, focused on architecture and earthenware and became a popular advertiser for ceramics studios by the early twentieth century; House Beautiful began publication in 1896; and the Craftsman rolled off the presses in 1901. Niche magazines concentrated on a particular subject or

1
Marblehead Pottery
Designed by Annie E. Aldrich
Made by John Swallow
Decorated by Sarah Tutt
Vase
c. 1909
The Art Institute of Chicago
Cat. 90

2
Newcomb
Made by Joseph Fortune Meyer
Decorated by Katherine Louise Wood
Vase
1905
Collection of Crab Tree Farm
Cat. 100

3
Newcomb
Made by Anna Frances Simpson
Cypress Trees Table Runner
1905/15
Collection of Crab Tree Farm
Cat. 101

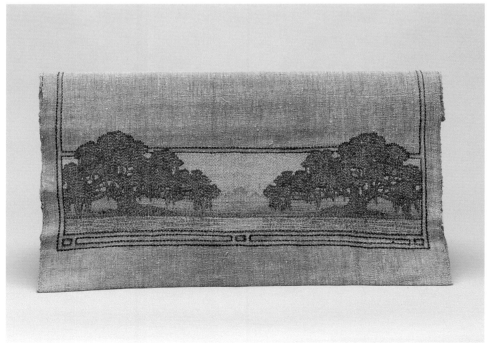

medium—*Keramic Studio* or the *Basket*, for example—while European magazines such as *International Studio* created editions specifically for American readers.

These titles, each in its own way, helped democratize the American Arts and Crafts movement, bringing its social and artistic philosophies, designers and producers, and products and styles into closer contact with a larger audience. At the same time, these publications played a significant role in turning the American Arts and Crafts movement into a capitalist venture, advertising and promoting specific artists, manufacturers, and even stylistic trends under the guise of journalism. As Wendy Kaplan pointed out, the American Arts and Crafts movement was "[not] ambivalent about marketing."[10] In America perhaps no two men exploited the Arts and Crafts movement's contradictions, capitalized on the new trends in American purchasing, and mainstreamed the movement by creating advertising empires more than Elbert Hubbard and Gustav Stickley.

ELBERT HUBBARD AND THE ROYCROFTERS

For his part, Elbert Hubbard brought what has been called a "P. T. Barnum showmanship" to the American Arts and Crafts movement.[11] Hubbard began his career as a salesman for the Chicago-based soap firm Larkin and Weller and then followed John D. Larkin to Buffalo, New York, in 1875, when he established his own business. At the Larkin Company, Hubbard became head of sales and promotion and instituted a number of then-innovative marketing techniques: he eliminated salesmen through the use of direct-mail catalogues and motivated consumers through the introduction of purchasing incentives and customer-to-customer solicitations.[12] After nearly twenty years with Larkin, Hubbard left in early 1894 to explore a writing career. In an effort to sidestep the pesky editorial process of commercial houses, Hubbard began self-publishing with the help of newspaperman Henry Taber, who operated a small press in East Aurora, New York. In June 1895, Hubbard and Taber put out the first issue of the *Philistine: A Periodical of Protest*, a journal devoted to late-nineteenth-century culture that gave Hubbard a monthly platform.

The *Philistine* covered a broad range of topics, varying from college slang to opera, from Christian Scientist Mary Baker Eddy to the Qur'an, from J. Pierpont Morgan to engineer Nikola Tesla. Despite the publication's array of subjects, Hubbard did not provide a far-reaching forum for the societies and practitioners of the Arts and Crafts movement. He did, however, lavish particular attention on those figures he wished to emulate or who were integral to the promotion of his enterprise: William Morris and the Kelmscott Press, Sir Edward Burne-Jones, Dante Gabriel Rossetti, and John Ruskin, as well as social philosophers such as Jane Addams and Oscar Lovell Triggs. To meet the circulation demands of the *Philistine*, Hubbard and Taber established the Roycroft Press in fall 1895. Months later, Hubbard bought out Taber, and in 1896 Roycroft Press published its first book.[13] According to Roycroft

hagiography, Hubbard's inspiration to start his own publishing venture came after a two-month trip in spring 1894 to England and Ireland, where he visited Morris's Merton Abbey and the Kelmscott Press at Hammersmith.[14] Roycroft Press's earliest books imitate this familiar style and formula: heavily ornamented introductory initials surrounded by curving tendrils that evoke Celtic design and medieval manuscript illumination. The earliest phase of Roycroft Press was clearly a female endeavor: photographs of the shop reveal that the bookbinders were all local women. Hubbard's first wife, Bertha, acted as supervisor, and a neighbor, Minnie Gardner, supplied many of the watercolor illuminations.[15] Hand illumination was an unusual feature of luxury book production at the time, and it lends the pages a charmingly incongruous appeal. In the 1896 book *Little Journeys Made to the Homes of Ruskin and Turner* (FIG. 4), for example, brilliantly colored introductory letters in the medieval Kelmscott style compete with Bertha's softly painted flowers, which are dispersed throughout the text. Apparently, the small numbers of these hand-painted editions could not satisfy demand—or Hubbard's desire for sales—and he quickly replaced Bertha with William Denslow, a Chicago artist who would later gain fame for his illustrations in an edition of Frank Baum's

4
Roycroft
Written by Elbert Hubbard
Illustrated by Bertha Hubbard
Page from *These Pages Recount Little Journeys Made to the Homes of Ruskin and Turner*
1896
McCormick Library of Special Collections, Northwestern University Library
Cat. 117

Wizard of Oz.[16] Even so, the title-page designs for Roycroft's imprints retain the Morrisian flavor of the Kelmscott Press.

By the end of the nineteenth century, Hubbard and the Roycrofters began to branch out in other directions, particularly metalwork, and later furniture and ceramics. As the East Aurora campus expanded into a commercial enterprise under the pretext of becoming a utopian community, Hubbard kept the Roycroft brand tightly controlled and firmly on message. In his efforts to establish himself as the true heir to the English Arts and Crafts movement, he modeled the collective on a medieval guild, christening himself "Fra" (monastic brother) and giving his workers medieval (often saint) names to denote their artisanal status. To draw attention to himself, Hubbard grew his hair and donned old-fashioned clothes (SEE FIG. 5), and Roycroft catalogues promoted the qualities of simplicity, domesticity, communal work, and handcrafting associated with Arts and Crafts ideals. Hubbard's oversize personality attracted great interest and garnered him much criticism. According to one anecdote, while on a lecture tour of the United States, May Morris sneered at the prospect of meeting Hubbard, scowling that she had no desire to "see that obnoxious imitator of my dear father."[17] Roycroft, however, entered into a new era of aesthetic—if not commercial—refinement with the arrival of William "Dard" Hunter on the campus in 1904.

Born and raised in Ohio, Hunter had little formal artistic training outside of a few months at Ohio State University, where he took courses in architectural drawing and taught clay modeling.[18] Invariably described as imaginative and precocious, Hunter enjoyed a childhood enriched by artistic parents: his father, a newspaper publisher and editor by trade, founded and owned a third share in Steubenville's Lonhuda Art Pottery Company, a firm devoted to making "the finest faience" in the "Japanesque" style.[19] While Lonhuda's existence was short-lived, the household's creative atmosphere no doubt exerted an influence on Hunter and certainly motivated his own later experiments in clay.[20] Hunter's introduction to Roycroft was through his brother Philip's subscription to the *Philistine*, a magazine to which their father objected.[21] By summer 1904, Hunter had written to Hubbard requesting a position within the Roycroft community; he was denied due to his distance from East Aurora. Undeterred, Hunter moved to New York to attend the Roycroft summer school; after a successful session, he convinced Hubbard that the next step in Roycroft's design catalogue should be stained glass. Hubbard arranged for Hunter's apprenticeship with the New York firm J. and R. Lamb Company, where he studied for one month, and returned to East Aurora triumphant, as his father's newspaper, the Chillicothe, Ohio, *News-Advertiser* trumpeted: "Dard Hunter . . . went [to East Aurora] to spend a few weeks at the Roycroft summer school, but his own art ideas were so highly appreciated by the head masters that he was induced to stay and become a Roycrofter, with the result that he has been made the head of the stained-glass designing and making department."[22]

Fra Elbertus
and the little De Luxe.

All Good Roycrofters

5
"Fra Elbertus and the Little De Luxe" and "All Good Roycrofters," from *Roycroft Books* (1900), n.pag.

Hunter's first public designs for Roycroft, however, were not for stained glass but for the press. In 1905 he flexed his creative muscle with an edition of Washington Irving's *Rip van Winkle*, for which he designed the title page, chapter initials, and embossed suede cover (SEE FIG. 6). For the book, Hunter also planned a series of woodcuts evocative of the colonial period in which the story begins. The emphases here on the grain of the wood, the simplicity of design, and the fetishization of American colonial history are wholly in line with Arts and Crafts philosophy. Thereafter, Hunter created a number of title pages and bindings, introducing new variations and innovations to Roycroft Press's catalogue. In 1906, for example, Hunter produced what is considered by many as his masterpiece in book design, the title page to Alice and Elbert Hubbard's play *Justinian and Theodora* (FIG. 7). For this publication, Hunter broke from tradition and created a two-leaf title page clearly indebted to European precedents. A black background dominates the fine white stems of the eight orange daffodils that blossom at the top of the page, interrupted by a horizontal band containing the orange and black letters of the book's title. More than any previous work, *Justinian and Theodora* reflects Hunter's study

6
Roycroft
Written by Washington Irving
Designed by Dard Hunter
Page from *Rip van Winkle*
1905
McCormick Library of Special
Collections, Northwestern University
Library
Cat. 118

7
Roycroft
Written by Elbert and Alice Hubbard
Designed by Dard Hunter
Title page from *Justinian and Theodora: A Drama Being a Chapter of History and the One Gleam of Light During the Dark Ages*
1906
McCormick Library of Special Collections, Northwestern University Library
Cat. 119

of stained glass and European design—especially those of the Viennese Secessionists—through such periodicals as *Deutsche Kunst und Dekoration*, *Dekorative Kunst*, and *International Studio*, which he borrowed from the Roycroft library.[23]

Around the same time as *Justinian and Theodora*, Hunter also turned his attention to earthenware. The artist had initially experimented with the medium while at the Roycroft summer school, producing at least two floral form vases with a dark green glaze commonly used by other Arts and Crafts potters.[24] In 1906 he created the prototypes for five pieces of pottery, signing and numbering the molds. As in much of his previous work, Hunter's wares display motifs from the natural world— trees, dragonflies, and mushrooms. His design for a white porcelain vase (FIG. 8) shows a clear understanding of Arts and Crafts principles; the trapezoidal form follows a curving tree trunk whose abundant foliage ripples all the way up to the small lip. The molded inscription on the bottom—a conjoined *DH* and the Roycrofter logo—suggests that Hunter planned to retail these examples with the possible intention of establishing a pottery shop on the campus.[25]

Fulfilling a longtime desire to study the art of the Secessionists, Hunter left East Aurora for Austria in 1908. While he revisited Roycroft briefly later that year, after his return to the United States he devoted much of the rest of his life to the art of handmade paper and books.[26] Nonetheless, Hunter's ghost was much in evidence as the Roycrofters turned their concentration to a medium that would bring them nearly equal fame as the press: metalwork. In the same year as Hunter's departure, Roycroft's Arts and Crafts Shop rechristened itself the Art Copper Department (Copper Shop), signaling a new emphasis, and, with it, a new direction in design.

8
Roycroft
Designed by Dard Hunter
Vase
c. 1906
The Art Institute of Chicago
Cat. 120

The first hint of this development came in 1910, when Karl Kipp entered the shop. Like many Roycrofters, Kipp started in the bindery but eventually graduated to metalwork and even collaborated with Hunter on a set of chandeliers for the Roycroft Inn in 1909.[27] The pieces he produced for the 1910 catalogue clearly demonstrate his knowledge of the Vienna Secessionists and the Glasgow school. The square cutouts on Kipp's *Trapezoidal Vase* (FIG. 9) are reminiscent of the similar play of positive and negative space on Charles Rennie Mackintosh's flower stand of half a decade earlier (SEE CHECKLIST, CAT. 84). He coyly addressed the same issue in the equally impressive *Egyptian Flower Holder* (FIG. 10) by inlaying squares of silver at the top; the hammer marks, which run along even the four slender, extending buttresses, clearly denote that the object was crafted by hand.

Kipp left Roycroft to start his own metal firm, the Tookay Shop, in 1912, after which Roycroft received a large commission that would alter the style and appearance of much of Roycroft's metal. Edwin Grove and Fred Seely—financial backers of the Grove Park Inn, a resort hotel in Asheville, North Carolina—ordered seven hundred lighting fixtures from the Roycrofters, their largest request to date. Part of the job was the production of a number of Victor Toothaker's *American Beauty*

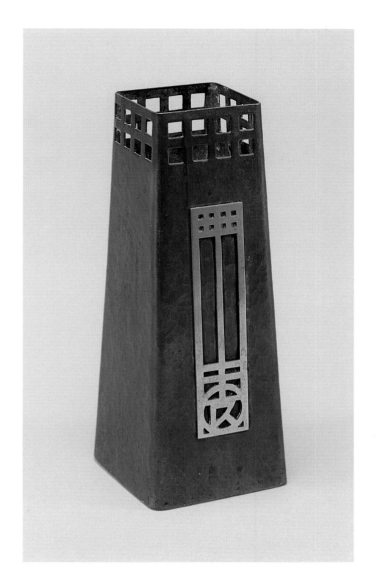

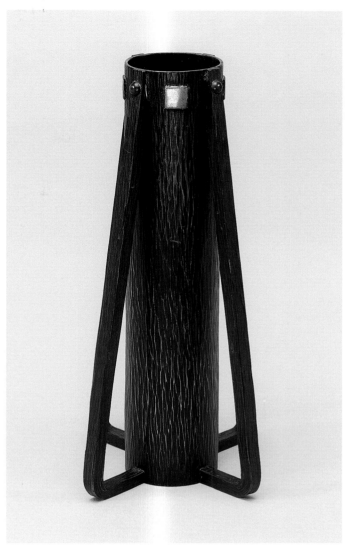

Vase—originally retailed to the public in seven-, twelve-, and nineteen-inch sizes—in a grander height of twenty-two-and-one-half-inches (SEE FIG. 11).[28] Toothaker had begun his career with Gustav Stickley, illustrating *Craftsman* magazine covers and designing some furniture, but his main responsibility was managing Stickley's metal shop.[29] After he moved to East Aurora in 1911, he began to oversee the Roycroft Copper Shop and thus was responsible for the Grove Park order. The sheer volume of the commission placed a new emphasis on quantity and opened markets for Roycroft's metalwork. While the vase retains hand hammering and Toothaker's signature rivets to denote its artisanal status, Roycroft increasingly turned to machine-turned metal and streamlined production to meet market demands. In addition, the deaths of Alice and Elbert Hubbard on the Lusitania, which was torpedoed by German forces in 1915, signaled the end of Roycroft's heyday. Although Hubbard's eldest son continued to keep the business alive for another two decades, without Elbert Hubbard's skilled self-promotion the company

9
Roycroft
Designed by Karl Kipp
Trapezoidal Vase
1910
Collection of Crab Tree Farm
Cat. 121

10
Roycroft
Designed by Karl Kipp
Egyptian Flower Holder (Buttress Vase)
c. 1912
Collection of Crab Tree Farm
Cat. 122

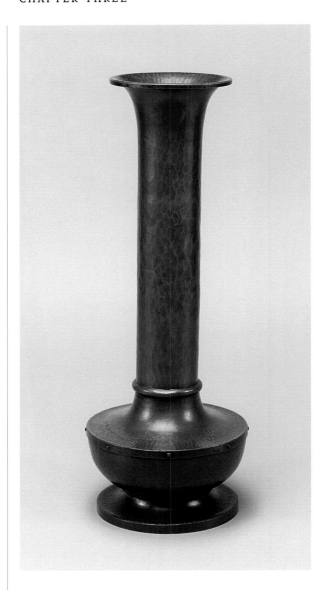

11
Roycroft
Designed by Victor Toothaker
American Beauty Vase
c. 1913
Collection of Crab Tree Farm
Cat. 123

turned to homespun products such as jams and honeys and plainly designed copper goods that lacked the experimental and innovative quality of top designers such as Hunter and Kipp.

GUSTAV STICKLEY AND THE *CRAFTSMAN*

Gustav Stickley turned a genuine interest in developing a new style of living and manufacturing into an empire, complete with showrooms, catalogues, production facilities, a magazine devoted to the Arts and Crafts movement, and even a restaurant. Stickley began his career in his family's furniture business, and in 1883, along with his siblings, formed Stickley Brothers. By 1888 he had separated from his brothers and formed a partnership with furniture salesman Elgin Simonds. After nearly ten years of producing furniture in a variety of then-popular styles, Stickley

subsequently formed his own corporation, Gustav[e] Stickley Company, in 1898 in Eastwood, New York, then a suburb of Syracuse.[30] A year later, he debuted his first line based on Arts and Crafts precedents; by the turn of the century, Stickley had renamed his business the United Crafts of Eastwood.[31]

Like Hubbard, Stickley consciously emulated and referenced British Arts and Crafts forebears, establishing himself as the spiritual descendent of Morris and Ruskin. He adopted Morris's motto, "Als ik kan" ("As best I can," or "To the best of my ability"),[32] as a hallmark and framed his new products in the context of socialist ideals, highlighting Morris's theories in the first issue of his magazine, the *Craftsman* (FIG. 12), which began publication in 1901: "The United Crafts endeavor [*sic*] to promote and to extend the principles established by Morris, in both the artistic and the socialist sense. In the interests of the workman, they accept without qualification the proposition formulated by the artist-socialist . . . the Master executing with his own hands what his brain had conceived, and the apprentice following the example set before him as far as his powers permitted."[33]

During the 1890s, as he began to reorganize his business interests, Stickley visited Europe for inspiration.[34] He toured both England and France, and while it is unclear if he met any Arts and Crafts luminaries, he admitted reading texts by Ralph Waldo Emerson, Morris, and Ruskin in preparation for the journey. One account claims that he returned from an 1898 trip with furniture by Charles Francis Annesley Voysey.[35] In addition, one writer has suggested that Stickley visited Charles Robert Ashbee's Guild of Handicraft and saw Mackay Hugh Baillie Scott's designs for the drawing and dining rooms of the grand duke of Hesse.[36] Stickley's earliest furniture—such as the *Celandine Tea Table* (FIG. 13)—reflects his immersion in British Arts and Crafts and European Art Nouveau, as well as the natural world, a fact touted by *House Beautiful* upon the furniture's debut in 1900.[37] These initial designs were introduced to a large audience through Chicago's Tobey Furniture Company, which advertised them as the "new furniture," distinguished by their "beauty and novelty" and advanced in style.[38] The tea table also shows a debt to Buffalo furniture maker Charles Rohlfs (SEE FIG. 14), whose designs from the same time were also influenced by European Art Nouveau. They are characterized by abstract vegetal patterns, beautifully carved fretwork, and exposed, ornamental joinery and stretchers. Although Rohlfs distanced himself from what he perceived as the commercial aspects of the Arts and Crafts movement—and Stickley reciprocated by publicly ignoring Rohlfs—both men worked in close-knit, artistic communities only miles from each other and frequently exhibited at the same venues.[39]

After this initial foray into Art Nouveau and historical styles, however, Stickley abandoned these principles in favor of the spare, unadorned works that became his hallmark. Writing about this decision, Stickley later explained: "After experimenting

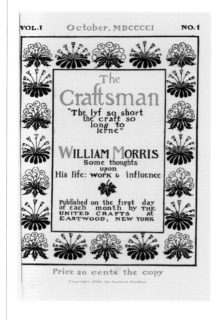

12
Craftsman 1, 1 (October 1901), cover.

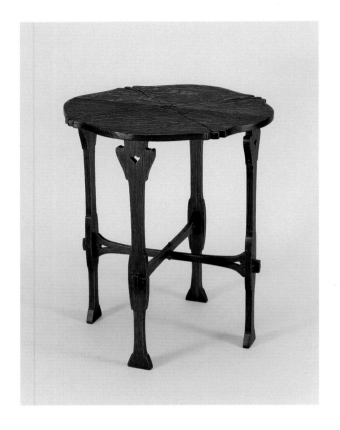

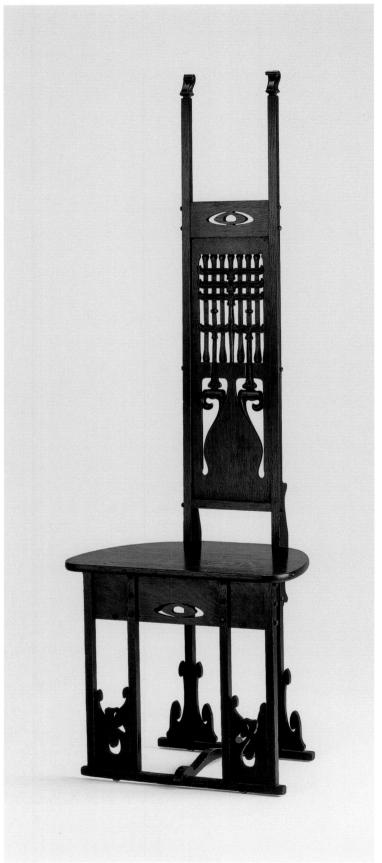

13
Gustav Stickley
United Crafts
Celandine Tea Table (no. 27)
c. 1900
Collection of Crab Tree Farm
Cat. 134

14
Charles Rohlfs
Hall Chair
c. 1900
The Art Institute of Chicago
Cat. 111

with a number of pieces, such as small tables giving in their form a conventionalized suggestion of such plants as the mallow, the sunflower and the pansy, I abandoned the idea. Conventionalized plant-forms are beautiful and fitting when used solely for decoration, but anyone who starts to make a piece of furniture with a decorative form in mind, starts at the wrong end."[40] Stickley first introduced his signature slat-back furniture in 1901, and his now-famous *Eastwood Chair* demonstrates the influence of Baillie Scott.[41] Both designers employed squat frames, thick horizontal slats, and decorative pegs on the arms, but Stickley widened his chair and added a leather cushion. These details gave his design its signature look. That same year, Stickley incorporated a similar style in a solid, rectilinear settle, and in his first reclining chairs (SEE FIG. 15), which he advertised in his 1901 catalogue and featured in the first issue of the *Craftsman*.[42] These 1901 publications are significant, for they introduced a wide range of Craftsman objects, including a leather-topped library table (FIG. 16), bookcases and china cabinets, bedsteads and cedar chests, chess tables, and mirrors. Most importantly, however, through the use of drawn illustrations, Stickley created a unified interior by including crafts other than furniture, such as lamps, metalwork (SEE CHECKLIST, CAT. 144), and pottery.

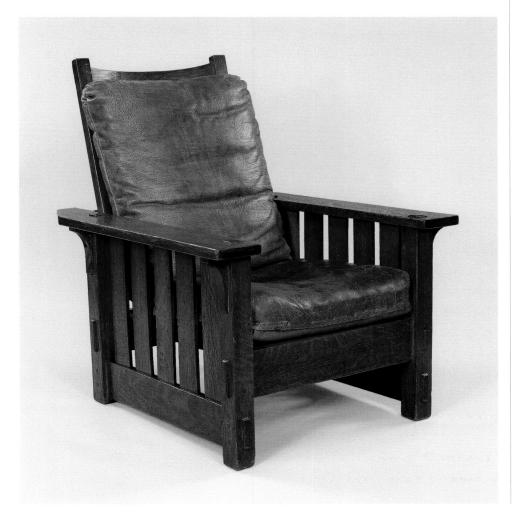

15
Gustav Stickley
United Crafts
Armchair (no. 2342)
1901
Collection of Crab Tree Farm
Cat. 136

Grueby pottery in particular became a fundamental part of Stickley's ideal interiors, and he incorporated several pieces into his own brochures and catalogues and featured examples in his installation at the 1902 Boston Mechanics Fair.[43] William H. Grueby established the Grueby Faience Company in Boston in 1894 and began marketing glazed bricks and tiles. Under the direction of designers associated with the Boston Society of Arts and Crafts, by the turn of the century, Grueby specialized in producing pottery in solid shapes based on Asian precedents in a small spectrum of matte colors, often with applications of distinct floral forms, most notably jonquils or daffodils (SEE FIG. 17). *Keramic Studio* confirmed Grueby's laborious creation process in a 1901 article: "Some sixteen young women, all graduates of the Boston School of Design, model the raised portions in detail. Unlike many other potteries, there is virtually no mechanical assistance employed and throughout every touch of individual hand work is retained."[44] Due to the handcrafted nature of the wares, combined with the beauty of the designs, Grueby became among the most popular pottery in the country. Grueby's enthusiasm for applied decoration, however, spelled its demise. The company could not compete with other firms who embraced standardization and mass-production and took advantage of the high regard for its matte green glazes.

Only five months after he began publication of the *Craftsman*, Stickley began a series of articles on the proper preparation of homes that capitalized on Grueby's popularity by coyly asserting its necessity for proper interior decoration. In the February 1902 article "The Planning of a Home," a conversation between a fictitious husband and wife and their architect clearly lays out the domestic ideal.

16
Gustav Stickley
United Crafts
Library Table (no. 410-L)
1902
Collection of Crab Tree Farm
Cat. 138

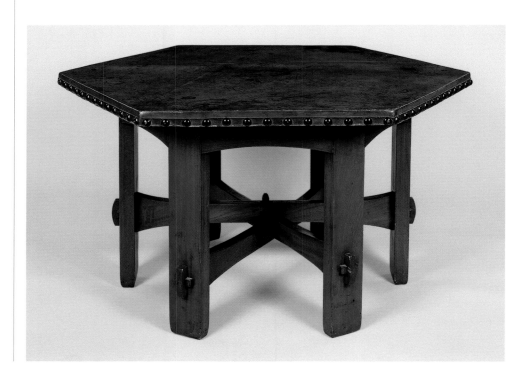

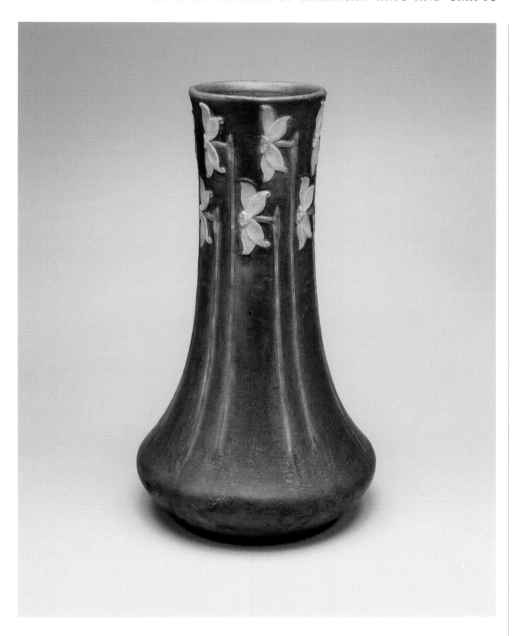

17
Grueby Faience Company
Design attributed to George Prentiss
Kendrick
Decoration attributed to Eva Russell
Vase
1903/09
The Art Institute of Chicago
Cat. 57

To the husband, "the exterior . . . should recall things that I saw in my long past journeys in Italy and England . . . the ground floor—must be largely given up to the living-room." For his wife, the "first requisite is a fire-place . . . surrounded by Grueby tiles in a soft melon green. The fittings must appear to be part of the house, and not an intruding, invading element. I want space, simplicity and solidity in my belongings—things made to use and to keep—and above all, a severity in form and color that shall make my home refined and distinctive."[45] Although not yet completely formed, the emphasis here on "simplicity and solidity," as well as on harmonious rather than "invading elements," reflects the uncomplicated design aesthetic that Stickley and the *Craftsman* would champion for years to come.

To be sure, the concept of unified home design became a priority for Stickley by late 1902. In December of that year, the *Craftsman* invited people into Stickley's own home via a laudatory article with text and drawings by architect Samuel Howe, a Stickley designer from 1902 to 1906.[46] Howe trumpeted the house as "singularly free from pretension . . . with abundant freshness and wholesomeness, which are innovations in these days of machine carving . . . quiet harmony is the prevailing note of composition, characterized by singular uprightness and sturdy independence."[47] Howe's drawings reinforce his written assessment, showcasing many of the new products Stickley debuted in 1901 and 1902, including the above-mentioned slat-armed settle and reclining chair, a sturdy yet elegant hall clock (FIG. 18), and the Colonial Revival high-back settle (FIG. 19)—an example of which can be glimpsed in Howe's rendering of both Stickley's inglenook and formal dining rooms (SEE FIG. 20).[48]

In 1903 Stickley continued his series on house design with three articles by New York architect Ernest George Washington Dietrich, which stressed color unity and "a fitting and happy harmony."[49] Most importantly, however, in March 1903, Stickley opened an Arts and Crafts exhibition at his Craftsman Building—a lecture hall and music venue where his workers could find edification and inspiration—which not only displayed individual works but featured ceramics, furniture, metalwork, and textiles (SEE CHECKLIST CAT. 145) often in carefully arranged domestic re-creations. For his exhibition, Stickley amassed extraordinary pieces by the Grueby, Newcomb, and Rookwood potteries, as well as by Artus van Briggle and Adelaide Alsop Robineau, founder of the journal *Keramic Studio* (SEE FIG. 21). He also included metalwork by Robert Riddle Jarvie and Jessie Preston. This event established a precedent that would guide his enterprise for the next decade: a coterie of artists, craftspeople, designers, and even aesthetic movements he plugged in the pages of the *Craftsman*.

Although Stickley's earliest years are referred to as experimental, the period from 1903 to 1905 proved equally investigational. Upon his arrival at United Crafts—then transitioning to the name Craftsman Workshops—architect Harvey Ellis is widely credited with bringing a new sense of lightness and color, grace and refinement to Stickley's furniture (SEE FIG. 22), as well as his interior designs for the *Craftsman* (SEE FIG. 23).[50] The introduction of inlays of pewter, copper, and light-colored woods on furniture from this period owes a fundamental debt to British Arts and Crafts designers, particularly Voysey, Baillie Scott, and Charles Rennie Mackintosh (SEE CHAPTER 1, FIGS. 35–37). In particular Baillie Scott's inlaid sofa—which was reproduced in the pages of John White's 1901 *Pyghtle Works* catalogue (SEE FIG. 24) and was exhibited at the London Arts and Crafts Exhibition in January 1903—bears striking resemblance to a cube chair (SEE FIG. 25) from the same year, as well as a settle Stickley designer LaMont Warner drew for the June issue of the *Craftsman*.[51] The settles' frames are remarkably alike, with large

18
Gustav Stickley
United Crafts
Hall Clock (no. 3)
1902
Collection of Crab Tree Farm
Cat. 137

19
Gustav Stickley
United Crafts
Settle
c. 1903
Collection of Crab Tree Farm
Cat. 139

20
Samuel Howe, "Dining-room, Mr. Stickley's House," from "Visit to the House of Mr. Stickley," *Craftsman* 3, 3 (December 1902), p. IV.

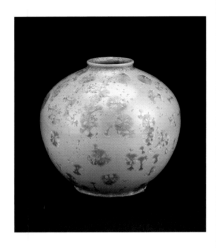

21
Adelaide Alsop Robineau
Vase
1926
The Art Institute of Chicago
Cat. 110

22
Gustav Stickley and Harvey Ellis
Craftsman Workshops
Drop-Front Desk
1903/04
Collection of Crab Tree Farm
Cat. 141

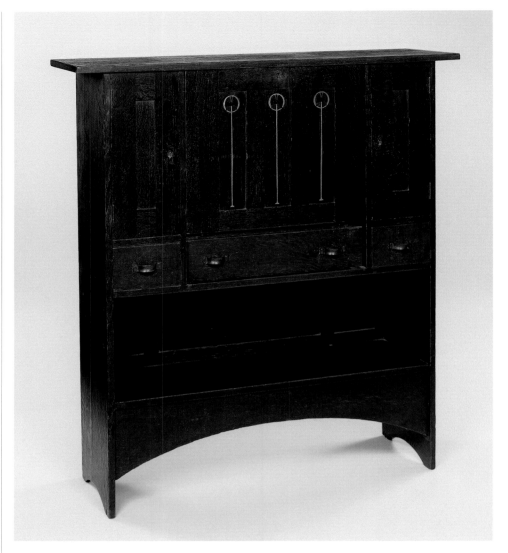

slats on each side and the back, although the Craftsman's stylized flower design for the inlay motif departs from Baillie Scott's more abstract patterns.

Ellis and Stickley may have also been influenced by Frank Lloyd Wright's early experiments with cube chairs. Wright's innovative designs for his Oak Park home and studio first appeared in *House Beautiful* in 1899. Reproductions of both the octagonal library and the drafting room (SEE FIG. 26) feature several examples of this style of chair, which the author described as "simple, strong, *modern*."[52] As the architect's fame and his reputation spread, similar reproductions appeared in other magazines, including the catalogue of the Chicago Architectural Club's 1900 exhibition.[53] Ellis exhibited with the Chicago Architectural Club in 1901, who published a version of Wright's lecture "The Art and Craft of the Machine" in its catalogue, and his drawings served as the same book's central focus and frontispiece. The following year, the Architectural Club catalogue devoted fourteen pages to Wright's designs, including a frontal view of the cube chair.[54]

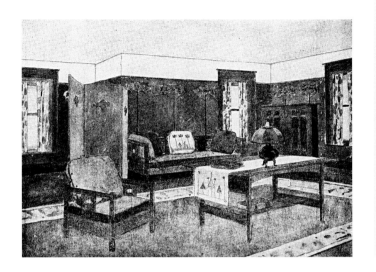

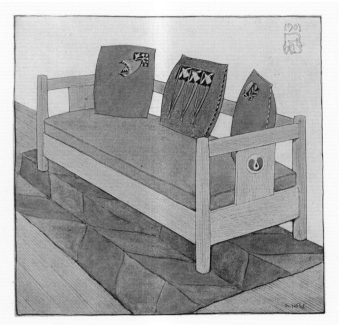

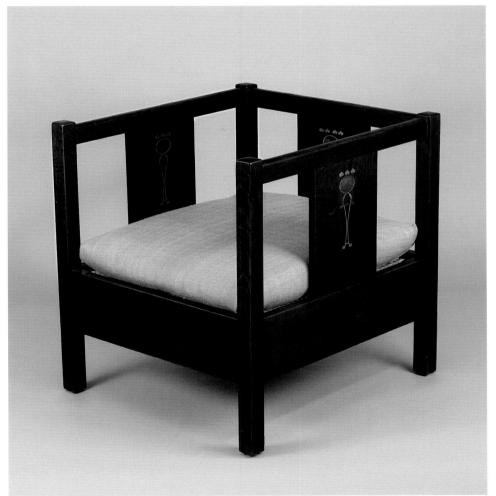

23
"What May be Done with an Ordinary Room," *Craftsman* 5, 2 (November 1903), p. 168.

24
Mackay Hugh Baillie Scott, inlaid settle, from John White, *Furniture Made at the Pyghtle Works, Bedford* (1901), p. 15.

25
Gustav Stickley and Harvey Ellis
Craftsman Workshops
Cube Chair
1903/04
Collection of Crab Tree Farm
Cat. 140

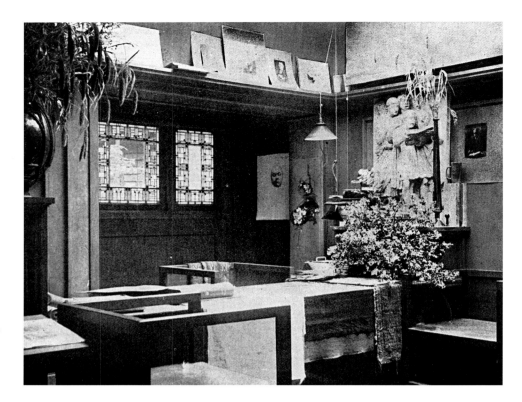

26
Frank Lloyd Wright, "Draughting Room," from Alfred N. Granger, "An Architect's Studio," *House Beautiful* 7, 1 (December 1899), p. 43.

27
Gustav Stickley
Craftsman Workshops
Spindle Settle (no. 286)
1905
Collection of Crab Tree Farm
Cat. 143

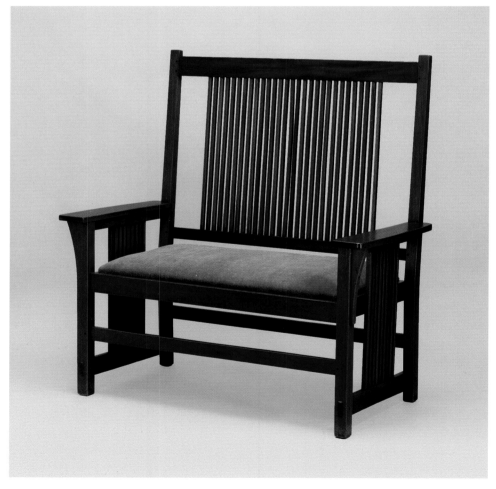

The year 1905 proved exploratory for Stickley's designs in other ways as well. In August he patented a line of spindle furniture (SEE FIG. 27) and began marketing it in the September issue of the *Craftsman*. Stickley's replacement of his previously heavy, solid slats with the lighter, elegant spindles, combined with the lingering effects of Ellis's tenure and the influence of Mackintosh and the Glasgow school, represented a departure. Indeed, Stickley's spindle settle is similar in height to Mackintosh's ladder-back chairs and repeats a motif seen on variety of late objects by the Scottish designer (SEE CHAPTER 1, FIG. 35). Like the cube chair, the spindle furniture shows the clear influence of Wright, who began seriously investigating the spindle form in the 1890s. The 1899 *House Beautiful* article illustrates examples of the ladder-back, spindle chairs in Wright's dining room.[55]

Stickley was most certainly aware of these important trends, as detailed in national magazines. More to the point, however, by the time he debuted his line of spindle furniture, Wright was working on a number of high-profile projects in Buffalo, just 150 miles east of Stickley's headquarters. Construction was proceeding at the Larkin Company Administration Building by late 1903; the George and Delta Barton House, part of the imposing Darwin D. Martin complex, was completed by the summer of 1904; and the Martin House itself was well under way by the end of that year, as was the William R. Heath Residence.[56] The number of Wright homes emerging just prior to Stickley's patenting his spindles, in fact, may be one reason for his foray into this design. In acclimating Wright's style to his own products, Stickley may have anticipated a whole new market previously closed to him. Years later, in fact, Wright dismissed Craftsman furniture as "clumsy" and "offensively plain, plain as a barn door," thus perhaps alluding to a rivalry between the two men.[57]

NATIVE AMERICAN ART AND THE ARTS AND CRAFTS MOVEMENT

As part of the Arts and Crafts movement's emphasis on handcrafting and its agenda to restore dignity to labor, many theorists looked to America's aboriginal peoples and crafts as paradigms of authenticity and enjoyable production. By highlighting the simple pleasures of creation (no matter how mundane), Arts and Crafts ideologues reminded consumers that Native American art was the product of love, absent of the dehuminizing conditions of modern industrialization.[58] In addition, they shifted scholarly discourse on Native American art away from ethnology to aesthetics, confirming for consumers "an object's worth outside of its context of production, along with professional explanations of aesthetic continuity and change."[59] An 1897 article from *House Beautiful* aptly illustrates this shift in tone: "Yet the most skilled weavers were in the great Apache nation, the wildest and most bloodthirsty of them all. The baskets of the southwestern squaw now have an

artistic value as well as an archaeological one, for rescued from oblivion, they find conspicuous places in the collections of the art lover."[60] From then on, *House Beautiful* regularly published articles on Native American design and carried some of the first retail advertisements of indigenous craft to reach a mass market.[61] Madeline Yale Wynne, an Arts and Crafts metalworker, encouraged shoppers in *House Beautiful*'s 1901 holiday issue to give themselves "a Christmas present, in or out of season . . . and buy a basket," drawing attention to those done in "Navajo" and "Indian" styles.[62]

For his part, Stickley routinely turned his attention to premodern societies as labor role models, advocating a "return to the spirit which animated the workers of a more primitive age, and not merely to an imitation of their working method."[63] In popular fashion, Stickley contrasted the perceived ills of urban, industrial modernity with the "red races of America" who were "fast perishing" with "civilization," extolling the "real quality of the land, the truth, simplicity, vitality."[64] He opened up the pages of the *Craftsman* to a variety of Native American art and craft that could be utilized in his interiors and thus advertised in his magazine. He first turned his attention to the subject in a 1903 article on wall coverings, where he lauded the work of Native Americans as an appropriate national version of the styles then being resuscitated in Britain: "North American Indian decorative motifs . . . known and valued by ethnologists, have been neglected by artists. But they are worthy to be ranked with the Briton and Celtic systems, which are now in active enthusiastic revival in England, furthered alike by the guilds and by individual artists and craftsmen."[65] That same year, Stickley published additional articles on Native Americans by George Wharton James, an influential—albeit imprecise—writer on indigenous art, who contributed to *House Beautiful* and worked for Hubbard and later for Stickley as editor of the *Craftsman* from 1904 to 1905.[66] In his writings on Native American design, James contrasted the failings of modern America with the beneficial characteristics of indigenous primitivism: "It is to the Indian that we owe the beginnings of the things we have carried to a greater or less [*sic*] degree of perfection. We, the highly cultured and civilized, are the followers; they the leaders . . . in copying Nature the Amerind has avoided our errors—there is not a single shape that is ugly or inappropriate to the work for which it is needed."[67]

Stickley's investigation of the origins of American art led him, and other Arts and Crafts proponents, in the words of scholar Melanie Herzog, to recognize "American Indian art as the earliest American art, baskets as the original American art, and basket makers as the original American artists" (SEE CHECKLIST, CAT. 32).[68] By the end of the nineteenth century, indigenous American basketry became highly collectible, serving as decorative objects in many Arts and Crafts homes. Aside from publishing a number of articles promoting Native American art, Stickley also advertised basketry retailers that offered readers a wide variety of styles.[69] As a result of surging demand, indigenous weavers both increased their output and

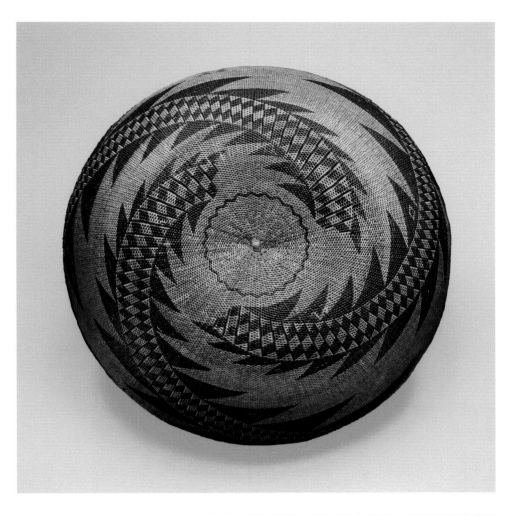

28
Pomo
Made by Sally Burris
Twined Basketry Bowl
1870/1900
The Art Institute of Chicago
Cat. 104

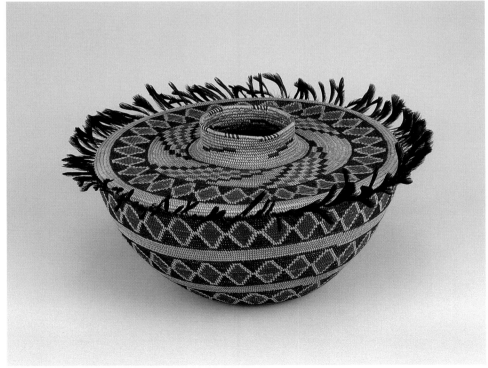

29
Yokuts
Bottleneck Feather Basket
c. 1900
The Art Institute of Chicago
Cat. 175

developed new forms. The Pomo people of north-central California enjoyed particular success, and their designs—such as the lightening-bolt pattern on a bowl by Sally Burris (FIG. 28)—were popular due to the play of positive and negative space. Even the ceramic journal *Keramic Studio* acknowledged these baskets as "famous" by 1907.[70] Equally, a Yokuts bottleneck feather basket (FIG. 29) is a perfect example of work made for Anglo-American collectors: the bands of concentric diamonds around the body—a distinctive Yokuts pattern—and circle of tufted quail feathers around the crown would have most likely appealed to Arts and Crafts consumers who appreciated decorative inlays and ornamental metalwork.[71]

After basketry, textiles became a similarly marketable form of native crafts; numerous magazines extolled their decorative virtues and several suppliers emerged that either sold native-made blankets and rugs or indigenous-inspired designs (SEE FIG. 30).[72] For his part, James celebrated the virtues of Native American weaving in the *Craftsman*, claiming that "it may confidently be said that there is not a single stitch or weave known to modern art, made with loom however complicated, that the Indian woman did not invent, and has not had in actual use for centuries."[73] Even

30
Navajo
Blanket or *Rug*
1910/20
The Art Institute of Chicago
Cat. 98

31
Gustav Stickley
Carpet
1900/10
The Art Institute of Chicago
Cat. 135

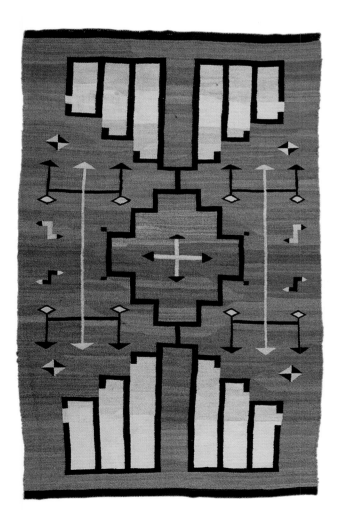

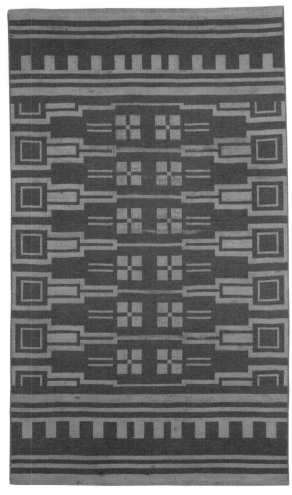

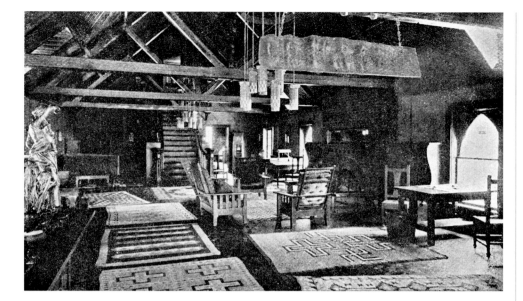

32
Lobby of the Roycroft Inn, from *The Book of the Roycrofters* (1914), p. XLVI. Photo: The Winterthur Library: Printed Book and Periodical Collection.

prior to James's late-fall 1903 article, Stickley advertised "hand made" Indian rugs through one of the same distributors that sold southwestern baskets.[74] That same year, he introduced his first textiles based on Native American designs, with embroidered motifs inspired by Pueblo pottery and basketry (SEE FIG. 31). His competitor Hubbard, in the 1907 catalogue *The Book of the Roycrofters*, featured Native American carpets in a furnished room, and he later adorned the Roycroft Inn with similar examples (SEE FIG. 32).[75]

By the end of the nineteenth century, images of Native Americans themselves appeared in an increasingly wide array of decorative objects. Sculptor Edward Kemeys, best known for his animal bronzes, applied such motifs on earthenware beginning in the 1890s, modeling portraits and profiles on pitchers (SEE CHECK-LIST, CAT. 76). While Cincinnati's Rookwood Pottery Company experimented with Native American themes as early as a year after its 1880 founding, one of its potters, Artus van Briggle, is credited with instituting and popularizing the subject by the early 1890s.[76] Van Briggle based his portraits on photographs taken by John K. Hillers, a staff photographer for the United States Bureau of Ethnology, that Rookwood likely purchased as early as 1888.[77] These examples remained an active and popular part of Rookwood's production for the next decade. Although he later shifted his concentration to developing glazes for the company, Van Briggle continued to create some notable pieces (SEE FIG. 33). After being diagnosed with tuberculosis, Van Briggle left Rookwood in 1899 for Colorado Springs, where he established Van Briggle Pottery, which became famous for its matte glazes.[78]

Potters such as Charles Fergus Binns also acknowledged a debt to Native American techniques in the pages of the *Craftsman*, although, in his case, the inspiration was construction and method rather than visible aesthetics. Considered the "father"

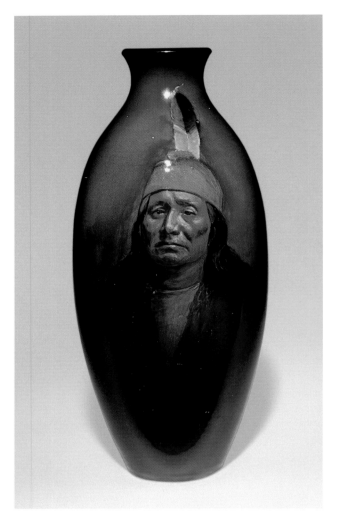

33
Rookwood Pottery
Decorated by Artus van Briggle
Vase
1897
Collection of Crab Tree Farm
Cat. 113

34
Charles Fergus Binns
Bottle Vase
1915
The Art Institute of Chicago
Cat. 16

of modern American studio ceramics, Binns advocated an artist's direct contact with the vessel from firing to glazing, repudiating the division of work and assembly-line nature of both commercial and art potteries. Binns's vessels (SEE FIG. 34) reflect the Arts and Crafts fascination with Asian aesthetics; his simple, graceful, luminously glazed vases are a direct result of his belief that form should precede decoration. Nonetheless, in 1903 Binns extolled the Native American practice of building wares with clay coils as "opening to the modern world of a new avenue of expressive handicraft."[79]

THE *CRAFTSMAN*, GREENE AND GREENE, AND STICKLEY: A RECIPROCAL RELATIONSHIP

If criticism and competition sometimes propelled Stickley's designs, so too did mutually beneficial and respectful relationships. Stickley's interest in Native American aesthetics coincided with not only the publication of James's 1903 articles, but also his own Native American–infused designs for wall coverings that

same year. Stimulated by these new ideas, Stickley and his family traveled by train to California. By summer 1904, they had reached Pasadena, where Stickley visited homes designed by the architect brothers Charles Sumner and Henry Mather Greene, including Charles Greene's own home and perhaps the Culbertson House (1902) and the Arturo Bandini House (1903). For their part, the brothers were enthusiastic supporters of Stickley. Charles Greene's home was decorated with a mixture of Japanese, Native American, and early Craftsman objects. The brothers first introduction to Stickley came via the 1901 Buffalo Exposition, where Craftsman furniture was exhibited, and Charles clipped particularly important articles and advertisements from the *Craftsman*.[80] Moreover, the Greene brothers integrated Craftsman furniture into the designs of their homes, and up until 1906, Stickley was the "dominant influence in the furniture the Greenes designed."[81] In their drawings for the Mary Darling House, reproduced in a 1903 issue of the British journal *Academy Architecture*, the brothers included Native American patterned rugs, built-in bookshelves, and a library table distinctly reminiscent of one Stickley had reproduced in a sales pamphlet earlier that year.[82]

Stickley in turn became a champion of the Greenes and published numerous articles about their designs, including one on Charles's own home in 1907.[83] An April 1909 article reproduced two Greene homes—a third residence for Dr. William T. Bolton (1906) and the Laurabelle A. Robinson House (1905–06)—and the author extolled the "permanence" of Japanese architecture and admonished that successful houses were "simple, dignified, and in harmony with the surroundings."[84] The *Craftsman* returned to the Greenes as a subject at the end of the year with a four-page story on the Edgar W. Camp Bungalow (1904).[85] In 1912 the magazine devoted a sixteen-page spread exclusively to the brothers and some of their most well-known masterpieces, including the Robert R. Blacker House (1907–09).[86] The reproductions and text emphasize an integrated, total-living environment, an aspect acknowledged by the author in referring to the Blacker House: "Not the least of its attributes is the exceptional harmony between the house and its surrounding garden . . . It will be noticed that the arrangement of the garden, the walks around the lake and the little stream that trickles over the rocks show the Japanese influence which is felt in so many of our American gardens today."[87] The author went on to lovingly describe the interiors as having a "homelike atmosphere that pervades rooms which are fortunate enough to owe the beauty of their furnishings to the care of Greene & Greene."[88]

Like many turn-of-the-century architects, the Greenes sought harmony in the overall concept of their buildings, from the exterior to the interior, to the garden, and even to the site. As such, they often selected a single motif for the interior design, occasionally varying the theme from room to room to modify the visual continuity. For the living room of the Blacker House, the Greenes chose the lotus and lily (SEE FIG. 35), inspired by the exterior pond. A living-room side chair

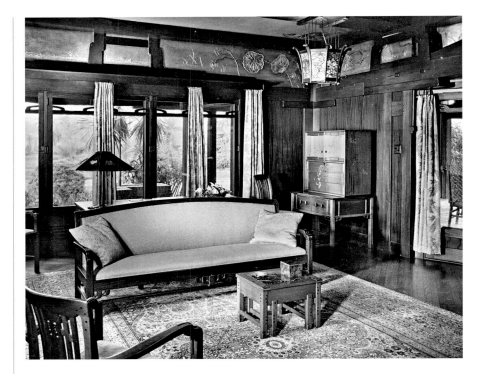

35
Greene and Greene, living room of the
Robert R. Blacker House, 1907–09.
Photo: 1947, Maynard L. Parker. Avery
Architectural and Fine Arts Library,
Columbia University.

(FIG. 36) displays not only such hallmarks of the Greenes' mature style as the exquisite workmanship and ornamental joinery but also poetic details like the ebony pegs and diminutive cut-outs, which are arranged on the chair back in an abstract floral design. The stylized root flowers inlaid in the splat provide a subtle balance to the chair's strong outline and a textural contrast to the cut-outs above and below. Similarly, the Blacker House's breakfast-room side table (FIG. 37) features the same robust profile, combined with a delicate twisting vine and blooming flower of inlaid copper, fruitwood, mother-of-pearl, and pewter. While Asian influences are evident here, the play of positive and negative space also owes its inspiration to Voysey and Mackintosh.

The Greenes may have shared their interest in the British designers with Stickley during his 1904 visit. Early the next year, he debuted a three-fold screen that reveals his appreciation for the Glaswegian designers, as well as the Viennese Secessionists. In an article titled "Our New Home Department"—the second in a series that directed subscribers on the correct decoration of their homes—Stickley emphasized the new textile products issued by his Craftsman workshop, including the fabric-covered *Rose Motif Three-fold Screen* (FIG. 38). The article touted the screen's appliqué and needlework as "more charmingly employed" than in any previous textile creation, describing in rich detail the "tapering leaves of the rose" and the "bloom linen of the richest gold."[89] The fine lines of the stems, along with the simplified and rectilinear rose blossom and geometric tapering leaves, are similar to those in Secessionist work, as well as the stylized roses Mackintosh designed for a table in the music salon of the Fritz Warndorfer House (SEE CHAPTER

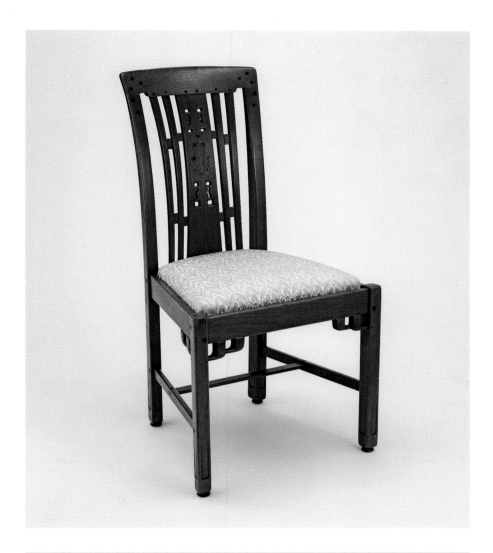

36

Charles Sumner Greene
Peter Hall Manufacturing Company
Made for the Robert R. Blacker House,
Pasadena, California
Side Chair
1907/09
The Art Institute of Chicago
Cat. 53

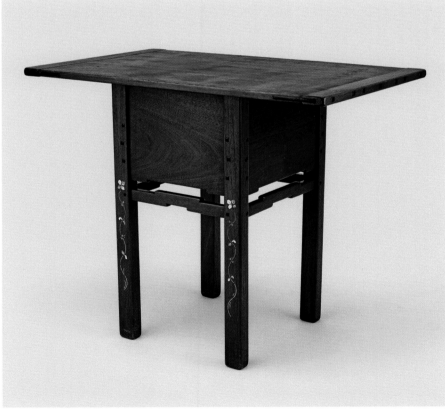

37

Charles Sumner Greene
Peter Hall Manufacturing Company
Made for the Robert R. Blacker House,
Pasadena, California
Serving Table
1907/09
The Art Institute of Chicago
Cat. 52

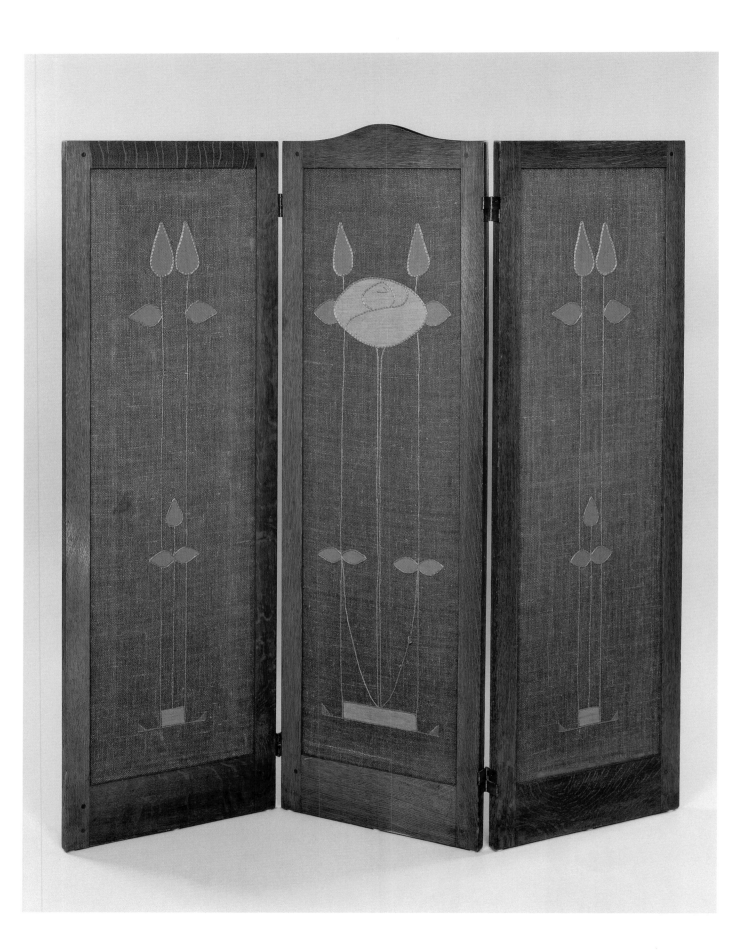

1, FIG. 36). Not surprisingly, one of the three known versions of this screen appeared in the Greenes' Pasadena masterwork, the David B. Gamble House (1907–09).[90]

As the example of the Greenes and Stickley demonstrates, cross-promotion and mutual support could eventually yield some stunning designs. At the same time, one finds some surprising cross-references and even some startling omissions. Hubbard certainly showed more of a debt to Stickley than vice versa: he purchased Craftsman pieces from the 1900 Grand Rapids furniture exhibition and had them shipped to his office and home.[91] More self-dramatizing and colorful than Stickley, he audaciously advertised Roycroft furniture in the April 1905 issue of the *Craftsman* (SEE FIG. 39). The text declares, "We think that we are making by far the best furniture in America today."[92] For his part, Stickley seemed to abide by the adage that any press might be good press and never mentioned any of his rivals by name in the pages of the *Craftsman*, unless they were willing to pay for the promotion. Perhaps Stickley's lack of attention to him finally hit a nerve, for in the April 1905 issue of the *Philistine*, Hubbard referred to Stickley as the "supernaculum of the trite . . . the loblolly of letters."[93] Despite—or perhaps because of—this contentious dialogue between Hubbard and Stickley, both men helped redefine the American Arts and Crafts movement. They brought attention to the movement through mass publications, vast empires devoted to producing and marketing consumer goods, and the force of their personalities. Hubbard's dramatic self-presentation, as well as the affordability of his products and portability of his books, and Stickley's awareness of international and national trends, emphasis on home construction and design, and introduction of craft enterprises such as Grueby and Newcomb, shaped an American aesthetic still popular over a century later.

38

Gustav Stickley
Craftsman Workshops
Rose Motif Three-fold Screen
1905
Collection of Crab Tree Farm
Cat. 142

39

Advertisement for the Roycrofters,
Craftsman 8, 1 (April 1905), p. XXXIII.

1. Boris 1986, pp. 41, 193.

2. Lears 1981, p. 83.

3. Kimmel 1987, p. 390.

4. Hall 1908, p. 31.

5. For more on the formation of Marblehead, illustrations of other versions of this vase, and more recent scholarship on designers and decorators, see Meyer and Montgomery 2007, pp. 153–74; Clancy and Eidelberg 2008, pp. 81–93; and Clancy and Eidelberg 2008/09, pp. 62–69.

6. "Exhibition of Society of Keramic Arts" 1909, p. 41. This article features an example of the vase, although it is inconclusive as to whether it is the Art Institute's version. See also Emerson 1916, p. 673.

7. Ellen Paul Denker and Bert Randall Denker, *Lamp, Vase, and Table Runner*, in Kaplan 1987, pp. 324–26, cats. 178–80.

8. In contrast, the male potters were given their equipment and paid for their work. For more on Newcomb's history, see Poesch and Mann 2003, esp. p. 29.

9. Boris 1987, pp. 208–22.

10. Kaplan 2004, p. 247.

11. Lambourne 1980, p. 154.

12. For an effective biographical treatment of Hubbard, including his early career and his contributions to the Larkin Company, see Quinan 1994, pp. 3–7.

13. Accounts differ as to when the first Roycroft book actually appeared. According to Eileen Boris, it was a "heavy-set imitation of Pre-Raphaelite design" in 1895; see Boris 1987, p. 218. Jack Quinan put the date at 1896 and cited specifically *The Song of Songs*; see Quinan 1994, p. 7.

14. There appears to be some question as to whether Hubbard and Morris actually met. Boris and Quinan mentioned only that he visited Kelmscott Press; see Boris 1987, p. 218, and Quinan 1994, p. 7. Lambourne insisted he met Morris himself; see Lambourne 1980, p. 154.

15. For photographs, albeit of promotional nature, of the Roycroft bindery and illumination shop, see *Roycroft Books: A Catalog and*

Some Comment Concerning the Shop and Workers at East Aurora (Roycroft, 1900). For a more impartial view, see Quinan 1994, p. 7; and Vilain 1994, p. 25. According to Vilain, Hubbard also employed child laborers as illuminators, an action that he would later be called upon to defend.

16. Only twenty-six copies of *Ruskin and Turner* were ever produced, for example. The Hubbards' strained relationship may also have been a factor in the change of personnel. Elbert's long-term affair with noted suffragist Alice Moore, who eventually became his second wife, finally took a toll on Bertha, who divorced him in 1903.

17. Quoted in Walsdorf 1999, pp. 20–21.

18. Baker 2000, pp. 16–17. Baker's biography, while oddly constructed, provides the most detailed information on the artist's life.

19. For more on Lonhuda Pottery, see Baker 1999, pp. 53–57.

20. Lonhuda lasted from 1891–94, when two of the partners sold their shares to Samuel A. Weller and it became part of Weller Pottery in Zanesville, Ohio. For more on this chapter in the company's history, see McDonald 1989, pp. 21–25.

21. Susan Otis Thompson, *Drawing for "Nature," by Ralph Waldo Emerson*, in Kaplan 1987, p. 318.

22. Quoted in Baker 2000, p. 25.

23. See ibid., p. 24. For examples of Hunter's stained-glass designs, see ibid., pls. 5–6. A window Hunter designed the following year for the Roycroft Inn's reception room has a motif similar to that of *Justinian and Theodora*, where he transformed the came, or metal strips that separate the glass, into thin, vertical stems that bloom into a rose at the top. For information on the Viennese Secession and its influence on Hunter and other American designers of the time, see Long 2007, pp. 19–20.

24. See Baker 2000, fig. 10. In a biography of his father, Dard Hunter II contended that the *Papyrus* and *Tulip* vases were created in 1906 as a "special present for Hubbard's young and attractive daughter, Miriam." For this information, as well as a color reproduction, see Hunter 1981, pp. 116–17.

25. Baker 2000, p. 30. No such plan came to fruition, however, and only four examples of this vase are known. The others are at the Metropolitan Museum of Art, New York; the Roycroft Art Museum, East Aurora; and a private collection. For a reproduction of the Metropolitan example, see R. Craig Miller, *Modern Design, 1890–1900, in the Metropolitan Museum of Art* (Metropolitan Museum of Art/ Abrams, 1990), p. 47.

26. For more on Hunter's post-Roycroft career as a papermaker and bookbinder, see Webster 2008, pp. 48–49.

27. Robert Rust, Kitty Turgeon-Rust, Marie Via, and Marjorie B. Searl, "Alchemy in East Aurora: Roycroft Metal Arts," in Via and Searl 1994, p. 81.

28. Leslie Greene Bowman insisted that since they were for the six ladies parlors, "probably no more than two dozen were made." See Bowman 1990, p. 114, no. 85.

29. Cathers 2003, pp. 214–15. Cathers's book provides concise biographies of all the architects, designers, and writers associated with the *Craftsman* magazine and United Crafts.

30. Stickley officially changed the spelling of his name to Gustav in 1903. For Stickley's early history, see ibid.

31. Stickley began using the name United Crafts by 1901, and by late 1903 and into 1904 he began to phase out United Crafts in favor of the Craftsman Workshops. Stickley's furniture is typically referred to as "Craftsman," an effect of his popular magazine.

32. The saying was originally the motto of early fifteenth-century Flemish painter Jan van Eyck.

33. "Foreword," *Craftsman* 1, 1 (Oct. 1901), n.pag. Recent scholarship has suggested that Irene Sargent, a University of Syracuse professor for romance languages and art history, was also responsible for the production of the *Craftsman*, including writing and editing. Moreover, Sargent penned numerous essays signed by Stickley, including the text for his first publication, *Chips from the Craftsman Workshop* (1901), and is largely credited with shaping Stickley's aesthetic and design principles. For more on Irene Sargent and her relationship with Stickley, see Reed 1979, pp. 3–13; Reed 1995, pp. 35–50; and Zipf 2007, pp. 139–63.

34. Scholars have given varying dates for the trips. Barry Sanders cited 1898, while the more reliable David Cathers indicated 1895 and 1896. See Sanders 1996, p. 14, and Cathers 2003, p. 20.

35. Sanders 1996, p. 14.

36. Mary Ann Smith 1983, p. 16.

37. Edgewood 1900, p. 655. See also Cathers 1996b, p. 222; Volpe and Cathers 1988, p. 25.

38. Advertisement, Tobey Furniture Company, *Chicago Daily Tribune*, Mar. 13, 1901, p. 16, and idem, *Chicago Daily Tribune*, Dec. 2, 1900, p. 10.

39. For more on Rohlfs and Stickley's relationship, see Cunningham 2008b, pp. 120–29. For a recent discussion in the dating and production of the chair, see Cunningham 2008a, pp. 65–79.

40. Stickley 1907, p. 21.

41. Cathers 2003, pp. 43–44. For a reproduction of Baillie Scott's design, see White 1901, p. 25, no. 32.

42. See Gray 1996, pp. 35, 41, and "An Argument for Simplicity in Household Furnishings," *Craftsman* 1, 1 (Oct. 1901), n.pag.

43. For a reproduction of Boston Mechanics Fair interiors, see Blanchon 1902, p. 76. For other examples of how Stickley used Grueby and other products in retail marketing, see Gray 1996, pp. 28, 45–46, 63, 84, 91.

44. Perry 1901, p. 251.

45. "The Planning of a Home," *Craftsman* 1, 5 (Feb. 1902), pp. 49–51. The article is accompanied by architectural renderings by Henry Wilhelm Wilkinson.

46. Howe 1902, pp. 161–69.

47. Ibid., pp. 161–62.

48. Ibid., pp. iv, 168, and Gray 1996, pp. 77, 95. A variation of this settle was also featured prominently in Sargent 1902, pp. 242–43.

49. Dietrich 1903, pp. 280–82; "An Interior," *Craftsman* 1, 4 (Apr. 1903), p. 57; and "The Craftsman House," *Craftsman* 2, 4 (May 1903), pp. 84–92.

50. Recently, Eileen Manning Michels has cast doubt on Ellis's authorship of these designs, instead arguing that the basic style of these pieces predates Ellis's tenure with Stickley and they more reflect examples that designer LaMont Warner studied and catalogued. See Michels 2004, pp. 306–21. See in particular "What May be Done with an Ordinary Room," *Craftsman* 5, 2 (Nov. 1903), pp. 167–69.

51. Cathers 2003, pp. 94–95, and White 1901, n.pag., no. 7. See also "House Keeping in Miniature," *Craftsman* 4, 3 (June 1903), p. 145. For more on Warner and his contributions to Craftsman furniture design, see Cathers 2003, pp. 41–42, 215–16, and Cathers 1996a, pp. 38–41 and 44–48, respectively.

52. Granger 1899, p. 41.

53. See Robert Spencer 1900, pp. 64–65, and *Chicago Architectural Club: Book of the Exhibition of 1900*, exh. fig. (Art Institute of Chicago, 1900).

54. Chicago Architectural Club, *Catalogue of the Fourteenth Annual Exhibition of the Chicago Architectural Club*, exh. cat. (Chicago Architectural Club, 1901), n.pag., and *The Chicago Architectural Club Annual*, exh. cat. (Chicago Architectural Club, 1902), n.pag.

55. Granger 1899, p. 38.

56. All of these commissions linked back to Elbert Hubbard: Larkin was the company from which he retired to found the Roycrofters, Martin Darwin took over his position, and William R. Heath was his brother-in-law. Wright, in fact, visited Hubbard in East Aurora in 1903 during a business trip to Buffalo.

57. Frank Lloyd Wright 1931, p. 196; see also Volpe and Cathers 1988, p. 40.

58. For more on this, see Lears 1981, pp. 83–86.

59. Dubin 1999, p. 150.

60. Percival 1897, pp. 152–53.

61. For the advertisement, see "Good Things From the West," *House Beautiful* 8, 5 (Oct. 1900), p. 658. See also Coles 1900, pp. 142–51; Cooley 1900, pp. 302–07; James 1901, pp. 235–43; and James 1903a, pp. 135–39.

62. Wynne 1901, p. 21.

63. "The Use and Abuse of Machinery and Its Relation to the Arts and Crafts," *Craftsman* 11, 2 (Nov. 1906), p. 204.

64. "A Noted Painter of Indian Types," *Craftsman* 7, 3 (Dec. 1904), p. 281, and "Our Western Painters," *Craftsman* 19, 3 (Dec. 1910), p. 271.

65. "Nursery Wall Coverings in Indian Designs," *Craftsman* 5, 1 (Oct. 1903), p. 95.

66. For an example of James's imprecision, see Cohodas 1992, pp. 88–133. For two of James's more popular books on Native American subjects, see James 1902 and James 1914.

67. James 1903b, pp. 126, 128.

68. Herzog 1996, p. 82.

69. For a typical advertisement for Native American basketry that appeared in the *Craftsman*, see advertisement, "For the Esthetic," *Craftsman* 5, 1 (Oct. 1903), n.pag., and "A New Indian Basket," *Craftsman* 13, 5 (Feb. 1908), p. xv. The latter was placed by the Francis E. Lester Company of New Mexico, one of the most prolific traders in Native American art at the time and a frequent advertiser in the *Craftsman*. For *Craftsman* articles specifically on basketry, see Sargent 1904, pp. 321–34; Batchelder 1907, pp. 82–89; and "Indian Blankets, Baskets and Bowls: The Product of the Original Craftworkers of this Continent," *Craftsman* 17, 5 (Feb. 1910), pp. 588–90.

70. Buck 1907, p. 171.

71. See Herzog 1996, p. 80.

72. For examples of the manufacturers and suppliers, as well as lists of items and dates of catalogues, see Thurman 1993, pp. 104–05.

73. See James 1903b, p. 129.

74. "Indian Rugs," *Craftsman* 5, 3 (Feb. 1903), n.pag.

75. Thurman 1993, p. 104. See also Koch 1967, p. 77, fig. 12.

76. Van Briggle's first contributions were two painted and incised North American shell gorgets with a border design taken from a U.S. Bureau of American Ethnology report. Van Briggle painted his first Native American portrait on a Rookwood vessel in 1889, and in 1893 he produced two plaques that Rookwood exhibited at the World's Columbian Exposition in Chicago. For more on this and for a reproduction of the vases, see Ellis 2007, pp. 69–70, 230–36, fig. 5.

77. Ibid., p. 85. In addition to these photographs, advertisements, newspapers, and posters served as the basis for additional Rookwood pottery. The source for the example here is currently unidentified.

78. The *Craftsman* lauded these later wares as "of the most artistic order." See "An Arts and Crafts Exhibition," *Craftsman* 3, 6 (Mar. 1903), p. 376.

79. Binns 1903, p. 303.

80. Bosley 2000, p. 39.

81. Cooke 2008, p. 115.

82. For more information and reproductions, see Bosley 2000, pp. 55–56, figs. 33–34.

83. Keith 1907.

84. "The Value of Permanent Architecture as a Truthful Expression of National Character," *Craftsman* 16, 1 (Apr. 1909), pp. 82 (ill.), 83, 90.

85. "A Mountain Bungalow whose Appearance of Crude Construction is the Result of Skilful [*sic*] Design," *Craftsman* 17, 3 (Dec. 1909), pp. 327–30.

86. The final *Craftsman* article on the Greenes appeared in 1915 in a story on home building materials and featured, among others, the Culbertson House in Pasadena and the Thorsen House in Berkeley. See "Your Own Home, Number Three: Selecting the Material for Durability, Economy, and Picturesqueness," *Craftsman* 27, 5 (Feb. 1915), pp. 537–38.

87. "California's Contribution to a National Architecture: Its Significance and Beauty as Shown in the Work of Greene and Greene, Architects," *Craftsman* 22, 5 (Aug. 1912), pp. 534–35.

88. Ibid., p. 535.

89. "Our New Home Department," *Craftsman* 7, 5 (Feb. 1905), pp. xviii, xx.

90. For this version, see Clark 1972, p. 39, fig. 39.

91. Cathers 2003, p. 34.

92. "Aurora Colonial Designs: The Roycrofters," *Craftsman* 8, 1 (Apr. 1905), p. xxxiii.

93. Hubbard 1905, p. 138.

"A NEW AND LIVING SPIRIT": PICTORIALIST PRINCIPLES AND THE ARTS AND CRAFTS MOVEMENT

*C*REATIVE ART DEMANDS THAT THE ARTIST *should know life, either by experience or by inspiration, and this knowledge of life must develop a profound sympathy with humanity. The technical method of expression may be whatever the artist wishes, whatever seems the simplest process. There is not a variety of creative arts; there is imagination and impulse to create and a variety of methods. The past few years have proved that photography is one of these methods.*
—GILES EDGERTON[1]

With the revelation of the invention of the daguerreotype in 1839, and announcements of additional photographic processes shortly thereafter, photographers almost immediately found themselves involved in an intense debate about the status of their new medium: was it art, or was it simply mechanical?[2] This dispute continued over many decades on both sides of the Atlantic. While it is thus not surprising that in 1907 the critic Giles Edgerton still found it necessary to declare that the expression of creativity had ample space for the camera, what is more unexpected is where she made her plea: the *Craftsman* magazine, the foremost publication of the American Arts and Crafts movement. Associated as they were with "the simple life"—one of self-sufficiency, spiritual understanding, handcraftsmanship, and honest labor—Arts and Crafts practitioners would not seem likely to have had anything in common with the camera, a potent symbol of modernity. Yet over the course of the magazine's fifteen-year existence, its editor, Gustav Stickley, repeatedly published articles on pictorialist photography, championing the photographic medium in general and, in particular, the group of practitioners known as the Photo-Secessionists (SEE FIG. 1). The aims of pictorialists and craftsmen, however, were not always in exact harmony, as is suggested by Gertrude Käsebier's seemingly tongue-in-cheek print *The Simple Life* (FIG. 2), in which a lone duck sits on a grassy expanse.[3] Yet the *Craftsman* articles, and the photographs themselves, reveal considerable resonances between the goals of artistic photographers and the ideals of the Arts and Crafts movement.[4] Early on the *Craftsman* celebrated the medium, when Sadakichi Hartmann, an art critic who wrote extensively on photography for pictorialist and craft journals alike, noted that "a new and living spirit has been introduced into a work hitherto dominated by dilettantism and commercialism."[5] As a reaction against industrialization, the Arts and Crafts community similarly

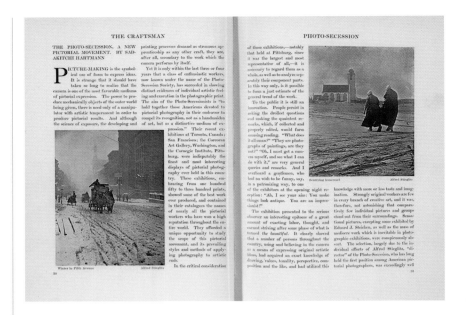

1

Sadakichi Hartmann, "The Photo-
Secession: A New Pictorial Movement,"
Craftsman 6, 1 (April 1904), pp. 30–31.

worked in opposition to such ignoble conditions. This "new and living spirit" thus linked photographers and craftsmen as both attempted to create works of beauty and originality.

Pictorialism describes an international movement whose advocates believed unequivocally in photography as an artistic medium. They were dedicated to turning photographs into "pictures," seeking to attain for their works the same status enjoyed by paintings. While British and European pictorialist photography societies

2

Gertrude Käsebier
The Simple Life
c. 1907
The Art Institute of Chicago
Cat. 75

existed, the movement coalesced in the United States around Alfred Stieglitz and his organization, the Photo-Secession. Like Stickley, Stieglitz promoted his views through the periodical press: he published two highly influential photographic journals, *Camera Notes* and *Camera Work*, which between 1897 and 1910 showcased the pictorialist works and writings of such seminal figures as Käsebier, Edward Steichen, Clarence White, and Stieglitz himself (SEE FIG. 3).[6] The Photo-Secession represented only a small fraction of pictorialist photographers working in the United States, yet its influence was widely felt.

Pictorialists employed a variety of subjects and processes to realize their aesthetic objectives, and the resulting photographs reveal the diversity of their craft. Similarly, as the other chapters in this catalogue have suggested, the Arts and Crafts movement took on many different guises, with distinct styles emanating from the various regional centers. Yet certain commonalities united Arts and Crafts practitioners with one another and, in turn, with pictorialist photographers. Many displayed an interest in the people and artistic styles of other cultures, borrowing most notably from Japanese and Native American art and traditions. Others explored themes drawn from rural life, nature, and domesticity. Attracted by the promise of such creative expression, women joined both of these movements in considerable numbers, many developing into skilled booksmiths, ceramicists, metalsmiths, photographers, and textile makers. Fine craftsmanship and the truth and beauty of form were of paramount importance to both groups. While most craftsmen privileged handwork, many nonetheless also embraced the machine in their quest for beauty at a reasonable cost. Conversely, although photographers necessarily relied on their cameras, many pictorialists emphasized their individual creativity by hand working their negatives or prints. In both Arts and Crafts and photographic circles, acceptance or rejection of the machine could be a source of tension, and the issue of the handcrafted versus the machine-made proved to be a divisive one as the modern era progressed.

PHOTOGRAPHY AND CRAFT

Photographers shared a common culture with craftsmen, and not surprisingly, they incorporated objects of Arts and Crafts design into their lives and work. James Craig Annan's *Portrait of Mrs. C.* (FIG. 4) reveals the sitter amid a refined British Arts and Crafts display. Resting on the dark wood furniture are a kettle-on-stand and a globular vase containing a Japanese-inspired spray of branches. The back wall features a muted series of cloth or painted panels adorned solely with three plates and a mirror, suggesting that the subject had an interest in ceramics. Wallpaper designed with a cross pattern reminiscent of Gothic Revivalism adorns the upper third of the wall. Indeed, the decorative elements almost dominate the composition, a sign of their importance in defining the sitter's taste and character.[7]

3
Camera Work 1 (January 1903), cover design by Edward Steichen.

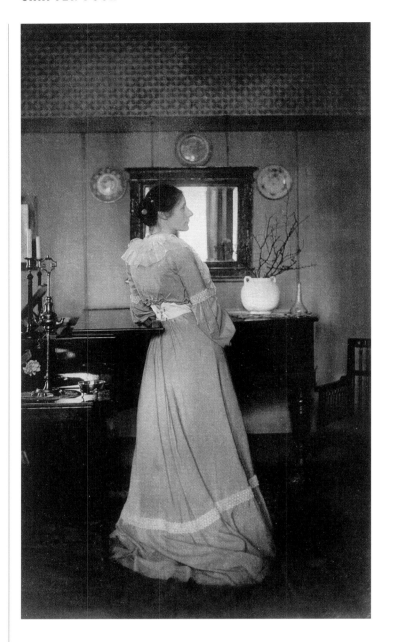

4
James Craig Annan
Portrait of Mrs. C.
Published in *Camera Work* 19
(July 1907), pl. 3
The Art Institute of Chicago
Cat. 1

Photographers employed such Arts and Crafts interiors in more than just their work. For many of them, the inclusion of beautiful, frequently handcrafted objects in their studios would have signaled their high artistic intentions. Käsebier's New York atelier was attired in a spare and refined fashion, as she chose to display her cultured sensibilities by limiting the furniture and art to only a few unembellished green screens and some framed photographs carefully positioned on the walls (SEE FIG. 5).[8] Anne Brigman's California workspace was decorated in the earthy palette used by many American craftsmen: "Up in the studio the light is subdued, the walls are hung with natural burlap, and the woodwork is dark green. The few pictures are warm gray and sepia prints of nature subjects, framed in dull wood."[9] Lest this aesthetic be thought characteristic of women alone, Edward Steichen's studio was

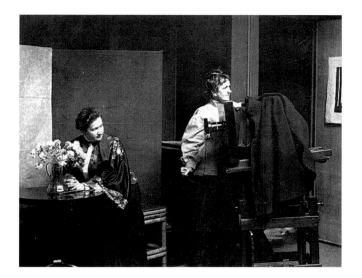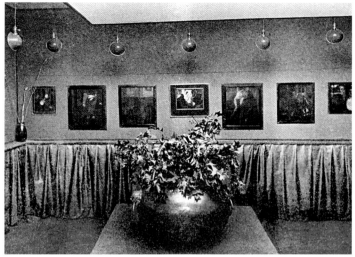

likewise decorated using a subdued palette described as consisting of "cool grays and pale terra-cotta," enlivened by the rare touches of color afforded by Japanese lanterns and brass vessels.[10] From the 1870s on, many artists used their studios to project their desired self-images to clients and the media, and pictorialists found that the subtle sophistication of the Arts and Crafts style helped advance their quest to be taken seriously as artistic workers.[11]

The careful consideration Steichen and others gave to their studio surroundings was only the first step in promoting the aesthetic quality of their work. Hartmann thus described how the Photo-Secessionists valued the overall presentation of the work: "the whole effect of print, mounts, or mat, signature, frame, should be an artistic one, and the picture be judged accordingly."[12] This holistic approach extended as well to the special settings used to display their works. When in 1905 Stieglitz opened his Little Galleries of the Photo-Secession in New York (also called "291" for its location at 291 Fifth Avenue), he was determined to showcase the best examples of artistic photography in an intimate, refined setting. Steichen was instrumental in the design of the opening series of exhibitions held there; a photograph of an installation of his own works in the spring of 1905 reveals an austere room, punctuated only by a modest floral arrangement in a large brass urn (SEE FIG. 6).[13] The photographs themselves were hung sparely in a single row, with ample space around each print, in matching dark frames that were undoubtedly carefully selected to best complement the artistic intentions of the photographs. Charles H. Caffin described the gallery during its first year, emphasizing its quiet, harmonious tonalities of color: "Each of the three rooms is small and low; the walls covered with some material that leaves the impression of pearly gray, or grayish grass; a shelf running round to mark the 'line,' and below it curtains of a slightly lower tone than that of the walls; here and there the accent of a piece of Japanese pottery, a flowering spray, a morsel of sculpture."[14]

5
A. K. Boursault (American 1863–1913)
Under the Skylight (Gertrude Käsebier in Her Studio)
c. 1903
Photomechanical reproduction;
11.1 x 14 cm (4 ⅜ x 5 ½ in.)
The Museum of Modern Art, New York, gift of Miss Mina Turner

6
Alfred Stieglitz, *The Little Galleries of the Photo-Secession* (detail). Published in *Camera Work* 14 (April 1906), p. 42.

Steichen thus employed at the gallery principles of design similar to those he used at his studio, a continuity of approach not unlike the manner in which many Arts and Crafts practitioners strove to incorporate art and beauty into all aspects of their lives and work. Although photographers sought specifically to elevate their medium, craftsmen embraced photography for its potential to uplift society. The works of the pictorialists certainly revealed, as Hartmann noted, a beneficial tendency toward "exacting labor, though, and earnest striving after some phase of which is termed the beautiful."[15] But for Stickley, the achievements of the Photo-Secessionists lay not just in the exquisite nature of their compositions, but in the relative inexpense of their prints in contrast to that of oil paintings.[16] Since the medium enabled photographers to produce multiple images from the same negative, the greater availability of photographs enabled beauty seekers of all incomes to enhance their lives with attractive art. Pictorial photography thus helped achieve the Arts and Crafts goal of integrating beauty into the home at a reasonable cost.

SOURCES OF BEAUTY—EAST AND WEST

Pictorialists relied on a variety of means to produce beautiful photographs. The appropriation of accepted "aesthetic" compositional choices was certainly one way that photographers could elevate their pictures to works of art. As the descriptions of their studios and exhibition spaces indicate, one considerable influence on photographers was that of exotic cultures, most notably Japan. Beginning in the 1860s, progressive artists began studying Japanese woodblock prints as they sought

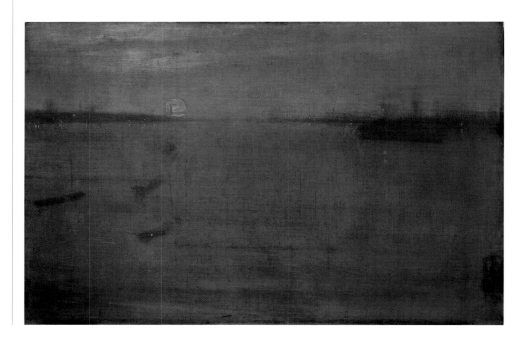

7

James McNeill Whistler (American 1834–1903)

Nocturne: Blue and Gold— Southampton Water

1872

Oil on canvas; 50.5 x 76 cm (19⅞ x 29 ¹⁵/₁₆ in.)

The Art Institute of Chicago, Stickney Fund, 1900.52

8
James Craig Annan
East and West
Published in *Camera Work* 32,
(October 1910), pl. 1
The Art Institute of Chicago
Cat. 2

new modes of expression.[17] The American expatriate James McNeill Whistler, for example, looked to Japanese aesthetics as he developed his art-for-art's-sake philosophy, in which pictorial concerns for color and form outweighed the traditional emphasis on narrative.[18] By the turn of the twentieth century, the delicate, even rarified quality of his work—most notably his nocturnes (SEE FIG. 7)—was a significant influence on many other artists in Britain and the United States. Photographers and craftsmen alike appropriated Japanese aesthetics in their work as a means of claiming a similar sense of artistry (SEE CHAPTER 2).

James Craig Annan alluded to the pervasiveness of such cultural borrowings in his photogravure *East and West* (FIG. 8), in which a Caucasian woman, attired in

Western-style dress, poses amid an array of Eastern objects and prints. Although *East and West* is a testament to the popularity of Japanism, the work itself is not particularly Japanesque. Stieglitz, on the other hand, clearly used principles of Japanese composition in *Spring Showers* (FIG. 9), an elegant image reminiscent of Whistler's atmospheric art.[19] First, the elongated format of the print—three times as high as it is wide—suggests a panel of a Japanese screen. Stieglitz's construction of a shallow, asymmetric pictorial space further reveals his debt to Asian sources. As Whistler did before him, Stieglitz recorded a misty haze that precludes any clear view of the background and dramatically flattens the perception of depth. He also deliberately cropped the buildings, using them to frame the slender tree that bisects the composition at a slightly skewed angle. Finally, although the view singles out an industrious street sweeper, his presence at the far left and his diminished scale in relation to that of the tree minimizes his importance and recalls the treatment of figures in some Japanese woodblock prints. As an urban photograph, the image could have exposed the rough and unattractive side of the city. Yet by aligning his work with non-Western aesthetics, Stieglitz instead associated *Spring Showers* with the refinement and poetry of Japanese art.

Besides Japanism, some artists found inspiration in the land and peoples of the American Southwest. At the time, Native Americans were thought to have an authentic tie to the land and to possess an inherent purity and sanctity not seen among more "civilized" peoples. Both pictorialists and craftsmen therefore adopted native motifs and imagery as a means of tapping into this natural spirituality (SEE CHAPTER 3). By the 1890s, however, many Americans shared a concern that the expansion of the nation was causing Native Americans to lose their traditional grounds, threatening their extinction. Artists and scientists alike strove to record details of tribal rituals and dress. The photographer Edward S. Curtis, for instance, spent decades producing his monumental publication *The North American Indian*.[20] The first image in the twenty-volume set, entitled *The Vanishing Race* (SEE FIG. 10), portrays a somber line of Apache horsemen riding away from the camera. This famous picture, which includes a caption noting that the subjects were "passing into the darkness of an unknown future," came to symbolize their possible eradication.[21] For many Americans, Curtis's photographs thus became one of the primary means of maintaining a connection to a vanishing way of life. The Arts and Crafts community felt similarly and noted the parallels between their efforts and those of people like Curtis: "We are just waking up here in America to appreciating the big interests of our country and to a sense of cherishing our original greatness. We are painting our plains, protecting our forests, creating game preserves, and . . . making and preserving records of [Native Americans]."[22]

Although Curtis promoted his work as ethnographic records, his early photographs were emphatically pictorial.[23] As a young man, he studied paintings to learn principles of composition, with an eye toward producing artistic photographs. He

9
Alfred Stieglitz
Spring Showers
1901
The Art Institute of Chicago
Cat. 149

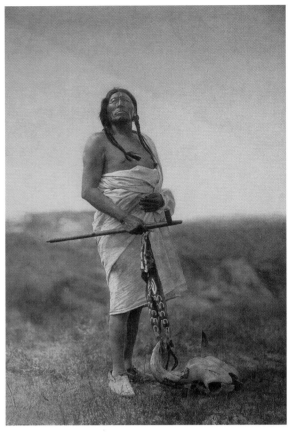

10
Edward S. Curtis
The Vanishing Race, from *The North American Indian*
1907
Photogravure; 40 x 26.1 cm
(15 ¾ x 10 ¼ in.)
Charles Deering McCormick Library of Special Collections, Northwestern University Library

11
Edward S. Curtis
The Medicine Man, from *The North American Indian*
1907
The Art Institute of Chicago
Cat. 30

applied this knowledge to his Native American images, which he frequently orchestrated, composing the settings and employing backdrops, costumes, and props to best exemplify his expectations of both artistry and ethnography. His pictures were occasionally exhibited alongside Photo-Secessionist works and were clearly seen as artistic. *The Medicine Man* (FIG. 11), for instance, is an iconic portrait of an old warrior, pipe in hand, his body wrapped in simple drapery like that of an ancient Greek sculpture.[24] By identifying the man's spiritual vocation rather than his tribal affiliation, Curtis emphasized the man's mystical powers and minimized the documentary nature of the work. *Arikara Girl* (FIG. 12), a striking portrait of a young woman with her hair pulled back in a simple braid, is another example of the blurring of art and ethnography. Although the accompanying caption states that her features give evidences of a mixed heritage, Curtis posed the girl against a plain studio backdrop and cast her face in deep shadow, emphasizing the artistry of his image over her ethnic identity.[25] The beadwork on her garment, bathed in light, is the most prominent element in the picture. As such, it surely would have appealed to Arts and Crafts audiences, who would have appreciated this glimpse of native craftsmanship. It is not surprising that the *Craftsman* declared, "Mr. Curtis is first of all a craftsman, and after that equally a historian, a scientist, an artist and an understanding human being."[26]

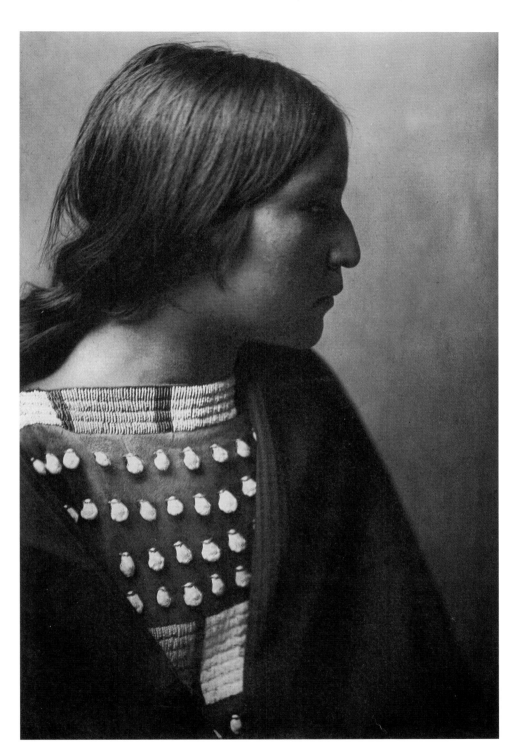

12
Edward S. Curtis
Arikara Girl, from *The North American Indian*
1908
The Art Institute of Chicago
Cat. 31

Some of Curtis's works reveal his knowledge of Japanese art. In the *Canoe of Tules—Pomo* (FIG. 13), he photographed his subject through a screen of delicate reeds. Although no horizon line is visible, the placement of the figure evokes the tilted perspective and shallow space of many Japanese woodblock prints, while the intrusion of the reeds into the pictorial frame recalls Whistler's subtle inclusion of sprays of blossoms in some of his paintings as a means of highlighting his radically cropped compositions. Curtis's use of Japanese aesthetics to convey a Native American subject is intriguing; it indicates that the nature of the "exotic," whether Eastern or Western, was fluid well into the twentieth century.

Curtis was not the only photographer fascinated by Native American culture; over a five-year period, Käsebier repeatedly photographed members of Buffalo Bill's Wild West troupe, who were primarily Sioux, in a wide variety of poses.[27] While many of their portraits reveal elaborate details of their costumes, which were designed presumably for their shows at Madison Square Garden and other locations around the country, *The Red Man* (FIG. 14), like Curtis's *Medicine Man*, deliberately offers a less ethnographic viewpoint. Here, Käsebier suppressed evidence of the model's tribal identity, preferring instead to suggest a universal Indian presence, which she reinforced by means of the nonspecific title. Perhaps for this reason, *The Red Man* was published more frequently than Kasebier's other Native American portraits, including by Stieglitz in *Camera Work* and by Stickley in the *Craftsman*.[28]

13
Edward S. Curtis
Canoe of Tules—Pomo, from *The North American Indian*
1924
The Art Institute of Chicago
Cat. 32

14
Gertrude Käsebier
The Red Man
c. 1900
The Art Institute of Chicago
Cat. 72

Unlike Käsebier, who brought models to her New York studio, Curtis worked in the field, and thus could photograph the southwestern landscape itself. In one of his most magnificent images, *Cañon de Chelly—Navaho* (FIG. 15), the dramatic cliffs of the canyon dwarf the figures on horseback. Here Curtis evoked the awesome beauty of the Southwest, suggesting that his inspiration was as much the vanishing land as it was the vanishing people. Significantly, unlike most of his photographs, which appeared only in the volumes of *The North American Indian* as photogravures, Curtis produced *Cañon de Chelly* as an orotone as well. Nicknamed the "Curt-Tone," this process, in which an image is printed on glass backed with a gold emulsion, gives the photograph a luminous glow. Seemingly unique despite being

15
Edward S. Curtis
Cañon de Chelly—Navaho
1904
Collection of Crab Tree Farm
Cat. 28

sold by the hundreds, each photograph was framed in a simple, dark Arts and Craft–style frame with gilt-corner ornamentation. In its emphasis on beauty over commercialism, however, the orotone was a striking testament to the value of preserving the ancient cultures and extraordinary landscapes of the Southwest.

THE RURAL IDEAL

Many craftsmen were equally attracted to the rural world, which they saw as the antidote to the increasing industrialization and urbanization of modern life. In particular, mechanization was thought to divorce workers from the products of their labor. British Arts and Crafts proponents like John Ruskin and William Morris saw that design and execution were no longer the responsibility of one person, and they

felt that this alienated workers, who could take no joy or personal satisfaction in their effort (SEE CHAPTER 1). Labor, and in general the preindustrial traditions of agrarian communities, thus became romanticized as the embodiment of the craft ideal. The countryside signified the relatively uncorrupted remnant of a past world, a place where work could be honestly pursued without concern for modern-day materialism. Idealized for its simplicity, integrity, and faith, country living was thought to be a more authentic existence.

Pictorialists similarly turned to the rural world for inspiration, in part because their focus on preindustrial subject matter allowed them to downplay the fact that they depended on a mechanical process for their livelihood. Furthermore, since rustic themes had become popular in the fine arts, pictorialists employed similar subjects as a means of elevating their medium. An author in the *Craftsman* wrote, "The greatest art is that which brings vividly back to us the simplest experiences of our lives. There must be, too, experiences that are universal that have touched the lives of all men. [Jean-François] Millet's *Angelus* is great, because it sets forth three universal factors of human existence—labor, love and religion."[29] This statement, from an article about the photographs of the Photo-Secessionist Clarence White, suggests that photographers tapped into this sentiment through picturesque images of rural labor and life.

In one highly acclaimed print, *The Net Mender* (FIG. 16), Stieglitz celebrated the traditional work of a Dutch woman, who leans over her torn net in rapt concentration.[30] By capturing her figure in profile against the horizon line, he endowed the composition with a monumentality that elevates her labor. In 1899 he declared this carbon print his favorite photograph, singling out the woman's industry as particularly praiseworthy: "It expresses the life of a young Dutch woman: every stitch in the mending of the fishing net, the very rudiment of her existence, brings forth a torrent of poetic thoughts in those who watch her sit there on the vast and seemingly endless dunes, toiling with that seriousness and peacefulness which is so characteristic of these sturdy people. All her hopes are concentrated in this occupation—it is her life."[31]

Stieglitz suggested similar sentiments in prints such as *Early Morn* (FIG. 17), an idyllic harvesting scene reminiscent of Millet's famed painting *Angelus* (1857–59; Musée d'Orsay, Paris).[32] Here, Stieglitz photographed two quaintly dressed Bavarian farmers, hard at work as the morning light shimmers on a luxurious field of grain. Stieglitz recommended the location of *Early Morn*—the German farm town of Gutach—as particularly inspiring to artists; it was admirable for having "no tall factory buildings with their modern rectangular lines of bricks and windows to disturb, no railroads with smoky locomotives to dim the pure atmosphere."[33] Similarly, the coastal village of Katwyck, Netherlands (where Stieglitz had taken *The Net Mender*) provided an ideal, rustic environment populated by resilient

16
Alfred Stieglitz
The Net Mender
1894
The Art Institute of Chicago
Cat. 147

17
Alfred Stieglitz
Early Morn
1894
The Art Institute of Chicago
Cat. 146

18
Alfred Stieglitz
Scurrying Home
1897
The Art Institute of Chicago
Cat. 148

seafarers.[34] Stieglitz's famed *Scurrying Home* (FIG. 18), for instance, captures two darkly clad figures crossing a bleak Dutch landscape, relieved only slightly by the stark outline of a church.[35] The powerful austerity of the print, suggesting the deep ties between country life and religious faith, brought Stieglitz acclaim in both photographic and craft circles; indeed, the print was published in Hartmann's 1904 *Craftsman* article on the Photo-Secession. The author wrote of Stieglitz that "simplicity is the keynote of his work," continuing that the photographer offered "picturesque ideas which suggest themselves in a quiet, natural manner."[36] For Stieglitz, these seemingly preindustrial societies where traditional folkways still existed, offered photographers—with their modern apparatuses—an opportunity to experience and record a premodern world.

While Stieglitz looked to bucolic European locales for inspiration, many Americans looked closer to home for evidence of the simple life. In *Spinning* (FIG. 19), Emilie

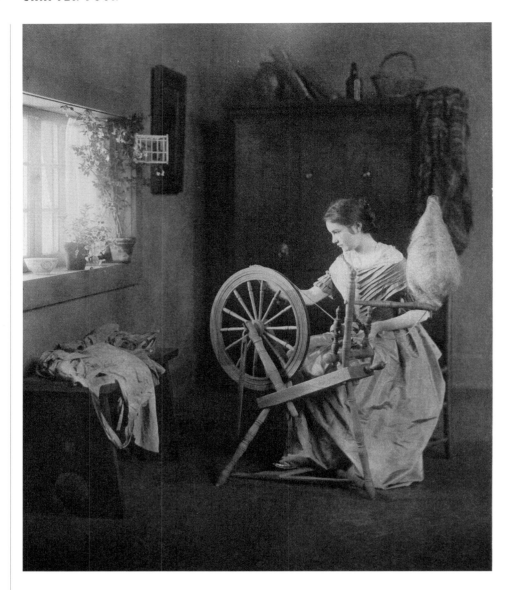

19
Emilie V. Clarkson
Spinning
c. 1898
The Art Institute of Chicago
Cat. 24

V. Clarkson revealed her interest—as had Ruskin and other Arts and Crafts fore-
runners such as Augustus Welby Northmore Pugin—in reviving past values.[37]
While Ruskin and Pugin found their exemplar of honest craftsmanship in the
Gothic past, Clarkson and others needed a more personally relevant model, which
they found in the colonial era. Spinning was considered an honorable form of labor
for women, practiced by sturdy settlers and revived by their descendants in such
Arts and Crafts centers as Deerfield, Massachusetts. In Clarkson's photograph, light
from the window accentuates the details of the figure's costume, which features a
pleated bodice and lace tucker that deliberately recall colonial styles. Clarkson also
emphasized aspects of the woman's work, highlighting the wheel's spokes and the
large, soft bundle of fiber. By idealizing the practice of spinning, Clarkson thus
associated her photograph with the noble activities and honest craftsmanship of a
specifically American past.

WOMEN AND PICTORIALISM

Clarkson might have been particularly interested in spinning because it was a largely feminine activity, but the female form became an important inspiration for pictorialist photographers of both genders. In the traditional roles of the day, men typified the built world, while women symbolized the natural world, along with beauty, creativity, and the artistic impulse. Clarence White frequently photographed his wife and other family members in pastoral settings as a means of achieving artistically and spiritually authentic images.[38] In *Sunlight* (FIG. 20), White positioned his subject against several slender tree limbs, while a leafy branch frames her head. The shapeless gown—although perhaps a sign of an interest in clothing reform—appears timeless and eternal, while the model's hair is loosely swept up onto her head. A diffuse, golden light unifies the image, implying an idyllic moment of communion between woman and nature. The asymmetrical composition and diagonal lines of the trees in *Sunlight* also reveal White's close study of Japanese woodblock prints.

Anne Brigman similarly worked with images of women in nature. A Photo-Secessionist from Northern California, Brigman frequently photographed her

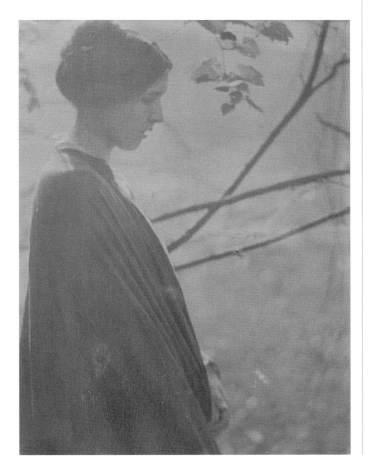

20
Clarence H. White
Sunlight
1901
The Art Institute of Chicago
Cat. 164

friends nude in wild landscape settings.[39] In *Untitled (The Breeze)* (FIG. 21), a woman draped in diaphanous cloth stands silhouetted against a dramatic sky. The graceful curves of her body echo the hilly terrain behind her, rendered through a misty haze that obliterates details and further unites the figure with her surroundings. Due to Brigman's rendering of nature as primeval and seemingly untouched by humanity, her works found favor with Arts and Crafts circles, who saw in them, as they also saw in Curtis's landscapes, a shared concern for the threat posed to the environment by industrialization and settlement.[40]

Brigman's work, however, points to the importance of woman not just as objects but as authors. Women joined the ranks of pictorialist photographers and the Arts and Crafts movement in large numbers. In both circles, they could pursue their creative endeavors—often denigrated as simply feminine pastimes—as art forms. Their activities also allowed them to claim autonomy: first, craftsmanship offered

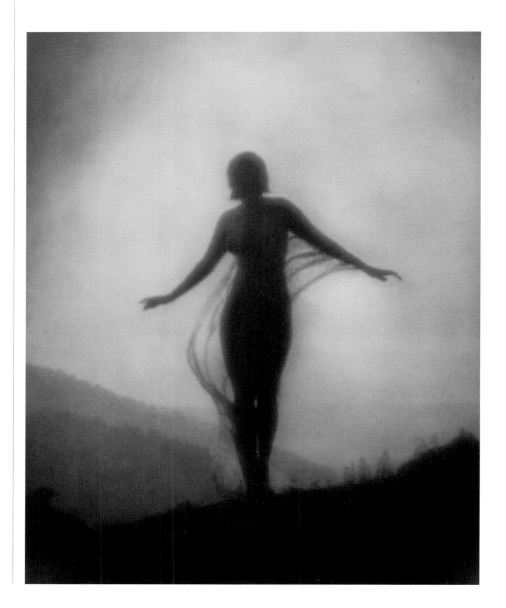

21
Anne Brigman
Untitled (The Breeze)
1918
The Art Institute of Chicago
Cat. 20

22
Eva Watson-Schütze
Jane Addams
1910
The University of Chicago Library
Cat. 163

them liberation from the close confines of the domestic sphere; and second, a num-
ber of women earned money from the sale of their art, which gave them a degree
of self-sufficiency.[41] For instance, Käsebier became an artist after raising three chil-
dren in a loveless marriage; her work and ties to the art world surely alleviated some
of her personal frustrations. Yet her actions caused other strains, for when Käsebier,
motivated by concerns over her husband's ill health and the possible loss of family
income, established herself as a professional photographer, her husband became
resentful.[42] Facing similar tensions, Brigman left her husband as a means of realizing
complete creative independence, traveling soon thereafter to New York to meet
Stieglitz and be at the epicenter of artistic photography.[43] Käsebier's and Brigman's
choices distanced them from the era's social norms for women of their class, not
unlike those of the many women of the Arts and Crafts movement who joined
utopian communities or worked at commercial firms such as Rookwood Pottery.
Eva Watson-Schütze, however, successfully balanced the demands of a photographic
career with marriage. Already an active participant in exhibitions—which included
being a juror for the first annual Chicago Photographic Salon in 1900, along with
Stieglitz and White—she followed her new husband to Chicago in 1901. There she
continued her work as a photographer and was a founding member of the Photo-
Secession.[44] Her photograph of Jane Addams (FIG. 22) reveals her ties to the pro-
gressive settlement worker and founder of Hull House, the heart of the Arts and
Crafts movement in Chicago (SEE CHAPTER 5). Depicting the reformer writing at
her desk, but looking up with a serious expression at something beyond the frame,

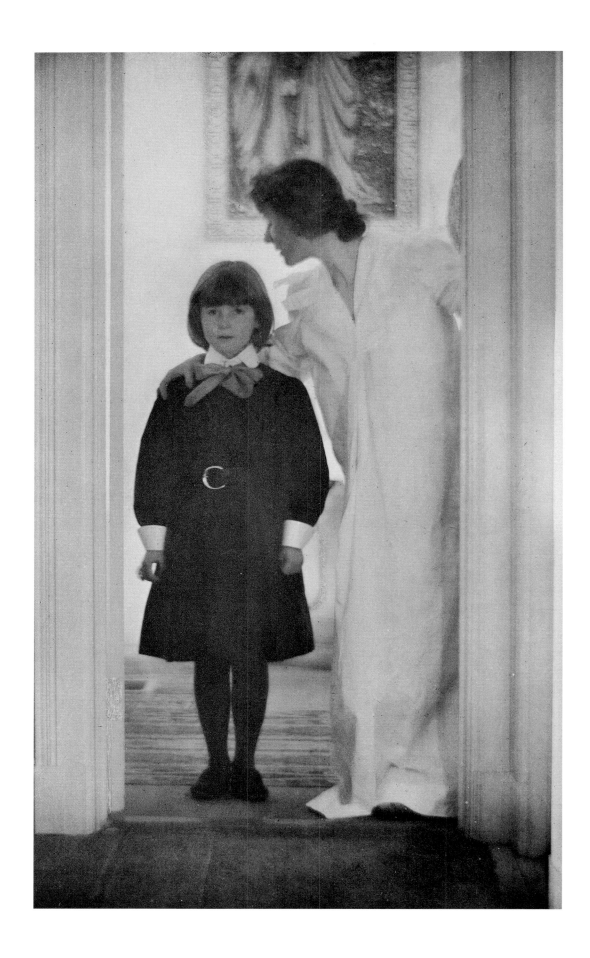

the portrait suggests Addams's keen intelligence and intense commitment to her work. Watson-Schütze had her own reformist inclinations; in 1902 she began spending summers at Byrdcliffe, a utopian Arts and Crafts colony near Woodstock, New York, where she photographed its residents.

Despite—or perhaps because of—the modernity of their chosen medium, Käsebier and Watson-Schütze frequently focused on women and children as their subjects. Domestic scenes were acceptable themes for women photographers, even those whose own lives transgressed familial and societal boundaries, because they were aligned with more traditional notions of femininity. Käsebier's most lauded photographs, for instance, focus on motherhood. *Blessed Art Thou Among Women* (FIG. 23) depicts a tender moment between mother and daughter. Framed by a narrow doorway, the girl cautiously gazes out as if poised on an important threshold. Her mother, almost ethereal in her light, flowing garb, bends toward her, appearing to whisper to her.[45] The work's title refers to the Annunciation, a depiction of which hangs behind the figures.[46] The frontal stance of the daughter echoes that of the Virgin Mary, while the profile view of the mother suggests that of the angel. Although the photograph appears to celebrate traditional feminine roles, it also presents subtle references to progressive beliefs. The large-scale print of the Annunciation is recognizable as the work of Selwyn Image, an English designer and important member of the Century Guild (SEE CHAPTER 1). Furthermore, the mother's gown is uncorseted, allowing for free movement, a goal of the clothing reform movement active at this time. Finally, Käsebier's models here were the author Agnes Lee and her daughter, Peggy. Lee's husband, Francis Watts Lee, was an amateur photographer and printer who promoted the works of William Morris in the United States; the family's involvement with forward-thinking Arts and Crafts practices would thus have been known to contemporary audiences.

Not surprisingly, pictorialist and Arts and Crafts circles alike acclaimed *Blessed Art Thou Among Women*. Stieglitz published it in the premier issue of *Camera Work* in 1903, signaling its status as an artistic photograph.[47] Giles Edgerton, in her 1907 *Craftsman* feature article on Käsebier's work, commended the picture as depicting a "great spiritual moment." Although Edgerton celebrated the naturalism of Käsebier's works by describing them as "simply photographs taken for portraits," she emphasized that despite their origins as portraits, they possessed a heightened spirituality due to the artist's uncanny ability to capture a sitter's emotions and temperament.[48] For instance, *The Heritage of Motherhood* (FIG. 24), another portrait of Agnes Lee and one of Käsebier's most admired photographs, hauntingly evokes profound loss and mourning. Käsebier here showed Lee grieving after the death of Peggy, her face upturned in an expression of supplication. But Edgerton also noted that Käsebier's mastery of her craft contributed to the power of the image. Lee's inner turmoil is echoed in the bleakness of the landscape, which Käsebier enhanced by brushing away the platinum emulsion of the negative, scraping and roughening

23
Gertrude Käsebier
Blessed Art Thou Among Women
c. 1899
The Art Institute of Chicago
Cat. 71

the surface in a manner befitting the subject. The dramatic contrasts of dark and light she achieved in the clothing and background unify the image, further accentuating the trauma of bereavement. The meaning conveyed in this photograph recalls one of the most important Arts and Crafts tenets: that art and spirituality can be united, even through a mechanized process. The camera may have taken the picture, but the evocative nature of the work derives in large part from Käsebier's skill in harnessing her artistry.

THE CRAFT OF PHOTOGRAPHY

Käsebier's interventions on the negative of *The Heritage of Motherhood* reveal the importance of photographic process to pictorialists, just as Arts and Crafts practitioners valued their creative labor. As photography grew increasingly popular, pictorialists tried to refute conceptions of the medium as purely mechanical. "You Press the Button, We Do the Rest," proclaimed Eastman Company in advertisements for their new, handheld Kodak camera, which had debuted in 1888. Would-be photographers could point and shoot, and Kodak would develop and print their images. For Stieglitz, this slogan, and the absence it implied of individual craftsmanship in producing prints, was anathematic to the ideals of artistic photography. Pictorialists thus justified the artistry of their work by emphasizing two crucial elements of the photographic process: their creative impulses in composing their shots and their skills in the darkroom in achieving the most beautiful

prints. In this, they were not unlike craftsmen, who made pieces that showed their mortise and tendon joinery techniques or who developed innovative ceramic glazes as signifiers—whether true or not—of hand construction.

Edward Steichen's platinum print *The Pool* (FIG. 25) demonstrates his eye for composition as well as his considerable skill as a printer. His use of an asymmetrical arrangement and high horizon line reflect his absorption of both Japanese and Whistlerian aesthetics. Moreover, the platinum process enabled him to attain rich velvety tones of black and soft atmospheric effects without sacrificing desired details to the inky depths of the dark areas, as is evident, for example, in the distinct appearance of the trees in the background or the leaves strewn across the dark, shimmering water. Charles Caffin praised Steichen's delicate sense of tonality and deft handling of the photographic medium, noting that *The Pool* "represented an original and very personal vision of nature; at once large and embracing, yet very sensitive in its feeling both for the sentiment of the scene and for the method of its expression."[49]

New or reconceived photographic processes and a willingness to transcend the seemingly straightforward nature of photography made it possible for many pictorialists to emphasize the handcrafted individuality of their work. The platinum medium, for instance, allowed artists to create more than just subtly beautiful gradations of tone; some photographers took advantage of the opportunities the medium offered to alter the negative through handwork. In Käsebier's portrait of Stieglitz (FIG. 26), her removal of the platinum emulsion around the figure blurs and softens the background. In a manner reminiscent of Renaissance painting, she also added to the negative a title and date in block letters, making them integral parts of the composition. In addition, some pictorialists favored gum bichromate, a method that entails coating paper with a gum-arabic emulsion, which is then developed in contact with a negative. The gum on the positive print hardens in relation to its exposure to light, and when rinsed with water, its softer areas can be washed away or altered through brushing and scraping. It thus enabled pictorialist photographers to selectively control the final appearance of their prints.

Steichen's *Self-Portrait with Brush and Palette* (FIG. 27) is one of the finest manifestations of such gum-bichromate handwork.[50] The artist surely saw gum bichromate as a means of rebutting claims that photography was not sufficiently artistic. Indeed, in discussing this work, James Craig Annan noted Steichen's technique, likening it to working on an oil painting: "At one stage of the process . . . the print is in a soft state, somewhat analogous to a recently painted oil picture, and while it is in this state liberties may be taken with it by rubbing off portions of the semi-fluid picture."[51] Steichen took such liberties most notably in the depiction of the brush and palette, blurring their forms together with swift, fluid brushstrokes. He thus literally associated painting and photography, emphasizing his dual identity as a

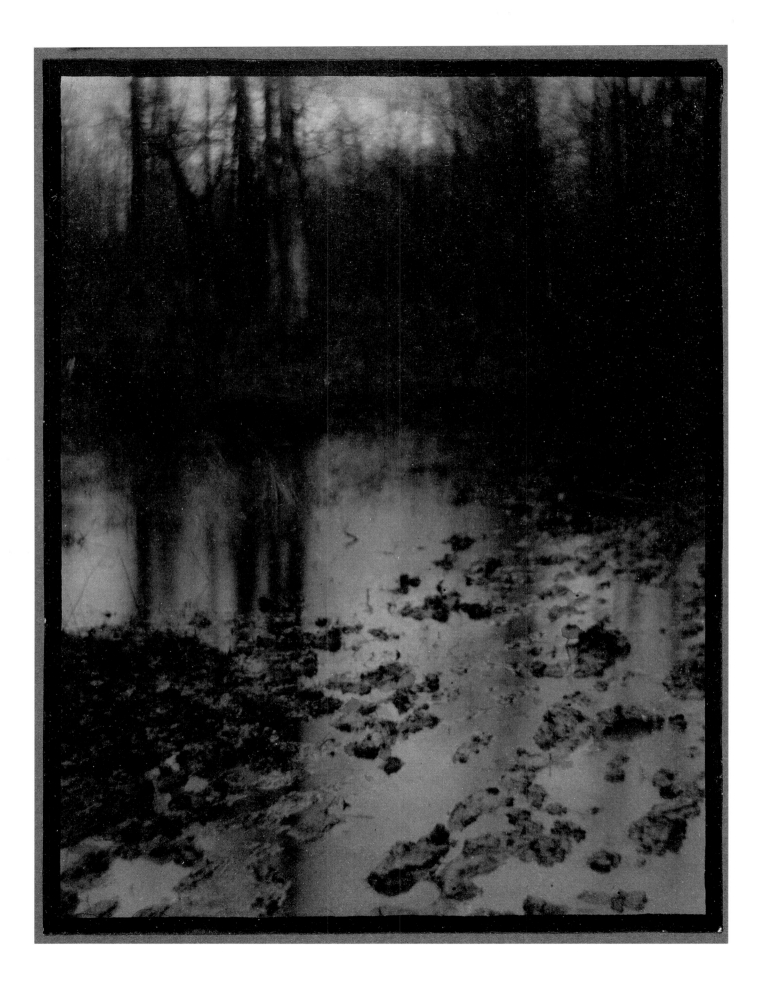

painter who holds the tools of his artistry and a photographer who could manipulate his medium in a painterly fashion. He also altered the coating around his figure, drawing attention to his high-collared outfit. Through the selective suppression of details, Steichen's self-consciously artistic persona registers first and foremost. The image thus makes a strong statement: although he employed a camera, his work is original and unique—the artist prevails over the machine. The Arts and Crafts community quickly agreed: *Self-Portrait with Brush and Palette* was published in the *Craftsman's* first feature article on photography, in 1904.[52]

25
Edward Steichen
The Pool
1900
The Art Institute of Chicago
Cat. 130

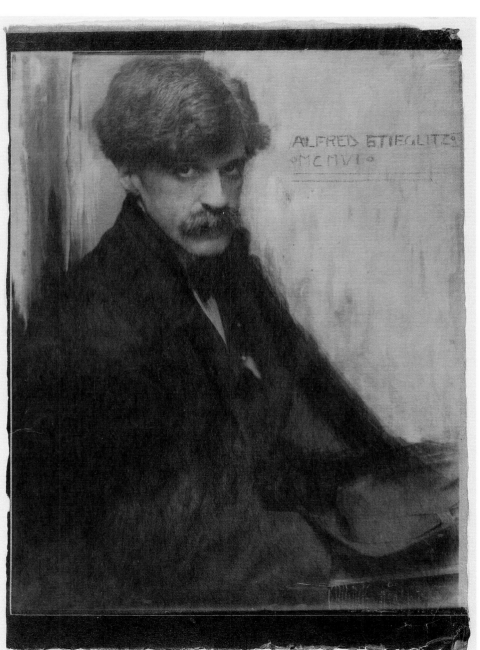

26
Gertrude Käsebier
Alfred Stieglitz
1906
The Art Institute of Chicago
Cat. 74

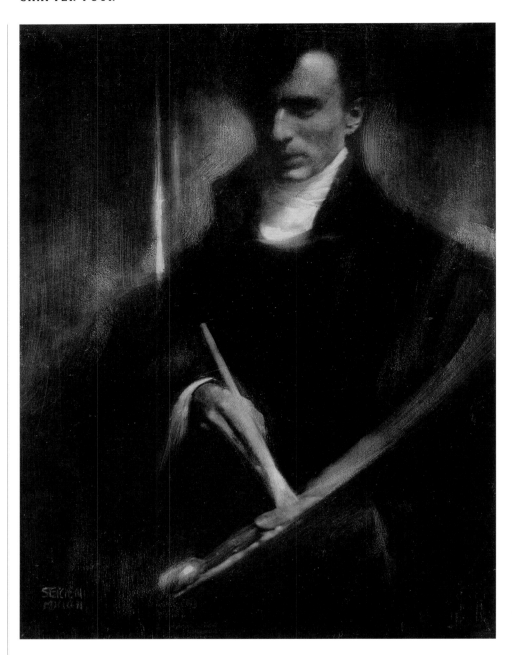

27
Edward Steichen
Self-Portrait with Brush and Palette
1902
The Art Institute of Chicago
Cat. 131

In addition to handwork, gum bichromate offered artists great flexibility in color and tone because the gum mixture could be tinted with a range of pigments or employed in conjunction with other processes. Steichen therefore used the process to individualize particular photographs, as in two prints of *Midnight Lake George* (FIGS. 28–29). Here, he started with a platinum process negative, reversing the orientation of the image in one of the prints. He then tinted the gum-bichromate coatings of his two papers with different concentrations of blue and green pigments to create their unique tonalities of color. Furthermore, by varying the degree to which he washed the gum in the two prints, he achieved a far deeper, more shadowy effect in one (FIG. 28), greatly reducing the suggestion of light emanating from

28
Edward Steichen
Midnight Lake George
1904
The Art Institute of Chicago
Cat. 132

29
Edward Steichen
Midnight Lake George
1904
The Art Institute of Chicago
Cat. 133

the moon. By adding color effects, Steichen (and other pictorialists using the gum process) could alleviate complaints about the black-and-white nature of photography. More importantly, Steichen's complex processes enabled him to create unique prints of the same landscape image, transcending the purely mechanistic and multiplicative implications of his camera-based medium.

However, just as the use of the handworking caused debate in Arts and Crafts circles, so too did it—with different meaning—among the Photo-Secessionists. While Steichen and others attempted to downplay dependence on the camera through their own unique interventions, Stieglitz wanted to celebrate its inherent abilities. Handwork was denounced as "fakery," despite Steichen's assertion that "every photograph is a fake from start to finish, a purely impersonal, unmanipulated photograph being practically impossible."[53] A schism arose between Steichen and others who intervened in the photographic processes and proponents of "straight photography" like Stieglitz, who relied purely on focus, composition, and tone. As Hartmann noted, "[Stieglitz] never employs anything but photography pure and simple; disdaining artificial means by which other camera-workers like Steichen and Eugene have attained their startling results."[54] As the modern era developed, mechanical processes gained in prominence and stature, and machine aesthetics were celebrated. By World War I, straight photography had won the day, and pictorialism was largely replaced by modernism, with its preference for sharp focus and abstracted form. Similarly, the Arts and Crafts movement lost out to the demands for sleek designs and machine-made products, setting the stage for the streamlined elegance of Art Deco.

Yet this does not diminish the fact that around the turn of the twentieth century, pictorialist photographers gained respect for their medium through their adroit use of artistic subjects and handcrafted prints. As Stickley himself wrote about pictorialist photographs, "Such work is no more mechanical because of the use of camera than a painting is mechanical because of the handling of the brush. It is all the reproduction of beauty, grown into art through the imagination."[55]

1. Edgerton 1907, p. 80.

2. In January 1839, the announcement of the daguerreotype was followed shortly by the revelation by William Henry Fox Talbot of the existence of a second photographic process, which he called photogenic drawing. Louis-Jacques-Mandé Daguerre's eponymous process produced a unique image on a metal plate, whereas Talbot's photogenic drawing, which later evolved into the calotype, depended on the use of a negative, and thus could be printed multiple times. Talbot's negative-positive process was highly influential in shaping the subsequent development of photography. The litera-ture on origins and history of photography is extensive, but one classic study is Beaumont Newhall, *The History of Photography: From 1839 to the Present*, 5th ed. (New York, Museum of Modern Art, 1982). More recent studies include Michel Fritzot, ed., *A New History of Photography* (Könemann, 1998), and Mary Warner Marien, *Photography: A Cultural History*, 2nd ed. (Laurence King Publishing, 2006).

3. Barbara Michaels interpreted this photograph, taken while Käsebier was living in the country, as reflecting her distaste for such isolated living. See Michaels 1992, p. 130.

4. For additional reading on this subject, see the groundbreaking article by Christian A. Peterson; Peterson 1992, pp. 189–232. For Boston photographers in particular, see Havinga 1997, pp. 134–50.

5. Allan [Hartmann] 1904, p. 37.

6. Stieglitz's initial publication, *Camera Notes* (1897–1903), was the testing ground for the Photo-Secession and *Camera Work*. As Christian A. Peterson observed, *Camera Notes* enabled Stieglitz to bring together a group of like-minded photographers and critics who would form the backbone of *Camera Work*. Stieglitz resigned from *Camera Notes* in 1902 and began planning *Camera Work*, which debuted in 1903. By 1910, due in part to his interest in modern art and "straight" photography, the focus of *Camera Work* had shifted away from pictorialist photography. For the history of *Camera Notes*, see Peterson 1993. For *Camera Work*, see Green 1973, pp. 9–23. See also Homer 2002.

7. Stieglitz admired Annan's work tremendously and published this portrait in *Camera Work* 19 (Jul. 1907). For further information on Annan, see Buchanan 1992.

8. Käsebier's studio is described by Child R. Bayley in his article "Mrs. Käsebier," *Photography* (Jan. 17, 1903), p. 63. For further discussions of Käsebier's studio, see Michaels 1992, pp. 56–60, and Hutchinson 2002, pp. 40–65.

9. Hamilton 1907, p. 663.

10. Allan [Hartmann] 1903b, p. 25.

11. See, for instance, Nicolai Cikovsky, Jr., "William Merritt Chase's Tenth Street Studio," *Archives of American Art Journal* 16, 2 (1976), pp. 2–14. Chase assiduously promoted his image as a cosmopolitan artist through his lavishly decorated studio, starting a trend among American artists for using their studios in this manner.

12. Allan [Hartmann] 1903a, pp. 31–33.

13. For a discussion of Stieglitz's galleries, see Sarah Greenough, "Alfred Stieglitz, Rebellious Midwife to a Thousand Ideas," in Greenough 2000, esp. pp. 27–33. Such changes in exhibition practices can also be attributed to the influence of the American expatriate artist James McNeill Whistler. His solo exhibitions revolutionized the display of art and had great impact on Arts and Crafts practitioners. See Deanna Marohn Bendix, *Diabolical Designs: Paintings, Interiors, and Exhibitions of James McNeill Whistler* (Smithsonian Institution Press, 1995); see also David Park Curry, "Total Control: Whistler at an Exhibition," *Studies in the History of Art* 19 (1987), pp. 67–82.

14. Caffin 1906, p. 33.

15. Allan [Hartmann] 1904, p. 31.

16. "Als Ik Kan: Notes, Reviews," *Craftsman* 12, 5 (Aug. 1907), p. 566.

17. For overviews of Japanism in the United States and Great Britain, see Hosley 1990, and Sato and Watanabe, 1991.

18. The literature on Whistler is extensive, but a good introduction to his career is Richard Dorment et al., *James McNeill Whistler*, exh. cat. (Tate Gallery Publications, 1994). For an exhaustive biography, see Ronald Anderson and Anne Koval, *James McNeill Whistler: Beyond the Myth* (John Murray, 1994).

19. The literature on Stieglitz's life and career is extensive. One excellent resource is Greenough 2002, which includes an in-depth essay on Stieglitz as well as detailed exhibition histories and bibliographic entries of many of the works by Stieglitz included in the present exhibition. For *Spring Showers*, see vol. 1, p. 160, cat. 269.

20. For a thorough exploration of the production of *The North American Indian*, see Gidley 1998.

21. For the complete caption, see "Edward S. Curtis's *The North American Indian*," Web site, Northwestern University Digital Library Collections, http://curtis.library.northwestern.edu/, portfolio 1, pl. 1.

22. "Telling History by Photographs. Records of our North American Indians Being Preserved by Pictures," *Craftsman* 9, 6 (Mar. 1906), p. 846.

23. For a discussion of Curtis's artistic efforts, see "Cracker Jack Pictures," ch. 2 in Gidley 1998, pp. 51–79. However, Shannon Egan recently argued that, contrary to traditional views (including Gidley's) of Curtis's work as being primarily pictorialist for the duration of *The North American Indian*, his project instead shifted from pictorialist to modernist in the 1910s, as his politics evolved from progressivism to nativism. See Egan 2006, pp. 58–83.

24. The photograph was accompanied by a caption that reads: "Invocation and supplication enter so much into the life of the Indian that this picture of the grim old warrior invoking the Mysteries is most characteristic." See "Edward S. Curtis's *The North American Indian*," Web site, Northwestern University Digital Library Collections, http://curtis.library.northwestern.edu/, portfolio 3, pl. 76.

25. The caption reads: "A type produced by several generations of tribal and racial intermarriage. The subject is considered by her tribesmen to be a pure Arikara, but her features point unmistakably to a white ancestor, and there is little doubt that the blood of other tribes than the one which claims her flows in her vein." Ibid., portfolio 5, pl. 5.

26. "Telling History," p. 849.

27. For a discussion of these photographs, see Hutchinson 2002, pp. 40–65.

28. Ibid., p. 61. *The Red Man* was published in *Camera Work* 1 (Jan. 1903) and in *Craftsman* 12, 1 (Apr. 1907).

29. Bicknell 1906, p. 509.

30. For additional resources on *The Net Mender*, see Greenough 2002, vol. 1, pp. 126–27, cat. 212.

31. Alfred Stieglitz, "My Favorite Picture," *Photographic Life* 1 (1899), pp. 11–12, repr. in Stieglitz c. 2000, p. 61.

32. For additional resources on *Early Morn*, see Greenough 2002, vol. 1, pp. 116–17, cats. 194–196.

33. Stieglitz and Schubart 1895, p. 10.

34. Katwyck's inhabitants were "immense in stature, hardy, brave beyond belief, stoical from long habit." See ibid., p. 11.

35. For further research on *Scurrying Home* (also called *Hour of Prayer*), see Greenough 2002, vol. 1, pp. 130–31, cats. 218–221.

36. Allan [Hartmann] 1904, p. 33.

37. The little-known Clarkson was an enthusiastic member of the Camera Club of New York, becoming the only female life member upon the club's founding in 1896. Stieglitz published *Spinning* in *Camera Notes* 2, 2 (Oct. 1898), p. 47. For a brief biography of Clarkson, see Peterson 1993, pp. 161–62. See p. 88 for a reproduction of *Spinning*.

38. For further information on White, see Homer 1977, and Bunnell 1986.

39. For biographical information and a critical assessment of Brigman's work, see Ehrens 1995; see also Heyman 1974.

40. Emily Hamilton wrote that "the picture [Brigman's *The Dryad*] brings to one through this symbolism the pang that comes to every lover of the woods at the thought of what commercialism is doing to destroy the great beauty of our native forests." See Hamilton 1907, p. 663.

41. For the participation of women in Arts and Crafts, see Callen 1979. For a discussion of some of the women involved with the Photo-Secession, see Pyne 2007, particularly the chapters on Käsebier and Brigman. Pyne argued that the evolving models of feminine modernism presented by Käsebier and Brigman, as well as Pamela Colman Smith and Katherine Nash Rhoades, enabled Stieglitz to shape Georgia O'Keeffe as the ultimate woman modernist.

42. In 1896 Käsebier's husband was thought to have only one year to live. Although he in fact lived for another twelve years, the fear of widowhood prompted Käsebier to establish her studio in 1897 or early 1898. See Michaels 1992, esp. pp. 14, 25–28.

43. Ehrens 1995, p. 25.

44. See Block 1985. However, in part due to Watson-Schütze's isolation in Chicago, by late 1905 her association with Stieglitz had ended.

45. As Barbara Michaels noted, many of Käsebier's mother-child photographs suggest the independence of the child, implying their ability to break away from family bonds. See Michaels 1992, p. 76.

46. The frame bears a biblical inscription [Luke 1:28]: "And the angel came in unto her, and said, Hail thou that art highly favoured, the Lord is with thee: blessed are thou among women." Quoted in ibid., p. 49.

47. See *Camera Work* 1 (Jan. 1903), which includes articles on Käsebier by Charles Caffin and Frances Benjamin Johnston.

48. See Edgerton 1907, pp. 83 (ill.), 92.

49. Caffin 1910, p. 33. As with Stieglitz, Steichen has been the subject of much scholarly interest. For further reading on his pictorialist photography, see Longwell 1978, and Joel Smith, 1999. See also Steichen 1963.

50. For a fine analysis of Steichen's various self-portraits, see Cookman 1998, pp. 65–71. This includes a discussion of the Art Institute's print.

51. Annan 1910, p. 23.

52. Allan [Hartmann] 1904, p. 33.

53. Steichen 1903, p. 48. By this he meant to emphasize the photographer's agency in selecting the composition, light, focus, and other components of any image.

54. Allan [Hartmann] 1904, p. 33.

55. "Als Ik Kan: Notes, Reviews," *Craftsman* 11, 4 (Jan. 1907), p. 506.

CHAPTER FIVE ❧ JUDITH A. BARTER AND MONICA OBNISKI

CHICAGO: A BRIDGE TO THE FUTURE

O N JUNE 27, 1893, WHILE THE WORLD'S Columbian Exposition was in full swing, the New York stock market crashed, beginning a major recession. The more than twenty-seven million tourists in the Chicago area buoyed the city's economy only temporarily. When the fair closed, the ensuing panic was especially acute, for many people had moved to the city to take jobs related to the fair. Chicago also served as the industrial and railroad hub of the nation. When the Pullman Palace Car Company's production plummeted and wages were cut 30 percent, steel mills closed and unemployment soared. In May 1894, railway employees went on strike and refused to move trains containing Pullman cars. Within four days, 125,000 workers on twenty-nine railroads had joined the protest.[1]

The 1894 Pullman strike was especially important because it involved the newly formed American Railway Union (ARU), led by Eugene V. Debs. The ARU was a trade union, a coalition of brakemen, conductors, engineers, firemen, switchmen, and telegraphers, all of whom had their own brotherhoods. Debs unified these groups, and the Pullman incident was one of the earliest walkouts in which workers from various trades joined in sympathy, effectively shutting down the railway systems west of Chicago. Shortly thereafter, George Pullman convinced the Illinois National Guard and federal government to send troops to break the strike, and violence began. Railroad cars and property were vandalized and burned, tracks obstructed, and dozens of strikers injured in clashes with the military.

Sympathetic to the plight of the defeated strikers were three young, progressive University of Chicago professors—John Dewey, the newly hired chair of the philosophy department; Oscar Lovell Triggs, a Walt Whitman scholar in the English department[2]; and Thorstein Veblen, who was just beginning his teaching career in economics. Dewey wrote to his wife after the strike had ended:

> There has been a good deal of violent talk—particularly it seems to me by the "upper classes," yet the exhibition of what the unions might accomplish, if organized and working together, has not only sobered them, but given the public mind an object lesson that it won't soon forget. I think [the cost of] the few thousand freight cars burned up a pretty cheap price to pay—it was

the stimulus necessary to direct attention, and it might easily have taken more to get the social organism thinking.[3]

It certainly got Dewey thinking. The principles of laissez-faire economics that rewarded Pullman with the right to own a town (located at the south end of Chicago, Pullman was designed with the assistance of architect Solon S. Beman) and the dwellings in which his workers lived, to deduct rent from their paychecks, to make them buy food and other necessities from his stores, and to dictate the nature of their work came under attack. Pullman's employees wanted the right to own their labor and sell it as they saw fit. Although the railroad magnet believed that good housing and sanitation built morale and made for happy, productive workers, in the end, his town constituted another form of paternalism and oppression. It did not speak to notions about the dignity or worth of labor, nor to the social organization of democracy.[4] Indeed, like the English reformers who embraced socialism and its aesthetic counterpart, the Arts and Crafts movement, Dewey, Triggs, Veblen, and others espoused the value of worker-owned labor promoted by Thomas Carlyle. So too, they embraced the preindustrial aesthetics of John Ruskin and the emphasis William Morris and his followers placed on craftsmanship.

CHICAGO, HULL HOUSE, AND THE ENGLISH MODEL

Dewey and Triggs soon became the leading philosophers for educational and work reform in Chicago.[5] They were primary supporters of Hull House—established in 1889 in the heart of Chicago's poorest neighborhoods. Its founder, Jane Addams, and her college classmate Ellen Gates Starr based the center on Toynbee Hall, a settlement house in London's East End that was the workplace of Charles Robert Ashbee and his Guild and School of Handicraft (SEE CHAPTER 1). Addams had visited the establishment in 1888, and she returned to Chicago with the idea that the working classes were culturally, not just materially, impoverished.[6]

Chicago's immigrant population tripled between 1880 and 1900. The nineteenth ward, where Hull House was located, was home to over fifty thousand people, more than half of whom were Bohemian, German, Irish, Italian, and Russian transplants.[7] In addition to providing monetary relief to the poor, the settlement house became a place for clubs and ethnic groups to meet; it offered athletics, daycare (including a kindergarten, nursery, and a safe playground), and other help to working families. Teaching English and social skills, and offering classes in art history, cabinet-making, cooking, metalworking, needlework, pottery, and more, the staff hoped to provide ways for the organization's clients to move out of poverty into mainstream American life. Hull House became not only the city's center for social reform, fighting tirelessly for worker protections and child welfare, but also for the Arts and Crafts movement. It is significant that the first new building added to the

Hull House complex was the Butler Art Gallery, donated by Chicago businessman and art collector Edward Butler. At its dedication in 1891, both Canon Barnett (one of the founders of Toynbee Hall) and Art Institute President Charles L. Hutchinson argued for the value of art as an educator and uplifter of the masses.

From the beginning, Hull House supporters and teachers such as Starr embraced the British Arts and Crafts model of education and handcrafting. In addition to social work, Starr taught bookbinding at Hull House. In 1897–98 and 1899, she studied in England at the Doves Bindery with T. J. Cobden-Sanderson, thus delivering English aesthetics and philosophies directly to the constituents Hull House served. About her experience, she noted, "I began to feel that it was not enough to talk about and explain beautiful and well-made things which have been done long ago, and that it would be a great deal better to make something myself, ever so little, thoroughly well, and beautiful of its kind."[8] Her binding for the *Life of William Blake* (FIG. 1) exhibits a variety of motifs, skillful tooling of leather, and a delicate application of gold leaf.

The influence of political, social, and artistic ideas originating in Great Britain was felt in Chicago beyond Hull House. Some of the most important figures in the British Arts and Crafts movement visited the city in the 1890s. Designer-illustrator Walter Crane embarked on a lecture tour of the United States in 1891, arriving in Chicago in mid-December to view the site of the World's Fair, for which he would paint two panels depicting Justice and Mercy, and Purity and Temperance for the Women's Temperance Building.[9] Americans would have known about Crane's ideas

1
Written by Alexander Gilchrist
Binding by Ellen Gates Starr
*Life of William Blake, Pictor Ignotus,
Volume 1*
Printed in 1863; bound in 1913
Special Collections, University of Illinois
at Chicago Library
Cat. 128

from articles he contributed to *Scribner's* magazine. In one such piece, he touted Morris's design rhetoric as representing "in the main a revival of the medieval spirit (not the letter) in design; a return to simplicity, to sincerity; to good materials and sound workmanship; to rich and suggestive surface decoration, and simple constructive forms."[10] A lecture Crane gave at the Art Institute on January 5, 1892, entitled "Design in Relation to Use and Material," was well received (although reviewers found his comments on art more intelligible than his ideas about economic systems or social theory).[11]

In addition to British Arts and Crafts ideas circulated by Hull House and visiting lecturers, English designs and Chicago reinterpretations of them were available at the Tobey Manufacturing Company.[12] Interior decorator and furniture designer Joseph Twyman, an Englishman who had moved to Chicago in 1870, had met William Morris and visited his workshops at Merton Abbey in the summer of 1883.[13] Impressed by Morris's commitment to the betterment of people, Twyman designed a William Morris Memorial Room (FIG. 2) for the Tobey firm in 1902. Twyman furnished the room with textiles, wallpapers, and a Hammersmith carpet. He claimed that some of the room's furniture came from Morris's Red House (although this was likely a marketing ploy).[14] Twyman also lectured on Morris at the Art Institute in December 1903 and helped establish Chicago's Morris Society, which attracted mainly artists and intellectuals. Triggs, the society's secretary, lectured tirelessly to spread Morris's ideas. Even so, just a few years after its founding and after Twyman's death in 1904, the organization ceased to exist.

The English model in architecture and domestic interiors was also felt in Chicago by the late 1880s. In the city's affluent Prairie Avenue district, farm-equipment manufacturer John J. Glessner and his wife, Frances, built a house designed by Boston architect Henry Hobson Richardson in 1885–87 (FIG. 3). With its rustic stone courses, low circular-arched entrance door, and massed asymmetry, the structure epitomizes the architect's interest in Romanesque architecture, an aesthetic fostered by trips to Europe, especially Spain, and one he shared with English proponents of the Arts and Crafts movement. The interiors were furnished with spindle-backed oak chairs designed by Boston's Charles A. Coolidge and with Morris's *Sussex* chairs; custom-designed Morris and Company wallpapers and carpets; and curtains and portières in Morris patterns, perhaps embroidered by Frances Glessner.[15] But the Glessners also moved furniture and decorative accessories made by Chicago designer Isaac Elwood Scott from their Washington Avenue home to their new one on Prairie Avenue.[16] Scott, a talented artisan and woodcarver, had moved from Philadelphia to Chicago, where he became a modeler at the Chicago Terra Cotta Works. Familiar with British artistic ceramics and the works in English author Charles Eastlake's *Hints on Household Taste* (1868), Scott, like Eastlake, did not eschew decoration but sought to meld function and beauty. To accommodate the Glessners' large collection of Northern European prints, Scott designed frames

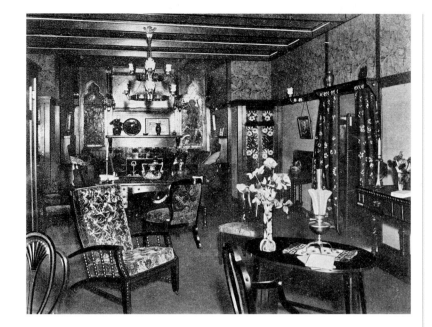

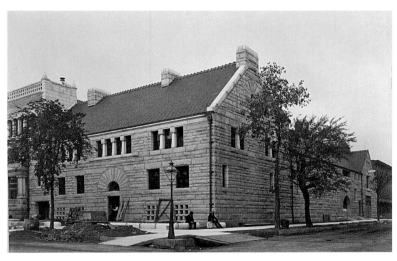

2
Joseph Twyman, William Morris
Memorial Room, 1902, from *House
Beautiful* 13, 3 (February 1903), p. 169.

3
Henry Hobson Richardson, John J.
Glessner House, Chicago, 1885–87.
Photo: Courtesy of Cornell University
Library.

(SEE FIG. 4) that feature the same decorative vocabulary of artistic carvings and turnings as his neo-Gothic furniture. While at Boston's Chelsea Keramic Art Works in 1879, Scott had also modeled earthenware pilgrim bottles for Mrs. Glessner. With its flattened circular body, short neck, and looped shoulders, this example (FIG. 5) artfully blends a utilitarian function with a Ruskinian fidelity to nature.[17] Like other architectural terracotta of the 1870s and 1880s, Scott's piece features applied raised Japanesque decoration depicting reptiles, insects, birds, and flowers, that make the form modern and fanciful.[18]

Even as Chicago's academics and artists absorbed and reinterpreted the English model, British Arts and Crafts luminaries made pilgrimages to the city to evangelize the movement's key philosophies. Called one of the "guiding lights" of Chicago's Arts and Crafts movement, Charles Robert Ashbee visited in December 1900. He

4
Isaac Elwood Scott
Frame
c. 1880
Glessner House Museum, Chicago
Cat. 126

5
Isaac Elwood Scott
Chelsea Keramic Art Works
Pilgrim Bottle
1879
Glessner House Museum, Chicago
Cat. 125

addressed almost a dozen societies while in the city and formed a sympathetic relationship with Frank Lloyd Wright. While Chicago struck Crane as a brutal place (he called its tall buildings "Towers of Babel"[19]), Ashbee was more tolerant. He stated, "Chicago is the only American city I have seen where something absolutely distinctive in aesthetic handling of material has been evolved out of the Industrial system."[20] In Chicago Ashbee detected the beginnings of artistic and social reform—an awakening to the utopian vision in which art and life melded.

Oscar Lovell Triggs based many of his lectures on Ashbee's model, combining teaching and workshop experience—in short, learning by doing. In his book *Chapters in the History of the Arts and Craft Movement* (1902), he described the philosophies of Carlyle, Morris, and Ruskin in chapters that serve as a prologue to an increasingly practical interpretation of the movement. Triggs recognized that the industrial era was permanent and could not be discarded. He viewed the modern age as increasingly democratic and considered the machine an accessible tool that could be utilized for artistic expression.

In 1899 Triggs founded the Industrial Art League of Chicago as a training ground for young men to learn skills that could forever alter the quality of industrial production and rehumanize the drudgery of handwork. Joining the league's membership rolls were architects Louis Sullivan and Frank Lloyd Wright, painter and *Brush and Pencil* editor Charles Francis Browne, and author Hamlin Garland. In 1901 Triggs proposed that, in addition to the exhibition and sales gallery it had established on Michigan Avenue, the league open workshops "equipped with the best modern appliances . . . [in order to] effect a revolution in our conceptions and methods of work, and incidentally benefit the world by increasing good taste and raising the standard of living."[21] Echoing this approach, Wright delivered his now-famous lecture "The Art and Craft of the Machine," at Hull House in 1901, in which he represented the machine as a way to enhance creative design, as well as enable a new aesthetic based on simplicity.[22] Thus, the Arts and Crafts movement in its Chicago iteration acknowledged the validity of machine work alongside the more traditional emphasis on handcraft inherited from the British model.

ASSIMILATION AND TRANSFORMATION: CHICAGO ARTISANS

Early on, Ashbee's visual vocabulary, along with his Guild of Handicraft's labor organization, encouraged Chicago's metalworkers and decorative artists. In fact, Ashbee's work preceded his arrival in the city: objects produced by his guild were included in the first exhibition of the Chicago Arts and Crafts Society (formed at Hull House in 1897), which was held at the Art Institute in 1898.[23] Native Chicagoan and School of the Art Institute graduate Clara Pauline Barck opened the Kalo Shop, named after the Greek word for beauty, in 1900. After her marriage in 1905, Clara Barck Welles shifted the shop's focus from leather to metalwork and moved her operation to Park Ridge, Illinois, retaining the retail store downtown. Inspired by the Arts and Crafts model of a craft community working in a rural setting—particularly Ashbee's move to the Cotswold countryside in 1902—Welles took with her a number of artisans (at its zenith, Kalo employed over thirty people) and served as teacher, designer, and smith. The Kalo Shop was a training ground for many silversmiths, including Matthias William Hanck, Daniel Pederson, Julius Randahl, and Grant Wood (who, as a painter, would later create the Art Institute's iconic *American Gothic*). Some Kalo metalwork were commissions, and therefore unusual designs for the firm. A liturgical alms plate (FIG. 6), for example, contains a central trefoil that radiates outward and up onto the lip, which features winged cherub heads and the inscription: "All things come of thee O Lord, and of thine own have we given thee."[24] The majority of Kalo designs, however, break away from past models and possess a clean, more modern aesthetic and incorporate a combination of mechanical production methods and handwork. Barck Welles favored raised panels and fashioned vessels from machine-rolled silver. Seams were

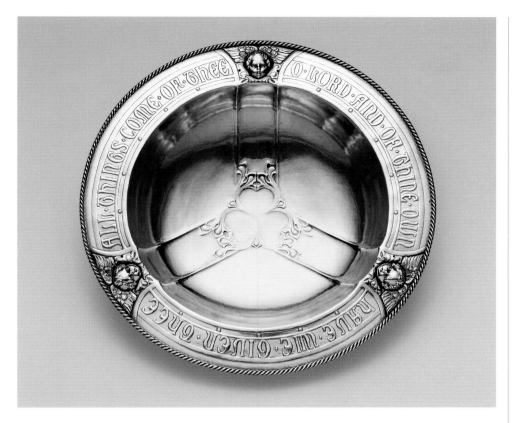

6
Kalo Shop
Alms Plate
1912
Collection of Ira Simon
Cat. 70

then covered with hand hammering, one of the Kalo Shop's distinguishing characteristics, to impart a handcrafted look, although the forms maintain bold, geometric, modern shapes (SEE FIG. 7).

As the example of Barck Welles demonstrates, women were a force for aesthetic and social reform in Chicago. Between 1880 and 1930, the female portion of the workforce grew from 2.6 million to 10 million.[25] The traditional domestic sphere was challenged not only by new arrivals—both from the rural United States and from Europe—but by "career" women, or "the New Woman." Some New Women, such as Addams and Starr, had independent means and chose to lead successful lives outside of marriage.[26] Even those middle- and upper-class women who remained at home became more independent. Some of them established organizations that used arts and crafts as a way to enhance the lives and work of women.

Indeed, many Arts and Crafts bookmakers, jewelers, metalsmiths, and textile workers were women who often made products for consumption by other women in order to beautify households in a morally and socially responsible way. Frances Glessner—an accomplished pianist, teacher, and member of many women's groups—became engaged in silversmithing around 1900. Her silver sweetmeat dish (FIG. 8), intended for the Chicago women's literary organization the Fortnightly club, reveals the hand-hammering techniques so important to this modern re-interpretation of a traditional English form. Many other female metalworkers in

7
Kalo Shop
Water Pitcher
1910
The Art Institute of Chicago
Cat. 68

8
Frances Macbeth Glessner
Sweetmeat Dish
1905
The Fortnightly Club of Chicago
Cat. 49

the United States also adopted traditional motifs and themes for their designs. Mary Catherine Knight and Elizabeth Copeland—both of whom exhibited with the Chicago Arts and Crafts Society—for example, created works in medieval and American colonial styles. Copeland's imaginative covered box (FIG. 9) especially recalls medieval reliquaries and British examples such as those by Ashbee's Guild of Handicraft (SEE CHECKLIST, CAT. 8), and its elaborate surface detailing stands in stark contrast to the simple, spare forms that the Kalo Shop created for their historicist commissions.

Just as many Chicago artisans adopted or transformed British aesthetics and styles, others began to look for and assume different visual influences and means of production. Jessie Preston, another graduate of the School of the Art Institute and member of the Chicago Arts and Crafts Society, for example, took her stylistic queues from contemporary European trends. The sinuously arranged blossoms of her delicate floriform candelabrum (FIG. 10) bear an affinity to Art Nouveau designs, and the solid cast bronze marries industrial and traditional methods. Similarly, designers for Chicago's most famous earthenware, Teco, used stylized naturalism for their predominant visual vocabulary. William Day Gates developed Teco wares as part of his firm, the American Terra Cotta and Ceramic Company, in Terra Cotta, Illinois, which began production in 1899. Like other potteries, most notably Grueby in Massachusetts, Teco favored matte green glazes associated with nature. Although he was familiar with Arts and Crafts aesthetics, Gates, seeking

9
Elizabeth E. Copeland
Covered Box
c. 1920
The Art Institute of Chicago
Cat. 25

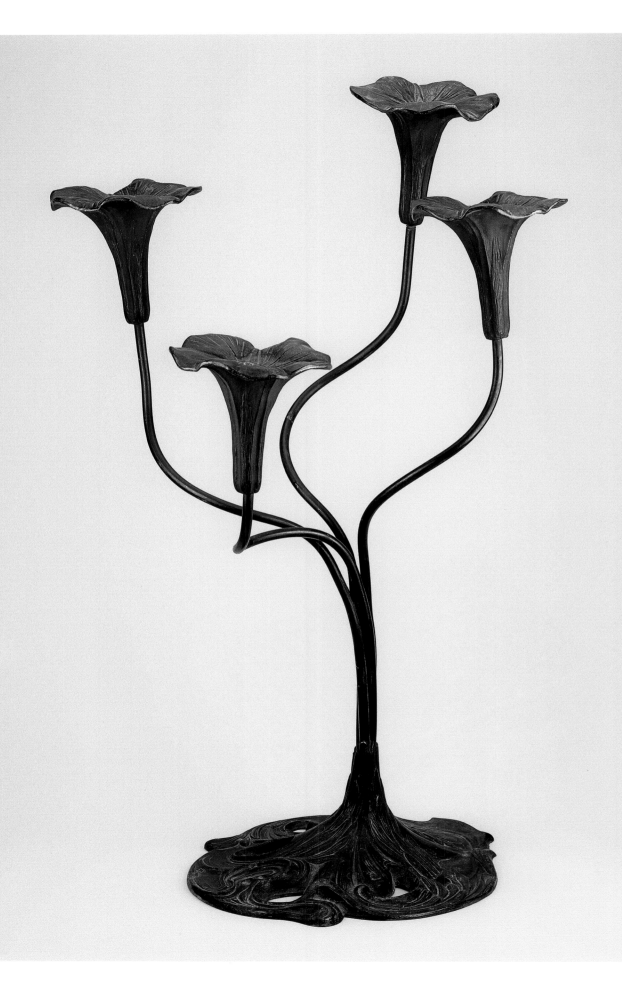

to make affordable wares, countered the movement by relying on mass production and standardization.[27] Gates commissioned notable Chicago architects, including William Le Baron Jenney, Howard Van Doren Shaw, Wright, and Hugh Mackie Gordon Garden, to design pottery. Garden's graceful jardinière (FIG. 11) displays a scalloped rim and overlapping leaves that form delicate tendrils supporting the shape. Sculptors such as Fritz Albert also provided the firm with designs.[28] Demonstrating his love of nature, Albert played with the fluid lines of trailing leaves, gently swirling them at the base of a vase (FIG. 12) to create openwork, which infuses the vessel with a sense of movement and a suggestion of instability. Teco's designers developed a modern line of unique shapes nearly devoid of excess ornamentation, emphasizing the vessel's form and the subtle tonalities of color in the glaze. Perhaps more importantly, Teco's example suggests that intricate forms and beautiful colors could be produced through standardized production such as casting and spray glazes, confirming Ashbee's claim that "something absolutely distinctive" could be achieved through craft and industry.

Self-taught Chicago metalworker Robert Riddle Jarvie explored several different visual idioms—from Celtic Revival to Native American to Viennese Secession—in

10
Jessie M. Preston
Candelabra
1902/05
The Art Institute of Chicago
Cat. 105

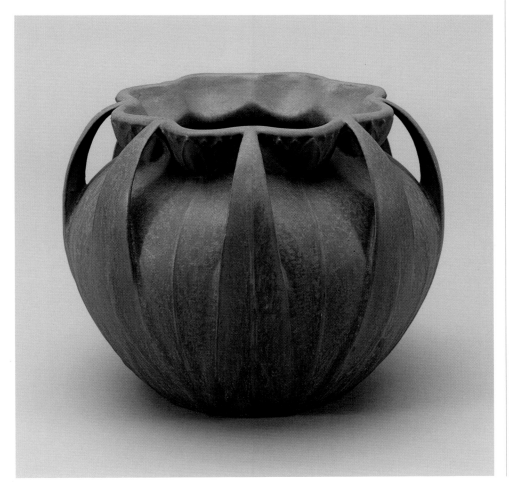

11
Teco Pottery
Designed by Hugh Mackie Gordon Garden
Jardinière (shape 106)
c. 1903
Collection of Crab Tree Farm
Cat. 153

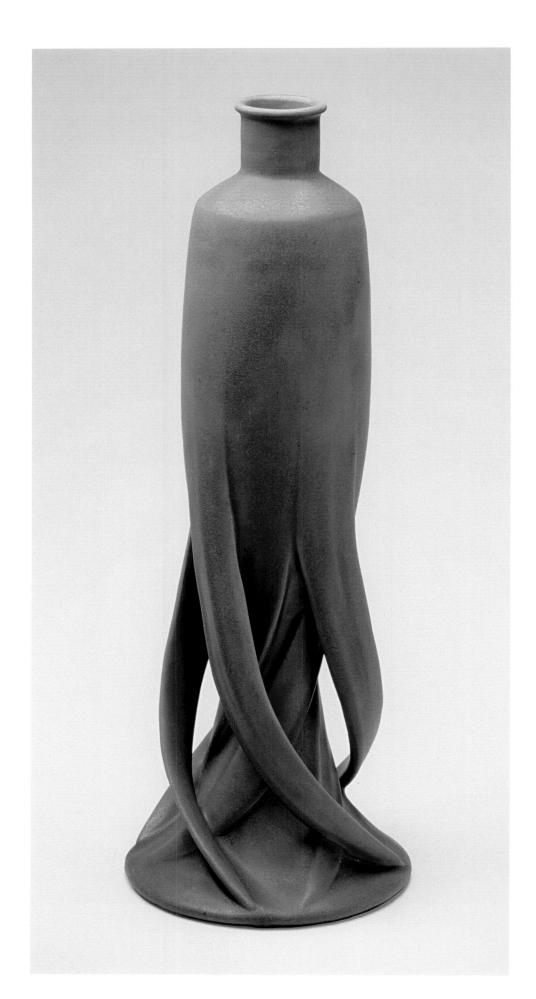

12
Teco Pottery
Designed by Fritz Albert
Vase
c. 1905
The Art Institute of Chicago, promised
gift of Crab Tree Farm Foundation
Cat. 154

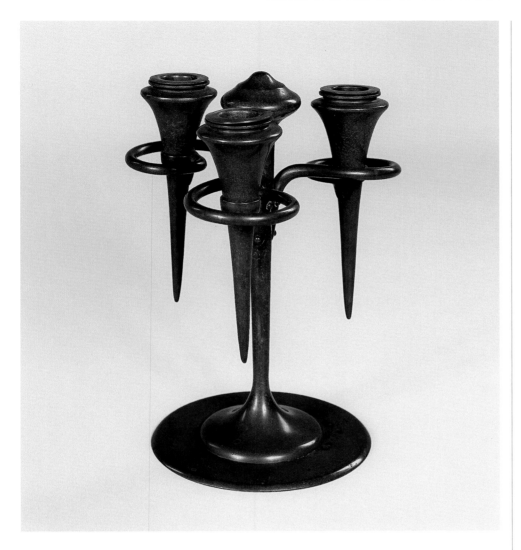

13
Robert Riddle Jarvie
Jarvie Shop
Omicron Candelabrum
c. 1905
Collection of Crab Tree Farm
Cat. 59

crafting his distinctive pieces. Jarvie's unique *Omicron Candelabrum* (FIG. 13) incorporates a slender central base and shaft on which three spiraling arms terminate in attenuated cone-shaped holders. By 1905 he had opened a shop in the Fine Arts Building in downtown Chicago, and in 1912 he moved to the Old English Cottage Building near the Chicago Union Stock Yards, a convenient location for trophy and commemorative items to be sold.[29] Jarvie's silver presentation pieces are among his boldest designs. They reflect the influence of the many different styles he would have been exposed to as a silversmith working in Chicago. A monumental hand-hammered punch bowl (FIG. 14), commissioned by Art Institute President Charles L. Hutchinson for the Cliff Dwellers Club and exhibited at the 1910 Arts and Crafts Exhibition, suggests the highly textured weave of Native American baskets that had been exhibited at the 1893 fair and the Cliff Dwellers Club, and illustrated in the *Craftsman* magazine. (The Cliff Dwellers Club was an important association of architects, artists, businessmen, and writers who emulated Arts and Crafts ideals of high quality and romanticized Native American culture

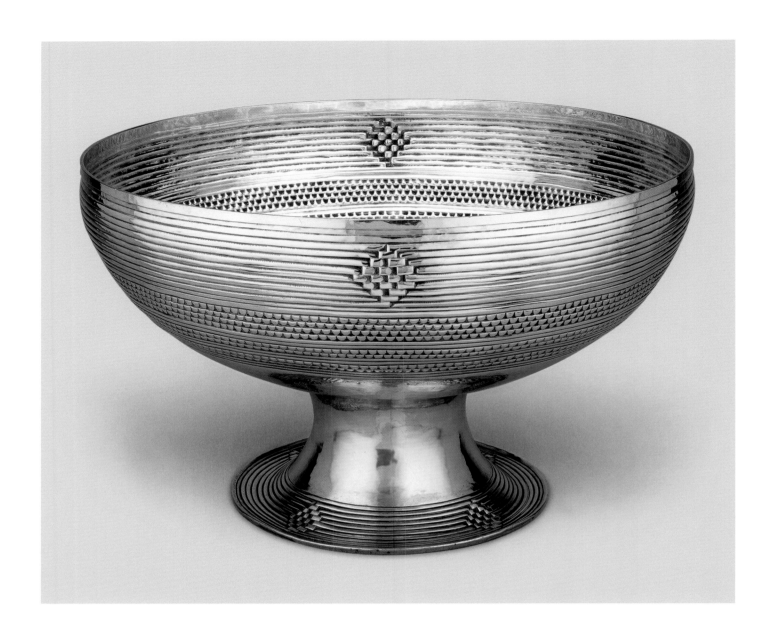

14
Robert Riddle Jarvie
Jarvie Shop
Punch Bowl
1910
The Cliff Dwellers Club, Chicago
Cat. 61

as pure and spiritually coherent.[30]) The punch bowl, ladle, and tray that Jarvie exhibited at the 1911 exhibition (FIG. 15) are boldly conceived, with broad, simple lines and imperceptibly hand-hammered surfaces.[31] Jarvie's design recalls elements of the Celtic Revival wares produced by Irishman Edmund Johnson. Jarvie could well have encountered Johnson's Celtic facsimiles, including his majestic copy of the eighth-century *Ardagh Chalice* (FIG. 16) at the 1893 fair.[32] However, the spare, linear fretwork pattern that Jarvie often used seems more related to the later geometric styles of the Viennese Secession, some of which Jarvie could have seen in contemporary journals.[33]

Indeed, by the early twentieth century, periodicals became a vital resource for designers working in Chicago. Such publications as *Architectural Record*, *Good Housekeeping*, *House Beautiful*, *House and Garden*, *Inland Architect and News Record*,

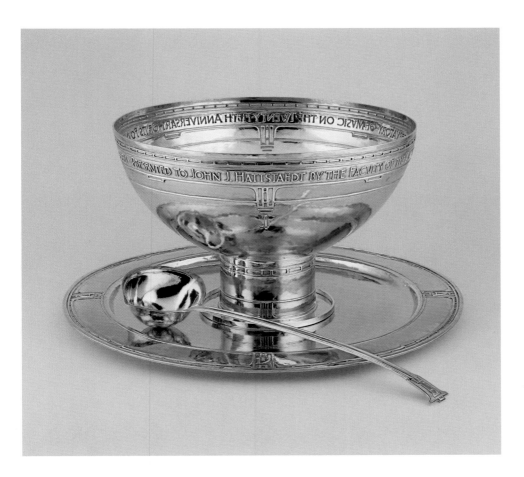

15
Robert Riddle Jarvie
Jarvie Shop
Punch Bowl, Ladle, and Tray
1911
The Art Institute of Chicago
Cat. 63

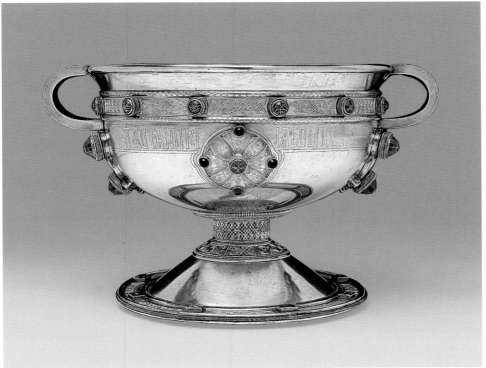

16
Edmund Johnson
Ardagh Chalice
1891/92 (facsimile of eighth-century original)
The David and Alfred Smart Museum of Art, University of Chicago
Cat. 64

17
J. S. Ford, Johnson and Company
Armchair
1904–05
Brown-stained oak; 81 x 52 x 50 cm
(31 ⅞ x 20 ½ x 19 ⅝ in.)
The Art Institute of Chicago, restricted
gift of Gilda and Henry Buchbinder,
1995.100

International Studio, *Ladies Home Journal*, and *Western Architect* helped to popularize Arts and Crafts products and introduce the movement's tenets to a wide audience. Chicagoan Herbert Stone, publisher of the *Chap Book* (SEE CHAPTER 2) also published *House Beautiful*, a proponent of good taste and social reform that was founded in 1896. Like Stickley's *Craftsman* (SEE CHAPTER 3), *House Beautiful* championed the principles of Morris and promoted designs for middle-class residences. It featured articles on the importance of hygiene, progressive politics, home and community, and women's issues, and put forward ideas about affordable housing and health. In the pages of these periodicals, simple, unadorned parlors and furnishings reigned. Just as magazines spread the Arts and Crafts style to a large middle class, the fashion for the Arts and Crafts look prompted Sears, Roebuck and Company and Montgomery Ward—both headquartered in Chicago—to industrially produce simple, undecorated, and inexpensive objects for mass consumption.[34] J. S. Ford, Johnson and Company, also a Chicago firm and the largest manufacturer of chairs in the United States, produced an oak armchair (FIG. 17) that is indebted to Arts and Crafts precedents in its exposed wood rivets and cut-out design. However, the simplicity and style of the cut-outs is more akin to the work of the Wiener Werkstätte and Viennese Secessionists, a group that would increasingly influence Chicago's Prairie school architects as the city's designers began to abandon the English model in favor of a more international one.

THE RISE OF THE PRAIRIE SCHOOL

At the turn of the century, *House Beautiful* began to illustrate designs of the Prairie school, endorsing the affinity of this new style with cottage and villa architecture and the commitment of its practitioners to creating suburban, garden communities, which were admired by midwestern progressive thinkers.[35] New Yorker Edward Bok's *Ladies Home Journal* also picked up on the innovative Prairie-style architects, publishing designs by the Minneapolis firm Purcell, Feick, and Elmslie, as well as by Chicago-based George Washington Maher and Frank Lloyd Wright.

Maher, Wright, and George Grant Elmslie were knowledgable about the works of English architects and designers, but they were also influenced by the American architect Louis Sullivan, a partner in the Chicago firm Adler and Sullivan. Sullivan's early ornamentation comprises attenuated, interlocking patterns based on natural forms; his designs reflect the influence of both the contemporaneous Celtic Revival and French Art Nouveau, as well as, to some extent, Ruskin's Gothic naturalism (SEE CHECKLIST, CAT. 124).[36] His aim in merging organic forms with structural materials was to evoke the mystical whole he believed connects nature and the man-made.[37] Sullivan's stencils for the 1893–94 Chicago Stock Exchange Trading Room (SEE FIG. 18), executed by the Chicago decorating firm of Healy and Millet, exhibit patterns of stylized abstracted vines rendered in fifty-two hues, from earthy

russets to golds and greens. The vertical orientation and intertwined forms of the stencils are not unlike the decorative patterns of Knox, Voysey, and other Celtic-inspired British designers. Sullivan's mature aesthetic is embodied in a 1906/08 copper-plated cast-iron teller's wicket (designed with Elmslie, his chief draftsman) for the National Farmers Bank in Owatonna, Minnesota (FIG. 19). The dynamic composition features vigorous curvilinear elements that suggest scrolling leaves, tendrils, and clusters of berries combined with geometric patterns.

Another proponent of stylized naturalism, George Washington Maher honed his skills in the office of Joseph Lyman Silsbee, where both Elmslie and Wright apprenticed as draftsmen. After starting his own firm in 1888, Maher developed what he termed the "motif rhythm theory," a system that harmonized the interior and exterior of his houses through decorative details. He first used this principle in the John Farson House, Oak Park, Illinois (1897), where he repeated honeysuckle blossoms and lion's heads throughout the building and in the furnishings. An armchair from the Farson House (FIG. 20) possesses the heft of massive medieval great chairs, but its rectilinearity is softened by the slightly curving rear stiles and the double C-scrolls at the upper corner of each leg. Maher would have seen houses designed by English architects Voysey and Baillie Scott reproduced in *Studio* magazine between 1897 and 1905; their architectural vocabulary derives in part from the massed forms and gables of medieval prototypes.

18
Louis H. Sullivan
Adler and Sullivan
Made by Healy and Millet
Stencil
Made for the Chicago Stock Exchange
Trading Room
1893/94
The Art Institute of Chicago
Cat. 150

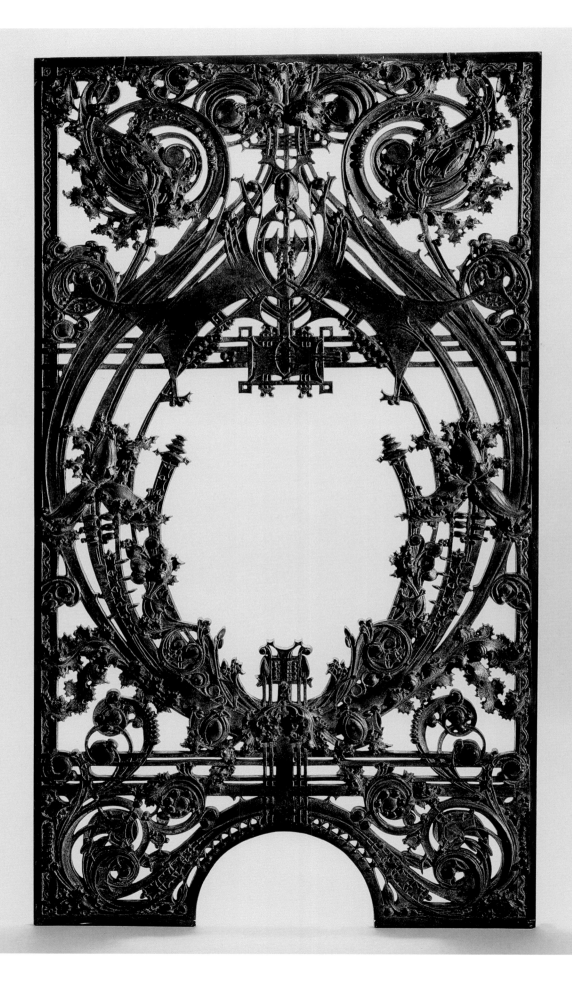

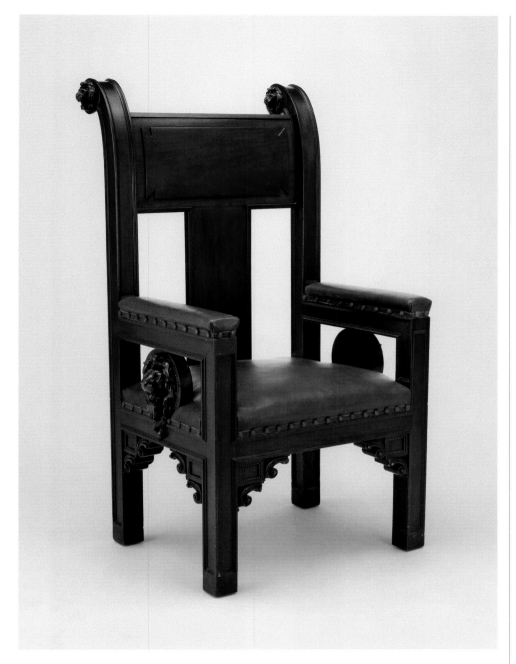

19
Louis H. Sullivan with George Grant Elmslie
Winslow Brothers Company
Teller's Wicket
Made for the National Farmers Bank, Owatonna, Minnesota
1906/08
The Art Institute of Chicago
Cat. 152

20
George Washington Maher
John A. Colby and Sons
Armchair
Made for the John Farson House, Oak Park, Illinois
1897
The Art Institute of Chicago, lent by the Park District of Oak Park, Pleasant Home Foundation
Cat. 87

However, unlike Voysey, who often repeated his motifs from one commission or design to another, Maher created a new decorative program for each project. The Evanston residence of James A. Patten (1901) was a collaborative effort between Maher and Louis Millet (of the firm Healy and Millet). Under Maher's direction, Millet worked on frescoes, art glass, and glass mosaics for the Patten House.[38] Everything was designed en suite, from the stenciled walls and ceilings to the quartered-oak furniture upholstered with dark velvet to a portière with an exuberant wild-thistle design (FIG. 21).[39] Thistles (combined with modified octagons) were a fitting decorative motif for the Patten residence because they grew wild on the

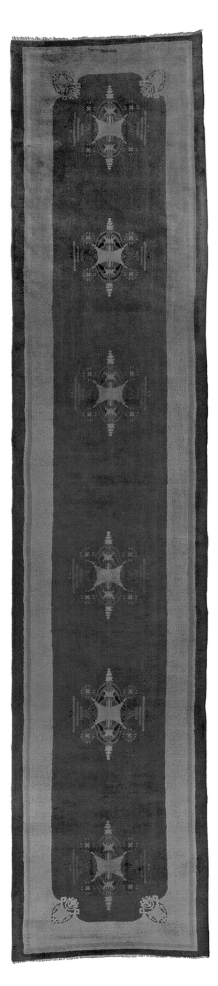

21
George Washington Maher and
Louis J. Millet
Portière
Made for the James A. Patten House,
Evanston, Illinois
1901
The Art Institute of Chicago
Cat. 88

22
George Grant Elmslie
Purcell, Feick, and Elmslie
Carpet
Made for the Henry B. Babson House,
Riverside, Illinois
1908/12
The Art Institute of Chicago
Cat. 44

site; they may also refer to Patten's Scottish ancestry, as the thistle is that country's national flower. As one contemporary critic wrote about the Patten House, "The ornament is never obtrusive but, like a clear musical overtone, it vibrates in harmony with the rich chord predominating."[40]

Like Maher, George Grant Elmslie initially studied with Silsbee before joining Adler and Sullivan, where he continued as Sullivan's chief draftsman until 1909, when he moved to Minneapolis to work with William Gray Purcell. In 1912 Purcell and Elmslie remodeled a section of the Henry B. Babson House in Riverside, Illinois; the original residence had been designed in 1907 by Sullivan's firm and Elmslie had overseen the project.[41] Elmslie produced custom furniture for the renovation, working with an abstracted natural motif to unify the rooms in the house. The design of a carpet for the first-floor hallway (FIG. 22) would have reso- nated with the elliptical shapes in the glass panels of the sitting-room doors (SEE FIG. 23) and the chandelier composed of flat panes of yellow-green glass.[42] Other furnishings include a tall clock (FIG. 24) featuring one of Elmslie's trademark sawn, cut-out decorative panels. The plain incised lines and the Japanesque finials that

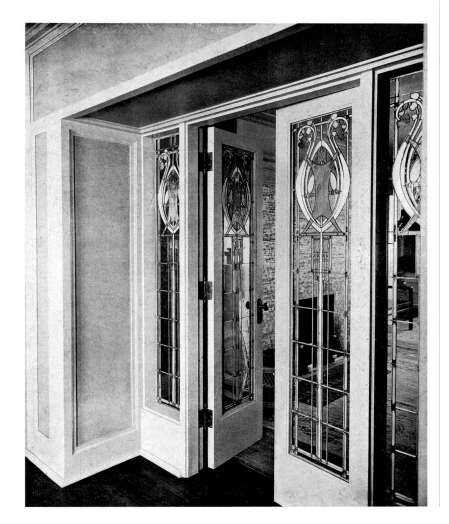

23
Purcell, Feick and Elmslie, sitting-room doors, Henry B. Babson House, Riverside, Illinois, 1912, from *Western Architect* 22, 1 (July 1915), pl. 5.

24
George Grant Elmslie
Purcell, Feick, and Elmslie
Made by Niedecken-Walbridge
Clock face modeled by Kristian Schneider
Clock hands made by Robert Riddle Jarvie
Tall Clock
Made for the Henry B. Babson House,
Riverside, Illinois
1912
The Art Institute of Chicago
Cat. 47

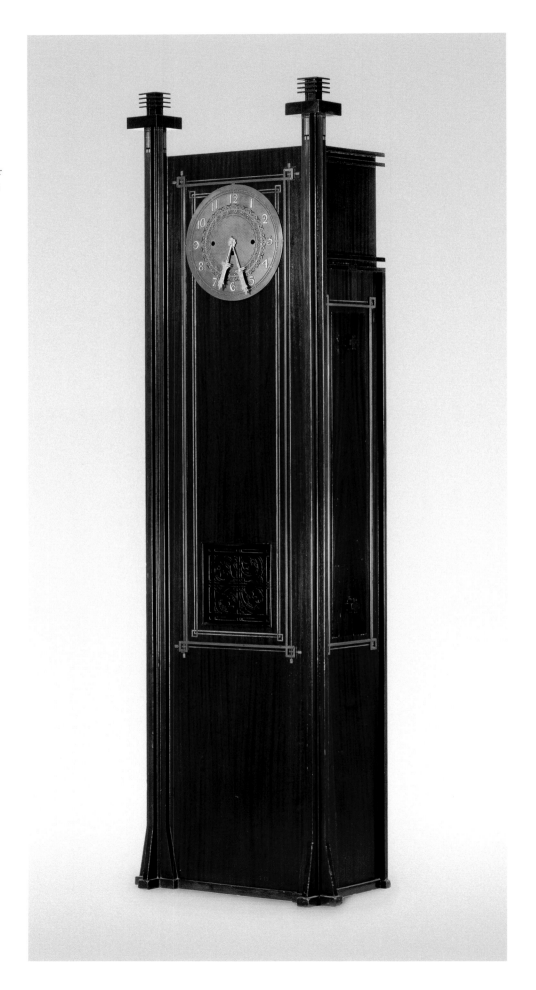

25
Frank Lloyd Wright
John W. Ayers
Library Table
Made for the Charles E. Roberts House,
Oak Park, Illinois
1896
The Art Institute of Chicago
Cat. 167

extend above the face accentuate the clock's verticality. Indeed, the piece's severe rectilinearity is strikingly modern and demonstrates Elmslie's and the rest of the Prairie school's increasing interest in international design.

FRANK LLOYD WRIGHT AND CHICAGO'S NEW AESTHETIC

Frank Lloyd Wright also began his career with Silsbee before joining Adler and Sullivan, where, as Sullivan's assistant, he absorbed the master's stylized naturalism. Wright witnessed the design and construction in Chicago of major structures, including the Auditorium Building (1887–89) and the Chicago Stock Exchange (1893–94). In mid-1893 the young architect left Sullivan to pursue his own interests. Wright's early designs reflect the influence of the British Arts and Crafts movement, as well as the styles of the preceding generation of American architects, such as Richardson and Sullivan. Yet the low, precise geometric lines that inform his mature style are already evident in his early work. A circular library table (FIG. 25) that Wright designed for a remodeling of the Charles E. Roberts House in Oak Park, Illinois (1896), recalls an earlier model by the English architect Philip Webb (FIG. 26). However, the cabinet of Wright's table has been separated from the top by four short piers, creating a striking play between a circle and a cube. Furthermore, Wright balanced the sober modernity of the table's machine-made aesthetic with decorative beading on the front that suggests handcrafting, indicating that the

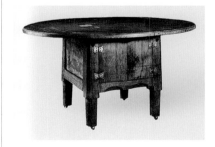

26

Philip Webb, table, c. 1861, from Nikolaus Pevsner, *Victorian and After*, vol. 2 of *Studies in Art, Architecture, and Design* (1968), p. 121.

27
Frank Lloyd Wright
Spindle Cube Chair
Made for the Frank Lloyd Wright Home
and Studio, Oak Park, Illinois
1902/06
The Art Institute of Chicago
Cat. 169

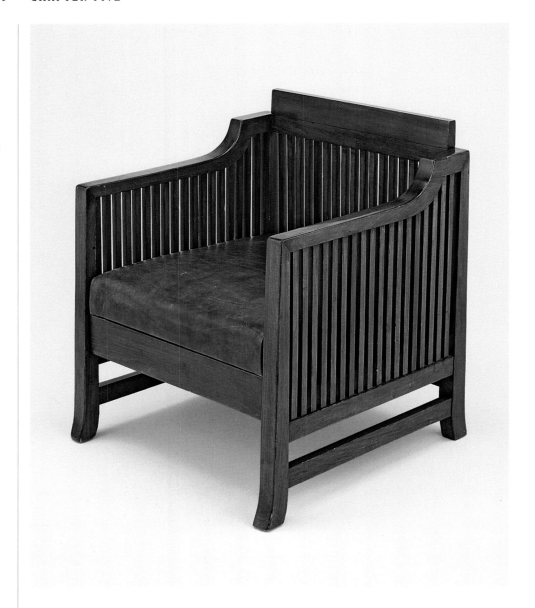

table served as a valuable, transitional design. Like Gustav Stickley and Harvey Ellis (SEE CHAPTER 3), Wright would have been familiar with the architectonic furniture and cube chairs of Voysey (SEE CHECKLIST, CAT. 158). For his Oak Park studio, completed in 1898 as an addition to the original 1889 home, Wright designed several such chairs.[43] An example from 1902/06 (FIG. 27) displays repeated machine-made vertical elements softened by the curved shoulder and feet, adding a sophisticated lightness and fluidity that is lacking in its British and American counterparts.

A charter member of the Chicago Arts and Crafts Society, Wright supported the group's handcrafted works and annual exhibitions at the Art Institute. Nevertheless, as we have already seen, he believed that the machine could help an architect achieve a singular vision. He recognized the power of industry to make beauty

available to all, recalling Trigg's belief that it would be the basis of a new democracy. But while Triggs, like the British philosophers he admired, thought that the process of creation would save the soul of the worker, Wright considered the beauty of the end product to be far more important than the process of making it.[44] He and others in Chicago thus embraced a progressive attitude toward the machine that distinguished their expression of the Arts and Crafts movement.

In his domestic architecture, Wright took the English model beyond its Arts and Crafts confines, doing away with the cozy interiors and massed gables of cottages by Voysey or Baillie Scott. Although his preference for open spaces; large expanses of fenestration; plain, natural materials; and simple furniture reflects the impact that Arts and Crafts architects had on him, Wright's design innovations gave his dwellings a completely new look. For his Prairie school homes, he often designed everything from the exterior structure to the smallest details. While the round arch and horizontal courses of his Arthur Heurtley House in Oak Park (1902; FIG. 28) echo those of Richardson's Glessner House, the look of Wright's residence—with its low-slung roof, banding of windows into distinct zones, and emphatic horizontal lines and brickwork—make the house appear to hug the ground.[45]

For the Frederick C. Robie House (1908–10) in the Chicago neighborhood of Hyde Park, Wright collapsed interior spaces, merging the living and dining rooms into one large, open area. The house's art-glass windows feature organic designs that blur the division of interior and exterior, bringing natural light inside. The various planes of the exterior, including, as in the Heurtley House, the creative brickwork and the cantilevered overhangs, echo and celebrate the insistent flatness of the midwestern prairie. The Robie House also illustrates Wright's attraction to Japanism (SEE CHAPTER 2). The architect traveled to Japan just as the project was

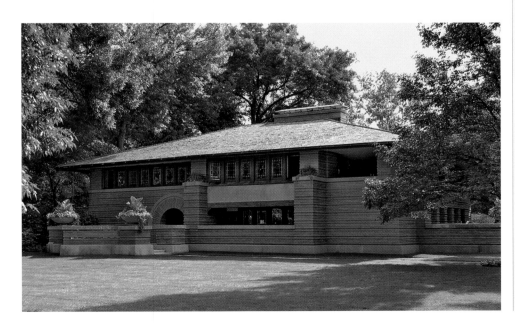

28
Frank Lloyd Wright, Arthur Heurtley House, Oak Park, Illinois, 1902. Photo: 2009, Joseph Mohan.

beginning. Not surprisingly, therefore, the interior details of wood and brick, the abstraction of natural motifs, and the simple, unified spaces all reveal the impact that Japanese teahouses and some of the traditional imperial residences had on the architect.

A study in precise proportion and severe lines, Wright's dining-room ensemble (FIG. 29) for the Robie House includes a table with four light fixtures extending from the legs to a point slightly higher than the six tall-back, square-spindle chairs. Positioned in an open-plan dining room (SEE CHAPTER 2, FIG. 38), the suite created a sense of enclosure or intimacy through chairs and fixtures. The chairs owe a debt to Scottish architect Charles Rennie Mackintosh's oak tall-backed seats for one of Miss Cranston's Tea Rooms on Argyle Street in Glasgow (1898; see background of FIG. 30).Wright certainly knew Mackintosh's work, and, like the Scottish designer, he simplified his forms and played with positive and negative space to achieve a sense of decoration. While the oak chairs reflect the traditional Arts and Crafts preference for solidity, the verticality and simplicity of their design mark a clear step toward a new aesthetic. The originality and strength of the Robie House chairs derives from their proportions, the attenuation of the spindles, and the spaces between them. Kolomon Moser's reception room chairs

29
Frank Lloyd Wright
Dining Table and Six Chairs
Made for the Frederick C. Robie House,
Chicago, Illinois
1908/10
The David and Alfred Smart Museum of
Art, University of Chicago
Cat. 172

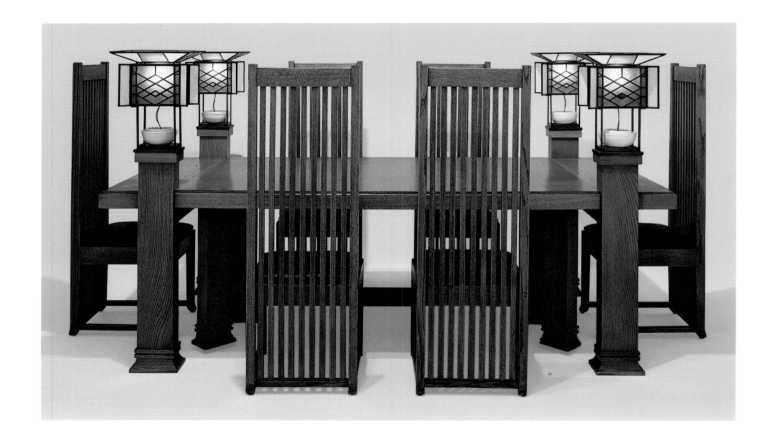

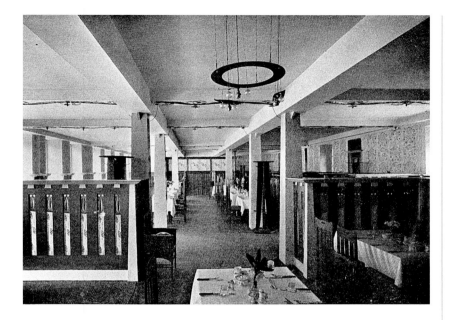

30
Charles Rennie Mackintosh, Miss
Cranston's Tea Rooms, Argyle Street,
Glasgow, Scotland, 1898, from *Studio* 39
(October 1906), p. 34.

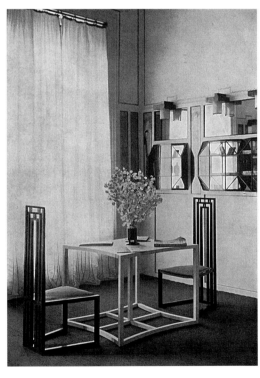

31
Koloman Moser, reception room for
Flöge sisters' fashion house, 1904, from
Deutsche Kunst und Dekoration 16 (1905),
p. 524.

for the Flöge sisters' fashion house (SEE FIG. 31) also show that Wright clearly
looked at Viennese design.

Wright's experiments with form may have also been influenced by Mackintosh's
use of open and closed vertical designs on smaller decorative objects, such as a
flower holder for Glasgow's Willow Tea Room (SEE CHECKLIST, CAT. 84). However,
Wright's design for a Japanesque weed holder (FIG. 32) represents a strict departure
in its tall, slender, tapering shaft and crisply attenuated silhouette. The weed

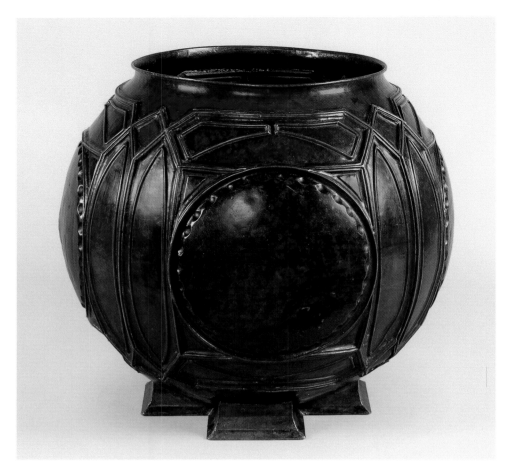

32–33
Frank Lloyd Wright
James A. Miller and Brother
Weed Holder and *Urn*
Weed holder: 1893/1902;
Urn: 1895/1900
Collection of Frank Lloyd Wright
Preservation Trust, Oak Park, Illinois
Cats. 165–66

34
Frank Lloyd Wright, private study, Frank
Lloyd Wright Home and Studio, Oak Park,
Illinois, from Robert C. Spencer, Jr., "The
Work of Frank Lloyd Wright," *Architectural
Review* [Boston] 7, 6 (June 1900), p. 64.

holder, as well as an urn constructed of molded and hand-hammered soldered segments (FIG. 33), were fabricated by Chicago's James A. Miller and Brother, a firm typically responsible for roofing and commercial fixtures, confirming that artistic elegance could be achieved through industrial production. The decoration of the globular vessel comprises a series of outlined, organic shapes that frame a large circle; the motif is repeated on all four sides, reinforcing the urn's shape. Obviously fond of these two objects, Wright placed them in his private study at his Oak Park home and studio (SEE FIG. 34), as well as in several commissions, including the Susan Lawrence Dana House in Springfield, Illinois (1902/04).

Wright's work appealed to Mr. and Mrs. Avery Coonley, who were considering building a large estate in Riverside, Illinois, along the Des Plaines River. Like many other young families, the Coonleys moved to the suburbs to escape the unhealthiness of the city.[46] The Coonleys were highly educated and at the forefront of progressive thinking about education. Mrs. Coonley was drawn to Christian Science and Swedenborgianism. Such turn-of-the-century Americans as the architect Daniel Burnham, arts patron Charles L. Hutchinson, philospher William James, and painter George Inness, took from Swedenborgianism the belief that we live in a spiritual as well as material world, even though we are seldom conscious of the dimensions of our existence. Wright's architectural philosophies sought to join nature, humanity, and dwellings, and not surprisingly, the Coonleys selected him as their architect. For the couple, Wright designed a U-shaped building with a long, sweeping facade and principle rooms on the second floor overlooking gardens and a pool (FIG. 35). He also took charge of the interior, providing designs for carpets, decorative accents, furniture, linens, and a table service. A desk

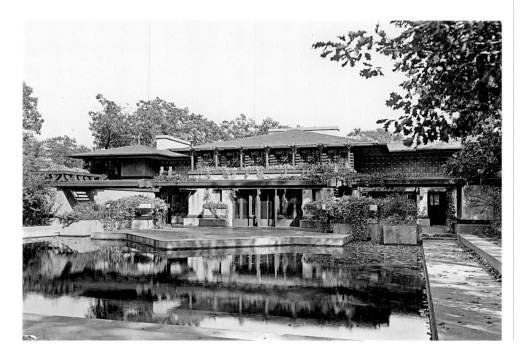

35
Frank Lloyd Wright, Avery Coonley House, Riverside, 1908. Photo: Art Institute of Chicago Archives.

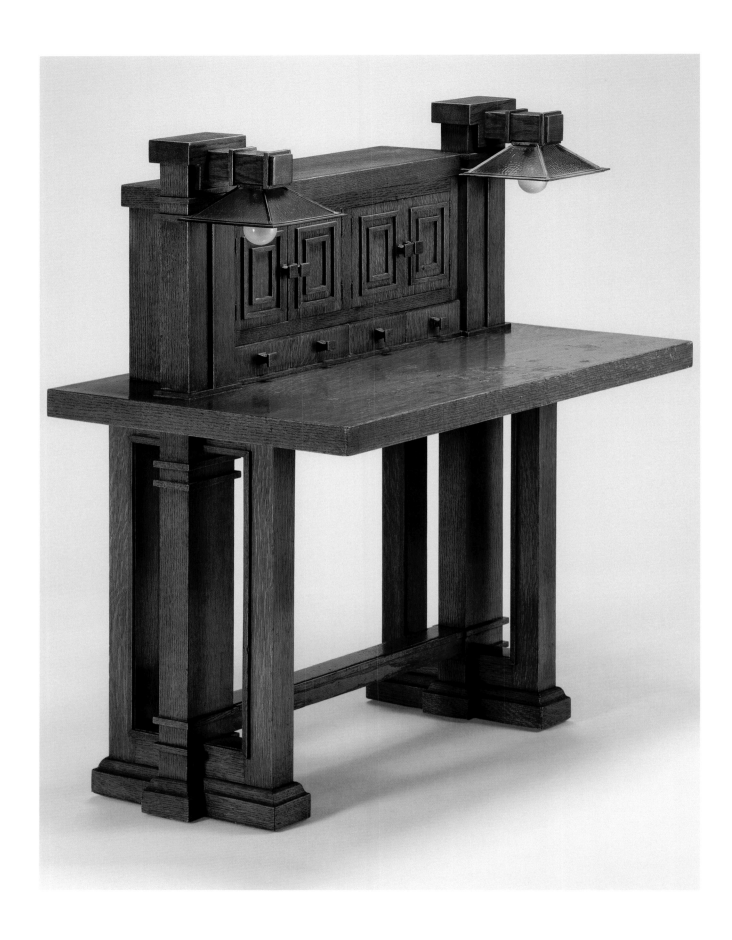

intended for the rear guest room (FIG. 36) recalls the house's geometric forms and broad, cantilevered roof. Small square doors with decorative banding suggest the casement windows; applied horizontal moldings across the base supports echo those on the building's exterior; and light shades repeat the flattened, horizontal gables of the house. While Wright designed the desk, George Mann Niedecken made renderings and had it manufactured.[47] The two men probably met through the Chicago Arts and Crafts Society, and Niedecken worked in Wright's studio in 1904. He may have finished the furnishings for the Coonley House after Wright departed for Germany in 1909.

Wright's two-year European sojourn seems to have been a watershed in his career. While in Germany, he oversaw the publication of his *Wasmuth Portfolio*, a two-volume folio of over one hundred lithographs of his architectural work. The publication became extremely influential for European architects and designers, including Le Corbusier, Ludwig Mies van der Rohe, and Walter Gropius. Although Wright himself often denied the effect that seeing European architecture had upon him, his later commissions display tighter, smaller structures. After his return in 1911, Mrs. Coonley asked Wright to design a playhouse where she could teach kindergarten. Like his client, Wright was conversant with the relatively new "kindergarten" movement, and shared Mrs. Coonley's interests in the theories of the early nineteenth-century German educator Friedrich Wilhelm Froebel. Froebel considered early childhood to be the most important time for development and learning. He proposed that such growth could be achieved most effectively through outdoor activities. This, he believed, helped children to learn, compose, and impose rational order on the world.[48]

Froebel designed educational materials, including building blocks to teach children to think in three dimensions. Some historians believe that the repeating circle, square, and cube forms so important in Wright's decorative designs show the influence of Froebel's kindergarten blocks.[49] These patterns are clear in the witty designs of the Coonley Playhouse windows (SEE FIG. 37). While colored glass was part and parcel of the Arts and Crafts movement, favored by the first generation of designers including Morris and Burne-Jones, here all historicizing emphasis is gone. The circles, arcs, and lines of Wright's design—suggesting balloons and confetti—have become formal elements. The natural shapes interpreted in the earth tones of Wright's 1904 design for a window in the Darwin D. Martin House, Buffalo, New York (FIG. 38), have been replaced in the Coonley composition by bright colors and bold abstraction. Some scholars have accounted Wright's abstract windows to his familiarlity with non-objective European painters, including Robert and Sonia Delaunay, Vasily Kandinsky, and Franz Kupka, as well as the works of the Viennese Secessionists.[50] Clearly, the pastiche of influences that had loosely formed Wright's Arts and Crafts style gives way here to a new, fresh simplicity.

36
Frank Lloyd Wright and George Mann Neidecken
Desk
Made for the Avery Coonley House, Riverside, Illinois
1908
The Art Institute of Chicago
Cat. 173

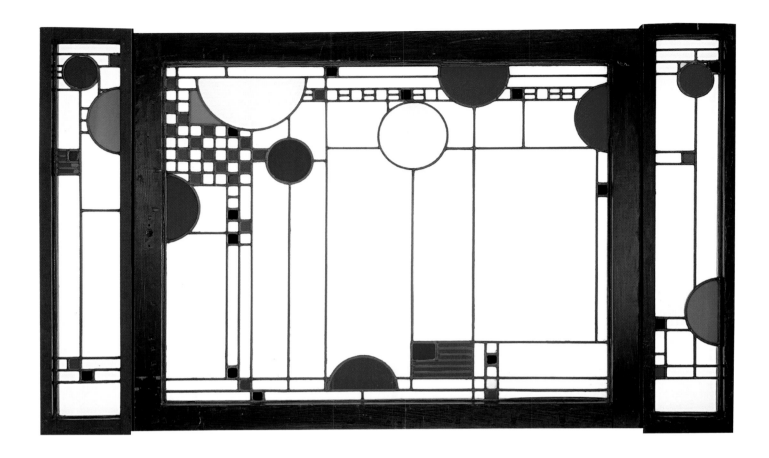

37
Frank Lloyd Wright
Triptych Window
Made for the Playhouse of the Avery
Coonley House, Riverside, Illinois
1912
The Art Institute of Chicago
Cat. 174

38
Frank Lloyd Wright
Linden Glass Company
Tree of Life Window
Made for the Darwin D. Martin House,
Buffalo, New York
1904
The Art Institute of Chicago
Cat. 171

Indeed, the Arts and Crafts movement—and, in particular, the contributions of Chicago-based artists and designers before the war—can be seen as a predecessor to a number of modern ideas. It broke down barriers between architects, craftsmen, designers, graphic artists, painters, and sculptors—between the so-called fine and applied arts. It encouraged a unified environment. While Arts and Crafts practitioners drew on past models to achieve new styles, technologies, and utopian relations, one must also keep in mind what they broke away from. They rejected the oppression of brutal hours, factory piece-work, mass production, and poor wages. They sought to relieve city squalor and give immigrants the skills with which to earn both an income and respect. Aesthetically, these reformers rejected the pomposity of machine-made and poorly designed Victorian decorative arts and developed a visual language of simplicity in materials and design. Yet over time its antibourgeois, anticapitalist stance was lost. Attempting to provide a universal market that transcended class or nationality, the movement became integrated into the new age of advertising, commercial competition, and the marketing of culture.[51] American historian T. J. Jackson Lears defined the Arts and Crafts movement as both modern and antimodern.[52] Its proponents looked forward in their desire to reshape society and elevate craft and aesthetics, yet they initially believed that the path to progress was to be found in emulation of the past. As Van Wyck Brooks wrote in 1918, the past is "an inexhaustible storehouse of apt attitudes and

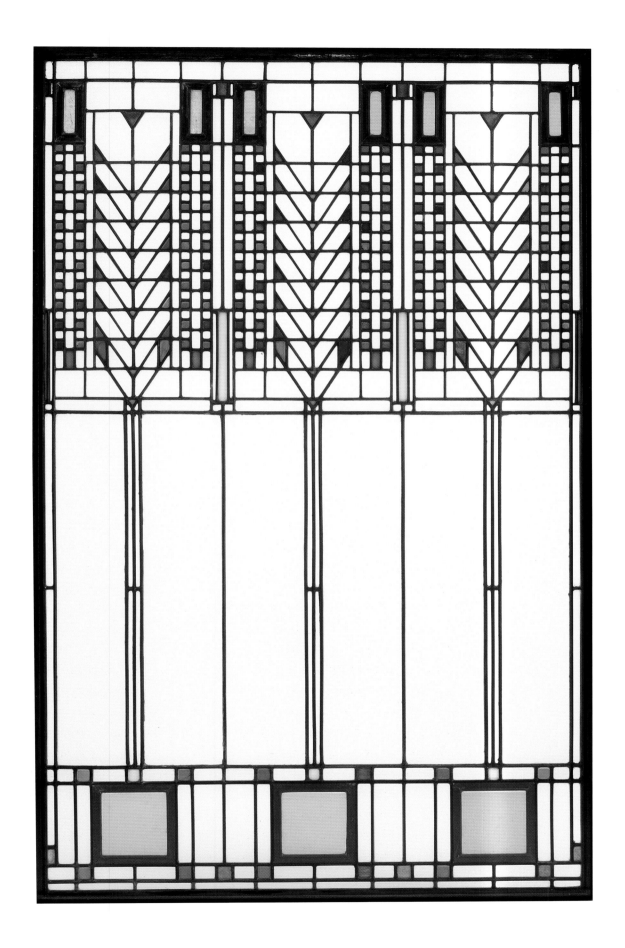

adaptable ideals; it opens of itself at the touch of desire; it yields up, now this treasure, now that, to anyone who comes to it armed with a capacity for personal choices."[53] His essay, published in the Chicago periodical the *Dial* and entitled "On Creating a Usable Past," is precisely what the Arts and Crafts movement achieved—a usable past at the service of the dream of the future.

In America, that dream of the future took on a different form than it had in Britain. Morris, Ashbee, and other English upper-class reformers tried to bridge class distinctions and reform society from the top down, while the Americans, less prone to such divisions, incorporated reform from the bottom up. Addams, Dewey, and Triggs were public intellectuals who formed close ties with labor unions and politicians. They sponsored progressive reforms in education, child welfare, and labor law, supporting ideas that came from the working classes. Socialism did not fully take hold in the United States because there was little homogeneity in the American working class. Thousands of immigrants arrived in America every year, each with differing cultural and linguistic roots. American reformers and politicians, fearing socialism and anarchy, used the machinery of government to address changes, ameliorate injustice, and promote education. Finally, economic determinants, such as the rational management systems devised by Henry Ford and others meant that factory work, rather than craft, was a more viable method of production.[54]

In breaking down past models to devise new proponents of craft, Chicago practitioners provided fertile ground for architecture and design. This spirit of progress that failed to be fulfilled with the Arts and Crafts movement was picked up anew by the burgeoning modernist scene. As a city rife with the spirit of experimentalism, Chicago was to become a natural crux of the Modern. By the late 1930s, Chicago had welcomed Mies van der Rohe, László Moholy-Nagy, and other German Bauhaus proponents who used the Arts and Crafts ideals in new ways. As Walter Gropius, founder of the Bauhaus, wrote in 1919:

> Let us therefore create a new guild of craftsmen without the class-distinctions that raise an arrogant barrier between craftsmen and artists! Let us desire, conceive, and create the new building of the future together. It will combine architecture, sculpture, and painting in a single form, and will one day rise toward the heavens from the hands of a million workers as the crystalline symbol of a new and coming faith.[55]

The authors would like to thank Brandon K. Ruud for his advice and guidance in the writing of this essay.

1. For more information on the Pullman strike, see Hirsch 2003 and Carl S. Smith 1995.

2. Triggs was not only the author of *Chapters in the History of the Arts and Crafts Movement* (1902), which is discussed in this chapter, but also of *Browning and Whitman, a Study in Democracy* (1893).

3. Quoted in Menand 2001, p. 296.

4. For Dewey's ideas on these topics, see ibid., p. 303.

5. Dewey established the University of Chicago Laboratory School in 1896; Triggs founded the Industrial Art League of Chicago in 1899.

6. See "Notes," *House Beautiful* 3, 1 (Dec. 1897), p. 29.

7. Knight 2005, pp. 194–95.

8. Quoted in Rice 1902, p. 13.

9. Isobel Spencer 1975, pp. 173–74, and Crane 1907, p. 405.

10. Crane 1897, pp. 96–97, quoted in Kahler 1986, p. 36.

11. Kahler 1986, pp. 40–41.

12. Founded in 1856, Tobey produced furniture in many popular styles, including historic revivals, Art Nouveau, and Mission, until it ceased operation in 1954.

13. Twyman 1904, p. 44.

14. McCougall 1903, pp. 169–77. On either side of the mantel were stained-glass windows of Saint Cecilia and Saint Margaret by the Pre-Raphaelite artist Sir Edward Burne-Jones (these were later installed in Chicago's Second Presbyterian Church). It is possible that Twyman purchased these windows on a trip to Merton Abbey in the summer of 1883, as he noted a "Saint Cecilia gowned in sapphire blue and purpled shadows, all bedded in a bower of lemon leaves and fruits" while walking through the workshop with William Morris. See Twyman 1904, p. 43. Although documentation has not yet surfaced, perhaps Franklin Darius Gray, the donor of the windows to Second Presbyterian Church, purchased them from the Tobey room.

15. Many of the original textiles from the Glessner House are located in the collection of the Art Institute of Chicago; embroidered panel (1918.298); Morris "Kennet" curtains (1971.682 a–b); Morris carpet (1974.524); Lewis F. Day furnishing textile (1978.190 a–b); J. H. Dearle "Cherwell" furnishing textile (1978.193); Thomas Wardle furnishing textile (1978.194 a–b); Sidney Mawson furnishing textile (1978.191); and Morris "Acanthus" furnishing textile (1978.192). Richardson visited Morris in 1882 and encouraged his clients to decorate with Morris textiles, tiles by William De Morgan, and lamps by Benson.

16. Hanks 1974.

17. The prototypes for this vessel date to ancient times when they were used by travelers as canteens.

18. For further reading on the interiors of the Glessner House, see Harrington 1987, pp. 189–207.

19. Crane 1907, p. 378.

20. Quoted in Crawford 1985, p. 96.

21. Quoted in Kahler 1986, p. 235.

22. Brooks 1972, p. 19.

23. Two brooches, a napkin ring, a covered dish, and a card receiver by Ashbee were loaned to the exhibition by Mrs. Lydia Avery Coonley. See *Eleventh Annual Exhibition of the Chicago Architectural Club* (1898), p. 133. The Chicago Arts and Crafts Society catalogue was issued as part of this yearly event.

24. This passage is found in 1 Chronicles (29:14b).

25. Meyerowitz 1991, p. xvii. In the last decade of the nineteenth century, the University of Chicago Law School admitted women, and Northwestern University's Women's College opened in 1889.

26. The increase in independent women can be deduced from the fact that, in 1880, in the United States, there was one divorce for every twenty-one marriages; by 1916 there was one in nine. Ibid.

27. For more on the modern pottery practices of Teco, see Frackelton 1905b, pp. 13–19.

28. Fritz Albert first came to Chicago to work for the German government at the 1893 World's Fair. For more on him, see Frackelton 1905a, pp. 73–80.

29. Jarvie was invited by Arthur G. Leonard, President of the Union Stock Yard Company, to produce trophies on an ongoing basis. This prompted his relocation. Maher 1997, pp. 20–21.

30. For information on the collections and influence of the Cliff Dwellers Club see Barter 2003, pp. 48–51.

31. Harriet Monroe, "Rare Displays at Art and Crafts Exhibition," *Chicago Tribune*, Oct. 4, 1911, p. 31.

32. See Washer 1992, pp. 107–21.

33. For more on the connection between Prairie school practitioners and the Vienna Secessionists, see Long 2007, pp. 6–44.

34. Gwendolyn Wright 1980, pp. 128–29.

35. Two other publications with large circulations, *Inland Architect and News Record* and *Architectural Record*, appealed to the middle class, featuring articles on new house plans and young architects.

36. For Ruskin's influence on Sullivan, see Weingarden 2000, pp. 322–33.

37. See all plates in Louis Sullivan, *A System of Architectural Ornament According with a Philosophy of Man's Powers* (American Institute of Architects, Inc., 1924).

38. "Description of Mr. James A. Patten's House, Evanston, Illinois," *Inland Architect and News Record* 42 (Aug. 1903), pp. 7–8.

39. "Some of the Most Artistic Homes in Chicago," *Chicago Daily Tribune*, Feb. 16, 1908, p. E6.

40. "Studio-Talk," *Studio* 30 (1903), p. 85.

41. Three architectural partnerships spanned the years 1907–21: William Gray Purcell and George Feick; Purcell, Feick, and Elmslie; and Purcell and Elmslie.

42. The leaded-glass lighting fixture is in the collection of the Riverside (Ill.) Historical Commission Museum.

43. These chairs also appear in the living room of the home and studio around 1911. Wright often moved furniture around when photographing rooms. A version of the chair was also used at Taliesin (1911; Spring Green, Wisc.), but with a slightly higher back rail.

44. Gwendolyn Wright 1980, p. 131.

45. For Richardson's influence on both Sullivan and Wright, see O'Gorman 1991.

46. During the 1890s, interest in the new discovery of germ theory prompted magazines to print articles about the evils of sewer gas and the importance of simple, unupholstered, easy-to-clean furniture, cross ventilation, sanitation, and cleanliness. Wright's open-plan houses with large windows seemed the ideal solution for a healthy lifestyle.

47. Niedecken's rendering of the desk is in the Art Institute of Chicago (1990.41). See Barter 1995, p. 131 (ill.).

48. Froebel's theories were spread through the Midwest by German immigrants. By 1880 Chicago had its first kindergarten training school, run by Alice Putnam. Over the next thirty years, more than eight hundred kindergarten teachers—mostly female—established charity kindergartens for children of all classes, and formed a link to already established settlement work as part of the early feminist movement. Supported and promoted by education philosopher John Dewey at the University of Chicago, the Chicago kindergarten movement became part of the public-school curriculum in the 1890s.

49. Brosterman 1997.

50. Julie L. Sloan, *Light Screens: The Complete Leaded Glass Windows of Frank Lloyd Wright* (Rizzoli, 2001), pp. 287–88.

51. Williams 1989, pp. 34–35.

52. Lears 1981.

53. Van Wyck Brooks, "On Creating a Usable Past," *Dial* 64 (April 11, 1918), pp. 337–41.

54. See Herbert G. Gutman, *Work Culture and Society in Industrializing America* (Vintage, 1977), pp. 13–19, and Louise Knight, *Citizen: Jane Addams and the Struggle for Democracy* (University of Chicago Press, 2005), pp. 410–11.

55. Walter Gropius, "Program of the Staatliche Bauhaus in Weimar," in Hans M. Wingler, *The Bauhaus: Weimar, Dessau, Berlin, Chicago* (Cambridge, Mass., 1969), p. 31.

ILLUSTRATED CHECKLIST

JAMES CRAIG ANNAN
(Scottish, 1864–1946)

1
Portrait of Mrs. C.
Published in *Camera Work* 19 (July 1907), pl. 3
Photogravure on cream Japanese paper, edge
mounted on cream wove paper; overall: 26.9 x
19 cm (10 %16 x 7 ½ in.)
The Art Institute of Chicago, Ryerson and
Burnham Libraries
Chap. 4, fig. 4

2
East and West
Published in *Camera Work* 32 (October 1910), pl. 1
Photogravure on cream Japanese paper, edge
mounted on cream wove paper; overall: 27.7 x
19.8 cm (10 ⅞ x 7 ³⁄16 in.)
The Art Institute of Chicago, Ryerson and
Burnham Libraries
Chap. 4, fig. 8

CHARLES ROBERT ASHBEE
(English, 1863–1942)

3
Guild of Handicraft, London, England
Armchair
1893/94
Oak and rush; 97.2 x 54 x 53.3 cm
(38 ¼ x 21 ¼ x 21 in.)
Collection of Crab Tree Farm
Chap. 1, fig. 22

4
Guild of Handicraft, London, England
Interior painting by Charles Francis Annesley
Voysey
Lovelace Escritoire
c. 1900
Oak (stained dark green), poplar (painted on
interior), macassar ebony writing surface, and
pierced wrought-iron hinges backed with
Moroccan leather; 147.3 x 123.2 x 61 cm
(58 x 48 ½ x 24 in.)
Private collection
Chap. 1, fig. 30

5
Guild of Handicraft, London, England
Coffee Pot
1900/01
Silver, ivory, and chrysoprase; 17.3 x 18 x 12.7 cm
(6 ³⁄16 x 7 ¹⁄16 x 5 in.)
The Art Institute of Chicago, gift of the
Antiquarian Society through the Eloise W.
Martin Fund in honor of Edith Bruce, 1987.354

6
Guild of Handicraft, London, England
Loop-Handled Dish
1902/03
Silver and chalcedony; 8.1 x 30.5 x 13.5 cm
(3 ³⁄16 x 12 x 5 ⁵⁄16 in.)
The Art Institute of Chicago, European
Decorative Arts Purchase Fund, 1985.261

7
Guild of Handicraft, London, England
Two-Handled Cup and Spoon
Cup: 1903; spoon: 1902
Silver, enamel, and mother-of-pearl;
cup: 10.2 x 24.1 x 11.1 cm (4 x 9 ½ x 4 ⅜ in.);
spoon: 14 x 2.9 cm (5 ½ x 1 ⅛ in.)
Collection of Crab Tree Farm
Chap. 1, fig. 20

8
Guild of Handicraft, London, England
Enamel attributed to William Mark (English
1868–1956)
Box with the Figure of Saint Michael
1903
Silver and painted enamel; 5.7 x 9.5 x 18.6 cm
(2 ¼ x 3 ¾ x 7 ⁵⁄16 in.)
Collection of Crab Tree Farm

9
Guild of Handicraft, Chipping Campden, England
Necklace
c. 1905
Mother-of-pearl cabochon panels, jade beads, and
gold chain; 25.7 x 12.7 cm (10 ⅛ x 5 in.)
Collection of Crab Tree Farm
Chap. 1, fig. 18

5

6

8

MACKAY HUGH BAILLIE SCOTT
(English, 1865–1945)

10

Movement made by John Broadwood and Sons, London, England
Cabinet and metalwork attributed to Charles Robert Ashbee, Guild of Handicraft, London, England
Manxman Pianoforte
1897
Oak and ebony with marquetry decoration with ivory and mother-of-pearl inlay; copper mounts, escutcheons, and candlesticks; 129.5 x 143.5 x 70 cm (51 x 56 ½ x 27 ½ in.)
The Art Institute of Chicago, restricted gift of Robert Allerton, Mrs. Joseph Regenstein, Sr., Walter S. Brewster, Emily Crane Chadbourne, Richard T. Crane, Jr., Mr. and Mrs. Leopold Blumka, Henry Manaster, Jack Linsky, Margaret Day Blake, Mr. and Mrs. John Wilson, Mrs. Henry C. Wood, by exchange; Florene May Schoenborn and Samuel A. Marx Fund; European Decorative Arts Purchase Fund, 1985.99
Chap. 1, fig. 31

11

Deutsche Werkstätten, Munich or Dresden, Germany, or Pyghtle Works, Bedford, England
Chair
c. 1903
Ebonized wood (possibly pearwood and alderwood), mother-of-pearl, and pine; 82.6 x 61.6 x 43.8 cm (32 ½ x 24 ¼ x 17 ¼ in.)
Private collection
Chap. 1, fig. 33

AUBREY BEARDSLEY (English, 1872–1898)

12

Panel
Early 20th century
Cotton, plain weave; block printed; 155.6 x 116.2 cm (61 ½ x 45 ¾ in.); warp repeat: 107 cm (42 ½ in.)
The Art Institute of Chicago, gift of Marjorie Freed, 1989.524
Chap. 2, fig. 30

WILLIAM ARTHUR SMITH BENSON
(English, 1854–1924)

13

W. A. S. Benson and Company, London, England
Pair of Wall Sconces
c. 1880/1900
Copper and brass; each: 27.9 x 29.2 x 22.9 cm (11 x 11 ½ x 9 in.)
The Art Institute of Chicago, anonymous gift, 1995.97.1–2

14

W. A. S. Benson and Company, London, England
Three-Pint Kettle and Stand
1890/1914
Brass, copper, wicker, and onyx; 81.3 x 27.3 cm (32 x 10 ¾ in.)
Collection of Crab Tree Farm

15

W. A. S. Benson and Company, London, England
Firescreen
c. 1900
Copper and brass; 75.6 x 51.4 cm (29 ¾ x 20 ¼ in.)
The Art Institute of Chicago, through prior acquisition of Margaret Day Blake, 1996.363
Chap. 1, fig. 25

CHARLES FERGUS BINNS
(American, 1857–1934)

16

Alfred, New York
Bottle Vase
1915
Glazed earthenware; h. 23.2 x diam. 10.1 cm (9 ⅛ x 4 in.)
The Art Institute of Chicago, Atlan Ceramic Club Fund, 1916.436
Chap. 3, fig. 34

WILLIAM H. BRADLEY
(American, 1868–1962)

17

Published by Herbert Stuart Stone and Hannibal Ingalls Kimball, Jr., Chicago, Illinois
When Hearts Are Trumps
December 1894
Color zincograph on cream wove paper; image: 28.9 x 33 cm (11 ⅜ x 13 in.); sheet: 43.7 x 35.7 cm (17 ¼ x 14 in.)
The Art Institute of Chicago, gift of George F. Porter, 1927.7743
Chap. 2, fig. 32

18

Published by Herbert Stuart Stone and Hannibal Ingalls Kimball, Jr., Chicago, Illinois
The Pink, for *The Chap-Book*
May 1895
Color zincograph on ivory wove paper; image: 51 x 33.8 cm (20 ⅛ x 13 ¼ in.); sheet: 56.2 x 40.6 cm (22 ⅛ x 16 in.)
The Art Institute of Chicago, gift of George F. Porter, 1927.7736
Chap. 2, fig. 33

19

Published by Herbert Stuart Stone and Hannibal Ingalls Kimball, Jr., Chicago, Illinois
Thanksgiving, for *The Chap-Book*
November 1895
Color zincograph on cream wove paper; image: 49.9 x 33.6 cm (19 ⅝ x 13 ¼ in.); sheet: 53 x 35.3 cm (20 ⅞ x 14 in.)
The Art Institute of Chicago, gift of George F. Porter, 1927.7740
Chap. 2, fig. 34

13

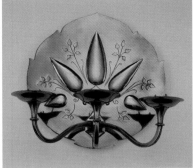

14

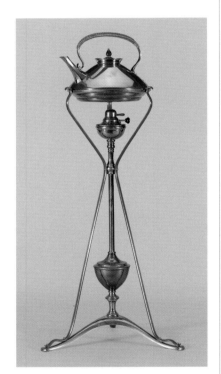

ANNE BRIGMAN (American, 1869–1950)

20
Untitled (The Breeze)
1918
Gelatin silver print; 24.8 x 19.7 cm (9 ¾ x 7 ¾ in.)
The Art Institute of Chicago, Julien Levy
Collection, gift of Jean Levy and the Estate of Julien
Levy, 1988.157.11
Chap. 4, fig. 21

WILLIAM BURGES (English, 1827–1881)

21
Painted by Nathaniel Hubert John Westlake
(English, 1833–1921)
Made by Harland and Fisher, London, England
Sideboard and Wine Cabinet
1859
Pine and mahogany, painted and gilt, iron straps,
and metal mounts; 126.5 x 157 x 58 cm
(49 ¾ x 61 ¾ x 22 ¾ in.)
The Art Institute of Chicago, restricted gift of the
James McClintock Snitzler Fund through the
Antiquarian Society, Mrs. DeWitt W. Buchanan, Jr.,
Mr. and Mrs. Henry M. Buchbinder, Mr. and Mrs.
Stanford D. Marks, Mrs. Eric Oldberg, Harry A.
Root, and the Woman's Board in honor of Gloria
Gottlieb; Harry and Maribel G. Blum Foundation,
Richard T. Crane, Ada Turnbull Hertle, Mr. and
Mrs. Fred Krehbiel, Florence L. Notter, Mr. and Mrs.
Joseph Varley and European Decorative Arts
Purchase endowments; through prior acquisitions of
Robert Allerton, the Antiquarian Society, Mr. and
Mrs. James W. Alsdorf, Helen Bibas, Emily Crane
Chadbourne, Mr. and Mrs. Richard T. Crane, Jr.,
R. T. Crane, Jr., Memorial Fund, H. M. Gillen,
George F. Harding Collection, Mrs. John Hooker,
and the Kenilworth Garden Club, 1999.262
Chap. 1, fig. 5

SIR EDWARD BURNE-JONES
(English, 1833–1898)

22
Samuel (Cartoon for Vyner Memorial Window, Lady
Chapel, Christ Church, Oxford)
March 1872
Brown-black charcoal with smudging, and brush and
brown ink, over graphite, on cream wove paper;
176.3 x 61.7 cm (69 ⅜ x 24 ¼ in.)
The Art Institute of Chicago, 1912.1676

23
Timothy (Cartoon for Vyner Memorial Window,
Lady Chapel, Christ Church, Oxford)
March 1872
Blue-black charcoal with smudging and erasing, and
brush and brown ink, over graphite, on cream wove
paper; 176.5 x 60.1 cm (69 ½ x 23 ⅝ in.)
The Art Institute of Chicago, 1912.1675
Chap. 1, fig. 7

EMILIE V. CLARKSON
(American, 1863–1946)

24
Spinning
c. 1898
Photogravure; 15.3 x 12.6 cm (6 x 4 ¹⁵⁄₁₆ in.)
The Art Institute of Chicago, gift of Daniel,
Richard, and Jonathan Logan, 1984.1654
Chap. 4, fig. 19

ELIZABETH E. COPELAND
(American, 1866–1957)

25
Boston, Massachusetts
Covered Box
c. 1920
Silver, painted enamel, cloisonné, and applied
cabochon stones; 7 x 14 x 10.2 cm (2 ¾ x 5 ½ x 4 in.)
The Art Institute of Chicago, Laura S. Matthews
Fund, 1982.1291
Chap. 5, fig. 9

WALTER CRANE (English, 1845–1915)

26
Maw and Company, Jackfield, England
Pitcher
c. 1890
Lustered earthenware; h. 33 x diam. 18.4 cm
(13 x 7 ¼ in.)
Collection of Crab Tree Farm

27
Published by Cassell and Company, London, England
Title page from *Queen Summer*, or *The Tourney of the
Lily and the Rose*
1891
Color lithograph on cream wove paper; 28.6 x 21 x
1.3 cm (11 ¼ x 8 ¼ x ½ in.)
The Art Institute of Chicago, Ryerson and Burnham
Libraries
Chap. 1, fig. 16

EDWARD S. CURTIS (American, 1868–1952)

28
Cañon de Chelly—Navaho
1904
Orotone; 26.7 x 34.3 cm (10 ½ x 13 ½ in.)
Collection of Crab Tree Farm
Chap. 4, fig. 15

29
Watching the Dancers, from *The North American
Indian*
1906
Photogravure; 39 x 28.7 cm (15 ⅜ x 11 ⁵⁄₁₆ in.)
The Art Institute of Chicago, gift of Mr. and Mrs.
Frank Kolodny, 1975.1062

30
The Medicine Man, from *The North American Indian*
1907
Photogravure; 40 x 26.1 cm (15 ¾ x 10 ¼ in.)
The Art Institute of Chicago, gift of Mr. and Mrs.
Frank Kolodny, 1975.1095
Chap. 4, fig. 11

31
Arikara Girl, from *The North American Indian*
1908
Photogravure; 40.1 x 26.3 cm (15 ¾ x 10 ⁵⁄₁₆ in.)
The Art Institute of Chicago, gift of Mr. and Mrs.
Frank Kolodny, 1975.1087
Chap. 4, fig. 12

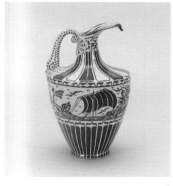

22

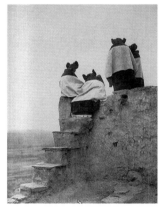

26

29

33

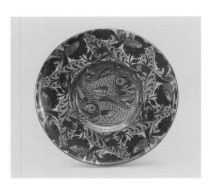

34

35

32

Canoe of Tules—Pomo, from *The North American Indian*
1924
Photogravure; 39.3 x 29.3 cm (15 ½ x 11 ½ in.)
The Art Institute of Chicago, gift of Mr. and Mrs. Frank Kolodny, 1975.1113
Chap. 4, fig. 13

33

Yokuts Basketry Designs, from *The North American Indian*
1924
Photogravure; 29.2 x 39.5 cm (11 ½ x 15 ½ in.)
The Art Institute of Chicago, gift of Mr. and Mrs. Frank Kolodny, 1975.1060

WILLIAM FREND DE MORGAN

(English, 1839–1917)

34

William Frend De Morgan Pottery, Merton Abbey, England
Charger
1882/88
Lustered earthenware; h. 6 x diam. 51.4 cm (2 ⅜ x 20 ⁵⁄₁₆ in.)
Collection of Crab Tree Farm

35

William Frend De Morgan Pottery, Merton Abbey, England
Vase
1882/88
Polychromed earthenware; h. 53.3 x diam. 28.5 cm (21 x 11 ¼ in.)
The Art Institute of Chicago, gift of Margaret Fisher in memory of her mother, 1981.638

ARTHUR WESLEY DOW

(American, 1857–1922)

36

L. Prang and Company, Boston, Massachusetts
Modern Art
1895
Color lithograph on paper; 45.1 x 34.9 cm (17 ¾ x 13 ¹¹⁄₁₆ in.)
Collection of Crab Tree Farm
Chap. 2, fig. 25

37

Boats at Rest
c. 1895
Oil on canvas; 66 x 91.4 cm (26 x 36 in.)
The Art Institute of Chicago, through prior acquisition of the Charles H. and Mary F. S. Worcester Collection, 1990.394
Chap. 2, fig. 21

38

Moonrise "Common Fields" Ipswich
1905
Color woodcut on cream Japanese paper; 10.8 x 17.8 cm (4 ¼ x 7 in.)
Collection of Crab Tree Farm
Chap. 2, fig. 23

CHRISTOPHER DRESSER

(English, born Scotland, 1834–1904)

39

Minton and Company, Stoke-on-Trent, England
Plate and Bowl
1872
Porcelain; plate: 23.9 x 24.1 x 3.5 cm (9 ⅜ x 9 ½ x 1 ⅜ in.); bowl: h. 7.9 x diam. 17.6 cm (3 ⅛ x 6 ⁵⁄₁₆ in.)
Collection of Crab Tree Farm
Chap. 2, fig. 7

40

James Dixon and Sons, Sheffield, England
Teapot
c. 1880
Electroplate silver and ebony; 13.7 x 10.2 x 20.3 cm (5 ⅜ x 4 x 8 in.)
Collection of Crab Tree Farm
Chap. 2, fig. 10

41

J. W. Hukin and J. T. Heath, Birmingham and London, England
Tureen and Ladle
c. 1880
Electroplate silver and ebony; tureen: 19.7 x 30.5 x 23.3 cm (7 ¾ x 12 x 9 ³⁄₁₆ in.); ladle: 35.6 x 7.6 x 10 cm (14 x 3 x 3 ¹⁵⁄₁₆ in.)
Collection of Crab Tree Farm
Chap. 2, fig. 11

42

Attributed to Christopher Dresser
J. T. Heath and J. H. Middleton, Birmingham, England
Claret Jug
1892/93
Silver, glass, and ebony; 42.2 x 15.6 x 15.6 cm (16 ⅝ x 6 ⅛ x 6 ⅛ in.)
The Art Institute of Chicago, gift of the Auxiliary Board of the Art Institute of Chicago, 1991.116
Chap. 2, fig. 12

43

James Couper and Sons, Glasgow, Scotland
Clutha Vase
c. 1895
Glass; h. 42.8 x diam. 11.1 cm (16 ⅞ x 4 ⅜ in.)
The Art Institute of Chicago, Richard T. Crane, Jr., Endowment, 1981.647
Chap. 2, fig. 13

GEORGE GRANT ELMSLIE

(American, born Scotland, 1871–1952)

44

Purcell, Feick, and Elmslie, Minneapolis, Minnesota
Carpet
Made for the Henry B. Babson House, Riverside, Illinois
1908/12
Linen, cotton, and wool, plain weave with supplementary wrapping wefts forming cut pile through a technique known as "Ghiordes knots"; 560.1 x 115.7 cm (220 ½ x 45 ½ in.)
The Art Institute of Chicago, restricted gift of Mrs. Theodore D. Tieken, 1972.1144
Chap. 5, fig. 22

45
Purcell, Feick, and Elmslie, Minneapolis, Minnesota
Side Chair
Possibly made for T. B. Keith House, Eau Claire,
Wisconsin
1910
Oak, laminated wood, leather, jute webbing, and
horsehair (original upholstery); 127.3 x 48.9 x 41.2
cm (50 ⅛ x 19 ¼ x 16 ¼ in.)
The Art Institute of Chicago, Mrs. William P.
Boggess II Fund, 1973.342

46
Purcell, Feick, and Elmslie, Minneapolis, Minnesota
Andirons
Made for the Henry B. Babson House, Riverside,
Illinois
1912
Brass, bronze, and cast iron; each 26.5 x 20 x
72.4 cm (10 ⁷/₁₆ x 7 ⅞ x 28 ½ in.)
The Art Institute of Chicago, gift of Mrs. George A.
Harvey, 1971.788a–b

47
Purcell, Feick, and Elmslie, Minneapolis, Minnesota
Made by Niedecken-Walbridge, Milwaukee,
Wisconsin
Clock face modeled by Kristian Schneider
Clock hands made by Robert Riddle Jarvie
Tall Clock
Made for the Henry B. Babson House, Riverside,
Illinois
1912
Mahogany with brass inlay; 213.3 x 66 x 40 cm
(84 x 26 x 15 ¾ in.)
The Art Institute of Chicago, restricted gift of Mrs.
Theodore D. Tieken, 1971.322
Chap. 5, fig. 24

ERNEST GIMSON (English, 1864–1919)

48
Alfred Bucknell, Sapperton, England
Firedogs
c. 1905
Steel and iron; h. 57 cm (22 ½ in.)
The Art Institute of Chicago, anonymous gift,
1999.553.1–2
Chap. 1, fig. 23

FRANCES MACBETH GLESSNER
(American, 1848–1932)

49
Chicago, Illinois
Sweetmeat Dish
1905
Silver; 5.1 x 17.5 cm (2 x 6 ⅞ in.)
The Fortnightly of Chicago
Chap. 5, fig. 8

EDWARD WILLIAM GODWIN
(English, 1833–1886)

50
William Watt, London, England
Sideboard
c. 1876
Ebonized mahogany with glass, silvered brass;
181.6 x 255.3 x 50.2 cm (71 ½ x 100 ½ x 19 ¾ in.)
(with leaves extended)
The Art Institute of Chicago, restricted gift of
Robert Allerton, Harry and Maribel G. Blum, Mary
and Leigh Block, Mary Waller Langhorne, Mrs.
Siegfried G. Schmidt, Tillie C. Cohn, Richard T.
Crane, Jr., Memorial, Eugene A. Davidson, Harriet
A. Fox, Florence L. Notter, Kay and Frederick
Krehbiel, European Decorative Arts Purchase, and
Irving and June Seaman endowments; through prior
acquisition of the Reid Martin Estate, 2005.529
Chap. 2, fig. 15

51
William Watt, London, England
Side Chair
c. 1885
Ash with cane seat; 101 x 36.2 x 42.6 cm
(39 ¾ x 14 ¼ x 16 ¾ in.)
Private collection

CHARLES SUMNER GREENE
(American, 1868–1957)

52
Peter Hall Manufacturing Company, Pasadena,
California
Serving Table
Made for the Robert R. Blacker House, Pasadena,
California
1907/09
Mahogany and ebony, fruitwood, copper, pewter,
and mother-of-pearl inlay; 75.8 x 91.5 x 56.2 cm
(29 ⅞ x 36 x 22 ⅛ in.)
The Art Institute of Chicago, Wentworth Greene
Field Memorial Fund and Maurice D. Galleher
Endowment, 1982.1207
Chap. 3, fig. 37

53
Peter Hall Manufacturing Company, Pasadena,
California
Side Chair
Made for the Robert R. Blacker House, Pasadena,
California
1907/09
Mahogany and ebony; 95.3 x 50.2 x 45.7 cm
(37 ½ x 19 ¾ x 18 in.)
The Art Institute of Chicago, restricted gift of the
Graham Foundation for Advanced Studies in the
Fine Arts, 1982.990
Chap. 3, fig. 36

MARION MAHONY GRIFFIN
(American, 1871–1962)

54
Thomas P. Hardy House, Racine, Wisconsin
1905
Published in *Ausgeführte Bauten und Entwürfe von
Frank Lloyd Wright* (Berlin, 1911), pl. 15
Lithograph on tan wove paper; 63.5 x 40 cm
(25 x 15 ¾ in.)
The Art Institute of Chicago, Ryerson and Burnham
Libraries
Chap. 2, fig. 39

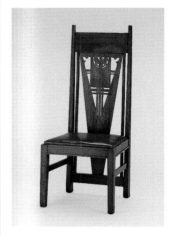

45

46

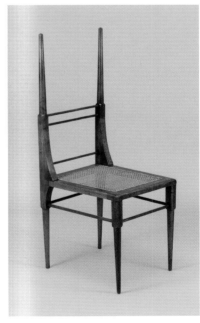

51

55
Designed by Walter Burley Griffin (American, 1876–1937)
Delineated by Marion Mahony Griffin
Rock Crest/Rock Glen: Perspective Rendering
c. 1912
Lithograph and gouache on green satin;
59 x 201 cm (23 ¼ x 79 ⅛ in.)
The Art Institute of Chicago, gift of Marion Mahony Griffin through Eric Nicholls, 1988.182
Chap. 2, fig. 40

GRUEBY FAIENCE COMPANY
(Boston, Massachusetts)

56

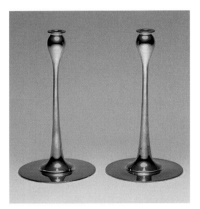

56
Decorator unknown, marked CP
Vase
c. 1900
Glazed earthenware; h. 17.2 x diam. 20.3 cm
(6 ¾ x 8 in.)
Collection of Crab Tree Farm

57
Design attributed to George Prentiss Kendrick (American, 1850–1919)
Decoration attributed to Eva Russell (American, active c. 1905)
Vase
1903/09
Glazed earthenware; 37.5 x 20.3 x 20.3 cm
(14 ¾ x 8 x 8 in.)
The Art Institute of Chicago, restricted gift of the Antiquarian Society; through prior acquisition of the B. F. Ferguson Fund; Skinner Sales Proceeds Fund; Wesley M. Dixon, Jr., and Roger and J. Peter McCormick endowments; through prior acquisition of the Antiquarian Society; The Goodman Fund; Simeon B. Williams, Harriet A. Fox, and Mrs. Wendell Fentress Ott funds; Highland Park Community Associates; Charles R. and Janice Feldstein Endowment Fund for Decorative Arts, 2008.558
Chap. 3, fig. 17

60

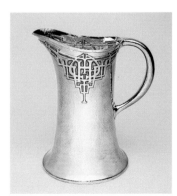

58
Designed by Addison Le Boutillier (American, 1872–1951)
The Pines
1906
Glazed earthenware; 14.6 x 122.5 cm
(5 ¾ x 48 ¼ in.)
Collection of Crab Tree Farm
Chap. 2, fig. 26

62

ROBERT RIDDLE JARVIE
(American, 1865–1941)

59
Jarvie Shop, Chicago, Illinois
Omicron Candelabrum
c. 1905
Brass; 26 x 18.1 cm (10 ¼ x 7 ⅛ in.)
Collection of Crab Tree Farm
Chap. 5, fig. 13

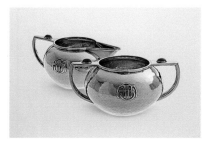

67

60
Jarvie Shop, Chicago, Illinois
Candlesticks
1905/15
Silver-plated bronze; 35.7 x 8.1 cm (14 x 3 3/16 in.)
The Art Institute of Chicago, Bessie Bennett and Mrs. Herbert Stern funds, 1973.377–78

61
Jarvie Shop, Chicago, Illinois
Punch Bowl
1910
Silver; 26 x 41.9 cm (10 ¼ x 16 ½ in.)
The Cliff Dwellers Club, Chicago, gift of Charles L. Hutchinson, 1910
Chap. 5, fig. 14

62
Jarvie Shop, Chicago, Illinois
Pitcher
1911
Silver; 26 x 20.3 cm (10 ¼ x 8 in.); diam. of base 16 cm (6 5/16 in.)
The Art Institute of Chicago, gift of Raymond W. Sheets, 1973.357

63
Jarvie Shop, Chicago, Illinois
Punch Bowl, Ladle, and Tray
1911
Silver; punch bowl: 25.7 x 39.3 cm (10 ⅛ x 15 ½ in.); ladle: 45.7 cm (18 in.); tray: d. 52.7 cm (20 ¾ in.)
The Art Institute of Chicago, gift of Mr. and Mrs. John R. Hattstaedt in memory of his father, John J. Hattstaedt, 1974.293a–c
Chap. 5, fig. 15

EDMUND JOHNSON (Irish, c. 1840–1900)

64
Dublin, Ireland
Ardagh Chalice
1891/92 (facsimile of eighth-century original)
Wrought and cast silver with gilt, enamel, and colored glass decoration; h. 15.9 x diam. 19.1 cm
(6 ¼ x 7 ½ in.)
The David and Alfred Smart Museum of Art, University of Chicago, gift of Mr. and Mrs. Edward A. Maser
Chap. 5, fig. 16

OWEN JONES (English, 1809–1874)

65
Day and Son, London, England
Drawn in stone by F. Bedford
Moresque No. 3, from *The Grammar of Ornament*
1856
Color lithograph on cream wove paper; 53.7 x 38.1 x 6.4 cm (21 ⅛ x 15 x 2 ½ in.)
The Art Institute of Chicago, Ryerson and Burnham Libraries
Chap. 2, fig. 2

66
Warner, Sillett, and Ramm, London, England
Fragment Entitled "Sutherland"
1870/71 (produced c. 1872)
Silk, warp-float faced 4:1 satin weave with 1:2 'Z'
twill interlacings of secondary binding warps and
supplementary patterning wefts; 39 x 53.7 cm (15 ¼
x 21 ⅛ in.); repeat: 11.3 x 6.7 cm (4 ⅜ x 2 ⅝ in.)
The Art Institute of Chicago, Royalties from the
Minasian Rug Corporation, 1995.386
Chap. 2, fig. 3

KALO SHOP (Park Ridge, Illinois)

67
Cream Pitcher and Sugar Bowl
c. 1908
Silver and jade; cream pitcher: 5.4 x 10.2 cm
(2 ⅛ x 4 in.); sugar bowl: 5.4 x 11.8 cm
(2 ⅛ x 4 ⅝ in.)
Museum Purchase, Chicago History Museum

68
Water Pitcher
1910
Silver; 18.4 x 16.5 cm (7 ¼ x 6 ½ in.)
The Art Institute of Chicago, gift of Mrs. Eugene A.
Davidson, 1973.345
Chap. 5, fig. 7

69
Necklace
c. 1910
Gold and pearl; 45.7 cm (18 in.)
Collection of Ira Simon

70
Alms Plate
1912
Silver; diam. 33 cm (13 in.)
Collection of Ira Simon
Chap. 5, fig. 6

GERTRUDE KÄSEBIER
(American, 1852–1934)

71
Blessed Art Thou Among Women
c. 1899
Photogravure; 23.6 x 14 cm (9 ¼ x 5 ½ in.)
The Art Institute of Chicago, gift of Daniel,
Richard, and Jonathan Logan, 1984.1638
Chap. 4, fig. 23

72
The Red Man
c. 1900
Gum-bichromate print; 33.5 x 25.6 cm
(13 ³⁄₁₆ x 10 ¹⁄₁₆ in.)
The Art Institute of Chicago, gift of Mina Turner,
1973.16
Chap. 4, fig. 14

73
The Heritage of Motherhood
c. 1905
Platinum print; 22.9 x 29.1 cm (9 x 11 ⁷⁄₁₆ in.)
The Art Institute of Chicago, gift of Mina Turner,
1973.6
Chap. 4, fig. 24

74
Alfred Stieglitz
1906
Platinum print; 30.2 x 23.2 cm (11 ⅞ x 9 ⅛ in.)
The Art Institute of Chicago, Alfred Stieglitz
Collection, 1949.862
Chap. 4, fig. 26

75
The Simple Life
c. 1907
Toned silver print on Japanese paper; 21.7 x 28.6 cm
(8 ½ x 11 ¼ in.)
The Art Institute of Chicago, gift of Mina Turner,
1973.4
Chap. 4, fig. 2

EDWARD KEMEYS (American, 1843–1907)

76
Joseph Green, Ottawa, Illinois
Pitcher
c. 1890
Glazed earthenware; h. 14.3 x diam. 22.9 cm (5 ⅝ x
9 in.)
The Art Institute of Chicago, the Chipstone
Foundation Endowment, 2001.477

MARY CATHERINE KNIGHT
(American, c. 1876–c. 1928)

77
Handicraft Shop, Boston, Massachusetts
Sauce Set
1902/08
Silver and champlevé enamel; bowl: h. 5 x diam.
10.5 cm (2 x 4 ⅛ in.); plate: h. 1.2 x diam. 14 cm
(½ x 5 ½ in.); ladle: 11.4 cm (4 ½ in.)
The Art Institute of Chicago, Americana Fund,
1982.205a–c

ARCHIBALD KNOX (English, 1864–1933)

78
Liberty and Company, Birmingham, England
Covered Cup
1900
Silver and enamel; h. 26.7 x diam. 15.2 cm
(10 ½ x 6 in.)
Collection of Crab Tree Farm

79
Liberty and Company, Birmingham, England
Pendant
1900/04
Gold, opal, and pearl; 25.4 x 3.8 cm (10 x 1 ½ in.);
pendant: 5.6 cm (2 ³⁄₁₆ in.)
Collection of Crab Tree Farm

80
Liberty and Company, Birmingham, England
Rose Bowl
1902
Silver, enamel, and turquoise; h. 18.7 x diam.
40.6 cm (7 ⅜ x 16 in.)
The Art Institute of Chicago, promised gift of Crab
Tree Farm Foundation, 94.2008
Chap. 1, fig. 34

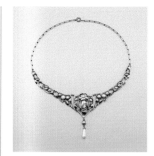

69

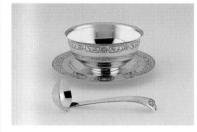

76

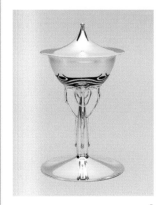

77

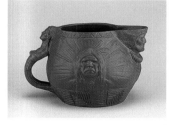

78

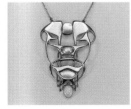

79

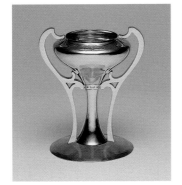

81

LEBOLT AND COMPANY (Chicago, Illinois)

81
Loving Cup
1912/17
Silver; 25.4 x 16.2 cm (10 x 6⅜ in.)
The Art Institute of Chicago, restricted gift of
Martha and William Steen and the Dr. Julian
Archie Fund, 1987.123

CHARLES RENNIE MACKINTOSH
(Scottish, 1868–1928)

82
Armchair
1897
Oak (stained dark), with horsehair upholstery
(modern); 96.4 x 57.2 x 45.8 cm (38 x 22½ x 18 in.)
The Art Institute of Chicago, gift of Neville F.
Bryan, 2000.464
Chap. 1, fig. 35

83
Table
1902
Wood (painted white) and clear and opaque leaded
glass insets; 61 x 92 cm (24 x 36¼ in.)
The Art Institute of Chicago, Richard T. Crane, Jr.,
and Edward E. Ayer Endowment, 1981.168
Chap. 1, fig. 36

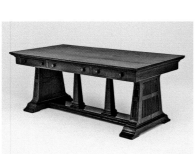

84

84
Flower Stand
1903
Oak with metal liner; 38.1 x 15.2 x 15.2 cm
(15 x 6 x 6 in.)
Collection of Crab Tree Farm

85
W. J. Bassett-Lowke, Northampton, England
Mantel Clock
c. 1917
Ebonized wood and erinoid; 32.4 x 14.5 x 12.5 cm
(12¾ x 5¹¹⁄₁₆ x 4¹⁵⁄₁₆ in.)
Collection of Crab Tree Farm

ARTHUR HEYGATE MACKMURDO
(English, 1851–1942)

86
Published by G. Allen, Kent, London, England
Title page from *Wren's City Churches*
1883
Woodcut print on cream laid paper; 30.5 x 24.1 x
2.1 cm (12 x 9½ x ⅞ in.)
The Art Institute of Chicago, Ryerson and
Burnham Libraries
Chap. 1, fig. 15

GEORGE WASHINGTON MAHER
(American, 1864–1926)

87
John A. Colby and Sons, Chicago, Illinois
Armchair
Made for the John Farson House, Oak Park, Illinois
1897
Mahogany; 129.7 x 76.3 x 63.3 cm (51 x 30 x 25 in.)
The Art Institute of Chicago, lent by the Park
District of Oak Park, Pleasant Home Foundation,
72.1971
Chap. 5, fig. 20

88
George Washington Maher and Louis J. Millet
(American, 1853–1923)
Portière
Made for the James A. Patten House, Evanston,
Illinois
1901
Cotton and silk, plain weave with pile warps
forming cut solid velvet; appliquéd with silk and
cotton, 7:1 satin damask weave; linen and gilt-
metal-strip-wrapped linen, 4:1 satin weave; cotton
and wild silk, plain weaves; embroidered with silk,
cotton, linen, and gilt-metal-strip-wrapped linen in
chain, cross, and overcast chain stitches; 203.7 x
121.9 cm (80⅛ x 48 in.)
The Art Institute of Chicago, restricted gift of the
Antiquarian Society, 1971.680
Chap. 5, fig. 21

89
Library Table
Made for the Emil Rudolph House, Highland Park,
Illinois
1905
Oak; 75.5 x 102.8 x 92.8 cm (29¾ x 72 x 36½ in.)
The Art Institute of Chicago, Robert R. McCormick
Charitable Trust, 1983.511

MARBLEHEAD POTTERY (Marblehead,
Massachusetts)

90
Designed by Annie E. Aldrich (American,
1857–1937)
Made by John Swallow (born England, active
c. 1910)
Decorated by Sarah Tutt (American, 1859–1947)
Vase
c. 1909
Glazed earthenware; 21.6 x 17.5 x 17.5 cm
(8½ x 6⅞ x 6⅞ in.)
The Art Institute of Chicago, Vance American
Fund; restricted gift of the Antiquarian Society,
2008.74
Chap. 3, fig. 1

WILLIAM MORRIS (English, 1834–1896)

91
Attributed to Dante Gabriel Rossetti
Morris, Marshall, Faulkner, and Company, London,
England
Sussex Armchair
c. 1863
Ebonized beech and rush; 87.6 x 50.8 x 53.3 cm
(34½ x 20 x 21 in.)
Collection of Crab Tree Farm
Chap. 1, fig. 10

92
Philip Webb (English, 1831–1915)
Morris, Marshall, Faulkner, and Company, London,
England
Adjustable-Back Chair
c. 1866
Ebonized wood with velvet upholstery (modern);
97.8 x 87 cm (38½ x 26 x 34¼ in.)
Collection of Crab Tree Farm
Chap. 1, fig. 12

85

89

93
Morris and Company, Decorators, Ltd., London
Printed by Hencroft Dye Works, Leek, England
Panel Entitled "Snakeshead"
1876 (produced 1925/40)
Inscription (on selvage): MORRIS & COMPANY; (on detached label): MORRIS & COMPANY, ARTWORKERS, LTD., 17, ST. GEORGE STREET, HANOVER SQUARE, LONDON, W.1.
Telephone: MAYFAIR 1664/5. / No. 1840 / Name Snakeshead / Width 36 inches / Price 7/11 yard / PATTERNS WILL BE CHARGED FOR, IF NOT RETURNED WITHIN ONE MONTH. / 1650
Cotton, plain weave; block printed; 70.4 x 97.7 cm (27 ⅝ x 38 ½ in.); repeat: 32.2 x 21.5 cm (12 ¾ x 8 ½ in.)
The Art Institute of Chicago, restricted gift of Mrs. Theodore D. Tieken, 1972.395

94
Morris and Company, London, England
Woven at Queen Square, London, or Merton Abbey Works, Wimbledon, England
Panel Entitled "Peacock and Dragon"
1878 (produced 1878/1940)
Two panels joined: wool, three-colored complementary weft, weft-float faced 3:1 'Z' twill weave; 217.5 x 171.7 cm (85 ⅝ x 67 ⅝ in.); repeat: 110.5 x 84.3 cm (43 ½ x 33 ⅛ in.)
The Art Institute of Chicago, restricted gift of Natalie Henry, 1985.74
Chap. 2, fig. 4

95
Morris and Company, London, England
Woven and printed at Merton Abbey Works, Wimbledon, England
Two Panels Entitled "Cray"
1884 (produced 1885)
Inscription (on selvage): Rec. D. Morris & Company, 449 Oxford Street, W.
Two panels: cotton, plain weave; block printed; a: 277 x 97.2 cm (109 x 38 ⅞ in.); b: 278.9 x 97.8 cm (109 ⅞ x 38 ½ in.); repeat: 94.5 x 45 cm (37 ¼ x 17 ¾ in.)
The Art Institute of Chicago, gift of Mrs. Charles F. Batchelder, 1974.419a–b
Chap. 1, fig. 14

96
Attributed to John Henry Dearle (English, 1860–1932)
Morris and Company, London, England
Three Panels Entitled "Poppy," "Anemone," and "Poppy and Briony"
1885/90
Three panels: canvas embroidered with silk in darning, stem, and satin stitches; each panel: 136.5 x 55.3 cm (53 ¾ x 21 ¾ in.)
Collection of Crab Tree Farm
Chap. 1, fig. 9

97
Written by Geoffrey Chaucer (English, c. 1343–1400)
Illustrated by William Morris and Sir Edward Burne-Jones
Published by Kelmscott Press, Hammersmith, England
Title page from *The Works of Geoffrey Chaucer Now Newly Imprinted*
1896
Woodcut print on ivory laid paper; 44.5 x 30.9 x 7.6 cm (17 ½ x 12 ⅛ x 3 in.)
The Art Institute of Chicago, Ryerson and Burnham Libraries
Chap. 1, fig. 17

NAVAJO (Northern Arizona or New Mexico, Southern Utah, United States)

98
Blanket or *Rug*
1910/20
Wool, dovetailed and single interlocking tapestry weave; twined selvages and headings; 237.5 x 149.2 cm (93 ½ x 58 ¾ in.)
The Art Institute of Chicago, gift of Mrs. Lee Winfield Alberts, 2005.443
Chap. 3, fig. 30

NEWCOMB (New Orleans, Louisiana)

99
Made by Joseph Fortune Meyer (American, 1848–1931)
Decorated by Marie de Hoa Le Blanc (American, 1874–1954)
Vase
1903
Glazed earthenware; h. 37.2 x diam. 15.2 cm (14 ⅝ x 6 in.)
Collection of Crab Tree Farm
Chap. 2, fig. 28

100
Made by Joseph Fortune Meyer (American, 1848–1931)
Decorated by Katherine Louise Wood (American, 1874–1919)
Vase
1905
Glazed earthenware; h. 12.1 x diam. 15.2 cm (4 ¾ x 6 in.)
Collection of Crab Tree Farm
Chap. 3, fig. 2

101
Made by Anna Frances Simpson (American, 1880–1930)
Cypress Trees Table Runner
1905/15
Linen with silk embroidery; 221 x 66 cm (87 x 26 in.)
Collection of Crab Tree Farm
Chap. 3, fig. 3

102
Made by Joseph Fortune Meyer (American, 1848–1931)
Decorated by Anna Frances Simpson (American, 1880–1930)
Vase
1908
Glazed earthenware; h. 31.8 x diam. 14 cm (12 ½ x 5 ½ in.)
Collection of Crab Tree Farm

JOHN PEARSON (English, active 1885–1910)

103
Newlyn Industrial Class, Newlyn, England
Charger
1901
Copper; h. 2.5 x diam. 61.9 cm (1 x 24 ⅜ in.)
Collection of Crab Tree Farm
Chap. 1, fig. 19

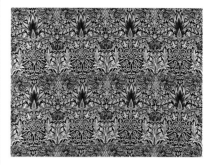

93

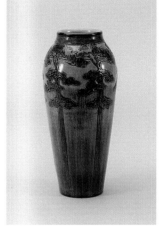

102

POMO (Northern California, United States)

104
Made by Sally Burris (American, 1840–1912)
Twined Basketry Bowl
c. 1870/1900
Plant fibers; h. 17.8 x diam. 44.5 cm (7 x 17 ½ in.)
The Art Institute of Chicago, Charles H. and Mary
F. S. Worcester Collection Fund, 2007.213
Chap. 3, fig. 28

106

JESSIE M. PRESTON
(American, 1873–after 1942)

105
Chicago, Illinois
Candelabra
1902/05
Bronze; 49.9 x 34.3 x 33 cm (19 ⅝ x 13 ½ x 13 in.)
The Art Institute of Chicago, restricted gift of Celia
and David C. Hilliard, 2003.170
Chap. 5, fig. 10

106
Chicago, Illinois
Necklace
1904/05
Gold-washed silver and opal; 35 x 4.5 cm
(13 ¾ x 1 ¾ in.)
The Art Institute of Chicago, restricted gift of
Neville and John H. Bryan; through prior
acquisition of various donors, 2006.34

**AUGUSTUS WELBY NORTHMORE
PUGIN** (English, 1812–1852)

107
Hall Chair
c. 1840
Oak; 95 x 40 x 45 cm (37 ⅜ x 15 ¾ x 17 ¾ in.)
Private collection
Chap. 1, fig. 3

108
Minton and Company, Stoke-on-Trent, England
Dessert Plate
c. 1849
Glazed stoneware with molded relief and underglaze
painted and overglaze gilt decoration; diam. 23.5 cm
(9 ¼ in.)
The David and Alfred Smart Museum of Art,
University of Chicago, gift of Patricia John in
memory of Richard Louis John
Chap. 1, fig. 2

109
John Hardman and Company, Birmingham, England
Model Chalice
c. 1849
Base metal, gilt and set with enamels and
semiprecious stones; h. 26 cm (10 ¼ in.)
The Art Institute of Chicago, Bessie Bennett Fund,
1981.640
Chap. 1, fig. 4

ADELAIDE ALSOP ROBINEAU
(American, 1865–1929)

110
Syracuse, New York
Vase
1926
Glazed porcelain; 12.7 x 13 x 13 cm
(5 x 5 ⅛ x 5 ⅛ in.)
The Art Institute of Chicago, gift of Mr. and Mrs.
Morris S. Weeden through the Antiquarian Society,
1999.294
Chap. 3, fig. 21

CHARLES ROHLFS (American, 1853–1936)

111
Buffalo, New York
Hall Chair
c. 1900
Oak with original black stain; 144.8 x 48.3 x
38.7 cm (57 x 19 x 15 ¼ in.)
The Art Institute of Chicago, gift of the
Antiquarian Society through Mrs. Eric Oldberg and
Mr. and Mrs. Morris S. Weeden, 1998.2
Chap. 3, fig. 14

ROOKWOOD POTTERY (Cincinnati, Ohio)

112
Decorated by Martin Rettig (American, 1866–1956)
Small Jug with Handle
1883
Glazed stoneware with underglaze slip-painted
decoration and overglaze gilded decoration;
11.7 x 8.9 x 8.3 cm (4 ⅝ x 3 ½ x 3 ¼ in.)
The David and Alfred Smart Museum of Art,
University of Chicago, gift of Carol Bowman
Stocking
Chap. 2, fig. 19

113
Decorated by Artus van Briggle (American,
1869–1904)
Vase
1897
Glazed stoneware; h. 33.7 x diam. 14.6 cm
(13 ¼ x 5 ¾ in.)
Collection of Crab Tree Farm
Chap. 3, fig. 33

114
Decorated by Kitaro Shirayamadani (Japanese,
1865–1948)
Vase
1908
Earthenware with slip-painted decoration under a
matt vellum glaze; h. 40 x diam. 14.6 cm (15 ¾ x
5 ¾ in.)
The David and Alfred Smart Museum of Art,
University of Chicago, gift of Mr. and Mrs. Leon
Despres
Chap. 2, fig. 20

DANTE GABRIEL ROSSETTI
(English, 1828–1882)

115
Mrs. William Morris Seated in Chair
May 1870
Graphite, with stumping, on ivory wove paper;
50.5 x 35.5 cm (19 ⅞ x 14 in.)
The Art Institute of Chicago, Charles Deering
Collection, 1927.5296
Chap. 1, fig. 11

116
Beata Beatrix
1872
Oil on canvas; 87.5 x 69.3 cm (34 ⁷⁄₁₆ x 27 ¼ in.)
The Art Institute of Chicago, Charles L.
Hutchinson Collection, 1925.722
Chap. 1, fig. 6

ROYCROFT (East Aurora, New York)

117
Written by Elbert Hubbard (American, 1856–1915)
Illustrated by Bertha Hubbard (American, 1861–1946)
Page from *These Pages Recount Little Journeys Made to
the Homes of Ruskin and Turner*
1896
Letterpress print and watercolor on Japanese vellum;
22 x 16 cm (8 ⅝ x 6 ⁵⁄₁₆ in.)
McCormick Library of Special Collections,
Northwestern University Library
Chap. 3, fig. 4

118
Written by Washington Irving (American, 1783–1859)
Designed by Dard Hunter (American, 1883–1966)
Page from *Rip van Winkle*
1905
Woodcut on ivory wove paper;
22 x 13 cm (8 ⅝ x 5 ⅛ in.)
McCormick Library of Special Collections,
Northwestern University Library
Chap. 3, fig. 6

119
Written by Elbert Hubbard (American, 1856–1915)
and Alice Hubbard (1861–1915)
Designed by Dard Hunter (American, 1883–1966)
Title page from *Justinian and Theodora: A Drama
Being a Chapter of History and the One Gleam of Light
During the Dark Ages*
1906
Letterpress print on ivory wove paper;
26 x 21 cm (10 ¼ x 8 ¼ in.)
McCormick Library of Special Collections,
Northwestern University Library
Chap. 3, fig. 7

120
Designed by Dard Hunter (American, 1883–1966)
Vase
c. 1906
Porcelain; h. 23.5 x diam. 15.2 cm (9 ¼ x 6 in.)
The Art Institute of Chicago, through prior
acquisition of the Antiquarian Society through the
Jessie Spalding Landon Fund, 2003.75
Chap. 3, fig. 8

121
Designed by Karl Kipp (American, active c. 1908–31)
Trapezoidal Vase
1910
Copper and German silver; 17.2 x 5.7 x 5.7 cm
(6 ¾ x 2 ¼ x 2 ¼ in.)
Collection of Crab Tree Farm
Chap. 3, fig. 9

122
Designed by Karl Kipp (American, active c. 1908–31)
Egyptian Flower Holder (Buttress Vase)
c. 1912
Copper and German silver; 19.7 x 7.9 x 10.8 cm
(7 ¾ x 3 ⅛ x 4 ¼ in.)
Collection of Crab Tree Farm
Chap. 3, fig. 10

123
Designed by Victor Toothaker (American, 1882–1932)
American Beauty Vase
c. 1913
Copper; h. 57.2 x diam. 20.3 cm (22 ½ x 8 in.)
Collection of Crab Tree Farm
Chap. 3, fig. 11

JOHN RUSKIN (English, 1819–1900)

124
Byzantine Column Capital
1839/1900
Pen and black ink with brush and gray wash and
white gouache, over traces of graphite, on cream
wove paper; 10.8 x 16.2 cm (4 ¼ x 6 ⅜ in.)
The Art Institute of Chicago, gift of Mrs. Chauncey
McCormick, 1942.194

ISAAC ELWOOD SCOTT
(American, 1845–1920)

125
Chelsea Keramic Art Works, Chelsea, Massachusetts
Pilgrim Bottle
1879
Unglazed earthenware; 36.8 x 27.3 cm
(14 ½ x 10 ¾ in.)
Glessner House Museum, Chicago
Chap. 5, fig. 5

126
Chicago, Illinois
Frame
c. 1880
Walnut; 85.1 x 99.1 cm (33 ½ x 39 in.)
Glessner House Museum, Chicago
Chap. 5, fig. 4

SHREVE, CRUMP AND LOW COMPANY
(Boston, Massachusetts)

127
Two-Handled Dish
1902/14
Silver and turquoise; 5.7 x 29.2 x 10.8 cm
(2 ¼ x 11 ½ x 4 ¼ in.)
The Art Institute of Chicago, restricted gift of
Mr. and Mrs. Robert A. Kubicek, 1982.206

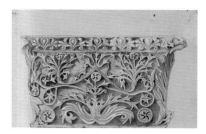

124

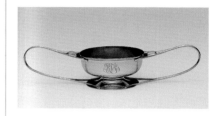

127

129

ELLEN GATES STARR
(American, 1859–1940)

128
Written by Alexander Gilchrist (English, 1828–1861)
Life of William Blake, Pictor Ignotus, Volume 1
Printed in 1863; bound in 1913
Leather, silk thread, and paper; 23 x 15.2 x 3.3 cm
(9 ¹⁄₁₆ x 6 x 1 ⁵⁄₁₆ in.)
Special Collections, University of Illinois at
Chicago Library
Chap. 5, fig. 1

129
Written by Henry Thornton Wharton (English, 1846–1895)
Sappho
Printed in 1885; bound in 1902
Leather, silk thread, and paper; 17.6 x 11.1 x 2 cm
(6 ¹⁵⁄₁₆ x 4 ⅜ x ¾ in.)
Special Collections, University of Illinois at
Chicago Library

EDWARD STEICHEN
(American, born Luxembourg, 1879–1973)

130
The Pool
1900
Platinum print with hand-darkened edges;
21.3 x 16.1 cm (8 ⅜ x 6 ⁵⁄₁₆ in.)
The Art Institute of Chicago, Alfred Stieglitz
Collection, 1949.873
Chap. 4, fig. 25

131
Self-Portrait with Brush and Palette
1902
Gum-bichromate print; 26.7 x 20 cm
(10 ½ x 7 ⅞ in.)
The Art Institute of Chicago, Alfred Stieglitz
Collection, 1949.823
Chap. 4, fig. 27

132
Midnight Lake George
1904
Gum bichromate over platinum print;
39.2 x 50.6 cm (15 ⅜ x 19 ⅞ in.)
The Art Institute of Chicago, Alfred Stieglitz
Collection, 1949.829
Chap. 4, fig. 28

133
Midnight Lake George
1904
Gum bichromate over platinum print;
39.5 x 48.7 cm (15 ½ x 19 ⅛ in.)
The Art Institute of Chicago, Alfred Stieglitz
Collection, 1949.830
Chap. 4, fig. 29

GUSTAV STICKLEY (American, 1858–1942)

134
United Crafts, Eastwood, New York
Celandine Tea Table (no. 27)
c. 1900
Oak; 61 x 50.8 x 51.1 cm (24 x 20 x 20 ⅛ in.)
Collection of Crab Tree Farm
Chap. 3, fig. 13

135
Carpet
1900/10
Cotton, paper, and wool, weft-faced complementary
weft plain weave with inner warps; 210.7 x 118.9 cm
(82 ⅞ x 46 ¾ in.)
The Art Institute of Chicago, gift of Mr. and Mrs.
John J. Evans
1971.685
Chap. 3, fig. 31

136
United Crafts, Eastwood, New York
Armchair (no. 2342)
1901
Oak and leather; 102.8 x 79.4 x 91.4 cm
(40 ½ x 31 ¼ x 36 in.)
Collection of Crab Tree Farm
Chap. 3, fig. 15

137
United Crafts, Eastwood, New York
Seth Thomas Clockworks, Thomaston, Connecticut
Hall Clock (no. 3)
1902
Oak and brass; 80.4 x 53.3 x 33 cm
(31 ⅝ x 21 x 13 in.)
Collection of Crab Tree Farm
Chap. 3, fig. 18

138
United Crafts, Eastwood, New York
Library Table (no. 410-L)
1902
Mahogany, leather, and brass; 76.6 x 123.8 x 142.2
cm (30 ³⁄₁₆ x 48 ¾ x 56 in.)
Collection of Crab Tree Farm
Chap. 3, fig. 16

139
United Crafts, Eastwood, New York
Settle
c. 1903
Oak; 167.3 x 144.8 x 50.8 cm (65 ⅞ x 57 x 20 in.)
Collection of Crab Tree Farm
Chap. 3, fig. 19

140
Designed by Harvey Ellis (American, 1852–1904)
Craftsman Workshops, Eastwood, New York
Cube Chair
1903/04
Oak with pewter, copper, and tinted wood inlay;
71.8 x 66 x 70.8 cm (28 ³⁄₁₆ x 26 x 27 ⅞ in.)
Collection of Crab Tree Farm
Chap. 3, fig. 25

141
Designed by Harvey Ellis (American, 1852–1904)
Craftsman Workshops, Eastwood, New York
Drop-Front Desk
1903/04
Oak with pewter, copper, and tinted wood inlay;
overall: 151.1 x 141 x 2.5 cm (59 ½ x 55 ½ x 1 in.)
Collection of Crab Tree Farm
Chap. 3, fig. 22

142
Craftsman Workshops, Eastwood and Syracuse,
New York
Rose Motif Three-fold Screen
1905
Oak, canvas, leather, and linen; 151.1 x 141 x 2.5
cm (59 ½ x 55 ½ x 1 in.)
Collection of Crab Tree Farm
Chap. 3, fig. 38

143
Craftsman Workshops, Eastwood, New York
Spindle Settle (no. 286)
1905
Mahogany; 124.5 x 119.7 x 64.8 cm
(49 x 47 ⅛ x 25 ½ in.)
Collection of Crab Tree Farm
Chap. 3, fig. 27

144
Craftsman Workshops, Syracuse, New York
Seed Pod Wall Plaque
c. 1905
Copper; diam. 50.5 cm (19 ⅞ in.)
Collection of Crab Tree Farm

145
Craftsman Workshops, Syracuse, New York
China Tree Table Runner
1908
Linen; 189.2 x 41.9 cm (74 ½ x 16 ½ in.)
Collection of Crab Tree Farm

ALFRED STIEGLITZ (American, 1864–1946)

146
Early Morn
1894
Photogravure; 14 x 19.8 cm (5 ½ x 7 ¹³⁄₁₆ in.)
The Art Institute of Chicago, gift of Daniel,
Richard, and Jonathan Logan, 1984.1628
Chap. 4, fig. 17

147
The Net Mender
1894
Carbon print; 41.9 x 54.4 cm (16 ½ x 21 ⅜ in.)
The Art Institute of Chicago, Alfred Stieglitz
Collection, 1949.690
Chap. 4, fig. 16

148
Scurrying Home
1897
Photogravure; 17.8 x 14.6 cm (7 x 5 ¾ in.)
The Art Institute of Chicago, Alfred Stieglitz
Collection, 1949.889
Chap. 4, fig. 18

149
Spring Showers
1901
Photogravure; 30.8 x 12.6 cm (12 ⅛ x 4 ¹⁵⁄₁₆ in.)
The Art Institute of Chicago, Alfred Stieglitz
Collection, 1949.849
Chap. 4, fig. 9

LOUIS H. SULLIVAN (American, 1856–1924)

150
Adler and Sullivan
Made by Healy and Millet, Chicago, Illinois
Stencil
Made for the Chicago Stock Exchange Trading Room
1893/94
Oil on canvas, mounted on panel; 145.42 x
307.42 cm (57 ¼ x 121 in.)
The Art Institute of Chicago, gift of Mr. and Mrs.
Arthur D. Dubin, 1971.747
Chap. 5, fig. 18

151
Designed by Louis H. Sullivan and George
Grant Elmslie
Section of a Screen from Third Floor Writing Room
Made for Schlesinger and Mayer Company Store
1899/1904
Five layers of fret-sawn mahogany; 35 x 35 x 2.5 cm
(13 ¾ x 13 ¾ x 1 in.)
The Art Institute of Chicago, gift of George Fred
Keck, 1970.1198

152
Louis H. Sullivan with George Grant Elmslie
Winslow Brothers Company, Chicago, Illinois
Teller's Wicket
Made for the National Farmers Bank, Owatonna,
Minnesota
1906/08
Copper-plated cast iron; 57.8 x 104.1 cm
(22 ¾ x 41 in.)
The Art Institute of Chicago, gift of Winslow Bros.
Co., 1908.73
Chap. 5, fig. 19

TECO POTTERY (Gates Potteries, a division of the
American Terra Cotta Tiles Works, Terra Cotta, Illinois)

153
Designed by Hugh Mackie Gordon Garden
(American, born Canada, 1873–1961)
Jardinière (shape 106)
c. 1903
Glazed earthenware; 22.9 x 30.5 cm (9 x 12 in.)
Collection of Crab Tree Farm
Chap. 5, fig. 11

154
Designed by Fritz Albert (American, born Alsace-
Lorraine, 1865–1940)
Vase
c. 1905
Glazed earthenware; 45.7 x 15.9 x 15.9 cm
(18 x 6 ¼ x 6 ¼ in.)
The Art Institute of Chicago, promised gift of Crab
Tree Farm Foundation, 557.2005
Chap. 5, fig. 12

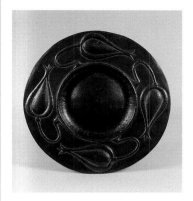

144

145

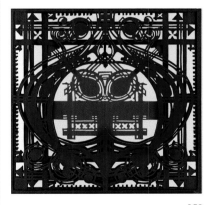

151

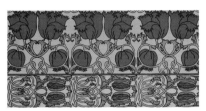

156

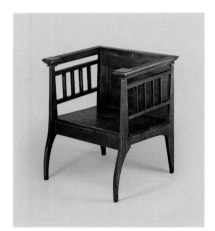

157

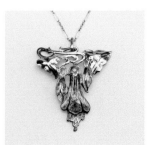

158

162

TIFFANY STUDIOS (Corona, New York)

155
Design attributed to Clara Pierce Wolcott Driscoll
(American, 1861–1944)
*Hanging Head Dragonfly Shade on Mosaic and
Turtleback Base*
By 1906
Favrile glass and bronze; h. 86.4 x diam. 57.2 cm
(34 x 22 ½ in.)
The Art Institute of Chicago, Roger and J. Peter
McCormick endowments, Robert Allerton Purchase
Fund, Goodman Endowment for the Collection of
the Friends of American Art, Pauline S. Armstrong
Endowment, Edward E. Ayer Endowment in memory
of Charles L. Hutchinson; restricted gift of the
Antiquarian Society in memory of Helen Richman
Gilbert and Lena Turnbull Gilbert, Sandra van den
Broek, Mr. and Mrs. Henry M. Buchbinder, Quinn
E. Delaney, Mr. and Mrs. Wesley M. Dixon, Jamee
and Marshall Field, Celia and David Hilliard,
Elizabeth Souder Louis, Mrs. Herbert A. Vance, and
Mr. and Mrs. Morris S. Weeden, 2006.2
Chap. 2, fig. 29

DIRK VAN ERP
(American, born Netherlands, 1859–1933)

156
Dirk Van Erp Studios, San Francisco, California
Lamp
1911
Copper and mica; 36.8 x 43.2 cm (14 ½ x 17 in.)
Collection of Crab Tree Farm

CHARLES FRANCIS ANNESLEY VOYSEY
(English, 1857–1941)

157
G. P. and J. Baker, Ltd., probably for Liberty and
Company
Panel Entitled "Poppies"
1888/95
Cotton; block printed; 63.5 x 120 cm
(25 x 47 ¼ in.); with frame: 73 x 129.5 cm
(28 ¾ x 51 in.)
Collection of Crab Tree Farm

158
Armchair
c. 1889
Oak; 76.2 x 62.6 x 51.1 cm (30 x 24 ⅝ x 20 ⅛ in.)
Private collection

159
Alexander Morton and Company, Darvel, Scotland
"Oswin" Retailer's Sample Panel
1896
Woven wool, double cloth; with frame: 233.1 x
170.2 cm (91 ¾ x 67 in.)
Collection of Crab Tree Farm
Chap. 1, fig. 26

160
Story and Company, London, England
Dining Chair
1898
Oak and rush; 132.1 x 40.6 x 48.3 cm
(52 x 16 x 19 in.)
Private collection
Chap. 1, fig. 28

161
Alexander Morton and Company, Darvel, Scotland
Panel Entitled "Purple Bird"
c. 1899
Wild silk and cotton, three-color complementary
weft plain weave, double cloth; 297.1 x 116.5 cm
(117 x 45 ⅞ in.); repeat: 76.8 x 20.1 cm (30 ¼ x
7 ⅞ in.)
The Art Institute of Chicago, Louise Lutz
Endowment, 1989.561
Chap. 1, fig. 27

MILDRED WATKINS (American, 1883–1968)

162
Cleveland, Ohio
Pendant and Chain
1904/14
Silver and enamel; 4.5 x 4 cm (1 ¾ x 1 ½ in.)
The Art Institute of Chicago, Dr. Julian Archie
Endowment; Neighbors of Kenilworth, Edgar J.
Schoen, and the Village Associates of the Woman's
Board of the Art Institute of Chicago funds,
1988.454a–b

EVA WATSON-SCHÜTZE
(American, 1867–1935)

163
Jane Addams
1910
Platinum print with mercury and graphite;
16 x 20.3 cm (6 ⁵⁄₁₆ x 8 in.)
Special Collections Research Center, the University
of Chicago Library
Chap. 4, fig. 22

CLARENCE H. WHITE
(American, 1871–1925)

164
Sunlight
1901
Platinum print; 20.7 x 15.7 cm (8 ⅛ x 6 ³⁄₁₆ in.)
The Art Institute of Chicago, Alfred Stieglitz
Collection, 1949.855
Chap. 4, fig. 20

FRANK LLOYD WRIGHT
(American, 1867–1959)

165
James A. Miller and Brother, Chicago, Illinois
Weed Holder
1893/1902
Copper; 72.4 x 12.7 cm (28 ½ x 5 in.)
Collection of Frank Lloyd Wright Preservation
Trust, Oak Park, Illinois
Chap. 5, fig. 32

166
James A. Miller and Brother, Chicago, Illinois
Urn
1895/1900
Copper; 45.1 x 48.9 cm (17 ¾ x 19 ¼ in.)
Collection of Frank Lloyd Wright Preservation
Trust, Oak Park, Illinois
Chap. 5, fig. 33

167
John W. Ayers, Chicago, Illinois
Library Table
Made for the Charles E. Roberts House, Oak Park,
Illinois
1896
Oak and pine; 77.9 x 120.7 x 121.3 cm (30 ⅝ x 47 ½
x 47 ¾ in.)
The Art Institute of Chicago, gift of Mr. Roger
White in memory of Mr. Charles E. Roberts,
1966.389
Chap. 5, fig. 25

168
Written by William C. Gannett (American,
1840–1923)
Designed and printed by Frank Lloyd Wright
Published by Auvergne Press, River Forest, Illinois
Title page from *The House Beautiful*
1896–97
Letterpress print on ivory wove paper; 35.9 x 30.5 x
1.8 cm (14 ⅛ x 12 x ¾ in.)
The Art Institute of Chicago, Ryerson and Burnham
Libraries

169
Spindle Cube Chair
Made for the Frank Lloyd Wright Home and Studio,
Oak Park, Illinois
1902/06
Poplar and leather; 73.7 x 73.7 x 73.7 cm
(29 x 29 x 29 in.)
The Art Institute of Chicago, restricted gift of the
Antiquarian Society; Roger McCormick Purchase,
Alyce and Edwin DeCosta and the Walter E. Heller
Foundation, Robert Allerton Purchase Income, Ada
Turnbull Hertle, and Mary Waller Langhorne
Memorial funds; Robert Allerton Trust; Pauline
Seipp Armstrong Fund; Bequest of Ruth Falkenau
Fund in memory of her parents; Mrs. Wendell
Fentress Ott, Bessie Bennett, Elizabeth R. Vaughn,
and Gladys N. Anderson funds; Estate of Stacia
Fischer; The Goodman Fund; Maurice D. Galleher
Endowment; Samuel P. Avery and Charles U. Harris
Endowed Acquisition funds; Estate of Cora
Abrahamson; Charles R. and Janice Feldstein
Endowment Fund for Decorative Arts, 2007.79
Chap. 5, fig. 27

170
Side Chair
Made for the Larkin Administration Building,
Employee Dining Area, Buffalo, New York
1904
Oak; 95.4 x 35.6 x 49.5 cm (37 ½ x 14 x 19 ½ in.)
The Art Institute of Chicago, Bessie Bennett Fund,
1977.523

171
Linden Glass Company, Chicago, Illinois
Tree of Life Window
Made for the Darwin D. Martin House, Buffalo,
New York
1904
Clear, translucent, and colored glass in brass-coated,
copper plated zinc cames, mounted in wood frame;
105.4 x 66.7 cm (41 ½ x 26 ¼ in.); frame: approx.
112.1 x 73 x 2.9 cm (44 ⅛ x 28 ¾ x 1 ⅛ in.)
The Art Institute of Chicago, gift of the
Antiquarian Society through the Mrs. Philip K.
Wrigley Fund, 1972.297
Chap. 5, fig. 38

172
Dining Table and Six Chairs
Made for the Frederick C. Robie House, Chicago,
Illinois
1908/10
Table: Oak, leaded, colored, and opaque glass, and
ceramic; 140 x 244.5 x 135.9 cm (55 ⅝ x 96 ¼ x
53 ½ in.)
Chairs: Oak and (replacement) upholstered seat;
h. 132.8 cm (52 ⅜ in.)
The David and Alfred Smart Museum of Art,
University of Chicago
Chap. 5, fig. 29

173
Frank Lloyd Wright and George Mann Neidecken
(American, 1878–1945)
Desk
Made for the Avery Coonley House, Riverside,
Illinois
1908
Oak; 144.9 x 102 x 60.6 cm (57 x 40 ⅛ x 23 ⅞ in.)
The Art Institute of Chicago, restricted gift of the
Graham Foundation for Advanced Studies in the
Fine Arts, 1972.304
Chap. 5, fig. 36

174
Triptych Window
Made for the Playhouse of the Avery Coonley
House, Riverside, Illinois
1912
Clear and colored leaded glass in oak frames; center
panel: 89.5 x 109.2 cm (35 ¼ x 43 in.); two side
panels each: 91.4 x 19.7 cm (36 x 7 ¾ in.)
The Art Institute of Chicago, restricted gift of Dr.
and Mrs. Edwin J. DeCosta and the Walter E. Heller
Foundation, 1986.88
Chap. 5, fig. 37

YOKUTS (Central or Southern California,
United States)

175
Bottleneck Feather Basket
c. 1900
Plant fibers, feathers, and wool; h. 14 x diam. 30.5
cm (5 ½ x 12 in.)
The Art Institute of Chicago, Louise Benton
Wagner Endowment, 2001.47
Chap. 3, fig. 29

MARIE ZIMMERMANN
(American, 1879–1972)

176
New York, New York
Brooch
c. 1920
Gold, amber, and opals; 4.1 x 5.7 cm
(1 ⅝ x 2 ¼ in.)
The Art Institute of Chicago, Raymond W. Garbe
Fund in honor of Carl A. Erikson, Sr., 2007.463

168

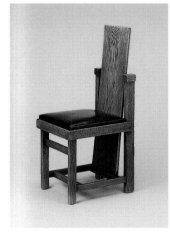

170

176

SELECTED BIBLIOGRAPHY

Alcock, Rutherford. 1862. *Catalogue of Works of Industry and Art, Sent from Japan.* William Clowes and Sons.

———. 1878. *Art and Art Industries of Japan.* Repr., Virtue, 1995.

Allan, Sidney [Sadakichi Hartmann]. 1903a. "The Influence of Artistic Photography on Interior Decoration." *Camera Work* 2 (April), pp. 31–33.

———. 1903b. "A Visit to Steichen's Studio." *Camera Work* 2 (April), pp. 25–28.

———. 1904. "The Photo-Secession, A New Pictorial Movement." *Craftsman* 6, 1 (April), pp. 30–37.

Annan, James Craig. 1910. "Photography as a Means of Artistic Expression." *Camera Work* 32 (October), pp. 21–24.

Aslin, Elizabeth. 1986. *E. W. Godwin: Furniture and Interior Decoration.* John Murray.

Baker, Cathleen A. 1999. "The Lonhuda Art Pottery at Steubenville." *Style 1900* 12, 2 (Spring/Summer), pp. 53–57.

———. 2000. *By His Own Labor: The Biography of Dard Hunter.* Oak Knoll Press.

Barter, Judith A. 1995. "The Prairie School and Decorative Arts at the Art Institute of Chicago." *The Prairie School: Design Vision for the Midwest.* Art Institute of Chicago Museum Studies 21, 2 (Fall), pp. 113–33.

———. 2003. *Window on the West: Chicago and the Art of the New Frontier, 1890–1940.* Exh. cat. Art Institute of Chicago.

Batchelder, Ernest. 1907. "Design in Theory and Practice: A Series of Lessons." *Craftsman* 13, 1 (October), pp. 82–89.

Bicknell, George. 1906. "The New Art in Photography: Work of Clarence H. White, A Leader among the Photo-Secessionists." *Craftsman* 9, 4 (January), pp. 495–510.

Bing, Siegfried. 1896. *La culture artistique en Amérique* [Artistic America, Tiffany Glass, and Art Nouveau]. Translated by Benita Eisler. Edited by Robert Koch. M.I.T. Press, 1970.

Binns, Charles Fergus. 1903. "Building in Clay." *Craftsman* 4, 4 (July), p. 303.

Blanchon, H.-L. Alphonse. 1902. "The Revival of the Lesser Arts in Foreign Countries." Translated by Irene Sargent. *Craftsman* 3, 2 (November), p. 76.

Block, Jean F. 1985. *Eva Watson Schütze: Chicago Photo-Secessionist.* University of Chicago Library.

Boris, Eileen. 1986. *Art and Labor: Ruskin, Morris, and the Craftsman Ideal in America.* Temple University Press.

———. 1987. "'Dreams of Brotherhood and Beauty': The Social Ideas of the Arts and Crafts Movement." In Kaplan 1987, pp. 208–22.

Bosley, Edward R. 2000. *Greene and Greene.* Phaidon.

Bosley, Edward R., and Anne E. Mallek, eds. 2008. *A New and Native Beauty: The Art and Craft of Greene and Greene.* Exh. cat. Merrell/Gamble House.

Bowman, Leslie Greene. 1990. *American Arts and Crafts: Virtue in Design.* Los Angeles County Museum of Art/Bulfinch.

Brandon-Jones, John, ed. 1978. *C. F. A. Voysey: Architect and Designer, 1857–1941.* Exh. cat. Lund Humphries.

Brooks, H. Allen. 1972. *The Prairie School: Frank Lloyd Wright and His Midwest Contemporaries.* University of Toronto Press.

Brosterman, Norman. 1997. *Inventing Kindergarten.* Abrams.

Buchanan, William. 1992. *The Art of the Photographer J. Craig Annan, 1864–1946.* Exh. cat. National Galleries of Scotland.

Buck, Mertice MacCrea. 1907. "The Crafts." *Keramic Studio* 11, 7 (November), p. 171.

Bunnell, Peter C. 1986. *Clarence H. White: The Reverence for Beauty.* Exh. cat. Ohio University Gallery of Fine Art.

Burke, Doreen Bolger, et al. 1986. *In Pursuit of Beauty: Americans and the Aesthetic Movement,* Exh. cat. Metropolitan Museum of Art.

Caffin, Charles H. 1906. "The Recent Exhibitions—Some Impressions." *Camera Work* 16 (October), pp. 33–37.

———. 1910. "The Art of Eduard J. Steichen." *Camera Work* 30 (April), pp. 33–36.

Callen, Anthea. 1979. *Angel in the Studio: Women in the Arts and Crafts Movement 1870–1914.* Astragal Books.

Cathers, David M. 1996a. "The Craftsman Designs of LeMont A. Warner." *Style 1900* 9, 3–4 (Summer/Fall), pp. 38–41 and 44–48.

———. 1996b. *Furniture of the American Arts and Crafts Movement.* Turn of the Century Editions.

———. 2003. *Gustav Stickley.* Phaidon.

Chong, Alan, and Noriko Murai. 2009. *Journeys East: Isabella Stewart Gardner and Asia*. Exh. cat. Isabella Stewart Gardner Museum.

Clancy, Jonathan, and Martin Eidelberg. 2008. *Beauty in Common Things: American Arts and Crafts Pottery from the Two Red Roses Foundation*. Exh. cat. Two Red Roses Foundation.

———. 2008–09. "Marblehead Revisited: The Myth of Hannah Tutt." *Style 1900* (Winter), pp. 62–69.

Clark, Robert Judson, ed. 1972. *The Arts and Crafts Movement in America*. Exh. cat. Princeton University Press.

Cohodas, Marvin. 1992. "Louisa Keyser and the Cohns: Mythmaking and Basketmaking in the American West." In *The Early Years of Native American Art History*, edited by Janet Catherine Berlo, pp. 88–113. University of Washington Press.

Coles, Claudia Stuart. 1900. "Aboriginal Basketry in the United States." *House Beautiful* 7, 3 (February), pp. 142–51.

Cooke, Edward S., Jr. 2008. "An International Studio: The Furniture Collaborations of the Greenes and the Halls." In Bosley and Mallek 2008, pp. 111–30.

Cookman, Claude. 1998. "Edward Steichen's Self-Portraits." *History of Photography* 22, 1 (Spring), pp. 65–71.

Cooley, Edith L. 1900. "Navajo Blankets." *House Beautiful* 7, 5 (April), pp. 302–07.

Crane, Walter. 1897. "William Morris." *Scribner's* (July), pp. 96–97.

———. 1907. *An Artist's Reminiscences*. 2nd ed. Metheun.

Crawford, Alan. 1985. *C. R. Ashbee: Architect, Designer and Romantic Socialist*. Yale University Press.

———. 1998. "Burne-Jones as a Decorative Artist." In *Edward Burne-Jones: Victorian Artist-Dreamer*, edited by Stephen Wildman and John Christian, pp. 5–23. Exh. cat. Metropolitan Museum of Art.

Cunningham, Joseph. 2008a. *The Artistic Furniture of Charles Rohlfs*. Exh. cat. American Decorative Art 1900 Foundation/Yale University Press.

———. 2008b. "Conversations in Western New York: Charles Rohlfs and Gustav Stickley." *Magazine Antiques* 173, 5 (May), pp. 120–29.

Darby, Michael. 1974. "Owen Jones and the Eastern Ideal." Ph.D. diss., University of Reading.

Darling, Sharon S. 1977. "Arts and Crafts Shops in the Fine Arts Building." *Chicago History* 6 (Summer), pp. 79–85.

Dietrich, E. G. W. 1903. "The Cottage Quality." *Craftsman* 3, 5 (February), pp. 280–82.

Dow, Arthur W. 1899. *Composition: A Series of Exercises Selected from a New System of Art Education*. J. M. Bowles.

Dresser, Christopher. 1862. *The Art of Decorative Design*. Day and Son.

———. 1874–76. *Studies in Design*. Cassell, Petter, and Galpin.

———. 1878. "The Art Manufacturers of Japan." *Journal of the Society of Arts* (February 1), pp. 169–78.

Dubin, Margaret. 1999. "Sanctioned Scribes: How Critics and Historians Write the Native American Art World." In *Native American Art in the Twentieth Century*, edited by W. Jackson Rushing, pp. 149–66. Routledge.

Duis, Perry R. 1977. "'Where Is Athens Now?' The Fine Arts Building 1898 to 1918." *Chicago History* 6 (Summer), pp. 66–78.

Dunn, Michael. 2001. *Traditional Japanese Design: Five Tastes*. Exh. cat. Japan Society.

Durant, Stuart. 1990. *The Decorative Designs of C. F. A. Voysey: From the Drawings Collection, the British Architectural Library, the Royal Institute of British Architects*. Lutterworth Press.

Edgerton, Giles [Mary Fanton Roberts]. 1907. "Photography as an Emotional Art: A Study of the Work of Gertrude Käsebier." *Craftsman* 12, 1 (April), pp. 80–93.

Edgewood, Margaret. 1900. "Some Sensible Furniture." *House Beautiful* 8, 6 (November), p. 655.

Egan, Shannon. 2006. "'Yet in a Primitive Condition': Edward S. Curtis's *North American Indian*." *American Art* 20, 3 (Fall), pp. 58–83.

Ehrens, Susan. 1995. *A Poetic Vision: The Photographs of Anne Brigman*. Exh. cat. Santa Barbara Museum of Art.

Ellis, Anita J. 1992. *Rookwood Pottery: The Glorious Gamble*. Exh. cat. Cincinnati Art Museum.

———. 2007. "Rookwood and the American Indian." In *Rookwood and the American Indian: Masterpieces of American Art Pottery from the James J. Gardner Collection*, pp. 69–70, 230–36. Exh. cat. Cincinnati Art Museum/Ohio University Press.

Emerson, Gertrude. 1916. "Marblehead Pottery." *Craftsman* 29, 6 (March), p. 673.

Faulkner, Rupert, and Jackson, Anna. 1995. "The Meiji Period in South Kensington: The Representation of Japan at the Victoria and Albert Museum 1852–1912." In *Meiji No Takara: Treasures of Imperial Japan (The Nassar D. Khalili Collection of Japanese Art)*, edited by Oliver Impey and Malcolm Fairley, pp. 152–95. Kibo Foundation.

Flores, Carol A. Hrvol, 2006. *Owen Jones: Design, Ornament, Architecture, and Theory in An Age of Transition*. Rizzoli.

Fontein, Jan. 1992. "A Brief History of the Collections." In *Selected Masterpieces of Asian Art: Museum of Fine Arts, Boston*, pp. 6–15. Museum of Fine Arts, Boston.

Fowler, Elizabeth J. 2005. "The Rookwood Sage: Kitaro Shirayamadani, Japanism, Art Nouveau, and the American Art Pottery Movement, 1885–1912." Ph.D. diss., University of Minnesota.

Frackelton, Susan Stuart. 1905a. "Our American Potteries: Maratta's and Albert's Work at the Gates Potteries." *Sketch Book* 5 (October), pp. 73–80.

———. 1905b. "Our American Potteries: Teco Ware." *Sketch Book* 5 (September), pp. 13–19.

Galloway, Francesca. 1999. *Arts and Crafts Textiles in Britain*. Fine Art Society.

Gidley, Mick. 1998. *Edward S. Curtis and The North American Indian, Incorporated*. Cambridge University Press.

Godwin, Edward W. 1875. "Japanese Wood Construction." Parts 5 and 6 of "Woodwork." *Building News and Engineering Journal* 28 (February 12), pp. 173–74, 189; 28 (February 19), pp. 200–01, 214.

———. 1876. "My Chambers and What I Did to Them." Parts 1 and 2 of *The Architect* [London] 16, "Chapter 1: A.D. 1867," (July 1), pp. 4–5; "Chapter 2: A.D. 1872," (July 8), pp. 18–19.

Granger, Alfred H. 1899. "An Architect's Studio." *House Beautiful* 7, 1 (December), pp. 36–45.

Gray, Stephen. 1996. *The Early Work of Gustav Stickley*. Turn of the Century Editions.

Green, Jonathan. 1973. Introduction to *Camera Work: A Critical Anthology*. Aperture.

Green, Nancy E., and Jessie Poesch, eds. 1999. *Arthur Wesley Dow and American Arts and Crafts*. Exh. cat. American Federation of Arts.

Greenough, Sarah. 2000. *Modern Art and America: Alfred Stieglitz and His New York Galleries*. Exh. cat. National Gallery of Art/Bulfinch.

———. 2002. *Alfred Stieglitz, The Key Set: The Alfred Stieglitz Collection of Photographs*. 2 vols. National Gallery of Art/Abrams.

Greensted, Mary. 1980. *Gimson and the Barnsleys: "Wonderful Furniture of a Commonplace Kind."* Repr., Evans Bros., 1996.

———, ed. 2005. *An Anthology of the Arts and Crafts Movement: Writings by Ashbee, Lethaby, Gimson and their Contemporaries*. Lund Humphries.

Hall, Herbert J. 1908. "Marblehead Pottery." *Keramic Studio* 10, 2 (June), p. 31.

Hamerton, Ian, ed. 2005. *W. A. S. Benson: Arts and Crafts Luminary and Pioneer of Modern Design*. Antique Collectors' Club.

Hamilton, Emily J. 1907. "Some Symbolic Nature Studies from the Camera of Annie W. Brigman." *Craftsman* 12, 6 (September), pp. 660–66.

Hanks, David A. 1974. *Isaac E. Scott: Reform Furniture in Chicago; John Jacob Glessner House* Chicago School of Architecture Foundation.

Harrington, Elaine. 1987. "International Influences on Henry Hobson Richardson's 'Glessner House.'" In *Chicago Architecture, 1872–1922: The Birth of a Metropolis*, edited by John Zukowsky, pp. 189–207. Exh. cat. Art Institute of Chicago/Prestel.

Havinga, Anne E. 1997. "Pictorialism and Naturalism in New England Photography." In *Inspiring Reform: Boston's Arts and Crafts Movement*, edited by Marilee Boyd Meyer, pp. 134–50. Exh. cat. Davis Museum and Cultural Center.

Herzog, Melanie. 1996. "Aesthetics and Meanings: The Arts and Crafts Movement and the Revival of American Indian Basketry." In *The Substance of Style: Perspectives on the American Arts and Crafts Movement*, edited by Bert Denker, pp. 69–91. Winterthur Museum/ University Press of New England.

Heyman, Therese Thau. 1974. *Anne Brigman: Pictorial Photographer, Pagan, Member of the Photo-Secession*. Exh. cat. Oakland Museum.

Hilliard, Celia. 2002. "'Higher Things,' Remembering the Early Antiquarians." *Gifts Beyond Measure: The Antiquarian Society and European Decorative Arts, 1987–2002.* Art Institute of Chicago Museum Studies 28, 2 (Fall), pp. 6–21.

Hirsch, Susan E. 2003. *After the Strike: A Century of Labor Struggles at Pullman*. University of Illinois Press.

Homer, William Innes, ed. 1977. *Symbolism of Light: The Photographs of Clarence H. White*. Exh. cat. University of Delaware/Delaware Art Museum.

———. 2002. *Stieglitz and the Photo-Secession, 1902*. Edited by Catherine Johnson. Viking Studio.

Hosley, William. 1990. *The Japan Idea: Art and Life in Victorian America*. Exh. cat. Wadsworth Atheneum.

Howe, Samuel. 1902. "A Visit to the House of Mr. Stickley." *Craftsman* 3, 3 (December), pp. 161–69.

Hubbard, Elbert. 1905. "There Is a Difference between Profanity and Dramatic Fervor." *Philistine* 20, 5 (April), p. 138.

Hunter II, Dard. 1981. *The Life Work of Dard Hunter*. Vol. 1. Mountain House Press.

Hutchinson, Elizabeth. 2002. "When the 'Sioux Chief's Party Calls': Käsebier's Indian Portraits and the Gendering of the Artist's Studio." *American Art* 16, 2 (Summer), pp. 40–65.

———. 2009. *Primitivism, Modernism, and Transculturation in American Art, 1890–1915*. Duke University Press.

James, George Wharton. 1901. "Indian Pottery." *House Beautiful* 9, 5 (April), pp. 235–43.

———. 1902. *Indian Basketry*. H. Malkan.

———. 1903a. "A Few Indian Houses." *House Beautiful* 14, 3 (August), pp. 135–39.

———. 1903b. "Primitive Inventions." *Craftsman* 5, 2 (November), pp. 124–37.

———. 1914. *Indian Blankets and Their Makers*. A. C. McClurg.

Jarves, James Jackson. 1876. *A Glimpse at the Art of Japan*. Hurd and Houghton.

Johnson, Arthur W. 1934. *Arthur Wesley Dow: Historian, Artist, Teacher*. Ipswich Historical Society.

Jones, Owen. 1856. *The Grammar of Ornament*. Day and Son.

Kahler, Robert. 1986. "The Arts and Crafts Movement in Chicago: 1897–1910." Ph.D. diss., Purdue University.

Kaplan, Wendy. 1987. *"The Art That Is Life": The Arts and Crafts Movement in America, 1875–1920*. Exh. cat. Museum of Fine Arts, Boston.

———. 2004. *The Arts and Crafts Movement in Europe and America: Design for a Modern World*. Exh. cat. Los Angeles County Museum of Art/Thames and Hudson.

Keith, Henrietta P. 1907. "The Trail of Japanese Influence in Our Modern Domestic Architecture." *Craftsman* 12, 4 (July), pp. 446–51.

Kimmel, Michael. 1987. "The Arts and Crafts Movement: Handmade Socialism or Elite Consumerism?" *Contemporary Sociology* 16, 3 (May), p. 390.

Knight, Louise W. 2005. *Citizen: Jane Addams and the Struggle for Democracy*. University of Chicago Press.

Koch, Robert. 1967. "Elbert Hubbard's Roycrofters as Artist-Craftsmen." *Winterthur Portfolio* 3, pp. 67–82.

Kornwolf, James D. 1972. *M. H. Baillie Scott and the Arts and Crafts Movement*. Johns Hopkins Press.

La Farge, John. 1870. "An Essay on Japanese Art." In *Across America and Asia*, by Raphael Pumpelly, pp. 195–202. Leopold and Holt.

Laidlaw, Christine Wallace. 1996. "The American Reaction to Japanese Art, 1853–1876." Ph.D. diss., Rutgers, the State University of New Jersey.

Lambourne, Lionel. 1980. *Utopian Craftsmen: The Arts and Crafts Movement from the Cotswolds to Chicago*. Astragal Books.

Landow, George P. 1979. "The Art Journal, 1850–1880: Antiquarians, the Medieval Revival, and the Reception of Pre-Raphaelitism." *Pre-Raphaelite Review* 2, pp. 71–76.

Lears, T. J. Jackson. 1981. *No Place of Grace: Antimodernism and the Transformation of American Culture, 1880–1920*. Pantheon.

Livingstone, Karen, and Linda Parry, eds. 2005. *International Arts and Crafts*. Exh. cat. Victoria and Albert Museum.

Long, Christopher. 2007. "The Viennese Secessionsstil and Modern American Design." *Studies in the Decorative Arts* 14, 2 (Spring–Summer), pp. 6–44.

Longwell, Dennis. 1978. *Steichen: The Master Prints 1895–1914, The Symbolist Period*. Exh. cat. Museum of Modern Art, New York.

Maher, Thomas K. 1997. *The Jarvie Shop: The Candlesticks and Metalwork of Robert R. Jarvie*. Turn of the Century Editions.

McCougall, Isabel. 1903. "A William Morris Room." *House Beautiful* 13, 3 (February), pp. 169–77.

McDonald, Ann Gilbert. 1989. *All About Weller*. Antique Publications.

Meech, Julia, and Gabriel P. Weisberg. 1990. *Japonisme Comes to America: The Japanese Impact on the Graphic Arts, 1876–1925*. Exh. cat. Jane Voorhees Zimmerli Art Museum.

Meech-Pekarik, Julia. 2000. *Frank Lloyd Wright and the Art of Japan: The Architect's Other Passion*. Abrams.

Menand, Louis. 2001. *The Metaphysical Club*. Farrar, Straus and Giroux.

Meyer, Marilee Boyd, and Susan J. Montgomery. 2007. "Marblehead Pottery: Simplicity and Restraint." *American Ceramic Circle Journal* 14, pp. 153–74.

Meyerowitz, Joanne J. 1991. *Women Adrift: Independent Wage Earners in Chicago, 1880–1930*. University of Illinois Press.

Michaels, Barbara L. 1992. *Gertrude Käsebier: The Photographer and Her Photographs*. Abrams.

Michels, Eileen Manning. 2004. *Reconfiguring Harvey Ellis*. Beaver's Pond Press.

Montgomery, Susan J. 1993. *The Ceramics of William J. Grueby: The Spirit of the New Idea in Artistic Handicraft*. Arts and Crafts Quarterly Press.

Morris, May. 1936. *Morris as a Socialist*. Vol. 2 of *William Morris: Artist, Writer, Socialist*. Basil Blackwell.

Morris, William. 1893. "Textiles." In *Arts and Crafts Essays*, pp. 22–38. Scribner.

Morse, Edward Sylvester. 1886. *Japanese Homes and Their Surroundings*. Ticknor and Company.

———. 1903. *Catalogue of the Morse Collection of Japanese Pottery*. Repr., C. E. Tuttle, 1979.

Muthesius, Hermann. 1987. *The English House*. Edited by Dennis Sharp. Rizzoli.

Naylor, Gillian, ed. 1988. *William Morris by Himself: Designs and Writings*. New York Graphic Society/Little Brown.

Nichols, George Ward. 1878. *Pottery, How It Is Made, Its Shape and Decoration*. Putnam.

Nute, Kevin. 1993. *Frank Lloyd Wright and Japan: The Role of Traditional Japanese Art and Architecture in the Work of Frank Lloyd Wright*. Chapman and Hall.

O'Gorman, James F. 1991. *Three American Architects: Richardson, Sullivan, and Wright, 1865–1915*. University of Chicago Press.

Pearlstein, Elinor L., and James T. Ulak. 1993. *Asian Art in the Art Institute of Chicago*. Art Institute of Chicago.

Percival, Olive May. 1897. "Indian Basketry: An Aboriginal Art." *House Beautiful* 2, 6 (November), pp. 152–53.

Perry, Mary Chase. 1901. "Grueby Potteries." *Keramic Studio* 2, 12 (April), p. 251.

Peterson, Christian A. 1992. "American Arts and Crafts: The Photograph Beautiful 1895–1915." *History of Photography* 16, 3 (Autumn), pp. 189–232.

———. 1993. *Alfred Stieglitz's "Camera Notes."* Minneapolis Institute of Arts/W. W. Norton and Company.

Pevsner, Nikolaus. 1936. *Pioneers of Modern Design from William Morris to Walter Gropius.* Repr., Museum of Modern Art, New York, 1949.

Poesch, Jessie, and Sally Mann. 2003. *Newcomb Pottery and Crafts: An Educational Enterprise for Women, 1895–1940.* Schiffer.

Pyne, Kathleen. 2007. *Modernism and the Feminine Voice: O'Keeffe and the Women of the Stieglitz Circle.* University of California Press.

Quinan, Jack. 1994. "Elbert Hubbard's Roycroft." In Via and Searl 1994, pp. 3–7.

Reade, Brian. 1967. *Aubrey Beardsley.* Viking.

Reed, Cleota. 1979. "Irene Sargent: Rediscovering a Lost Legend." *Courier* 16, 2 (Summer), pp. 3–13.

———. 1995. "Gustav Stickley and Irene Sargent: United Crafts and the *Craftsman.*" *Courier* 30, pp. 35–50.

Rendell, B. 1901. "Charles Ashbee als Architeckt und Baumeister." *Kunst und Kunsthandwerk* 4, pp. 461–67.

Rice, Wallace. 1902. "Miss Starr's Bookbinding." *House Beautiful* 12, 1 (June), p. 13.

Roberts, Ellen E. 2006. "A Marriage of 'the Extreme East and the Extreme West': Japanism and Aestheticism in Louis Comfort Tiffany's Rooms in the Bella Apartments." *Studies in the Decorative Arts* 13, 2 (Spring–Summer), pp. 2–51.

Ruskin. John. 1849. *The Two Paths, Being Lectures on Art and Its Application to Decoration and Manufacture.* Repr., Smith, Elder, and Company, 1959.

Sanders, Barry. 1996. *A Complex Fate: Gustav Stickley and the Craftsman Movement.* Preservation Press.

Sargent, Irene. 1902. "Private Simplicity as Promotion of Public Art." *Craftsman* 2, 5 (August), pp. 242–43.

———. 1904. "Indian Basketry: Its Structure and Decoration." *Craftsman* 7, 3 (December), pp. 321–34.

Sato, Tomoko, and Toshio Watanabe, eds. 1991. *Japan and Britain: An Aesthetic Dialogue, 1850–1930.* Exh. cat. Lund Humphries/Barbican Art Gallery/Setagaya Art Museum.

Simpson, Duncan. 1979. *C. F. A. Voysey: An Architect of Individuality.* Lund Humphries.

Smith, Carl S. 1995. *Urban Disorder and the Shape of Belief: The Great Chicago Fire, the Haymarket Bomb, and the Model Town of Pullman.* University of Chicago Press.

Smith, Joel. 1999. *Edward Steichen: The Early Years.* Princeton University Press/Metropolitan Museum of Art.

Smith, Mary Ann. 1983. *Gustav Stickley: The Craftsman.* Syracuse University Press.

Soros, Susan Weber, ed. 1999. *E. W. Godwin: Aesthetic Movement Architect and Designer.* Exh. cat. Bard Graduate Center for Studies in the Decorative Arts.

Spencer, Isobel. 1975. *Walter Crane.* Macmillan.

Spencer, Robert C., Jr. 1900. "The Work of Frank Lloyd Wright." *Architectural Review* [Boston] 7, 6 (June), pp. 64–65.

Steichen, Eduard [Edward] J. 1903. "Ye Fakers." *Camera Work* 1 (January), p. 48.

Steichen, Edward. 1963. *A Life in Photography.* W. H. Allen/Museum of Modern Art, New York.

Stickley, Gustav. 1907. *Chips from the Craftsman Workshops, Number One.* Gustav Stickley.

Stieglitz, Alfred, and Louis H. Schubart. 1895. "Two Artists' Haunts." *Photographic Times* 26 (January), pp. 9–12.

Stieglitz, Alfred. c. 2000. *Stieglitz on Photography: His Selected Essays and Notes.* Compiled and annotated by Richard Whelan. Aperture.

Sussman, Herbert L. 1968. *Victorians and the Machine: The Literary Response to Technology.* Harvard University Press.

Thompson, Edward Palmer. 1994. "William Morris." In *Making History: Writings on History and Culture*, pp. 66–76. New Press.

Thurman, Christa C. Mayer. 1993. "Textiles as Documented by the *Craftsman.*" In *The Ideal Home: 1900–1920*, edited by Janet Kardon, pp. 104–05. Exh. cat. American Craft Museum/Abrams.

Trapp, Kenneth R. 1981. "Rookwood and the Japanese Mania in Cincinnati." *Cincinnati Historical Society Bulletin* 39, 1 (Spring), pp. 65–66.

Troy, Nancy J. 1991. *Modernism and the Decorative Arts in France: Art Nouveau to Le Corbusier.* Yale University Press.

Twyman, Joseph. 1904. "The Art and Influence of William Morris." *The Inland Architect and News Record* 42, 6 (January), p. 44.

Ulak, James T. 1995. *Japanese Prints: The Art Institute of Chicago.* Abbeville.

Ullrich, Polly H. 1994. "Women in the Arts and Crafts Movement of Chicago, 1877–1915," MA thesis, School of the Art Institute of Chicago.

Via, Marie, and Marjorie Searl, eds. 1994. *Head, Heart, and Hand: Elbert Hubbard and the Roycrofters.* University of Rochester Press.

Vilain, Jean-François. 1994. "The Roycroft Printing Shops: Books, Magazines, and Ephemera." In Via and Searl 1994, p. 25.

Volpe, Todd M., and Beth Cathers, 1988. *Treasures of the American Arts and Crafts Movement, 1809–1920.* Abrams.

Walsdorf, Jack. 1999. *Elbert Hubbard: William Morris's Greatest Imitator.* Yellow Barn Press.

Washer, Cheryl. 1992. "The Work of Edmund Johnson: Archaeology and Commerce." In *Imagining an Irish Past: The Celtic Revival 1840–1940*, edited by T. J. Edelstein, pp. 107–21. Exh. cat. David and Alfred Smart Museum of Art/University of Chicago Press.

Watanabe, Toshio. 1991. *High Victorian Japonisme.* P. Lang.

Webster, Cecile. 2008. "The Life Work of Dard Hunter." *Art Through the Pages: Library Collections at the Art Institute of Chicago.* Art Institute of Chicago Museum Studies 34, 2 (Fall), pp. 48–49.

Weingarden, Lauren S. 2000. "Louis Sullivan the Spirit of Nature." In *Art Nouveau, 1890–1914*, edited by Paul Greenhalgh, pp. 323–33. Exh. cat. Victoria and Albert Museum.

Weisberg, Gabriel P., Edwin Becker, and Évelyne Possémé, eds. 2004. *The Origins of L'Art Nouveau: The Bing Empire.* Exh. cat. Van Gogh Museum.

White, John P. 1901. *Furniture Made at the Pyghtle Works, Designed by M. H. Baillie Scott.* Bemrose and Sons.

Whiteway, Michael, ed. 2004. *Shock of the Old: Christopher Dresser's Design Revolution.* Exh. cat. Cooper-Hewitt, National Design Museum, Smithsonian Institution.

Williams, Raymond. 1989. *The Politics of Modernism.* Edited by Tony Pinkney. Verso.

Wong, Roberta Waddell. 1971. "Will Bradley: Exponent of American Decorative Illustration at the End of the Nineteenth Century." Ph.D. diss., Johns Hopkins University.

Wood, Debora, ed. 2005. *Marion Mahony Griffin: Drawing the Form of Nature.* Exh. cat. Mary and Leigh Block Museum of Art, Northwestern University.

Wright, Frank Lloyd. 1912. *The Japanese Print: An Interpretation.* Ralph Fletcher Seymour.

———. 1931. "Modern Architecture, Being the Kahn Lectures." Reprinted in *The Essential Frank Lloyd Wright: Critical Writings on Architecture*, edited by Bruce Brooks Pfeiffer, p. 196. Princeton University Press.

———. 1943. *An Autobiography.* Duell, Sloan and Pearce.

Wright, Gwendolyn. 1980. *Moralism and the Modern Home: Domestic Architecture and Cultural Conflict in Chicago, 1873–1913.* University of Chicago Press.

Wynne, Madeline Yale. 1901. "What to Give: Some Christmas Suggestions." *House Beautiful* 11, 1 (Christmas), p. 21.

Zelleke, Ghenete. 1993. "Harmonizing Form and Function: MacKay Hugh Baillie Scott and the Transformation of the Upright Piano." *Notable Acquisitions at the Art Institute of Chicago.* Art Institute of Chicago Museum Studies 19, 2 (Fall), pp. 161–73.

———. 2005. "Telling Stories in the Gothic Vein: William Burgess and the Art of Painted Furniture." *Objects of Desire: Victorian Art at the Art Institute of Chicago.* Art Institute of Chicago Museum Studies 31, 1 (Spring), p. 24.

Zipf, Catherine W. 2007. *Professional Pursuits: Women and the American Arts and Crafts Movement.* University of Tennessee Press.

INDEX OF ARTISTS